Interdisciplinary Per
Reformatting Real

Interdisciplinary Performance
Reformatting Reality

Natasha Lushetich

macmillan education palgrave

First published 2016 by
PALGRAVE

Palgrave in the UK is an imprint of Macmillan Publishers Limited, registered in England, company number 785998, of 4 Crinan Street, London, N1 9XW.

Palgrave Macmillan in the US is a division of St Martin's Press LLC, 175 Fifth Avenue, New York, NY 10010.

Palgrave is a global imprint of the above companies and is represented throughout the world.

Palgrave® and Macmillan® are registered trademarks in the United States, the United Kingdom, Europe and other countries.

ISBN 978–1–137–33502–9 hardback
ISBN 978–1–137–33501–2 paperback

This book is printed on paper suitable for recycling and made from fully managed and sustained forest sources. Logging, pulping and manufacturing processes are expected to conform to the environmental regulations of the country of origin.

A catalogue record for this book is available from the British Library.

A catalog record for this book is available from the Library of Congress.

Cover image: Helen Pynor, *Underneath*, 2006, knitted human hair. Photo by Danny Kildare. Image courtesy of the artist.

Printed in China

Contents

List of Figures vi

Acknowledgements viii

Introduction 1

PART I The Dynamic Turn 13

Chapter 1 Vital Action 15

Chapter 2 The World Becomes 37

Chapter 3 The Quest for Authenticity 61

PART II The Deconstructive Turn 83

Chapter 4 Against Commodity Fetishism 85

Chapter 5 The Way of the Body 107

Chapter 6 Resisting Determination, Resisting Interpretation 125

Chapter 7 Biopower and Female Writing 145

Chapter 8 Identity Politics 167

PART III The Digital Turn 189

Chapter 9 Mixing Reality 191

Chapter 10 Ludic (H)activism 213

Chapter 11 Beyond the Human–Non-Human Divide 235

Epilogue 255

Bibliography 259

Index 277

List of Figures

1.1 Hugo Ball at the Cabaret Voltaire, Zurich 1916 31
2.1 Jean Börlin in René Clair's *Entr'acte*, part of Francis
 Picabia's *Relâche*, 1924 48
3.1 Jackson Pollock act-painting in his studio in East
 Hampton, NY, in 1950 65
3.2 Kazuo Shiraga, *Challenging Mud*, First Gutai Art Exhibition
 at the Ohara Kaikan Hall in Tokyo, 1955 78
4.1 Situationists International détournement, part of *Le Retour
 de la Colonne Durutti (The Return of the Durutti Column)*,
 Situationist comic by André Bertrand, given away at
 Strasbourg University in October 1966 89
4.2 Allan Kaprow's 'women licking jam off a car', from
 happening *Household*, Cornell University, Ithaca,
 NY, 1964 101
5.1 Tatsumi Hijikata, *The Revolt of the Body*, 1968 118
6.1 Yoko Ono, *Sky Piece to Jesus Christ* and *Pieces for Orchestra
 to La Monte Young*, simultaneous performance at Carnegie
 Recital Hall, New York, 1965 135
7.1 ORLAN, *Le baiser de l'artiste (The Artist's Kiss)*, Foire
 Internationale d'Art Contemporain, Grand Palais,
 Paris, 1977 155
7.2 Bobby Baker, *Drawing on a Mother's Experience*,
 ICA, London, 1990 162
8.1 Adrian Piper, *The Mythic Being*, New York, 1973 172
8.2 Coco Fusco and Guillermo Gómez-Peña, *The Couple in the
 Cage or Two Undiscovered Amerindians*, Madrid, 1992 183
9.1 Lynn Hershman, *What's Up?*, 1985. *Phantom Limb Series*,
 1985–1987 192
9.2 Blast Theory, *Can You See Me Now?*, Dutch Electronic
 Arts Festival 2003 207
10.1 The Yes Men, *Management Leisure Suit*, Tempere, 2001 218
10.2 Critical Art Ensemble and Beatriz da Costa, *GenTerra*,
 2001–2003 231

11.1 Oron Catts and Ionat Zurr, *Semi-Living Worry Dolls*,
 The Tissue Culture & Art Project. From the Tissue Culture
 & Art Project Retrospective Crude Life (Laznia Centre for
 Contemporary Art, Gdansk, Poland) 2012 244
11.2 Helen Pynor and Peta Clancy, *The Body is a Big Place*,
 Science Gallery Dublin, 2012 251

Acknowledgements

My deepest thanks go to Karen Savage for the many animated conversations in which the idea for this book was born. I am also indebted to the University of Exeter for granting me research leave to write this book and to the College of Humanities for assisting me administratively and financially in obtaining image reproductions. I would also like to thank Joanna Bucknall, Cathy Turner, Jane Milling and Kara Reilly for all the interesting conversations we've had about the concerns of this book. Most of all, my heartfelt thanks go to my Interdisciplinary Pathway students at Portsmouth and my Intermedia and Live Art students at Exeter for helping me refine ideas about how to approach this task.

I am also deeply grateful to Matt Adams and Blast Theory, Oron Catts and Ionat Zurr, Lynn Hershman, Steve Kurz and Critical Art Ensemble, Jean-Jacques Lebel, Adrian Piper, Helen Pynor, Peta Clancy, Jacques Servin and Igor Vamos for their insightful comments, support, and the permission to reproduce images of their work. Huge thanks are also due to Ken Knabb and Raiji Kuroda for providing invaluable help with the Situationist International and the Zero Jigen material respectively. Last but not least, I would like to thank my editors at Palgrave, Lucy Knight and Clarissa Sutherland for their support and patience much like I would like to thank the staff of the Centre George Pompidou in Paris and MoMA in New York City for their knowledgeable assistance and useful advice. Unless otherwise stated, all translations in this book are mine.

Introduction

Performance

What is the relationship between performance and reality? Can performance in any way alter reality? Can it suggest, create and inaugurate new and different realities? If so, how is this done? This book is best described as an exploration of these questions. It examines the ways in which performance, as a method of enquiry, in particular, performance combined with one or more other disciplines – or, interdisciplinary performance – suggests a reality different from the hitherto existent one. This notion is based on several assumptions, however: first, that reality is socially constructed; second, that performance is a form of *thinking by doing* as well as a form of emergence, not an enactment of a pre-existing idea; and third, that the simultaneous use of two or more disciplines creates an interdisciplinary rather than a multidisciplinary enquiry. Let me deal with each of these assumptions before moving on to clarify the structure of this book and outline its contents.

Often contrasted with illusion, delusion, jokes, dreams and fiction, reality is a meshwork of lived experiences apprehended through the five senses: sight, hearing, smell, touch and taste. But reality is also a social consensus. If you hear of an imminent danger of the entire population of the Earth sliding off the planet because two of the four tortoises have died, you are not very likely to take this information seriously. The reason for this is that four tortoises supporting a flat board – planet Earth – does not correspond to the current scientific conception of the universe. If, however, a friend who is, say, in London tells you that they have just seen another friend's beautiful new Tokyo apartment, you will have no reason to disbelieve them. Skype communication is routine in this day and age. Seeing an apartment located on the other side of the world would not *really* have been possible thirty years ago, however. The technology of the time – analogue photography, film, postal service – would not have allowed it, not within such a short time period. Our notion of reality is dependent on the scientific conceptions of our age as well as on the current state of technology. It is also dependent on cultural and economic conceptions. If your bank manager tells you that the best way to make money is to photocopy

whatever bank notes you happen to have in your wallet as many times as possible, preferably several million times, you will know that this cannot *really* be their financial advice. Money is earned, inherited, financially engineered, even stolen or counterfeited, but not photocopied. Our conception of reality depends on the socio-culturally valid practices, transmitted through institutionalised forms of behaviour as well as through language, which, too, is a technology for communicating lived experiences to the next generation.

Apart from being rooted in scientific, technological and socio-economic notions and linguistic forms, reality is also anchored in the symbolic order. As French psychoanalyst and theorist Jacques Lacan (1997) suggests, the symbolic order refers to the 'imposition of the kingdom of culture on that of nature' through the use of symbols, such as myths (66). The purpose of such an order – an unquestionable set of beliefs on which all other regulations are based – is to provide legitimation for the prevalent social and behavioural structures. For example, the unquestioned belief of the current global world is that life should be preserved, not wasted. Disagreeing with this notion – by purposefully wasting life or killing someone – will, for this reason, not be seen as yet another view among many. It will be seen as a transgression of the rule of all rules and, as such, inadmissible to the realm of debate. When we first come to this world, as infants, we have no scientific, technological, cultural, economic or symbolic conception of reality. We acquire this particular historical and cultural formatting in childhood and adolescence. By the time we reach adulthood, we have a fairly good grip on what is possible, admissible and desirable. The reason for this is habituation or habit formation. Daily performances sediment through repetition and create habits and habitual ways of seeing. Performance thus has much to do with the forging of reality.

Coming from the Old French *parfournir* – which means to complete, to carry out thoroughly – to perform means to do, to execute. It also means to show, to display, to hold up as an example or an explanation of reality. Importantly, to perform also means to achieve, to measure up to a pre-existing norm. There are, of course, many different definitions of performance as well as many different performances. The most pertinent perhaps, for our purposes, is performance scholars Carol Simpson Stern and Bruce Henderson's (1993) claim that the term performance incorporates the entire field of human activity. Consisting of a '*performance act, interactional* in nature and involving *symbolic forms*', performance 'provides a way to constitute meaning and a reality from individual and cultural values' (3, emphasis original). 'Symbolic forms' here refer to any combination of word, movement, object and action, as used in ritual, as well as in

entertainment. As performance scholar Richard Schechner (2003 [1978])
suggests, ritual and entertainment are not separate. Instead, they 'form
two poles of a continuum' (130). While ritual is conspicuously constitutive
because it 'actualizes that which it symbolizes' (127), entertainment is
divested of social authority. An example of a conspicuously constitutive
ritual is the wedding ceremony, which the bride and the groom enter
as two individuals, but which they leave as members of a socially and
legally approved union. Because entertainment is not invested with social
authority – it is not performed by officiants – it cannot be *formally* consti-
tutive of a new reality. But this is not to say that it cannot be performatively
efficacious. Essentially, performance efficacy is the ability of any given per-
formance to bring about a new state of affairs – a new social status, a new
worldview, a new understanding or a new feeling. Anthropologists Sally
Moore and Barbara Myerhoff (1977) provide a useful distinction between
the two kinds of performance efficacy: doctrinal and operational. Doctrinal
performance efficacy refers to religious ritual and operates in an explicit
manner, by 'postulating a cosmic order' and simultaneously demonstrating
the 'validity of the explanations it offers' (12). An example of this is the
Catholic communion in which the host (placed in the believer's mouth)
both unites the believer's body with the body of Christ and simultaneously
affirms that all believers are united in the body of Christ. Operational
efficacy, on the other hand, is concerned primarily with 'social/psycho-
logical effectiveness' (12). It can be both explicit and implicit. If a partici-
pant's or a viewer's worldview is changed as a result of a particular ceremony
– regardless of whether this effect was overtly targeted, covertly targeted,
or not targeted at all – the ceremony is said to have been operationally
efficacious. For example, if a person decides to become a pacifist as a result
of a military demonstration they have seen, this ceremony could be said
to have been performatively efficacious, although it is highly unlikely that
this was the ceremony's targeted effect. By the same token, artistic per-
formance – an expression I prefer to 'performance as entertainment', as
it includes political performance, performance as meditation and private
performance, none of which seek to entertain but to engage, or, simply,
to execute – does not necessarily target specific effects. However, it can
nevertheless cause a profound change in the viewer and can, in this sense,
be performatively efficacious. This is why performance scholar Marvin
Carlson (1996) stresses that performance, defined as an 'experience made
up of material to be interpreted, to be reflected upon, to be engaged in –
emotionally, mentally and perhaps even physically' (198) is, in fact, 'one
of the most powerful and efficacious procedures that human society has
developed for the endlessly fascinating process of cultural and personal

self-reflexion and experimentation' (199). It is a form of cultural dialogue as well as a process of exchange.

The practices discussed in this volume are all a form of reflection; they use performance to propose a new outlook, a different apprehension of (a segment of) reality. They are resistant, disruptive and innovative. This means that they do not merely present, with a greater or lesser degree of virtuosity, the culturally operative forms, norms, systems and habits. Rather, they viscerally critique these forms, norms, systems and habits, and, in so doing, suggest changes and amendments to the current set of practices that make up social reality. That they are resistant and disruptive means that they work against habituation. This is an important point because habituation is closely related to hegemony. Hegemony refers to the sphere of the culturally and politically implicit practices that have become naturalised but which, in fact, serve the goals and interests of the dominant group. Cultural theorist Raymond Williams (1977) offers the following definition:

> Hegemony is ... a whole body of practices over the whole of living: our senses and assignments of energy ... a lived system of meanings and values – constitutive and constituting – which as they are experienced as practices appear as reciprocally confirming. (124)

An example of a 'reciprocally confirming' practice might be the tacit social consensus of what, until several decades ago, it meant to be a 'proper woman'. 'Proper women' were well groomed and elegant, they spoke softly, stayed slim, sat with their legs closed and took the passive role in decision-making. These attitudes were reaffirmed through performance, in daily life, in the street, in educational institutions, in the work place, in the media and, importantly, in those discrete events called works of art, a term I use in the broad sense, not to refer to only fine art but to all artistic activities and practices. Although there was no explicit law stating the requirement for dainty female behaviour, these norms were naturalised and, as such, in constant circulation. They were therefore reciprocally confirming – one grew up thinking that this was the desired form of behaviour and behaved in such ways. But the reason why this idea persisted was precisely because of repeated performances. Another way to explain this is through French theorist Michel Foucault's concept of power. For Foucault (1976), power is not 'an institution, a structure or a force with which certain people are endowed' (123). It is 'a complex strategic relation in a given society' (123). Consisting of numerous technologies and micro-technologies inherent in the prevalent discourses, in the opinions shared by smaller and larger groups of people, in social practices, and in the very rules that dictate the

formation of truth and knowledge, power has, for Foucault, little to do with overt oppression or coercion. It is an infinitely subtler set of action-reaction relations woven into (and therefore inseparable from) the social tapestry of everyday living. The practices discussed in this book all confront the notion of deeply ingrained habits, systems of valuing, notions of truth and inconspicuous forms of oppression. This is partly the reason why they also go by the name avant-garde. The other reason why they go by this name is the innovative use of new methodologies and/or techniques. Signifying breaking new ground in all senses of the word – what is done, where it is done, how it is done and who does it – avant-garde is a historical concept that belonged to a specific period, the pre–World War II years. Innovative practices that came after this period were often referred to as the neo-avant-garde. There have, however, been numerous debates about whether or not this is possible. According to art theorist Peter Bürger (1984), the historical avant-garde – Dadaism, Futurism, Surrealism and Constructivism – all failed in their intentions to bring about the changes specified in these groups' respective manifestos (58). According to art theorist Renato Pogglioli (1968), however, the failure of the avant-garde is precisely its success, as some of the Dadaist, Futurist, Surrealist and Constructivist practices, as well as many others, have been incorporated into the mainstream culture. For Pogglioli, this is proof of their poignancy and relevance (56). The term avant-garde, although referring to innovation, should not be understood as referring to practices never seen or heard of before either. Such an understanding would be naïve at best, as it would entail a linear concept of time and a cumulative, evolutionary concept of knowledge. Every practice discussed in this book, be it the Dada experimentation with chance, John Cage's ecological approach to sound or Lynn Hershman's distributed identities, can be traced to a previous concept or practice: linguistic relativism of the Swiss linguist Ferdinand de Saussure in the case of Dada, Zen Buddhism in the case of Cage, poststructuralism in the case of Hershman. It would therefore be far more accurate to describe the avant-garde as a break with the oppressive and ossified order whose hierarchies are complex and efficacious. In a similar vein, some of the practices discussed in this book have been termed performance art. My choice of a broader term – interdisciplinary performance – includes not only performance that comes from the field of fine art, as does performance art (which emerged in the 1960s in an effort to wrest the art object from the commercial art market), but also architecture, urban planning, dance, games, music, the culinary arts, ecology, biology, anthropology and computer science. Our main focus here is thus interdisciplinary performance as a form of thinking by doing.

Thinking by doing, interdisciplinarity

In *Frames of Mind: The Theory of Multiple Intelligences*, cognitive scientist Howard Gardner (1993 [1983]) argues that thinking cannot be seen as a cerebral activity only, but is embodied and related to the senses. A tennis player 'thinks' in and through movement, a complex interplay of rhythm, action, reaction and strategy that includes the environment, game elements and other player/s, and is, in this sense, kinaesthetic – rooted in movement – as well as interactional. The player does not think cerebrally first, then translate the cerebral activity into movement. Nor does thinking with one's body – or through other media – mean that the object of thought is limited to the repertoire of tennis movements. Indeed, much broader and infinitely more abstract themes, such as intimacy and estrangement, order and chaos, can be thought in movement much like they can be thought in and through music. For example, perceptions of order – regulated rhythm, pitch, duration and sequence – and perceptions of chaos – the collapse of all divisions, separations and organisation – can not only be fruitfully reflected upon but also viscerally felt in music, as they can in movement. But this is not the only reason why thinking can and should be seen as performative. Although the word *theoria*, from which the word 'theory' is derived, means 'image' or 'contemplation' in ancient Greek, it also means 'journey'. As American classicist Andrea Wilson Nightingale (2001) explains, *theoria* was a journey to a 'destination away from one's own city undertaken for the purpose of seeing as an eye-witness certain events and spectacles' (29). *Theoros* was an envoy sent on a mission to gather and exchange information: to witness a religious festival, to represent one Greek city to another, or to broaden the traveller's horizons. Regardless of whether their journey had a predominantly religious, political or personal function, the *theoroi* were required to report back on what they witnessed and experienced. This implies both performance and communication, and does not limit the practice of theorising to a passive reception of static images or their passive contemplation. Thinking in performance is thus simultaneously a communicational method and a way of making direct propositions. Instead of debating the possibility of eating or walking differently, performance substitutes action for debate. It presents a different way of eating or walking. In so doing, it makes the new way of eating or walking a *temporary reality*, which is to say that it re-structures, re-codes – or re-formats – the existing reality.

Interdisciplinary performance means that the above notions of performance are combined with at least one other discipline in a way that affects them mutually and creates a hybrid. A discipline is a field of human

endeavour with a specific set of methodologies and a delimited focus. Archaeology is very different from the medical sciences, which are very different from literary theory. While archaeology employs onsite research and excavation, literary theory employs textual analysis. However, these methodological differences are far from neutral. As Foucault (1977) argues in *Discipline and Punish* in reference to the post-Enlightenment period, many academic disciplines were shaped by the same social factors that gave birth to such institutions as the modern prison and the penal system: '[t]he disciplines characterize, classify, specialize; they distribute along a scale, around a norm, hierarchize individuals in relation to one another and, if necessary, disqualify and invalidate' (223). No less suspect, according to Foucault, is the idea of a pure intellectual or scientific history in which the various methodological practices exist independently of the politics of knowledge. Quite to the contrary, knowledge is always instrumental in subjugating people precisely because it defines fields of empirical truth. In *The Politics of Truth*, Foucault (2007 [1997]) repeatedly stresses that all relationships to truth, whether of a scientific, social or political kind, are, in fact, inseparable from what he terms 'the art of governing' (44). This refers not only to the management and governance of children, the poor and beggars, but also to the management of a family, a house, a group of people, an army, a city and entire states, as well as to governing 'one's own body and mind' (44). In other words, it refers to medical science, paediatrics, economy, politics, sociology, architecture, urban planning, ecology, engineering, technology, nutrition and psychology. All discipline-specific systems, techniques and methodologies are related to the production of (dogmatic) knowledge. Relying on scientifically ratified – thus unquestionable – principles, dogmatic knowledge, like the symbolic order, has the force of a law. It is beyond debate. This is why interfering with its systems of production through critique – which, for Foucault, is the 'art of not being governed' (44) – thwarts the hegemonic formatting of reality. This is also the reason why interdisciplinarity, or interference with the established boundaries of thought and action, is so important. Important is also the difference between multidisciplinarity and interdisciplinarity. In a multidisciplinary project, the different disciplines converge but do not create a new hybrid. A trip to the moon is an example of this. Here, astrophysics, engineering, anthropology, psychology and the medical sciences are employed simultaneously to a unified goal. However, each of these disciplines remains within its confines and does not intersect with others. Bio-art, on the other hand, is a hybrid in which biology and art intersect. That 'bio-art' is a hybrid is already evident from the word itself. But documentary film can also be a hybrid, if it combines film and ethnography – the study of human cultures.

Another very important distinction to make, in the present context, is the distinction between multimediality and intermediality. These terms are often used interchangeably with multidisciplinarity and interdisciplinarity. However, they are not the same. Although the different artistic fields – architecture, music, film – are sometimes referred to as disciplines, they are, in fact, media. In Latin, the word 'medium' means 'way' or 'means'. It refers to the way in which something is done, the means used and the corresponding form this endeavour takes. The Fluxus artist Dick Higgins, who coined the term intermedia, provides a useful distinction between intermediality and multimediality. According to Higgins (2001 [1966]), intermediality refers to 'works that fall conceptually *between* media' – such as visual poetry or action music – 'as well as *between* the general area of art media and life media' (49, emphasis mine). Here, 'life media' refer to such everyday activities as sleeping, eating and walking. While an opera is multi-medial in the sense that it employs a number of different media to a unified effect – music, movement, visual art, the written word – visual poetry, in which poetic concepts are embodied in visual forms, not the spoken word, is intermedial. It combines sculpture, painting, performance and poetry in a hybrid way. That said, intermediality can also lead to interdisciplinarity, as in the case of the Futurist banquets, discussed in Chapter 1, in which food is treated as an olfactory-gustatory art object and as performance. Here, the edible object is intermedial in the sense that it is both a sculpture and food. But this endeavour is also interdisciplinary, as it combines fine art with cooking, which, although much indebted to performance, has concerns that art does not, for example, nutrition and hygiene.

The structure and organisation of this book

This book is for practitioners and practical theorists. Although it spans a hundred years of interdisciplinary performance and follows a chronological order, organised around three turning points (clarified below), it does not include every performance ever created, nor does it focus on extensive historical detail. Rather, it sheds light on the intellectual-creative universes that have produced the performative strategies under discussion. In so doing, the book offers an insight into the main points of resistance and into the propositions for what a shared social reality should/could/might look like. Important to stress, however, is that the chronological order does not stand for linear, evolutionary, cumulative knowledge. On the contrary, the chronological order is here to show just how context-dependent, recombinant and recurrent knowledge is, and how cumulative hegemony

is. Although the book journeys through many theories and practices, not all the theories relate to the pertaining practices in the same way. In some cases, the theorists and the practitioners are indistinct – as are Guy Debord and the Situationists International discussed in Chapter 4, all of whom practised as well as wrote philosophical texts. In other cases, the practitioners have a very close relationship to the theories discussed and make frequent references to them, as does Tatsumi Hijikata to George Bataille in Chapter 5, or Lynn Hershman to Donna Haraway in Chapter 9. In other cases, the link is not 'lived' in the sense of contemporaneity or personal acquaintance. Nevertheless, it is a strong link which resides in the other meaning of the word *theoria*: a contemplative journey of one individual communicated to others through language. Contrary to the decade-long debates about the end of theory, in such works as British literary theorist Terry Eagleton's 2003 *After Theory*, which bemoans the twenty-first century's lack of strong thought systems, one individual's contemplative journey into previously unarticulated territories is more relevant today than ever. As Korean-German philosopher Byung-Chul Han (2015) explains in *Desire or the Hell of the Identical*, theory is not a model for practical applications, as the techno-scientific dogma would have us believe; it is a complex and committed effort to articulate experience and the world (90).

The three turning points are shifts in the way the world is conceptualised. They are also shifts in the dominant systems of knowledge production and transmission. Part I, the Deconstructive Turn, marks the shift from the static perception of the world to a moving, temporal one. Part II, the Deconstructive Turn, marks the passage from the entrenched categories of dominance such as 'man' (as opposed to 'woman'), 'heterosexual' (as opposed to 'homosexual'), 'white' (as opposed to 'coloured'), 'centre' (as opposed to 'periphery') to a perception of the world no longer based on definite differences. Part III, the Digital Turn, marks the shift from the world of single entities, the world of originals and copies, to the world of access and networks. Part I spans four decades, from the 1910s to the early 1950s, and consists of three chapters. Chapter 1 focuses on Futurism and Dadaism. Through a discussion of Friedrich Nietzsche's influential theories, which called for a re-evaluation of all values (a break with 'slave morality', the creation of a new human being, and the supremacy of doing over thinking), this chapter clarifies the innovative performative strategies introduced by the Futurists and the Dadaists: tactile sculpture, culinary feasts, areal painting, simultaneous poems, collage and chance operations. Chapter 2 deals with the 'discovery' of time. Following Henri Bergson's theories, in which time is seen as a flux of change, permanently pregnant with creative potential, this chapter offers a discussion of the Surrealist

performative practices: automatic writing, automatic drawing and inter-medial performance, such as Francis Picabia's *Performance Cancelled* and Salvador Dalí's paranoid-critical method. In addition, the Constructivist methods for performative filmmaking, as seen in Dziga Vertov's *Kino Pravda* or 'film truth' are here analysed. Chapter 3 introduces a different approach to (space-)time, as defined by Martin Heidegger's existential philosophy. It explores the notion of authenticity, of which there are two distinct kinds: personal authenticity as manifested in action painting, and the authen-ticity of the world, seen as constant change. In the latter, the author (com-poser, choreographer, painter) creates structures for 'letting be', as seen in the work of John Cage, Merce Cunningham and the Japanese Gutai Group.

Part II, the Deconstructive Turn, consists of five chapters and spans the period from the 1950s to the 1990s. In Chapter 4, commodity fetishism, in its advanced, 'spectacular' form, is discussed. While Karl Marx's notion of commodity fetishism referred to the reduction of social relations to object relations, Guy Debord's notion of 'the spectacle' marks a moment in history when commodity completes the colonisation of social relations. This chapter offers a discussion of resistant environmental practices, the Situationists International's drift (a technique for a rapid passage through varied ambiances), and the participatory happenings of Allan Kaprow and Jean-Jacques Lebel. Chapter 5 centres on the body. Apart from the human body, it includes animal bodies and the Earth. Departing from George Bataille's theory of general economy, whose basic principle is the super-abundance of energy, this chapter discusses performative practices that fore-ground transgression, sacrifice and cross-temporal relations. In focus here are the ritualistic practices of the Viennese Actionists, the *butoh* (the dance of darkness) of Tatsumi Hijikata and the shamanistic practices of Joseph Beuys. Chapter 6 focuses on resisting determination. Jacques Derrida's critical strategy of deconstruction, developed to dethrone the dominant categories of knowledge based on opposition, is here related to a number of 'undefinable' performative practices. These include interventions into public space, carried out by the Japanese groups Zero Jigen and Hi Red Center, and the intermedial work of the Fluxus group, which consists of *event scores* and games.

Chapter 7 offers a different view of the body, namely gendered body. Focusing on the theories of Luce Irigaray and Hélène Cixous, which unmask the operation of patriarchal power in language and representation, this chapter investigates the inscription of the female body in language, text and image. This is done by focusing on the performative practices of Carolee Schneemann, on ORLAN's carnal art and on Bobby Baker's food performances. Chapter 8 is about identity politics. Mobilising Judith

Butler's theory of gender performativity, which explores the ways in which the gendered subject comes into being, this chapter foregrounds four practices: Adrian Piper's cross-medial gender-bending, Tim Miller's explorations of queer identity, Vaginal Davis's club performance and Coco Fusco and Guillermo Gómez-Peña's performative critique of racial and cultural otherness.

Part III, the Digital Turn, spans the period between 1990 and 2010. Chapter 9 considers the import of Donna Haraway's concept of the cyborg and Katherine Hayles's notion of the posthuman, both of which mark a radical break with the hitherto accepted socio-cultural narratives of individuality and rational thought. Their view of knowledge as dependent on (plural) flows of information and the operation of networks is explored in the interactive projects of Lynn Hershman, the telematic performances of Paul Sermon and in the actual-virtual games created by Blast Theory. In Chapter 10, new forms of communication and new control mechanisms are related to the key theories of Jean Baudrillard, Michael Hardt and Antonio Negri. While Baudrillard analyses the problems of what he terms hyperreality – a closed system of values – Hardt and Negri discuss possible modes of resistance based on cellular self-organisation. The performative strategies developed in response to this are the culture-jamming, activist performances of The Yes Men, etoy's use of marketing tools to create 'corporate sculptures' and the Critical Art Ensemble's probing into the hyperreal world of science. Chapter 11 queries the human–non-human divide and the scientific construction of reality, which, until recently, has been almost exclusively human-centred. This chapter sheds light on the processes by which non-human elements perform in techno-scientific and artistic practices. The transgenic work of Eduardo Kac, the interspecies work of SymbioticA, Helen Pynor and Peta Clancy are here placed in dialogue with cultural theorist Bruno Latour's key concepts. Each chapter is also followed by several scores – performance instructions – which provide you with the opportunity of exploring the discussed ideas in a practical, embodied and, where applicable, interactional way.

PART I
The Dynamic Turn

The opening decades of the twentieth century were the age of technological acceleration as well as the age of disenchantment. After a series of failed revolutions in France, Germany and the Austro-Hungarian Empire, most of which took place in 1848, Europe was left in political turmoil. Ultimately, this led to the outbreak of World War I. The first two decades of the twentieth century also defined the irreversibility of the modernist march of progress with an array of life-changing inventions. Railways, steam engines and machine tools, automobiles and aeroplanes all promised to move humans further and faster; radio, postal and telephone services promised to bridge the physical distances and bring them closer together. The assembly line introduced the idea of exponential growth in the material world. Free of old restraints of manual production, the early twentieth-century industrialists were, with the aid of mechanisation, able to multiply output from scores of hundreds to thousands. Many times. This caused a tectonic shift in power relations. Propelled by the industrial momentum of the chemical, electrical and automotive industries, the burgeoning corporations with global interests, many of which were American, threatened to overthrow the existing economic relations based on Eurocentric interests and the colonial strategies of domination. This was accompanied by a collapse of the nineteenth-century authority structures as well as by the shift in the modern subject's perceptual dispositions. Formerly embodied in God, seen as the creator of the world, thus both paternal and external to the world, the nineteenth-century system of values was based on the unquestioned acceptance of external authority – the authority of the father, the teacher, the minister. The disorientation that ensued from the bankruptcy of religious institutions was accompanied by the effects of industrial capitalism; an intimate connection with the world, based on the proximity senses – taste, smell, touch – shifted to a more detached one, based on the sense of sight and the increased use of mechanical tools. Cultural critic Martin Jay (1994) christened this new organisation of the senses the 'scopic regime of perspectival control' (18). Presupposing a vantage point of view from which the world unfolds in a supposedly objective manner to the supposedly autonomous observing subject, this regime went hand in hand with the division of labour; both resulted in a sense of estrangement.

1 Vital Action

Nietzsche against obedience and empty clichés

German philosopher Friedrich Nietzsche's stormy entrance on the European philosophical scene in the last decades of the nineteenth century bears a strong resemblance to the Futurists' and the Dadaists' stormy entrance on the European artistic scene in the second decade of the twentieth century. For Nietzsche, the purpose of a philosopher was not to provide more nuanced ways of looking at old problems. Likewise, for the Italian Futurists and the pan-European Dadaists, the purpose of art was not to provide new styles with which to treat worn-out artistic topics. It was to tackle burning sociopolitical issues head on. In Nietzsche's case, this concerned the historically and politically manipulated notion of truth. The way he saw it, the human race had been relying on an external source of authority and significance – be it God, science, reason, history, the common good – since the beginning of the Judeo-Christian era. This tendency to seek a system with a built-in purpose to which to unquestioningly surrender, in a world in which human beings may take on an active, creative role, was, for Nietzsche (1979), disastrous. Truths derived from such systems were no more than fictions, which, 'poetically intensified, ornamented, and transformed, came to be thought of, after long usage by a people, as fixed, binding and canonical' (52). Nietzsche insisted that although such truths, seen as hard facts, were regularly contrasted with fiction, they were nothing but 'worn-out metaphors now impotent to stir the senses', 'coins that had lost their faces' and were now 'metal rather than currency' (52). When repeated a sufficient number of times, fictions become facts, but impotent facts, the direct results of which are apathy and the devaluation of values. By contrast, Nietzsche's main evaluative mechanism was *vitality*, the ability to act and react in an energetic way. This was related to the ways of valuing, of which there are three: passive valuing, active valuing and creative valuing. Passive valuing is a form of valuing in which, when presented with something – a novel, a car or a meal – we decide whether it is good or bad, according to the widely accepted standards – or 'truths'. Active valuing, by contrast, is the ability to produce a novel, a meal or a car in accordance

with the accepted standards for writing a good novel, making a tasty meal or manufacturing a high-performance car. Creative valuing, on the other hand, is the sort of valuing in which entirely new systems of valuing are brought into play. But the point here is not novelty for the sake of novelty either. Rather, it is liberation from oppression by established systems of value, accepted purely because they have been passed down *as* established systems of value. This is not merely a cultural point; it is closely related to morality. As Nietzsche (1909) explains in *Beyond Good and Evil*, there are only two types of morality – master morality and slave morality, although he repeatedly stresses that they are seldom found in a pure state. Unfair as this may seem, oppression – class, gender, racial, ethnic, religious, cultural – by dominant groups is one of the basic facts of life. The persistence of this oppression, in its various forms, is related to the ingrained differences in valuation. While the oppressors create the role of the masters for themselves, they cast the rest in the roles of the slaves (228–230). Important to understand, however, is that, in Nietzsche's writing, the term 'slave' is not used in an economic sense of the word. It does not mean, as it did in ancient Greece or America, that slaves were owned by masters. Rather, it means that they were enslaved by the masters' system of valuation – which is simultaneously a system of oppression – and, were, for this reason, dispossessed and helpless. It is masters, thus, who create a narrative about what they do, in which, needless to say, they are not portrayed as oppressors, but as intrinsically good. They see themselves as good because they possess certain qualities, such as vision, clarity of mind and courage. By contrast, slaves are seen as lacking these qualities, or possessing them only to an inferior degree. They are therefore 'bad'. The good are the natural masters and it is their prerogative to impose their values on the world; they are *value determining*. The 'bad', the slaves, are not in a position to determine their own values; their morality is always related to the morality of their masters. This enslavement, this helpless condition, makes the slaves see their masters as evil. In fact, it is the perceived evilness of the masters that enables the slaves to see themselves as good. Nietzsche writes: 'the slave … mistrusts, whatever is honored as "good"… Conversely, those qualities are underlined and spotlighted which serve to ease the existence of the sufferer … patience, diligence, humility, friendship – these are now honored – for they are the useful traits and almost the only means for enduring the crush of existence' (230–231). Because of this precarious condition, dependent on the masters' system of values, slave morality is manifested in constantly seeking guidance outside oneself. Due to this dependence and uncertainty, the 'slave' demands that there be utter conformism and, importantly, reassurance in numbers. The master morality, by contrast, does not

depend on external criteria; it grows out of self-affirmation. But, one may well ask: if one finds oneself trapped in the socio-historical position of a slave, how does one leave this position? Nietzsche's answer, similar to that of the Futurists and the Dadaists, is: by embracing vitality, by taking action, by seeking to actively transform one's condition, and life as such. In *Human, All Too Human*, Nietzsche (1985) speaks of the transformative power of performance:

> The man who always wears the mask of a friendly countenance eventually has to gain power over benevolent moods without which the expression of friendliness cannot be forced – and eventually then these moods gain power of him and he is benevolent. (35–36)

As mentioned in the Introduction, performance introduces the possibility of a new reality, in the moment of performance, and might even, if repeated and assimilated, begin to create new realities.

Futurism: the vitalist art of self-affirmation

On 20 February 1909, an inflammatory manifesto appeared in the influential French newspaper *Le Figaro*:

> We intend to sing the love of danger, the habit of energy and fearlessness. Courage, audacity, and revolt will be essential elements of our poetry. Up to now literature has exalted a pensive immobility, ecstasy, and sleep. We intend to exalt aggressive action, a feverish insomnia, the racer's stride, the mortal leap, the punch and the slap ... The world's magnificence has been enriched by a new beauty: the beauty of speed. ... Why should we look back, when what we want is to break down the mysterious doors of the Impossible? Time and space died yesterday. We already live in the absolute, because we have created eternal omnipresent speed. (Marinetti, 1973 [1909]: 21–22)

Written by the Futurists' chief spokesman, poet and writer Filippo Tommaso Marinetti, this manifesto revealed a fascination with the process of accelerated mechanisation. It called for dynamism, vitality and action; importantly, it also called for new systems of knowledge: 'we will destroy the museums, libraries, academies of every kind' (22). As many of the commentators on Futurism, as well as its critics, were quick to note, this call to action sounded very Nietzschean. Indeed, the Futurists were soon

labelled 'Neo-Nietzscheans' (Fogu, 2011: 3). However, not all Futurists were in agreement with this. The radical Marinetti (2006a [1910]) opined that Nietzsche was 'one of the fiercest defenders of the beauty and greatness of the past ... spawned from the three great stinking corpses of Apollo, Mars, and Bacchus' (81). Nietzsche's examples were, indeed, often drawn from ancient Greece, but the reason for this is that he regarded Christianity as largely responsible for the institution of slave morality and, for this reason, sought pre-Christian examples, mostly from Classical Greece. The praise of all things futurist and the corresponding rejection of all things past was, needless to say, inherent in Futurism; however, as we shall see later in this chapter, it was neither uniformly practised, nor was Marinetti's opinion always shared by other Futurists. Indeed, writers Bruno Corra and Emilio Settimelli (1973 [1914]) opposed what they saw as Marinetti's misreading of Nietzsche. They not only believed in the amalgamation of thinking, sensing and doing – one of Nietzsche's chief arguments – they even published a manifesto to this effect. Their 1914 'Weights, Measures and Prices of Artistic Genius Futurist Manifesto' sought to tear down the boundary between intellectual and artistic activity by insisting on the fact that 'intuition is no more than rapid and fragmentary reasoning' (148), and that 'the work of art is nothing but an accumulator of cerebral energy' (149). For Corra and Settimelli, all Futurist forms of performance – interventions into theatrical plays, music, cooking, aerial performance – were important cognitive propositions, much like, for Nietzsche, artistic endeavour was a form of truth-seeking.

Despite the fact that Futurist paintings depicted movement, either social, such as Luigi Russolo's 1911 painting *Revolt,* or physical and abstract, such as Umberto Boccioni's 1911 *The Street Enters the House,* performance was the medium where new forms of valuing could be communicated in a direct, unapologetic, energetic, even crowd-raising way. The Futurist *serate* – which, in Italian, means evenings – held at galleries and theatres across Europe, beginning with *Piedigrotta,* composed by Francesco Cangiullo and held at the Sprovieri Gallery in Rome in March and April 1914, consisted of four performative modes: *fisicofollia* or body madness; *parole in libertà,* or words in freedom; *sintesi,* condensed, almost telegraphic performative forms; and *intonarumori,* Luigi Russolo's mechanical noise-intoners which emitted hitherto musically non-reproducible sounds. While audience participation has always been a constituent part of public gatherings and entertainment – political speeches, presidential inaugurations, cabaret and vaudeville – it was generally viewed as a *by-product,* not an event in its own right. In the Futurist *serate,* however, *fisicofollia* or body madness, which, in some cases, led to utter pandemonium, was premeditated. Its purpose was to get

the spectators into a participatory, argumentative, even belligerent mode of spectating. As Marinetti (1973 [1913]) suggests in 'The Variety Theatre Manifesto':

Spread powerful glue on some of the seats, so that the male or female spectator will stay glued down and make everyone laugh ... sell the same ticket to ten people... offer free tickets to gentlemen or ladies who are notoriously unbalanced, irritable, or eccentric, and likely to provoke uproars with obscene gestures, pinching women, or other freakishness. Sprinkle the seats with dust to make people itch, sneeze, etc. (130)

An added impetus for impromptu audience–performer interaction came from the performers who regularly interrupted their declamations to shout at the audience. This resulted in veritable battles, such as the battle that took place at the Verdi Theatre in Florence in 1914, described by writer and painter Francesco Cangiullo in the following way:

The showers of potatoes, oranges and bunches of fennel became infernal. Suddenly he [Marinetti] cried 'Damn!' slapping his hand to his eye. We ran to help him; many in the public who had seen the missiles land protested indignantly against the bestial cowardice, and with what we shouted from the stage, the place became a ghetto market where things were said that cannot be repeated, much less written. I see Russolo again with saliva running from his mouth; I hear Carrà roaring 'Throw an idea instead of potatoes, idiots!'... I, with a table leg in my hand, wanted to look for a place ... in the audience. But Marinetti reproached me. (Cangiullo cited in Kirby, 1986 [1971]: 14–15)

The reason for such audience provocation was twofold: to discourage the purely receptive, passive behaviour in venues conducive to disciplinary conditioning – such as the gallery in which respect for objects of great cultural value, works of art, is shown by refraining from audible communication; or, indeed, the theatre, where social cohesion and behavioural uniformity is particularly prominent since audiences frequent theatres as much to watch the performance as to watch each other. This is why exemplary – well-bred, genteel and, ultimately, conformist – behaviour is readily displayed. The second reason was to encourage active, individualistic, self-affirmative behaviour in public spaces of cultural import, particularly those responsible for the production of conformist attitudes comparable to Nietzsche's

slave morality. Another crucial ingredient of the *serate* was *parole in libertà*. Such *parole in libertà* as Marinetti's *Zang-Tumb-Tumb*, which described the siege of Adrianople during the 1912 Balkan war, performed at the Doré Gallery in London in April 1914, introduced a 'renewal of human sensibility' brought about by 'the telephone, the telegraph, the phonograph, the train, the bicycle, the motorcycle, the automobile, the ocean liner, the aeroplane, the cinema' (Marinetti, 1973 [1913]: 96), in other words, new modes of thought. Marinetti (2006a [1910]) recounts his performance of *Zang-Tumb-Tumb,* which consisted of such words as: '*train train tron tron tron tron (iron bridge: tatatlontan) sssssiiii ssiissii ssissssssiii train fever of my train*', in the following way:

> I recited several passages ... in a dynamic and multi-channeled fashion. On the table, arranged in front of me, I had a telephone, some boards and the right sort of hammers, so that I could act out the orders of the Turkish general and the sounds of rifle and machine-gun fire ... In a room some distance away, two great drums were set up, and with these the painter Nevinson, who was assisting me, produced the thunder of canon, when I telephoned him to do so. (198)

As these examples show, *parole in libertà* took free verse a step further by abolishing all syntax and short-circuiting the clichéd poetic connections. Typically, Marinetti (1973) used technologically generated speed to describe the process of catapulting the spectator's imagination to new analogies:

> The rush of steam emotion will burst the sentence's steampipe, the valves of punctuation, and the adjectival clamp. Fistfuls of essential words in no conventional order. Sole preoccupation of the narrator, to render every vibration of his being. (98)

Sintesi, as the 'Futurist Synthetic Theatre Manifesto', written by Marinetti, Emilio Settimelli and Bruno Corra (1973 [1915]), proposes, are in the first place 'very brief'; their aim is to 'compress into a few minutes, into a few words and gestures, innumerable situations, sensibilities, ideas, sensations, facts and symbols' (183). The velocity and the energetics of these short, electrifying performances do, of course, have a lot in common with the technological compression of the world caused by the new modes of transport and the new technologies. However, they are also an expression of a non-regulated, non-hierarchical simultaneity of events resulting from perceiving the world in dynamic, rather than in static terms.

A good example of this is Giacomo Balla's *sintesi Disconcerted States of Mind* in which four differently dressed people appear on a white stage, first reciting numbers in unison – the first person repeats 'six' while the second repeats 'three', the third 'four' and the fourth 'nine'. This is followed by a pause and a series of equally repetitive, truncated vowels, followed by another pause and a series of actions – raising one's hat, looking at the watch, blowing one's nose and reading a newspaper. After this comes an 'expressive pause' and an enumeration of states (Balla in Kirby, 1986 [1971]: 232). Person one says loudly: 'sadness – aiaiaiaiai'; person two: 'quickness – quickly, quickly'; person three: 'pleasure – si si si si si' (meaning 'yes' in Italian); person four: 'denial – no no no no no'. After this they 'leave the stage walking rigidly' (232). Another example is Francesco Cangiullo's 1916 *Detonation*:

> Road at night, cold deserted
>
> A minute of silence. A gunshot
>
> CURTAIN
>
> (Cangiullo in Kirby, 1986 [1971]: 247, emphasis original)

These startling compositions were designed to break the didactic tendency of theatrical plays which trained the audience to react to pre-scripted material in pre-scripted ways – by nodding, sighing, laughing – and, in doing so, by accepting the proposed meaning-making processes and, indeed, incorporating them. Bruno Corra (1918) is adamant in insisting on the importance of 'absolutely exclud[ing]: grave tones, the knowing pause, careful engraving of key emotions' (170). The reason for this is that it is precisely in physiological processes – holding one's breath in suspense, sighing a sigh of relief, nodding in tacit understanding – that the valuing systems are inscribed on the body. As Nietzsche (1968) notes in *The Will to Power*, all our ways of valuing are, in essence, physiological conditions. '[E]ven our most sacred convictions … are judgments of our muscles' (173). Indeed, '[b]efore anything we may call conscious judgment occurs, there is cognitive activity that does not enter consciousness but operates through the living body' (289). Particularly important in this respect are values incorporated through the body in public, as these values are co-lived with others and co-affirmed with and by others. This is why Nietzsche insists on the need for 'an ever greater multiplication of the senses' and on the gratitude to the senses for 'their subtlety, plenitude, and power' (434). The Futurists did not only glorify speed and the new forms of movement and thought, they were acutely attentive to new forms of sensorial

perception, too. The Futurist new human being was, in Marinetti's (2006a [1910]) words:

> [t]he Man extended by his own labors, the enemy of books, friend of personal experience, relentless cultivator of his own will, [able to] make split-second judgments, possessing those instincts typical of the wild – intuition, cunning, and boldness. (81)

It is on account of these possibilities that the Futurists sought so vehemently to re-configure audience perception, to turn the audience into active rather than passive witnesses, into practitioners of a new set of values, privileging spontaneity, action, resoluteness and daring, the qualities of the Nietzschean master morality. Despite the fact that some Futurists had dubious political affiliations, the most obvious example being Marinetti, friend and fervent supporter of Fascist leader Benito Mussolini, and a member of the Italian Fascist Party, master morality should not be equated with Fascism, Nazism, nor, indeed, with any domination-orientated ideology. In properly Nietzschean terms, master morality refers to self-affirmation and self-possession, which, in fact, is the affirmation of life as such. It does not refer to the subjection of others. Indeed, it is out of a profound understanding of life as constant change, motion and mutation, that the Futurists demanded direct interaction with no aesthetic system acting as an insulator. The last, but certainly not the least ingredient of the Futurist *serate* was *intonarumori* or noise-intoners. Explained in Luigi Russolo's (1986 [1913]) manifesto entitled 'The Art of Noises', the theory of noise was born out of the technological advancements as much as it was born out of a responsiveness and a positive valuation of the here and now. In the twentieth century, Russolo writes,

> the machine has created many varieties and a competition of noises, not only in the noisy atmosphere of the large cities but also in to the country that, until yesterday, was normally silent, so that pure sound, in its monotony and exiguity, no longer arouses emotion. (167)

'Pure sound' implied that although sound itself was limited only by the physiology of the ear and contained an infinite number of subtle differences in tone, pattern and quality, only a small part of that infinite field of sound was acceptable as 'music'. Russolo proposed that all sound be valued as music, which is the reason why noise-intoners – rectangular wooden boxes with funnel-shaped acoustical amplifiers, or megaphones, played by means of a protruding handle on the top of the instrument – were used

in the Futurist *serate* instead of traditional instruments. Operating inside *intonarumori* were the various motors and mechanisms that produced six families of noises of the Futurist orchestra:

> 'roars, thunders, explosions, bursts, crashes, booms'; 'whistles, hisses, puffs'; 'whispers, murmurs, grumbles, buzzes'; 'screeches, creaks, rustles, hums, crackles, rubs' as well as percussion noises using 'metal, wood, skin, rock' and human and animal voices: 'shouts, shrieks, moans, yells, howls, laughs, groans, sobs'. (171–172)

By reconfiguring the notion of music, and introducing what, until then, was considered to be 'mere' noise, the Futurists paved the way to a greater inclusion of life in the realm of art (which was to remain the preoccupation of most artists discussed in this volume, from the Dadaists to John Cage and the Fluxus artists) as well as to a new, creative approach to valuing. By not only actively but also creatively valuing 'mere noise' as music, these performances introduced a different, Dionysian way of apprehending reality.

The way of Dionysus

For Nietzsche, beyond the learnt values, our mode of contact with the world is essentially that of an artist. Unwittingly, we make images, metaphors, and compose entire symphonies of sequential events in and through our daily experiences. Even more importantly, our experiences are in a constant state of transformation; they are never merely reproduced. And yet, our entire way of thinking, Nietzsche believed, is based on the assumption of an orderly, Apollonian universe. Referring to the Greek God of beauty and harmony, this universe posits order as the dominant category. But reality is, in fact, formless and Dionysian. Deriving its name from Dionysus, the Greek God of intoxication and ecstasy ('intoxication' being only a partial equivalent of the German word Nietzsche uses, '*rausch*', which has connotations of poetic and spiritual transport), reality is disorderly and dynamic. While Apollonian art is exemplified by an orderly depiction of things, Dionysian art dissolves boundaries; it lies beyond divisive reason. Futurism pioneered two Dionysian performative forms: tactile art and the gustatory–olfactory art of cooking. Marinetti's tactile tables were first presented during one of the *serate* at the Théâtre de l'Œuvre in Paris, in January 1921. The table presented on this occasion was entitled *Sudan-Paris* and effectively took the spectator – or, rather, the feeler

– on a tactile journey from Sudan to Paris. The table was produced after a self-imposed regime of tactile education which included wearing gloves for several days in order to experience the usual tactile sensations in radically different ways as well as 'swimm[ing] in the sea, trying to distinguish inter-woven currents and different temperatures tactilistically' and recognising and enumerating every object in one's bedroom 'every night, in complete darkness' (Marinetti, 2005 [1921]: 330). Marinetti created a scale of tactile values for the art of touch, resembling the musical scale and consisting of 'almost irritating, warm willful, grainy silk', 'spongy material', 'sensual, witty, affectionate' as well as 'rough iron', 'light brush bristles' and 'animal or peach down', among others (330). During the above *serata*, the specta-tors were invited to examine, on a one-to-one basis, eyes closed, a table consisting of three parts. The Sudan part had 'spongy material, sandpaper, wool, pig's and wire bristle'; the sea part consisted of the different grades of emery paper, while the Paris part contained 'silk, watered silk, velvet, large and small feathers' (330–331). Although Marinetti's depiction of Sudan as rough and uncouth, and of Paris as silky, soft and sophisticated, points to a problematic, possibly even colonial, prejudice, the journey from Sudan to Paris, involving the crossing of the sea, suggests a temporal structure. It resembles listening to music, only with one's fingertips. Indeed, music has the power to pervade one's entire body. But tactile experience can be said to go even further because the sense of touch has no isolated organ, like the sense of hearing or smell; rather, the entire body is the organ of touch. Due to the century-long, religious and philosophical association of the prox-imity senses – smell, touch and taste – with the imperfections, even the sins, of the body, these senses were seen as removed from the realm of the spirit and thus also from thinking and cognisance. However, for Nietzsche, as for the Futurists, thinking occurs in the realm of all senses, the prox-imity senses included. The Futurist art of cooking, although appearing in the later phases of the movement, is an elaborate development of this point. The first task of the Futurist cook was to abolish pastasciutta, a sort of pasta and *passéist* food, because it, in Marinetti's (2014 [1989]) words, made people 'sceptical, slow and pessimistic' (34). Opposed to all forms of apathy, often caused by particular combinations as well as large quantities of food, the Futurists called for the 'abolition of volume and weight in the conception and evaluation of food' (35). This went hand in hand with the ban on political and philosophical discussions. Indeed, in the Futurist banquets, usual dinner conversation gave way to musical, poetic and aro-matic accompaniments. The cooperation of the five senses in the appreci-ation of food was key; it comprised such experiments as 'prelabial tactile pleasure', the wearing of pyjamas covered with 'different tactile material

such as sponge, cork, sandpaper, felt, aluminium sheeting, bristles, steel wool, cardboard, silk, velvet', and 'magic balls', as suggested by Fillìa's 'Tactile Dinner Party' (Fillìa in Marinetti, 2014 [1989]: 170). The first dish served during this party was the 'polyrhythmic salad'. 'The waiters approach[ed] the tables carrying for each guest a box with a crank on the left side, and, fixed half way up the right side, a china bowl' in which 'undressed lettuce leaves, dates and grapes' awaited consumption (170–171). Fillìa was consistent:

> Without the help of cutlery, each diner uses his right hand to feed himself from the bowl while he turns the crank with his left. The box thus emits musical rhythms: the waiters dance slowly with grand geometrical gestures in front of the tables until the food has been eaten. (170–171)

After a variety of foods, including the vegetable garden, which required the eaters to bury their faces in a large plate of raw and cooked vegetables, since the purpose of this particular culinary experiment was to bring food into direct contact with the eater's skin, Fillìa's 'Tactile Dinner Party' ended with the promise of erotic pursuits; the guests were instructed to 'let their fingertips feast uninterruptedly on their neighbour's pyjamas' (171). Olfaction was also lavishly used; such aromas as the '*conprofumo* of carnations' were sprayed on the necks of the eaters of Fillìa's 'Aerofood' (194). Novel kitchen appliances, for example 'ozonizer' whose purpose was to give 'liquids the taste and perfume of ozone' (194), were used, too. Marinetti's two-day long 'Extremist Banquet' proposed that there be no eating at all, that 'the only satiety' be derived from 'perfumes' (155). During this banquet:

> along the length of the table ... things spring into view and glide along like cars, appearing and disappearing: a food sculpture equipped with a vaporizer and which looks and smells like a ship made of fried aubergines sprinkled with vanilla, acacia flowers and red pepper. (156)

The aim here was an even greater dissociation of smell from taste. Smell, with its rich associative powers, and its ability to catapult us to the past within seconds, introduces a porous perception of reality. It blurs boundaries. As anthropologist David Howes (1991) suggests, smell activates our 'uninhibited (untrained) perception [which] recognizes a continuum we are taught to impose a "discriminating grid" upon', a grid 'which serves to distinguish the world as being composed of a large number of separate things, each labelled with a name' (140). When we

smell a smell, we sense the continuum, rather than 'truncated' time and space, separated by reason into the present and the past, into 'here' and 'there'. Although, as already mentioned, Marinetti was vehemently against any return to the past, the Futurist banquets did, in fact, bear a striking resemblance to the Greek and Roman feasts. As anthropologist Constance Classen (1994) suggests, citing from Athenaeus's *Deipnosophists or The Banquet of the Learned*, a feast in antiquity was not a proper feast without its complement of perfume, used precisely for its associative powers:

> And always at the banquet crown your head
>
> With flowing wreathe of varied scent and hue...
>
> And steep your hair in rich and reeking odours,
>
> And all day long pour holy frankincense and myrrh, the fragrant fruit of Syria, on the slow slumb'ring ashes of the fire. (Athenaeus cited in Classen, 1994: 20)

Thus although the Futurists embraced speed, technology, even war, they also sought to augment the body's sensorial capacities, as well as the body's possibilities of cognition. As the above examples of the Futurist cuisine suggest, a deeper connection with the body, the purpose of which was to 'excavate' multi-sensorial experience, was clearly sought by the Futurists. This searching for depth and interconnection went hand in hand with the performative modes that sought to extend the body in space, as well as to extend the sphere of human action. A case in point is aeropainting, in which choreographies were made not with human bodies, but with planes. As aviator and aeropainter Fedele Azari, who, together with Fillìa, was the first to 'paint the sky', suggests in his manifesto: 'flight [of airplanes] is analogous to dance, but is infinitely superior to it because of its grandiose background, because of its superlative dynamism and the greatly varied possibilities that it permits' (Azari in Kirby, 1986 [1919]: 219–220). It is because of this desire for limitless expansion of the human potential that Futurism has often been associated with the most abused concept in Nietzsche, that of the *Übermensch*, usually translated as 'overman' or 'superman'. I say 'abused' because of the concept's association with Nazism, to which Nietzsche bears no relation whatsoever. Indeed, as will be shown below, the concept of the *Übermensch*, as related to a non-structured field of possibilities, and not to prescriptive ideas, is much closer to Dadaism, which, like Nietzsche, embraces nihilism and relates to it in a positive way.

Dada's nihilism: a rupture with meaning

Like Futurism, Dada was a movement, although of a far more international character, both in terms of location – Zurich, Berlin, Paris – and in terms of its participants. While Futurism glorified speed, change and technology, Dada favoured distortion of familiar contexts and the portrayal of worldly absurdity. The very word 'dada', as Dadaist Hans Richter (2004 [1965]) notes in *Dada: Art and Anti-Art*, meant anything from the Slavic affirmative '*da*', which means 'yes' and which poet and principal Dada spokesman, Tristan Tzara, often used in his conversations with his Rumanian colleague, painter Marcel Janco, to 'die or cube' in Italian, 'rocking horse' in French and 'the tail of a sacred cow' in Kru Africans (32). The name 'Dada' was therefore as elusive and non-specific of a name as could be. Similarly difficult to define was the movement. Dada lasted from 1915 to 1920 in Zurich, the capital of neutral Switzerland to which many European artists fled at the beginning of World War I to avoid being drafted into armies with whose political and military goals they did not agree. Dada lasted from 1915 to 1920 in New York, to which many prominent Dadaists, like Marcel Duchamp, fled for similar reasons. Taking on a different character, Dada appeared in post-war Berlin from 1918 to 1923, where artists like Raoul Hausmann, Richard Huelsenbeck and George Grosz were the most prominent agitators of the Dada cause. Not to forget was also the Paris Dada, 1919–1921, marked by Francis Picabia's work and the work of many future Surrealists, discussed in the following chapter. The Swiss Dada movement, which is of greatest interest to the Dada use of performance, dates from February 1916 when poet and thinker Hugo Ball founded Cabaret Voltaire in Zurich. It was at the Meierei, Spiegelgasse no. 1 that the critique of the chief principles that had led to World War I as reinforced by unquestioned 'truths', language and technology was examined. At first glance, Tzara's (1981 [1951]) words, which formed part of the 1918 Dada manifesto, may sound pronouncedly negative, subversive, even prankish. More than anything, however, they signal the need for a departure from the hitherto practised, logic-locked ways of making sense of the world:

> Dada: the *abolition of logic, which is the dance of those impotent to create* … the *abolition* of *every social hierarchy and equation set up for the sake of values by our valets* … the *abolition of archeology* … the *abolition of prophets* … the *abolition of the future*. (81, emphasis original)

Reason, logic, much like religion, military and economic reasoning, was for the Dadaists, as for Nietzsche, no more than a humanly created perspective, and an erroneous one at that. In *The Gay Science* Nietzsche (1974) writes:

a continuum stands before us from which we isolate a pair of frag-
ments, just in the same way as we perceive a movement as isolated
points and therefore do not properly see but infer it ... there is an
infinite set of processes in that abrupt second which evades us. (173)

Tzara's (1981 [1951]) 1918 manifesto ends on a similar note, by discarding
all rational systems and logics: 'Freedom: Dada Dada Dada, a roaring of
tense colors, and interlacing of opposites and of all contradictions ... incon-
sistencies: LIFE' (82, emphasis original). The Dadaist disruption – through
collage, the simultaneous poem, chance operations and life performances
– was precisely that: a way to discover what Nietzsche calls 'an infinite set
of processes' occurring in the present moment. Dadaist, like Nietzsche's,
was a nihilism that opened onto bright horizons, not the pessimistic frame
of mind in which the world is senseless and all hope is futile. In order to
facilitate this passage to liberating nothingness, however, it was important
to disrupt the current circuits of meaning: words and pictures. Language,
made of words as well as symbols, was the prime target, since language forms
part of consciousness, which, as Nietzsche (1974) suggests, does not belong
to the individual human being but to the 'community-and-herd-nature of
the human race' (298–299). Nietzsche's point is that unless a human being
is understood, s/he cannot survive; if s/he does survive, s/he does so on the
same terms as others. Language, for its part, is the glue of the commonly
shared social reality as it transmits attitudes, opinions and knowledge from
generation to generation. But given that language is always already part
of our experience, how can a different kind of experience be expressed?
By what means? Simultaneous poem is one option. On 30 March 1916,
Richard Huelsenbeck, Tristan Tzara and Marcel Janco performed a simul-
taneous poem at the Cabaret Voltaire, a recital in which several voices speak,
whisper, shout, whistle, gnarl, snarl, wail and sing simultaneously. The
poem, whose notation resembled a musical notation, in that it accentuated
partitions and rhythms, was entitled *The Admiral is Looking for a House to
Rent*. Simultaneously declaimed in German, French and English, the poem
consisted of random phrases, such as 'the fisherman turns to the countess,
in the church, after Mass, and says: "goodbye Mathilde"' (Grand, 2005: 75).
The poem debated the measurements of rooms, bathrooms and corridors,
and, as art historian Gilles Grand (2005) proposes, raised questions such
as 'Is the residence the admiral is looking for permanent or provisional?',
'Is the admiral handicapped or is he retired? Is he a [war] deserter?' (74).
But the intention of this poem was not to comment, in a formal way, on
deracination, the dissolution of borders or the war-induced chaos. Nor was
its intention solely nonsense as a response to the logical-sequence-locked

corruption of sense, sense corrupted through and by the preservation of what Nietzsche calls 'truths'. Unlike the Futurists, who were opposed to tradition – the past – the Dadaists were opposed to any other temporal dimension but the present. The present was not just a fragment of a bigger whole, be it traditionalism, conservatism or any other 'ism'. It was not part of unified, goal-orientated motion. As Richard Huelsenbeck (1981 [1920]) observes, the simultaneous poem:

> presupposes heightened sensitivity to the passage of things in time … Simultaneity is against what has become, and for what is becoming. While I, for example, become successively aware that I washed my hands an hour ago, the screeching of a streetcar brake and the crash of a brick falling off the roof next door reach my ear simultaneously and my (outward and inward) eye rouses itself to seize, in the simultaneity of these events, a swift meaning of life. From the everyday events surrounding me (the big city, the Dada circus, crashing, screeching, steam whistles … the smell of roast veal), I obtain an impulse which starts me toward direct action, becoming the big X. I become directly aware that I am alive, I feel the form-giving force behind the bustling of the clerks in the Dresdner Bank … and so ultimately a simultaneous poem means nothing but 'Hurrah for life!' (35–36)

When they first appeared on stage, Huelsenbeck, Janco and Tzara 'bowed like yodeling band about to elaborate lakes and forests in song, pulled out their "scores", and throwing all caution to the wind' (Huelsenbeck, 1969: 23) shouted their text. As Hugo Ball insightfully notes, the performance:

> resembled an incantation, more than it did a poetry recital. Huelsenbeck intoned 'Ahoi, ahoi! Das Admirals qwirktes Beinkleid schnell *zerfällt'* while Tzara shouted 'Il deshabilla sa chair quand les grenouilles humides commencèrent à bruler'. This was also interspersed by 'zimzim urallala zimzim…'. The phonetic poem in performance had become an act of respiratory and auditive combinations, firmly tied to a unit of duration. (Ball cited in Richter, 2004 [1965]: 121)

This anchorage in the present moment, unmediated by political discourse to which language was increasingly more subordinated, was, for Hugo Ball, who repeatedly declared that language had been 'ravaged and laid barren by journalism' (42), closely related to the value of the human voice. For Ball:

the vocal organ represents the individual soul, as it wanders ... The noises represent the inarticulate, inexorable and ultimately decisive forces which constitute the background ... In a generalised and compressed form, it [the poem] represents the battle of the human voice against a world which menaces, ensnares and finally destroys it. (31)

The voice, with its presentist orientation, is here foregrounded over and above the meaning of the words. However, as painter and innovator Wassily Kandinsky (1977), whose influence on Cabaret Voltaire was significant, suggests in *Concerning the Spiritual in Art:*

frequent repetition of a word (a favourite game of children forgotten in later life) deprives the word of its external reference. Similarly, the symbolic reference of a designated object tends to be forgotten and only the sound is retained. We hear this pure sound, unconsciously perhaps, in relation to the concrete or immaterial object. But in the latter case pure sound exercises a direct impression on the soul. (34)

For Ball, words were meaningful in being reminiscent of other words, and thus weaving together a thousand (poetic) universes. Inspired as he was by the Russian phoneticists Alexsei Kruchenykh and Victor Khlebnikov, who had created *zaumnyi jazyk* – '*zaumnyi*' means 'beyond mind' and '*jazyk*' means 'language' – which was 'cobbled together from existing phonemes of absolutely meaningless combinations in order to obtain freedom from meaning' (Markov, 1962: 7), Ball launched his own attempt at transcending the Nietzschean herd consciousness. This attempt, which consisted in taking apart well-known phrases, even words, took place on 14 July 1916 at the Zunfthaus zur Waag in Zurich, in the form of a poem entitled *O Gadji Beri Bimba*. Dressed in a costume designed by Janco and himself – legs in cylindrical pillars of blue cardboard, wearing a cardboard collar, scarlet inside and gold outside, and a high blue and white striped hat, as can be seen in Figure 1.1 – Ball recited his famous poem in liturgical tones:

Gadji beri bimba glandridi laula lonni cadori

Gadjama gramma berida bimbala glandri galassassa laulitalomini

Gadji beri bin blassa glassala laula lonni cadorsu sassala bim ... Rhinocerossola hopsamen

Nluku terullala blaulala looooo...

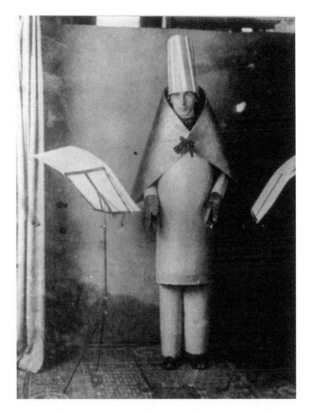

Figure 1.1 Hugo Ball at the Cabaret Voltaire, Zurich 1916. © Swiss Literary Archives (SLA), Berne. Literary Estate of Hugo Ball. Courtesy of Swiss Literary Archives (SLA), Berne. Literary Estate of Hugo Ball.

This marked the birth not only of the new abstract phonetic poem, which was to persist in performance for decades, but of an incantation of a different reality, free from all rules and precepts, which, according to Richter (2004 [1965]), enabled the Dadaists to listen to the voice of the 'unknown'. Indeed, 'the central experience of Dada' was drawing 'knowledge from the realm of the unknown" (50). This 'no rules, no precepts' logic extended to all of life, seen as an artistic medium and exemplified by such events as the visit to the courtyard of St Julien le Pauvre, a thirteenth-century church in Paris, in April 1921. Performed by the so-called Paris Dadaists, soon to become Surrealists – Louis Aragon, André Breton, Francis Picabia, Paul Éluard, Georges Ribemont-Dessaignes and Tristan Tzara, the purpose of this event, according to art historian T. J. Demos (2009), was to visit places 'that had no reason to exist' (135). This particular church was

chosen on account of its insignificance, made doubly palpable by its position opposite the Notre Dame, the longest-standing and the most famous church in Paris. In 'Artificial Hells', Breton (2003 [1921]) links the idea of a planned but unstructured visit to a non-historical, 'insignificant' site to Cabaret Voltaire (137–138). Its performative dimension, vaguely resembling a tour, is, for Breton, an extension of the Cabaret Voltaire performances with nonsensical as well as chance elements. The tour of St Julien le Pauvre, performed in heavy rain, was interspersed with two elements: Breton's and Tzara's declamations, such as 'Drink some beer, lead a regular life and live long enough to become a grandfather. I abhor that!' (Sanouillet, 1965: 257), and random entries from a dictionary, read by Ribemont-Dessaignes. Thoroughly explored in the late 1910s, by 1921 randomness had become firmly integrated into the Dada repertoire, and was, indeed, its structural trait.

Dadaist chance operations: an unconditional yes to life

In Zurich, experiments in the vocal domain were followed by experiments in drawing and painting. In fact, it was Hans Arp who, frustrated with a drawing he had been working on for a while, tore it up and left the pieces lying on the floor of his studio in Zeltweg. When he took a look at the scattered pieces a few days later, he noticed a clear pattern and pasted the scraps in the shape determined by chance. He named this composition *According to the Laws of Nature*. In a similar vein, but with a more performative bent in mind, Tzara cut up newspaper articles into tiny pieces a few days later, none longer than a word, put the words in a bag, shook them, then emptied the bag on a table. The arrangement in which they fell constituted *The Dadaist Poem*. Since language is composed of words and sentences, there is hardly a sequence of words to which some sort of meaning cannot be assigned. Every random poem has a meaning, only an illogical, new one. This practice corresponded to Nietzsche's nihilism, which centres around the idea that there is no order or structure objectively present in the world; that is, no form is present in the world *prior* to the form we ourselves give it. The world, for Nietzsche, is blank. But this, as the Dadaists well knew, is not a depressing fact. Quite to the contrary, it is an exhilarating fact, because, in Nietzsche's (1974) words, '[e]very hazard is again permitted the inquirer. Perhaps there never was so open a sea' (280). Intoxicated with this newly found freedom, the Dadaists abandoned themselves to the exploration of found materials and objects. As Richter (2004 [1965]) suggests:

chance was a magical procedure by which one could transcend the barriers of causality and of conscious volition, and by which the inner eye and ear became more acute, so that new sequences of thoughts and experiences made their appearance. (57)

Richter goes on to add that it was the conscious break with rationality that led to the explosion of new art forms and materials: scroll-pictures, relief, the object, *objet trouvé* and the ready-made, all of which arose from Dada's rejection of the 'staleness of either/or thinking', which excluded contradictions and incongruous novelties (60). For Nietzsche, the ability to embrace chance signifies a readiness to accept that the world is not structured but, in fact, blank. This stage of human development, which is the epitome of creative valuing, and which does not cling to any of the previously used purposive armatures – God, science – is the stage Nietzsche refers to as the beyond-man or *Übermensch*. Given that this term is among the most abused in history – indeed, in *Nietzsche: The Philosopher and Politician* (1931), Alfred Bäumler, influential German philosopher and close ally of the Nazi regime, erroneously identifies this concept with the supremacy of the Aryan race – it is important to clarify that Nietzsche's emphasis is on *process* and on *transition*, not on the final goal. In *Thus Spake Zarathustra*, Nietzsche (1967 [1909]) writes: '[m]an is rope, tied between beast and *Übermensch* – a rope across an abyss. What is great in man is that he is a bridge and not a goal. What can be loved in man is that he is an overgoing and an undergoing' (74). Nietzsche is careful not to be prescriptive. The *Übermensch* is merely contrasted with the 'last man' who is as much like everyone else as possible, and who would be happy just to be happy: '"we have invented happiness" says the last man, and blinks' (72). To contrast this conformist and, ultimately, disastrous attitude, which both the Futurists and the Dadaists sought to undermine, Nietzsche says: 'one must still have chaos in one, to give birth to a dancing star' (72). The Dadaists, in particular, not only embraced chaos, but glorified it performatively, on a scale much bigger than that of the cabaret stage – indeed, the scale of life. One of the most admired individuals by the Dadaists – and the Surrealists alike – was Arthur Craven. Initially known as the founder and editor of *Maintenant*, a French literary magazine launched in 1912, Craven was famous for living impulsively. He travelled on forged passports across Europe, the United States and South America amidst World War I, practised the jarring professions of poet and boxer, and was in the habit of taking his clothes off while lecturing. In April 1916, Craven challenged the world heavyweight champion, Jack Johnson, in Madrid, but was knocked out in the first round. Soon after this, he set off to sail the Caribbean in a small boat but never reached his destination nor, indeed, returned. Craven's chief idea, that all art was an expression of a

moribund society, to be replaced by direct, personal action, which was to take place in one's life, was echoed by Marcel Duchamp. A figure of considerable import, not only for Dada, but for contemporary art in general, Duchamp is best known for his ready-mades, ordinary, everyday objects shown in gallery settings. Perhaps the most famous example of this is his 1917 *Fountain*, which was a urinal. Clearly related to a radically new way of valuing were also his real-life personae, such as Rrose Sélavy, Duchamp's female alter ego, an elegant lady, often photographed by American photographer Man Ray. Meaning 'eros is life', since Rrose Sélavy is an Anglicised transcription of the French sentence '*eros, c'est la vie*', the elegant lady was, for Duchamp, a form of life performance – which many artists concerned with identity politics, such as Adrian Piper and Linda Montano, were to perfect in the 1970s – as well as a form of creative valuing. In fact, the logic of Rrose Sélavy was very similar to that of the ready-made, only reverse. While the ready-made was an ordinary object appearing in an extraordinary setting – such as a urinal in a gallery – Rrose was an extraordinary person, an imaginary, aesthetised version of Duchamp – making an appearance in everyday life. This tendency to perform in everyday life was a crucial concern of Duchamp's, for whom, as for Nietzsche, creation did not occur in the segregated realm labelled 'art'. Instead, life itself was the ultimate artistic medium, and 'all people were artists', as 'everyone does something ... everyone makes something' (Duchamp in Cabanne, 1987 [1967]: 16). Performance was Duchamp's preferred means of bringing temporary, provisional structures into the unstructured world. A case in point is his famous introduction of chance operations and performative procedures into painting and sculpture, which changed the static medium into a residue of performance, such as his *Bride Stripped Bare by her Bachelors, Even* or *The Large Glass*. For this work, which Duchamp spent eight years making, from 1915 to 1923, he devised a quasi-scientific procedure in which all shapes used in the painting were derived from chance operations. As the teasing title suggests, the work is concerned with the mechanics of eroticism, which Duchamp studied by devising a series of arbitrary procedures, interconnected through language games, jokes and chance operations. For example, the bride – whose 'bodily envelope', to use Duchamp's (1994 [1975]) words, was auto-mobilistic in nature (which is not a mere sexist equation of women with cars since, in French, '*automobile*' means 'self-moving' while the word for 'car' is '*voiture*') was described as the 'essence of love' (a word whose first meaning is 'essence' but second 'petrol' (62)). Glass, for its part, was used so that performative actions could be captured. Duchamp referred to this trace-leaving process as 'delay', which is what he called *The Large Glass* (41). The erotic dynamic was captured in distinctly non-anthropomorphic but nevertheless associative ways. For example, in one part of the work, the nine bachelors' desire is depicted by nine

malic moulds from which matches, dipped in colour, were fired with the aid of a children's toy gun. They were fired at a photograph of white gauze creased by the wind. The chance operations of the captured wind were thus amplified by the chance operations of the firing mechanism, as well as by the colour of the matches. All this was transposed onto the glass in which holes were drilled. *The Large Glass* should therefore not be seen as a painting, or a sculpture, but as a residue of performance. As Duchamp himself asserts, it is the 'sum of experiences whose architecture relied on a three-beat rhythm, a "magic code of sorts"' (Duchamp cited in Schwarz, 1974: 157). This meticulous pursuit of chance operations is characteristic of Nietzsche's will to power, where power should not be understood as a human will to domination. Although Nietzsche uses the word 'will' which he derives from Arthur Schopenhauer, who, in turn, was greatly influenced by the Buddhist philosophy, in which 'will' does not refer to the human will but, more broadly, to energetics, Nietzsche's use of the word does not refer to humans only. This means that not only are we, as human beings, an expression and manifestation of power, but so are animals, plants and the Earth in general. The entire world is will to power. For Nietzsche, a thing is not a definite substance, but the sum of its effects. If the effects are eliminated in an effort to see the thing as it 'really' is, there is nothing left. Things are 'power quantums' defined through 'the force they exert' and 'the forces they resist' (Nietzsche cited in Aydin, 2007: 28). In fact, life itself is will to power: action, effort, yearning, chance. Duchamp's *Large Glass*, although in its final phase an object, is the sum of actions and interactions including forces, resistances, receptivity, malleability, movement and delay. It is a performative sequence, and as such the epitome of Dada performance.

Although different in terms of temporal and ideological orientation (how the present, the past and the future are understood; what is thought to be socially, politically and culturally desirable), the Futurist and the Dadaist uses of performance are entwined with Nietzsche's key valuing systems: energetics and vitality. While the Futurists concentrated on expanding the human capacity for perception – whether in the area of food, smell, touch or sight – the Dadaists focused on derailing the established paths of meaning. Both movements articulated novel intersections between two or more media and disciplines. The Futurist tactile sculpture introduced a different way of 'viewing', situated between music and visual art. In contrast to visual art, music is never given all at once; it is experienced in sequence. The importance of this new way of seeing is already given in the similarity between the verbs 'to grasp', 'to see' and 'to understand'. Our understanding of reality is inseparable from the manner in which our senses format our experience. The Futurist banquets are a significant example of such re-formatting, too, because 'nutrition' does not refer

to the body's intake of minerals and vitamins only. It refers to nourishment, which is a complex physical, psychological and social process. By prompting the banquet participants to focus on particular combinations of taste, touch, smell and savour the prepared food in particular ways, even wear particular clothes – pyjamas – the Futurists did much more than expand the field of artistic endeavour. They re-formatted a cultural practice by taking attention away from the amount of calories, protein or carbohydrates consumed and focusing it on sensorial, social and relational nourishment. Like the practice of *fisicofollia*, this practice impacted the way the individual relates to the social body. Through the configuration of the individual body's movement, vocal expression and/or eating habits, these performances proposed a different relationship between the individual and the social space. They also demonstrated that language is not coagulated and fixed but, rather, an open system of communication; a growing and changing archive into which every individual can, at any given point, bring something new, different, idiosyncratic even. In practising such linguistic interventions, the Futurists and the Dadaists effectively dissolved the notion of language as a homogenous system of valuing. Any uniform logic – such as the political and economic logic that led to World War I – is always based on non-disrupted relays of meaning, supported by dogmatic knowledge and derived from insulated disciplines, both of which create homogenous valuing systems. Another seemingly solid form – painting – was dissolved and shown to be a residue of performance. This is an important point, one that urges an archaeological view of the world as a four-dimensional agglomeration of past temporal layers. It is not a poetic gloss but a concrete method for questioning received practices and concepts.

Scores:

1 Invent a recipe for olfactory–gustatory, tactile and kinaesthetic consumption drawing inspiration from *The Futurist Cookbook*, but not using one of the existing recipes. Purchase the necessary ingredients, prepare a meal, invite guests, choreograph movement, compose or improvise acoustic accompaniment; in short, design the entire experience.

2 Script and perform short texts that operate beyond spoken and written language. Find a venue. Take particular care to understand how language functions in this day and age, as influenced by the internet, Beatnik poetry, rap and mashups. Disrupt the existing flows of meaning by means of vocal, musical, syntactical, metaphoric, idiomatic and durational interventions.

3 Research procedures that take place at an archaeological site. Find a common physical occurrence that involves humans, animals and/or natural forces. Analyse this relationship in depth in terms of action, reaction, forces, traces, sedimentations and disruptions. Design a step-by-step procedure which involves a hard, flat surface (a wall, a table, a ceiling). Perform the various actions and procedures over one month, then exhibit the remains.

2 The World Becomes

Surrealism, the unconscious, performative writing

The Surrealists, whose name indicates a conception of reality that exists 'over', 'above' and 'beyond' ordinary reality, wholeheartedly embraced the Dadaist experimentation with chance, shock, irreverence and disorientation. Indeed, much of the early Surrealist activity was closely associated with the Paris Dada, inaugurated by Tristan Tzara in a performance of 23 January 1920, in which he, contrary to what had been announced – a poetry recital – read a political article with an electric bell ringing loudly and incessantly in the background. This commitment to the critique of language as a form of power, so characteristic of Dada, was taken further in a performance in which both the Dadaists and the emerging Surrealists took part: Tzara, Louis Aragon, Philippe Soupault, Georges Ribemont-Dessaignes and André Breton. Held at the Salle des Sociéteés savantes in Paris on 13 May 1921, this performance was a staged public trial of journalist and politician Maurice Barrès. Mimicking authoritative utterances pronounced by the representatives of the law – the judge, the prosecutor, the defence council – the purpose of this performance was, in Breton's (1993) words, to 'determine the extent to which a man could be held accountable if his will to power led him to champion conformist values that diametrically opposed the ideas of his youth' (53). Breton's phrase 'will to power' bears no relation to the Nietzschean concept discussed in the previous chapter, however. It refers to human, more specifically, to Barrès's intentions. Famous for his inflammatory anarchist texts, which celebrated personal liberty over imposed conventions, tellingly titled *The Free Man*, *The Enemy of the Law* and *The Cult of Me*, Barrès transformed into a reactionary conservative in his later life. What is more, he continued to use his former credentials to propagate reactionary values. The critique of language heralded by this performance was very different from the critique practised by the Futurists and the Dadaists, however. It was prescient in its focus on the relationship between authority, credibility and content. As British linguist J. L. Austin (1962) was to suggest in his famous 1955 Harvard lecture, words do not merely make statements about the world; they do things in the world (5). They have

a performative effect. The extent of this effect depends on the context and the authority invested in the speaker. If a judge pronounces a defendant guilty, the judge will unequivocally inaugurate a new reality. If a wedding officiant pronounces the bride and the groom a married couple, the officiant, too, will inaugurate a new reality. A pronouncement made by a figure with no legal authority will not have the same effect. But even if not legally binding, words pronounced in the public sphere have an effect. If negative things are said about a person in front of hundreds of people, these words will, at the very least, inaugurate the possibility of being true. The reason for this is that words are world-making. Like other performative acts, they create socially shared worlds. While the accused Barrès – who was invited but declined participation – was represented by a mannequin, Breton played the judge and president of the tribunal; Ribemont-Dessaignes was the prosecution council, Aragon and Soupault were the attorneys, Tzara was the chief witness on whose testimony the case hinged. By pronouncing Barrès 'the greatest rogue I have ever met in my political career; the biggest swine I have met in my political career; the greatest scoundrel which Europe has produced since Napoleon' (Tzara cited in Bonnet, 1987: 38), Tzara publicly denounced Barrès's work and person. Breton subsequently sentenced him to 20 years of forced labour. This performance, which was publicised in all Parisian newspapers, and which drew several hundred audience members, marked a clear stance against the abuse of rhetoric power – the power to persuade – inherent in all language.

However, although deeply concerned with language, Surrealism was to take a different, less demonstrative, yet highly original approach to performance and, in particular, to performativity. Performativity is the capacity of the various modes of communication such as speech, writing, image, and symbol to summon, create, construct and define reality. In fact, performativity was to become the Surrealist hallmark since it was by means of literary and pictorial performativity that infinitely richer realities than the reality governed by rational concerns were summoned into being. According to the Surrealist spokesman, Breton (1974 [1969]), surrealism was an 'automatism ... intended to express, either verbally or in writing, the true function of thought dictated in the absence of all control exercised by reason, and all aesthetic or moral preoccupations' (26). Furthermore, Surrealism was:

> based on the belief in the superior reality of certain form of association heretofore neglected, and in the omnipotence of the dream ... leading to the permanent destruction of all other psychic mechanisms, and to its substitution for them in the solution of the principal problems of life. (26)

Indeed, Surrealism was a movement of very serious revolutionary intentions whose realisation was sought, among other avenues, within the political framework of the communist party. Although this association was short-lived, the desire to transform human values through the transformation and enrichment of perception was at the heart of all Surrealist endeavour. The orientation towards the subconscious was in itself revolutionary; its purpose was to overthrow ingrained forms of behaviour. Access to the semi-conscious states meant access to the mysterious and the marvellous, to a direct correlation 'between the interior, subjective reality and the exterior one' (Breton, 1992 [1988]: 381). This searching was at the same time a quest for liberation from the reality of the post–World War I Europe, and a search for the origin of language as a basis of social reality. The beginnings of this search and, in fact, of Surrealism proper, can be found in Breton and Soupault's (1967 [1919]) *Magnetic Fields*, which contained dialogues such as:

'Have you forgotten that the police have arrived and that they have never been able to stop the sun?'

'No thank you. I know the time. Have you been locked in this cage long? What I need is the address of your tailor.' (57)

Apart from announcing the significance of collective creative activity, *Magnetic Fields* was produced through automatic writing. This practice, in which the practitioner elected to 'perform at the dictation of thought' (Breton, 1974 [1969]: 26), is indebted to the advances in the field of psychiatry – more specifically, to the psychoanalytic work of Sigmund Freud. The technologically revolutionary beginning of the twentieth century and, in particular, World War I, which many Surrealists – Breton, Max Ernst, André Masson – had direct experience of, were characterised by shock and trauma. Shock and trauma manifested as the inability to resume life. As a young medical student during World War I, Breton worked as a psychiatric aide in military hospitals practising the psychoanalytic method on the shell-shocked. The purpose of this method was to jump-start the soldiers' habitual mental operation through free association. Familiar with this practice, as well as, in his own words, 'occupied with Freud' (23), Breton subsequently tried to 'obtain from himself what he had obtained from his patients … a monologue spoken as rapidly as possible without any intervention on the part of the critical faculties', a monologue 'unencumbered by the slightest inhibition' (23).

Essentially, Freud's theory of the unconscious is based on the belief that we never grow out of the irrational childhood fantasy guided by the

indiscriminate pleasure principle, but also by greed and megalomania. For Freud, our adult reactions to the ups and downs of life are rooted in the behavioural patterns acquired in early childhood, which have left mnemonic traces but are unintelligible to the adult mind. Unfettered free association was, for Freud (1950), a method for releasing the stored but repressed memories. He differentiated between the merely forgotten and the repressed memories, defining repression as 'the struggle against acceptance of a painful part of reality' (297), which consisted in 'keeping something out of consciousness and rejecting it' (297). Repression is thus not something that takes place once and for all; by contrast, it requires a constant expenditure of energy. Curing this condition necessitates searching the unconscious and its three mental agencies: the ego, the super-ego and the id. While the ego represents the conscious mind, the super-ego is related to conscience. The id is the infant out of which the ego develops; it represents the unfathomable impulses that often interfere with what is considered to be rational human operation. This is why Freud (1967) placed so much emphasis on dreams, which, he argued in *The Interpretation of Dreams*, were a form of thought. 'Every dream reveals itself as a psychical structure which has a meaning and which can be inserted at an assignable point in the mental activities of waking life' (35). However, although dreams were, for Freud, 'the royal road to a knowledge of the unconscious' (647), the crucial difference between the Freudian notion of the unconscious and the Surrealist one was that Freud was a believer in causality. In *Introductory Lectures in Psycho-Analysis*, Freud (1949) speaks of 'the thorough-going meaningfulness and determinism of even the apparently most obscure and arbitrary phenomena' (87–88), but this meaningfulness remains subordinated to a single cause: elim- inating repression. The Surrealist endeavour, however, although greatly influenced by Freud – particularly in the case of Breton and Salvador Dalí – was very different in nature. The main purpose of automatic writing was to disengage signifiers from their signifieds – in other words, to disengage meaning from the usual carriers of meaning – and in this way widen the semantic field, not to decipher the 'message', as was the case with Freud. In *Magnetic Fields*, Breton and Soupault (1967) write: 'words and names lose their faces. The street is nothing but a deserted road' (89). Indeed, the experience of automatic writing is described as resembling an exotic journey, as a time when the writer 'comes to life for the second time', and finds his or her memory 'planted with treelike remembrances' (91). These hallucinatory texts, derived from the practice of writing 'quickly, without any preconceived subject, fast enough so that you will not remember what you're writing and [putting] your trust in the inexhaustible

nature of murmur' (Breton, 1974: 40), created entire worlds. In the early 1920s, this form of automatic, eliciting, performative writing, induced by trance, or sleep, was practised in groups. Breton, Soupault, Luis Aragon, Robert Desnos, Paul Éluard, René Crevel, Benjamin Péret, Max Ernst and Francis Picabia met each evening to create impromptu texts collaboratively, as well as to, according to Louis Aragon, give 'accounts of the day's catch: the number of beasts invented, the fantastic plants, the images excavated' (Aragon cited in Melzer, 1980: 170). It was by systematically populating the social and the linguistic reality with the marvellous, the mysterious and the unexpected that the Surrealist revolution was to take place. As could be seen from the Surrealist declaration of 27 January 1925, the Surrealists did not aim 'to change anything about people's morals', but 'to show the fragility of their thoughts, and on what shifting foundations ... they have affixed their tottering houses' (Aragon et al. cited in Richardson and Fijalkowski, 2001 [1925]: 24). The lived reality of the post–World War I Europe was a sorry one, indeed. However, this lived reality was only one of the many possible realities. In order to mine other, richer realities, many members of the Surrealist group developed an aptitude for falling asleep at will. As Aragon recalls: 'in a café, amidst the noise of voices, the full light ... Robert Desnos has only to close his eyes and he speaks, and in the middle of the beer stains and flying saucers, an entire ocean gives way' (Aragon cited in Melzer, 1980: 170). Although performance was used in these gatherings as a method for excavating diverse snippets of memory, and although recounting 'the day's catch', as Aragon calls it, brought new worlds into common social circulation, Surrealist writing was chiefly concerned with performativity. That is to say, it was concerned with the modes of bringing into existence, of rendering operative, not with public performance. Nor was it concerned with charting causal relationships between the various events, as was the case with Freud. Rather, the Surrealist search for what lies beyond the usual, the regulated and the everyday was related to the very processuality of discovery. Dream, trance and intoxication were used as much to transgress linear duration – the causal sequence of events Freud was searching for – as they were used in their capacity of performative matrixes; to 'summon' the marvellous, the perpetually changing and the intuitive into being.

Henri Bergson: duration and intuition

Unlike Freud, but very much like Nietzsche, French philosopher Henri Bergson did not see the world as a cause-and-effect-related system. This is why, for Bergson, no part of the world, however small – a plant, a microbe

or a pebble – could ever be considered as a thing in itself, a closed system, subjected to external forces. Because all particles of the universe are dynamic systems, as well as in continuous flux, evolution is invention, creation and an incessant state of vital becoming. In *Creative Evolution*, Bergson (1944) writes:

> As the smallest grain of dust is bound up with our entire solar system, drawn along with it in that undivided movement of descent which is materiality itself, so all organized beings, from the humblest to the highest, from the first origins of life to the time in which we are, and in all places as in all times, do but evidence a single impulsion ... all the living hold together, and all yield to the same tremendous push. (295)

In stark contrast to philosophers who did not distinguish between time and space and, in fact, treated them both as a causal sequence within which anything that happens happens in a deterministic way, such as influential German philosopher Immanuel Kant, Bergson saw time as a *dimension of creativity*: a complex dimension, consisting of many multiplicities, in which both the universe and human consciousness were in a constant process of change. In order to render this multiplicity intelligible, Bergson insisted on the difference between spatial and temporal multiplicity. Spatial multiplicity is quantitative; when looking at a hundred sheep, we might notice the difference between them but we will equally have no problem in agreeing that all hundred beings before us belong to the same category, namely sheep. Temporal multiplicity, by contrast, is qualitative. This means that it is not more of the same, or similar, but radically different in every instance as well as changing all the time. Duration – *la durée* in French – is, for Bergson, the interior temporal dimension of all living beings. It is the dimension of freedom, in which nothing is fixed or determined. In humans, this dimension corresponds to the human faculty of intuition. While the intellect operates in a spatial way – by finding common denominators or systems that can be placed in a productive relationship with other common denominators and systems – intuition enables us to perceive this quality of newness and difference in every moment, which is duration. For Bergson, the habit of the intellect to reduce the entire world and all its processes to a schematic way of seeing has very limited value. Far more important, in his view, is the ability to apprehend process. Whereas clock time – which is mechanical – fails to recognise the experience of time as process (slow time, heavy time, time as a source of pressure or relief), Bergson's duration is not external to the human subject. In *Time and Free*

Will, Bergson (1921) defines the link between duration and freedom in the following way:

> While the external object does not bear the mark of the time that has elapsed and thus, in spite of the difference of time, the physicist can again encounter identical elementary conditions, duration is something real for the consciousness which preserves the trace of it, and we cannot here speak of identical conditions, because the same moment does not occur twice … even the simplest psychic elements … are in a constant state of becoming, and the same feeling, by the mere fact of being repeated, is a new feeling. (199–201)

This differs radically from Freud's conception of consciousness, in which as soon as a pattern is established – and patterns are established with the aid of causal thinking – a closed system is created. Otherwise put, as soon as a symptom is found, other forms of behaviour are subsumed under this category as well. If a person gets the hiccups twice or three times in an embarrassing situation, all future hiccups are interpreted as caused by embarrassment. For Bergson, the feeling of freedom associated with the temporal dimension is related to the fact that the experience of time involves actuality, virtuality, physiological processes, imagination, and fantasy; in this dimension we jump from the past to the future and back to the present. Imagination and fantasy are not separate from reality. Duration is a process that in every moment is new – a permanent creation of novelty. It is impossible to establish a pattern then interpret all subsequent 'manifestations' of this pattern as belonging to the same cause. For Bergson:

> Freedom is the relation of the concrete self to the act which it performs. This relation is indefinable, just because we are free. For we can analyse a thing, but not a process … Or, if we persist in analysing it, we unconsciously transform the process into a thing. (219–220)

Duration, in Bergson's terms, is always an act, a performance, nothing is ever merely repeated but, instead, every repetition is new. Furthermore, our life is duration itself. Life is a flowing, continuous, undivided movement. A thing that lives is a thing that endures not by remaining the same but by changing all the time. The emphasis on automatic, unpremeditated, performative writing, which brings new worlds into being, is precisely the emphasis on this continually different dimension of time as personal velocity, the velocity of the world included. In *Lost Steps*, Breton (1924)

recalls the enquiry 'why do you write?' which featured in the pages of the magazine *Littérature* he co-founded with Aragon and Soupault. To the response of several readers, such as 'I write to shorten time', or 'I write to pass the time', Breton adds that he writes to lengthen time, to 'let time act and to act upon time' (13). Performative writing renders the intuitive processes palpable. It operates in the here and now as a torrent of unbridled words, with no time for censorship. Here memories mingle with fantasies, poetry, dreams and everyday banalities. The process of ordinary writing – of carefully choosing one's words and painstakingly constructing sentences – is here reversed. But the point is not merely the reversal of directions. Instead of searching for content, the writing process here is a process of emptying out, as well as a process of contagion, in which distant associations and unlikely realities come into close contact. Performative writing performs two distinct functions: it amplifies the occurring of life – life as process, life as duration – of which the written words are no more than a trace, and it brings the distant (sur)realities to bear on social reality.

The multiple temporalities of Francis Picabia's *Performance Cancelled*

In 1924, together with composer Erik Satie and cameraman René Clair, Francis Picabia, painter, poet and former Dadaist, staged what may be termed the first intermedial performance which thematised duration. Performed at the Théâtre des Champs-Élysées in Paris and entitled *Relâche*, which means *Performance Cancelled*, this performance revolved around self-cancellation in two ways. First, in cancelling the habitual frame which segregates a ballet performance from the rest of life, including the segregated stage area, the choreography, the lighting and the temporal organisation of the performance into acts and interludes. Second, the performance was cancelled in the literal sense, because on the opening night, scheduled for 27 November, the leading male dancer, Jean Börlin, was unwell. The performance premiered on 4 December instead. Like Bergson's concept of duration, in which fantasy mingles with actuality, illusion with memory, and like performative writing, the various frames of the performance – what the performance actually contained – were continually reconfigured. The elements of film, dance and set constantly subverted the spectators' expectations. While the dancers on the stage – members of Les Ballets Suédois – executed fairly standard ballet movements, a chain-smoking fireman was seen pouring water from one bucket to another. Photographer Man Ray was sitting on a chair near the edge of the stage, occasionally getting up to stretch his legs. A tableau vivant consisting of a naked man and

woman – the naked man was Marcel Duchamp – in the poses of Cranach's Adam and Eve was intermittently illuminated. The set consisted of 370 car headlights beaming directly into the eyes of the audience. As can be imagined, this made it difficult to see what was going on. Art theorist Rosalind Krauss (1993 [1977]) suggests that this feature radicalised the relationship between the stage and the audience, because the performance 'struck out at the audience directly – absorbing it, focusing on it – by lighting it'; the audience was 'blinded' while it was 'illuminated'; this 'double function demonstrates that once the watcher is physically incorporated into the spectacle, his dazzled vision is no longer capable of supervising its events' (212–213).

We have all been dazzled by the sun to the point of not being able to see the objects or people in our vicinity. While making the usually imperceptible space between our eyes and the sun visible – because saturated with light – strong sunlight blinds us to our immediate surroundings; it catapults us to a different world, much like trance-like, monotonal and/or minimally varied music does. The characteristic of both is that it envelops us; we can no longer 'supervise' our environment from a vantage point. Rather, we become a constituent part of the environment; we become immersed in it. Satie, whose reputation for constant innovation, such as in the scandalous *Parada* and the outrageous *Le Piège de Méduse*, both of which received much negative publicity prior to his collaboration with Picabia, was greatly admired by the Dadaists. But even critics who, like Jean Aubry, thought that the cause of Satie's 'apparent lack of respect for music' pointed to the composer's higher plane of existence, after seeing *Relâche* wrote that, in this performance, while listening to the musical accompaniment, the audience were 'in fact, listening to nothing' (Aubry cited in Gillmor, 1983: 108). Satie, who had been experimenting with minimalist music for some decades, said that he had composed 'for the chic set [the 370 headlights] an amusing and pornographic [*sic*] music' (Satie cited in Mayr, 1924: 11). The word 'pornographic', in the sense of 'exposed', could be understood as an allusion to the fact that the audience was blinded and bereft of their usual 'supervising position', much like they were exposed to minimally varied music rather than to music with a lot of tempo changes, melodic developments, rhythmic punctuations and arabesques. It could also be understood as referring to the fact that *Relâche* purposefully exposed the conventions of a ballet performance by introducing incongruous elements, such as the neither-performers-nor-non-performers walking in the area between the stage and the auditorium. In support of Satie's statement, Picabia, in a mock interview with the director of the Swedish ballet, Rolf de Maré (1924), who asked him to explain the performance, said:

'Explain what? Do you take me for Einstein?' (2). Referring to Albert Einstein (1920) and his famous theories of relativity – special and general, which established the simultaneous relativity of all measurements, the contraction of space and the dilation of time – Picabia is here playfully suggesting that there can be no absolute frame of reference, no overarching explanation, only relation of one element to another, or of one element to many others. In physics, every time an object's movement is measured, either as momentum or velocity, it is measured in relation to something else. There is no such thing as absolute velocity, much like there is no absolute value of any kind. All values are established in relation to something else. It is precisely this *interdependence* of different and mutually influencing elements that is at the heart of *Relâche*.

Although the use of film on stage had already been practised for some years, by such theatre directors as Erwin Piscator, who had employed cycloramas, moving sets and multiple projection screens as early as 1922, Picabia's use of film was radically novel. Entitled *Entr'acte* or *Intermission*, which was, indeed, shown in the intermission between the ballet and the various performative actions that syncopated the ballet, the film was revolutionary with regard to duration and the perception of time. Despite the fact that Bergson (1921) compares objective, 'external' time to cinematographic time (329), which has negative connotations as it robs time of its multiplicity, Picabia's frequent framing of the film in terms of the live performance and vice versa accentuates this very multiplicity. Bergson's reference to the cinematographic time alludes to the illusion of continuity created by the rapid succession of static frames only one twenty-fourth of a second long, which, although static, cannot be discerned as such by the naked human eye, but are mistakenly perceived as a continuous image. It also refers to the cinematic procedure in which movement is filmed as continuous in real life, then mechanically broken down into a series of static single frames and subsequently projected as an illusion of continuity, imitative of the original continuous motion. In *Creative Evolution*, Bergson (1944) compares this 'cinematograph' to 'objective' notions of time which place the observing subject outside the phenomena observed:

> Instead of attaching ourselves to the inner becoming of things, we place ourselves outside them in order to recompose their becoming artificially. We take snapshots, as it were, of the passing reality. (332)

This is why 'cinematographic time' is, for Bergson, the opposite of the qualitative multiplicity mentioned above. In the cinematographic time,

multiplicity is quantifiable. However, apart from abounding in frequent tempo changes – rapid cuts from close-ups of objects, such as a bald head, to long shots of streets, or from figures running in slow motion to vehicles moving in fast motion, all syncopated by canon and rifle shots and blurry cross-fades of indistinguishable images – *Entr'acte* also makes frequent out-of-the-frame references. A case in point is the shot of Picabia shooting from a rifle. This shot shows Picabia in two locations: first, standing in front of a blank cinema screen; then, on film, as part of the filmed action. This staged shooting – in a cinema, in front of a blank screen or, indeed, in a theatre with a screen, like the Théâtre des Champs-Élysées where *Relâche* was shown, points to the past live-ness of all filmed material. All filmed action was once live action. It also points to the transformation of the dur-ation of filmed material when interrupted by a reference to the shooting process and past live-ness.

Although it is generally thought that once shot, the film sequence does not change – because of the closed, finished, definite nature of the medium – Picabia, together with Claire, shows that with the aid of out-of-the-frame references which allude to the stage performance (the ballet), as well as to the past live-ness of the filmed action, the time frame of the film is, in fact, discontinuous. It is not closed, but multiplicitous. The reason for this is something that Bergson scholars have pointed out many times, namely that the past always 'grows without ceasing', and that it 'possesses an infinite capacity for novel reinvention' (Pearson, 1999: 149). What phil-osopher Keith Pearson is saying here is that, for Bergson, the past is *always* in the process of changing because it is always seen in a different context; it is also always seen by a different person since the observer has changed, too, and no longer has the same relationship to the past. By making fre-quent references to the live performance, in terms of tempo, movement and the protagonists, Picabia and Claire create a continually changing rela-tionship to the past-ness of the various actions. There are also numerous references to the theatre building in which *Performance Cancelled* took place, which appears on the screen three times. In one of the scenes, Duchamp and Ray, present in one of the intermittent live tableaus and sitting in the performance space, respectively, are seen sitting on the roof, playing chess with Erik Satie looking on. At the end of the film, Jean Börlin bursts through the screen, only to disappear back into the film and reappear on stage, thus echoing the past live-ness mentioned above. Added to these multiple temporalities, which tend to change the action in whose wake they occur, are frequent unusual angles, such as the shot in which the prin-cipal dancer, Jean Börlin, dressed in a gauze tutu and dancing on a glass surface, is filmed from below, as can be seen in Figure 2.1.

Figure 2.1 Jean Börlin in René Clair's *Entr'acte*, part of Francis Picabia's *Relâche*, 1924. © ADAGP, Paris and DACS, London 2015. Courtesy of DACS, London.

Seeing this sequence filmed from below makes it seem longer, since the human body and the tutu are no longer seen in their totality but as a pattern resembling a flower. These fluid transformations and the elusiveness of the shown object lend themselves to fantasy. Bergson's notion of *qualitative change*, as permanently pregnant with creative potential, is here conspicuously present. In fact, it is present throughout the film, particularly in the frequent changes of tempo in which the interpenetration of the different states of consciousness – reminiscence, memory, fantasy – flows into the present moment. This is further amplified by frequent costume changes, which occur onstage, and by the intermittent appearances of banners with 'Satie is the greatest musician in the world' and 'if you're not satisfied, buy a whistle for two sous from the attendant' written on them. Apart from a tricycle which appeared onstage, amidst dancers, in the first part, the authors also drove a Citroën onto the stage at the end of the performance. The ceaseless interpenetration of the different frames and spaces – the space of the actual auditorium, the building, the actions

filmed in front of the very film screen onto which they are projected – amplify the Bergsonian duration. The combination of the different media – film, staged performance (the ballet) and the supposedly non-staged performance, consisting of everyday actions, such as sitting, smoking and walking in the space between the stage and the auditorium – continually reconfigure the now moment in multiple ways. Clearly, for Picabia, as for Clair, cinema is not the photographic reproduction of the object as there is no external, sequential temporality in *Entr'acte*. The very subjective perception of time afforded by the film upsets any notion of the cinema as a temporally 'locked', closed medium. By not presenting the viewer with fixed time frames, in either medium – film or performance – but, instead, focusing on their relation, *Relâche* makes it possible to perceive the constantly changing nature of duration.

The performative object: the memory of the world

Bergson's intuition and duration exist in everything that lives, even in plants. They are identical with life itself; wherever there is life, there is duration and there might be consciousness of living that is intuition. When André Masson met Breton, in 1924, which is when he formally joined the Surrealist group, he had already completed two performative drawings, the 1923–1924 *Study of Nudes* and the 1924 *Furious Suns and Birth of Birds*. Characteristic of Masson's drawings, executed quickly, as if in a trance, is the continuum of plants, animals, persons, objects and environments. As Masson himself explains:

> the important detail [is] to make the bodies unite with an environment in order to create a space where as much as possible there is no longer either a top or a bottom – where that which is inside is also outside …
>
> The secret is the penetration of diverse elements.
> (Masson cited in Clébert, 1971: 32)

Never focusing on a single part but drawing with an agitated line, Masson created images that seem to be in constant motion. Key to this technique, in Masson's (1956) own words, was to '[s]urrender to the interior tumult (635). Drawing on bodily memory on the one hand, and on the Bergsonian open systems – which include all matter and all living beings, interconnected through the cycles of nourishment, discharge, birth, death and decomposition – performative drawing brings into view the (hidden)

resonances of the world, much like the Surrealist collage does. Both sought to show a different reality beyond the directly accessible one. According to painter Max Ernst, a collage should engage: 'images so mutually distant that the very absurdity of their collection produced in us a hallucinatory succession of contradictory images ... [thus bringing] forth a new plane in order to meet in a new unknown' (Ernst cited in Frey, 1936: 15). The purposefully hallucinatory state was, as Ernst explains, related to the Surrealist precursor poet Arthur Rimbaud's practice of deliberately substituting mosques for factories, seeing 'a drummers' school conducted by angels ... a salon at the bottom of a lake' (Rimbaud cited in Ernst, 1948: 12). This is why Ernst suggests that collage is, in fact, generative of hallucinations and in this sense performative. To the self-imposed question 'what is collage?', Ernst (1948) replies:

> Collage is something like the alchemy of the visual image. THE MIRACLE OF THE TOTAL TRANSFIGURATION OF BEINGS AND OBJECTS WITH OR WITHOUT MODIFICATION OF THEIR PHYSICAL OR ANATOMICAL ASPECT. (12, emphasis original)

For the Surrealists, the collage was like a magic door into a ready-made reality, produced of the coupling of two or more different and unlikely realities. But this procedure of re-mixing the world to create other realities had an archaeological bent, too. In 1925 Ernst discovered what has since then been called *frottage*. As Ernst suggests, '[f]rottages are obtained by rubbing charcoal or pigment on a paper which has been placed over some rough surface that is the object of study' (Ernst cited in Frey, 1936: 15). Such a surface, which can be placed over several different objects and rubbed, reveals entirely different images of familiar objects. As Pearson (1999) suggests, memory, in Bergson, is to be understood neither as a 'drawer for storing things away nor as a faculty' (149). Memory is a *process*. It is precisely this relaying and contagion of impressions that is brought into focus when a paper is placed over several different surfaces and drawn upon in succession. The paper 'documents' the various interactions and, as such, operates as a performative document. A performative document is a residue of performance and, in this sense, similar to automatic or performative writing. It calls forth – or resurrects – the trace, and thus also past performance. This way of calling forth images from the world embodies Bergson's discussion of memory and perception in *Matter and Memory*. For Bergson, being is no more than a continuous exchange of the most diverse energies emanating from multiple sources. Perception does not occur *in* time but is *of* time; it is a process, a relay of intuitive memory. Bergson (1939) writes:

'Your perception, as instantaneous as it may be, consists therefore in an incalculable multitude of memory fragments and, in fact, all perception is already memory' (39). Perception involves a 'jolt' whose function it is to:

> imprint on the body a certain attitude in which memories will insert themselves ... the present perception will always seek, in the depths of memory, the recollection of the anterior perception, to which it bears semblance. (112)

The incoming experiences are thus imprinted on the body by calling to memory, which answers by providing the closest match from the already created bank of images. But '[b]ehind these images identical to the object', Bergson writes, there are others, stored in memory, that resemble the object; it is just that their kinship to the object is more distant (112–113). Perception is therefore action. This is why Bergson does not separate dreams from reality but, instead, proposes a continuous transition from consciousness to unconsciousness. The plane of the dream is just as real as the plane of (waking) action. Although memory and matter are separate, they form a continuum since material elements are, for Bergson, vibrations. Each object has its own frequency. Memory is not a passive receptacle, a drawer; memory of past reality/ies is a deep, productive and ever-changing unconscious. Simply put, it is action. And it is this performative dimension of all matter, as process, as memory, as duration, as multiplicity, that the Surrealists sought to give expression to. Through frottage, they illuminated the subtly interpenetrating cycles of pattern recognition, moulded perception and action. We see what we are trained to see. While a hairdresser will, most likely, be able to provide a reasonably accurate description of a person's hairstyle, even if they only met them for several minutes, a speech therapist will be more likely to offer an accurate description of the person's speech patterns, use of voice and dialect. The reason for this is, of course, focus and attention, but also habit – ingrained ways of seeing – and the corresponding archive of similar experiences. The purpose of collage and frottage is to wrest multiple, particularly less-used images directly from the memory of the world, in a manner that makes them available, visible and, importantly, part of the communal bank of images. It is to show, through performance, that time is not separate from matter; that time is not an envelope or a container, that matter is not fixed but in constant transformation. This transformation – or duration – of material elements corresponds to human experiential activity; both create an attitude, a receptivity for future experiences. Experiential activity and material process are thus not only complementary but, in fact, entwined.

Salvador Dalí's paranoid-critical method: perception as action

Similar to Surrealism's celebrated predecessor Arthur Rimbaud's hallu-cinatory practice, Salvador Dalí's paranoid-critical method was designed to elicit (active) perception of the world. It often found its outlet in per-formance. The method consisted of bringing the obsession of paranoia to bear on everyday life. Unlike most other manifestations of mental illnesses, paranoia is often systematic. Although it may be delirious, in its interpret-ation of what is generally agreed upon as 'reality', paranoia is not illogical. Dalí's purpose was to falsify the already-existing memory moulds and illicit irrational interpretations so as to usher in a different perceptual organ-isation of the world. As Breton (1936) suggests, this method is applicable to everything: 'painting, poetry, the cinema, to the construction of typical surrealist objects, to fashions, to sculpture' (83). The relationship between image, process and performance was defined by Dalí (1968 [1942]) in the following way:

> The new delirious images of concrete irrationality tend towards their physical and actual 'possibility', they surpass the domain of phan-tasms and 'virtual psycho-analysable representations', they give 'objective value' on the real plane to the delirious unknown world of our irrational experiences. Against the remembrance of dreams and the virtual and impossible images of purely receptive states 'that can only be recounted', there are the physical facts of 'objective' irration-ality, with which one can actually wound oneself. (418)

Derived from chance operations but organised into a productive method-ology, this '*spontaneous method of irrational knowledge based upon the interpre-tive-critical association of delirious phenomena*' (418, emphasis original) was to be seen in Dalí's 1939 series of photographs entitled *Model with Lobster* and *Seafood Dress*. These photographs featured Murray Korman, naked or scantily dressed, with a lobster and seafood covering her erogenous zones and genitalia. However, this method also had a direct impact on knowledge production, as demonstrated by Dalí in his lectures, such as the lecture he delivered at the London International Surrealist Exhibition in 1936, in a diver's suit. Dalí gave a forty-five-minute lecture without opening the sealed face plate once – in other words, without being heard. If we look at this from a utilitarian point of view, we will invariably think, 'what is the purpose of delivering a lecture that cannot be heard?' But if we look at this as a performance – every lecture is always already a performance of know-ledge, since it does not consist of the communicated content only, but

also of communicative methodologies – then Dalí's approach to knowledge transmission reveals a number of things. First, it reveals Dalí's questioning of the medium – is a talking lecture by a person 'supposed to know' the only way of accessing knowledge, or can something far more important be transmitted, and, in a different medium – that of performative imagery? Does not ordered knowledge – knowledge that subsumes all or most phenomena under a single method of transmission, based on the enumeration of premises leading to a logical conclusion – negate the Bergsonian multiplicity? Does it not, in so doing, impoverish rather than enrich the intellect and the senses? At another lecture, delivered in Barcelona to a group of anarchists, Dalí kept inserting strings of obscenities into an otherwise logically organised sequence of thought. Needless to say, this caused a growing restlessness in the audience, which culminated in loud protests. Dalí responded to the tumult by strapping a specially prepared, oversized loaf of bread to his head while simultaneously continuing to lecture. This is when, according to Dalí, 'the general hysteria' broke out to which he responded by shouting a poem at which point 'an anarchist doctor with a face as red as if it had been boiled … was seized with a real fit of madness' (322–323). Dalí practised this surreal reversal of expectations and the insertion of different, richer, fuller realities in his later career, too. In December 1955 he delivered a lecture at the Sorbonne University in Paris, entitled 'On the Phenomenological Aspects of the Paranoiac-Critical Method' (phenomenology is the study of first-person human experience). Dalí arrived at the Sorbonne in a white Rolls Royce, which, for this purpose, had been filled with 500 kilograms of cauliflower. But this was far from a prank. Like the old masters, Leonardo da Vinci and Johannes Vermeer, Dalí was preoccupied with reducing form to elementary geometric shapes. As art historian Elliott H. King (2002) notes, Dalí believed that the 'logarithmic spiral found in rhinoceros could also be identified in sunflowers and cauliflower heads, as well as in Vermeer's paintings' (np). The Surrealist tendency to create multiple – experiential realities via performance – was present in an exhibition usually seen as belonging to the mature phase of Surrealism, the *Exposition internationale du Surréalisme*, held at the Galerie Beaux-Arts in Paris during January and February 1938. Directed by Marcel Duchamp, the exhibition was presciently christened by Breton *une oeuvre d'art événement* (a work of event art, which would gain momentum in the 1960s). Here, Dalí's *Rainy Taxi* – an old taxi with two mannequins inside it, one in the front seat, equipped with a shark's head, one in the back, seated among lettuce leaves over which live snails crawled. In equal intervals, the taxi's occupants were drenched by a set of water pipes running through the interior of the car. As art historian Lewis Kachur (2001) notes, Dalí was

inspired by the experience of waiting for a taxi during a downpour in Milan and was pleasantly surprised when the rain had ceased. Focusing on the radical difference between the two environments, the downpour and the dry taxi, Dalí simply decided to superimpose the former on the latter, as is, indeed, done in frottage (34). Important, however, is that the paranoid-critical method is practisable by anyone and not confined to artists only. Its purpose is to wrest startling, beautiful new images from the world and include them in everyday circulation. However, despite the erosion of boundaries between producer and receiver and the essentially recipe-like nature of all performative writing, performative drawing, frottage and, in particular, Dalí's paranoid-critical method (which could, indeed, be prac-tised anywhere and anytime), the Surrealists were a closed group. As art theorist Peter Bürger (1984) acknowledges, the Surrealist intention 'do away with art as a sphere that is separate from the praxis of life', means that their performative texts and objects should 'be read as guides to individual production' (53). They should be seen as methods that could be applied in the percipient-practitioner's own life, not as close-circuited works of art. Although Surrealism did, of course, flourish in many European countries, as well as in the US, the scale of its revolutionary reach, limited as it was to artists' circles, could hardly be compared to the movements flourishing in the 1920s Soviet Union, more specifically, in the period after the October Revolution of 1917, Vladimir Ilych Ulyanov's (alias Lenin's) death in 1924 and Joseph Stalin's subsequent rise to power.

Dziga Vertov: The performative camera

It is in this period that Dziga Vertov's performative approach to docu-mentary film-making came to prominence. A contemporary of Vsevold Mayerhold, whose biomechanics were inspired by the analytical study of time and motion, which approached the body of the performer as an element of the staged action, Vertov, like Meyerhold, was a Constructivist. Constructivism was a method, used in poetry, painting, literature, theatre and film that relied on the juxtaposition of incongruous parts to create a more meaningful whole. 'Meaning', however, much like in Surrealism, was here derived from the illogical elements and associative repercussions, not from neatly organised semantic elements. Like Meyerhold, Vertov was fascinated with kinetics, with the rhythm of machinery and the physical motion of factory workers, as can be seen from his early works such as the 1926 *One Sixth of the World*. However, the 1929 *Man with a Movie Camera*, the experimental documentary film which is our focus here, introduced an

entirely different relationship between time, space and perception. It also introduced an entirely new, performative as well as anthropological cinematic function. The film follows a cameraman, and Soviet life, in a number of cities, among which are Kiev, Moscow and Odessa. Using a variety of novel cinematic techniques, such as slow and fast motion, double exposure, freeze frames, tilted angles, tracking shots, jump cuts, backward projection and stop motion animation, the film is concerned with the kinetics of performance, the movement, rhythm and tempo inherent in all action. The prologue begins with a shot of a tiny cameraman climbing up a giant camera. This is followed by a series of shots of streets and a cinema, the projection booth and the orchestra pit, followed, in turn, by shots of empty streets at dawn, the increasing traffic, shops, factories, amusement parks, beaches, sport stadiums, bars, beauty parlours and concerts halls. Intercut in these kinetic shots are sequences of joy, sorrow, marriage, divorce, birth and death. Vertov believed that the camera should never disturb the natural course of events during shooting; he therefore advised his *kinoks* – cinema eyes, as he called them – to record the life-facts exactly as they were. He considered staged film as incompatible with the spirit of the revolution, which was to be cultural as well as perceptual; life itself was to be revolutionised. This meant abolishing old perceptual paths and creating new ones. As a strategy for achieving kinetic perception, which was itself action, Vertov proposed the principle of *Kino Pravda* or 'film-truth'. This phrase alludes to the first Bolshevik newspaper *Pravda* (truth), founded by Lenin, the chief instigator of the October Revolution of 1917, which seized state power in an armed insurrection. The newspaper was founded in 1912. From this notion emerged the notion of *kinoks* or film-eyes, whose purpose was to penetrate beneath the surface of external reality in order to show 'life-as-it-is', the richness of all its simultaneous events included. The specific task of the *kinoks* was to reveal the processes inaccessible to the naked eye, processes made visible only through the 'recording of movements composed of the most complex combinations' (Vertov cited in Petrić, 1993 [1987]: 4). In other words, their task was to reveal the multiplicity of life. In a book entitled *Laughter*, Bergson (1911) proposes that in order to see reality as unceasing change and complexity, a new, immediate 'virginal manner of perception' must be developed (154). For Bergson, this manner of perception cannot in any way be related to utilitarianism, preconceived goals or dramatic wholes, it has to 'brush aside ... the conventional and socially accepted generalities, in short, everything that veils reality from us, in order to bring us face to face with reality itself' (157). This perception is, of course, usually ascribed to art, but for Bergson, art is 'only a more direct vision of reality' (157). In fact,

[c]ould reality come into direct contact with sense and consciousness, could we enter into immediate communion with things and with ourselves ... probably art would be useless, or rather, we should all be artists. (157)

This 'virginal perception' is precisely the intention of Vertov, for whom documentary filmmaking is 'the continuous exchange of visible fact' (Vertov cited in Michelson, 1984: xxv). For Vertov, the task of a film editor is to 'find the most appropriate "route" for the viewer to get through the interaction, juxtaposition and the concatenation of movements created by the images on the screen' (Vertov cited in Petrić, 1978: 35). Through the complexity of cinematic integration, based on what he termed the 'montage way of seeing', Vertov developed a theory of intervals in 1919:

> the intervals lead toward a kinesthetic resolution [of the filmed event] on the screen. The organization of movement is the organization of intervals in each phrase. Each phrase has its rise peak and decline.
> A film is, therefore, composed of phrases [shots] as each phrase is composed of intervals. (35)

Clearly, Vertov's theory of intervals is derived from music. More specifically, it is related to contrapuntal composition, which in *The Man with a Movie Camera* can be seen in sets of movements, such as the blinking of human eyes, the shaking shots of the streets and the abruptly appearing and disappearing shots of the venetian blinds or, indeed, in the motorcyclist, the galloping train, the rapidly moving trees, the laughing women. The purpose of this juxtaposition, achieved through the gradual shortening of repeated shots, which function like a musical phrase, visually and kinaesthetically, is to create a visual melody. The film is, of course, silent, but the sounds linked to these actions – the opening and closing of the venetian blinds, the movement of the trams on a street, are amplified through the intensification of kinaesthetic elements. For Vertov, crucially important here is the interaction of shot scales (medium, close, long), the interaction of angles, of movements within the shots, of light and dark, and, of shooting speeds. For film theorist Vlada Petrić 1993 [1987], this musicality cannot be dissociated from the practice of Zaum, mentioned in the previous chapter.

> Comprised of the combination of sounds that do not represent concrete words but which are constructed on musical principles to evoke feelings and imply abstract ideas, Zaum poetry grew out of suprematist painting, particularly its concept of the emotional impact of colours.

The basic premise of the Zaum movement was that all art should be free from its subservience to thematic meaning so that sounds, colours, movements, and nonrepresentational shapes sustain their autonomous associations. (42)

This is why a direct relationship between nonrepresentational shots and optical pulsations in *The Man with a Movie Camera* resembles the '"syntactical drumming" achieved through the rhythmic beats and vowels and syllables in Zaum poetry' (43). The musical effect is further created through the 'disruptive-associative montage' (139) that develops through incongruous intercutting. For example, between the different points of view – the cameraman's, the editor's, the filmed person's and the ambiguous point of view – and the phi-effect. Determined by the stroboscopic nature of the cinematic projection, the phi-effect is derived when 'two objects or graphic forms are projected alternately on the same screen' which creates the 'illusion that one form is transformed into another, and/or that they exist simultaneously' (139). This has a highly kinaesthetic impact on the viewer who experiences intervals and the constant pulsating between the shots, which is why, for Vertov, montage is a dynamic and performative process. It means: '"writing" something cinematic with the recorded shots. It does not mean selecting the fragments for "scenes" (the theatrical bias) or for titles (the literary bias)' (Vertov cited in Michelson, 1984: xxix). Rather, it is the dynamism and the perpetual change that is shown and seen, or, in Bergsonian terms: life. Life as 'a microscope and telescope of time, the negative of time, the possibility of seeing without frontiers or distances ... sight in spontaneity' (xxix). In Vertov's work, it is the performative rendering of shot material that turns space into (one of) the dimensions of time. While Picabia's and Claire's *Performance Cancelled* shows film as multiplicitous duration, despite the medium's closed, pre-recorded nature, in Vertov's work, space is granted qualitative duration. This is achieved through Vertov's use of performativity in all stages of the process – shooting, selecting, editing.

In the Surrealist practices, as in Vertov, performance is a method, which, when applied to literature, poetry, painting, installation, and film, wrests live-ness from the world and catches unceasing change in mid-flight. It is a summoning force which populates the communal memory bank with generative images while simultaneously re-configuring (human) perceptual faculties. Not only does the performativity of words, written or uttered, images, matter, film and perception itself, clearly show that nothing is passive, more importantly, it invests the entire world, not just human beings, with agency. It is, of course, not an accident that the movements

that came to prominence in the wake of World War I, Surrealism and Constructivism, sought to re-combine the available media and methodologies to create new and alive ways of seeing and being. In the case of Surrealism, the poetic mystery of a world in which rationalism has no purchase, in the case of Constructivism, a more meaningful, richer whole created from unexpected and illogical elements. By breaking away from content as norm (the legacy of Futurism and Dada) and writing whatever comes to one's mind, or by filming life itself, as in *The Man with a Movie Camera*, these practices dissolve the form-content divide. They open new debates around old media (writing, painting, drawing) and newer media (such as film) while simultaneously addressing psychological and anthropological concerns. The chief focus of psychology is the working of consciousness, the formation of opinions and mental habits. By removing the usual procedures of thought-formation, focused on coherence and the established meaning-making patterns, and stimulating the stream-of-consciousness approach to speaking, writing, painting and perception in general, the Surrealists not only provide the many practical demonstrations of the Bergsonian duration, they establish an important link between duration and mental models. Mental models are socially inherited schema that frame experience and organise perception. However, as psychologists Patricia Werhane et al. (2011) argue, the very process of 'focusing, framing, organizing and ordering experience' simultaneously 'brackets and taints it' (107). Habit-ingrained reliance on schematic mental models, which apply the same schema to vastly different situations, has disastrous effects on ethical decision-making. Instead of enabling the individual to take in a multiplicity of factors, it creates 'bounded awareness', 'a limited processing of perceptions and phenomena' (108) that results in deeply flawed decisions. In contrast to such automatic-pilot schemes, duration effectively rewrites perception as action. Not only does this increase vigilance, it changes past mnemonic traces, all the time. This is profoundly redemptive; it has the capacity to heal. Not heal through the tracing of cause-and-effect chains (as in Freud), but heal through the sheer movement of life, through changing multiplicity and novelty. Similarly, Vertov's work establishes an important connection between duration and anthropological observation. Focusing on human cultures, whether in small or large groups, institutions, cities, and countries, anthropology's preferred method is participant observation. Here, the researcher spends a period of time with the group he or she is researching. Documentary film, of which *Kino Pravda* is an early example, affords similar 'participation' through a medium capable of occupying points of view (for example, the bird's or the frog's point of view) unavailable to the (human) observer. However, these points of

view are simultaneously those a human being can realistically occupy, by lying on the ground, or climbing a tree. They therefore bring new information into the archive of the known, they also accentuate the interdependence of knowledge and the medium of knowledge acquisition – in this case, film. Despite the fact that there has been much debate in anthropology around the words' and the images' respective aptitudes for showing the not so readily visible social reality, by such figures as Danish anthropologist Kirstin Hastrup (1992), performative filming (as opposed to static filming which imitates the human subject's passive point of view) is a significant addition to the anthropological method. What is today known as visual anthropology relies heavily on kinaesthetic cinematic participation in the study of human customs and material culture, initially developed by Vertov. Indeed, key visual anthropologists – Jean Rouch, David MacDougall – have afforded new forms of understanding through the use of experimental techniques. As MacDougall (1998) notes, while written words have the capacity to show us 'the *rules* of the social and cultural institutions by which [people] live', performative filming, which includes duration and multiplicity, shows us 'social agency, body practice, and the role the senses play in social life' (259, emphasis mine). It recodes reality by affording a kinaesthetic and relational, not a merely spectatorial, glimpse into its less visible workings.

Scores:

1 Engage in automatic, performative writing with two or more people. Where appropriate, use trance-inducing factors: music, lighting, movement, song. Set a time limit to these sessions. Print, distribute and read the writing in a different location and in a non-trance-influenced state.

2 Practise the critical-paranoid method for at least a day. Practise frottage for at least a day. Find newspapers, magazines and other printed matter. Disrupt the semantic flow of the printed words by introducing disparate worlds. Use objects, images, shapes, reliefs and patterns obtained through frottage.

3 Research ethnographic methods used in visual anthropology. Think how the various forms of life as related to place, objects, actions, goals of humans and animals are performed. Focus on the form, velocity, syncopation, tracing, stillness. Film the chosen area – a village, a motorway, a backyard – at dawn, in the afternoon, in the middle of the night. Edit the material using the method of incongruous juxtaposition to emphasise Bergsonian duration.

3 The Quest for Authenticity

The problem with technology

An overwhelmingly different ordering of reality to that practised by the Surrealists and Constructivists, centred on the incessant becoming of the world, was taking place in Europe and the US in the late 1930s and 1940s. Following the rise to power of the German Nazi party, led by Adolf Hitler, and the Italian Fascist party, led by Benito Mussolini, the outbreak of World War II displayed the greatest power of devastation in history. It also displayed the mobilisation of all economic, social, cultural and human resources, which is the reason why many artists and intellectuals, such as André Breton, Marcel Duchamp, Max Ernst and, in particular, those of Jewish origin – who were directly persecuted by the Nazi regime – fled to the US. Not only was the US a safe heaven for the European refugees and conscientious objectors, the late 1940s and the 1950s were the years of unprecedented prosperity, due largely to mechanisation and labour optimisation. Named after the car manufacturer Henry Ford, and the work organisation psychologist Frederick Taylor, Fordism and Taylorism implemented systematic mechanisation of production by determining and fixing the workers' effort levels within an accelerated dynamic of deskilling. This increased production. Affordable prices of cars and mod cons increased consumption. What ensued, however, was the division of life into productivism and consumerism. While productivism replaced the formerly polyvalent notion of work with a reductionist one – producing more of a given unit – consumerism proliferated leisure industries where fun and pleasure were consumed in a predominantly passive manner. Although the excess of production first arose as a protest against poverty, in the Fordist-Taylorist era the urgency of production became largely independent of the volume of production. Whereas in the past, more production meant more food for the hungry, more clothing for the cold and more housing for the homeless, production of the Fordist-Taylorist kind created a craving for more luxurious mod cons and more exciting forms of entertainment. As Canadian-American economist and prominent critic of the affluent society John Kenneth Galbraith (1984 [1958]) notes in the eponymous book, 'the

economic theory managed to transfer the sense of urgency in meeting consumer need to products of great frivolity' (116). Indeed, few economists of the post-war era were able to ward off the unease felt about 'the lengths to which it had been necessary to go with advertising and salesmanship to synthesize the desire for such goods' (118). Both the devastation of World War II, predicated, to a significant extent, on technological advances, and the accelerated mechanisation which went hand in hand with the increased consumption were experienced as an alienated and erroneous mode of existence by many. Among artists of the post-war era, there was a growing sense of malaise and hopelessness as well as a frantic searching for other, less regimented modes of existence. An example of this existentialist searching – a searching for sense amidst what appeared to be a disorientating and absurd world – were the action painters, such as Jackson Pollock and Franz Kline, who rejected the reduction of the world to a manipulable picture. Resulting from the technological-scientific advancement of the preceding centuries, this particular alliance of technology, science and, more generally, knowledge, was exceptionally clearly articulated by German philosopher Martin Heidegger. Writing against the background of the imperialist phase of the Third Reich and World War II, technology was, for Heidegger (1977), 'nothing technological', nor was it a 'matter for technicians' (4). Rather, as Heidegger explained in *The Question Concerning Technology*, it was a complex realm of challenging forth, of extracting labour and energies by promising ever-greater effectiveness and efficiency. It was an 'expediting force' (15), which, in re-ordering space and time, placed both at the service of a supposedly greater but abstract goal, namely progress. For Heidegger, the entire Western history is technological. From the Enlightenment onwards, the prevalent tendency in science has been to equate space with geometrical space; the result of this is the reduction of the world to a surface and the reduction of time to a measure of the distance between two points. Everything is integrated into the measurable and the calculable. Referring to the colloquial phrase 'to get the picture', Heidegger proposes that 'world as picture' – where 'world' does not only mean cosmos and nature, but also history – denotes that 'all that is', 'is set before us', in the sense that it 'is represented to us as a system' (129). There are two problems here: the human being as master and possessor of the world, and the world seen as a unified system. Both are the result of a particular form of ordering, simultaneously scientific, material, social and economic, as related to systems of knowledge, economic exchange structures, means of production, and the flow of capital, called *gestell* or enframing (20). Essentially, enframing, which refers to emplacement and fixing, means that all human efforts and all natural reserves are preordained. They are 'set

on a course of extraction' and are 'standing in reserve' (20). This expediting is directed from the beginning towards furthering something else, in other words, towards driving on to the maximum yield at the minimum expense:

> The coal that has been hauled out in some mining district has not been supplied in order that it may simply be present somewhere or other. It is stockpiled; that is, it is on call, ready to deliver the sun's warmth that is stored in it. (15)

The problem here is not a particular utilitarian function – delivering coal where it is needed – it is the summoning of the forces of life and nature into a set of *manipulable reserves*. As such, the technological-scientific-economic ordering takes the form of a total planning. It divides the whole world and the whole of being into sectors whose resources are systematically and endlessly extracted, stocked and distributed, not to satisfy concrete need, but desires manipulated by increasingly more sophisticated marketing techniques. For Heidegger, this enframing, which turns the entire world into standing-reserve and human beings into possessors of nature, is itself rooted in the separation of being and existence from the world. In Heidegger's (1962) conception, explained in *Being and Time*, as human beings we are not detached from the world but are always irreducibly open to and onto the world. This openness, this relationality, is also the reason why he does not speak of 'human beings' or 'individuals' but uses the phrase *'Dasein'*, which means 'being there'. Inextricably entwined with both space and time – *'Da'* means 'there', while *'sein'* means 'being' – *Dasein* discloses relation. There is a deep and intimate connection between who we are as humans, the being of being human and the broader concept of Being, which includes all forms of existence – animals, plants, rocks, minerals. Space is the dimension within which things, phenomena and experiences, appear in a dynamic way. We do not see doors, chairs and cars as objects located in space. Rather, we see them as something to go through, something to sit on and, and something to drive, as dynamic phenomena. A phenomenon is 'that which shows itself in itself, the manifest' (51). The purpose of phenomenology – of which Heidegger is one of the main proponents – is 'to let that which shows itself be seen from itself in the very way in which it shows itself from itself' (58). Although this may, at first, sound convoluted, Heidegger is very careful not to use words overburdened with layers of interpretation but, instead, to point to the novelty with which *Dasein* relates to time, space and, and the world. Space is not a container in which objects are located; it is an *intimate relation* to the world since existence is making room for things and beings, accommodating them and learning to

interact with them. This reality, very different from world as manipulable picture is, according to Heidegger, the reality that has been taken away from us and that needs to be reclaimed. In describing this reality, he uses the word 'truth'. However, this concept, in Heidegger, does not resemble the Nietzschean concept discussed in Chapter 1, nor does it designate a mere correspondence between a particular manifestation of a thing and the concept of that thing. Resorting to Aristotle's notion of truth, which is a verb and not a noun – *aletheuein* – Heidegger's use of the word 'truth' would be better served by a comparison to Vertov's notion of truth discussed in the previous chapter. It refers to that which arises when something is manifested and accompanied by due attention and care, since, in Greek, 'to truth' does not mean to possess the truth but to take the specificity of 'that which is revealed into safekeeping' (62). It implies an intimate, caring and meaningful relation to that which is disclosed or shown.

Action painting and authenticity

Using no brush but, instead, trickling the fluid paint on the horizontally positioned canvas and weaving streams of colour into what look like rhythmic labyrinths, action painting was initially seen as yet another painterly style. It was art critic Harold Rosenberg who first noticed that in this particular form of painting, which did, of course, have much in common with the work of Ernst and Masson, discussed in the previous chapter, painting (as object) was merely residual. The most important aspect of this practice lay in its performance, indeed, the canvas was here 'an arena in which to act ... What was on the canvas was not a picture but an event' (Rosenberg cited in O'Connor, 1967:52). Rosenberg stresses that 'a painting that is an act is inseparable from the biography of the artist. The painting itself is a "moment" in the adulterated mixture of his life. ... The act-painting is of the same metaphysical substance as the artist's existence' (52). This emphasis on the inseparability between process and residue, between the artist's movements, creative swings and the unfolding of his or her very existence is nowhere better seen than in the work of Jackson Pollock (shown in Figure 3.1). Alongside Franz Kline and Willem de Kooning, Pollock was the most prominent action painter. Among his early paintings were the 1943 *Guardians of the Secret*, the 1943 *The She-Wolf*, the 1948 *No. 5*, the 1950 *One: Number 31* and the 1952 *Convergence*. Apart from numbers, Pollock's paintings often bore titles associative of totemic animals or mythological figures. In a rare statement about his work, since Pollock was a believer in doing, not in talking, he affirms that action painting is a form of 'truthing':

I need the resistance of a hard surface. On the floor ... I feel nearer, more a part of the painting, since this way I can walk around it, work from the four sides and literally be in the painting. This is akin to the method of the Indian sand painters of the [American] West ... I continue to get further away from the usual painter's tools such as easel, palette, brushes, etc. I prefer sticks, trowels, knives and dripping fluid paint or a heavy impasto with sand, broken glass and other foreign matter added. When I am *in* my painting, I'm not aware of what I'm doing. It is only after a sort of 'get acquainted' period that I see what I have been about ... the painting has a life of its own. I try to let it come through. (Pollock cited in Rose, 1980: np, emphasis original)

Two things are immediately obvious here: Pollock's relation to the tools he uses, and his relation to the space, which, through the movement of his body, and the reference to the Native Indian sand painting, is predicated on time.

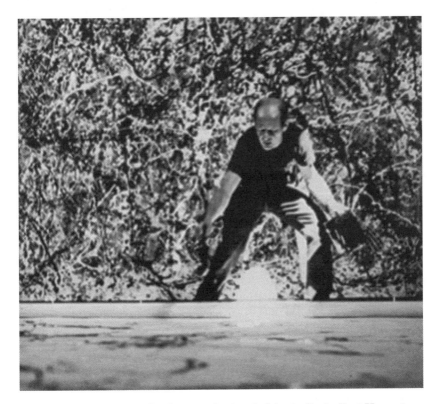

Figure 3.1 Jackson Pollock act-painting in his studio in East Hampton, NY, in 1950. Photo by Hans Namuth. Courtesy Center for Creative Photography, University of Arizona © 1991 Hans Namuth Estate.

For Heidegger (1962), a tool exists in the world as something that is ready to hand, a practical means to an end, for which he uses the word readiness-to-hand or *Zuhandensien*. This term designates the sphere of purely functional possibilities and interactions, limited both by the tool's specific shape and the purpose to which it is put (96). A hammer is thus very useful for nailing things, as is a brush for applying paint to canvas. But Heidegger proposes another category, which he terms presence-at-hand or *Vorhandensien*. Here, usefulness is superseded by a much more open set of relationships (134). Through the use of sticks, knives, gravel, glass and impasto, the relationship between the painter, the action and the materials is transformed, as these objects do not lend themselves to a simple 'means-to-an-end' operation. They do not fit into a pre-organised structure or procedure. Because some of these objects are difficult to use, even counterproductive – such as glass, which can cut through the canvas – no pre-organised procedure can be applied. What this interaction does afford, however, is novelty as well as specificity. The specific, unpremeditated result of the encounter between such an object, the canvas, the painter's movement, the specific climatic and environmental conditions – humidity, heat, cold weather – is existential. It reveals something; it brings a specific form of relationality out of concealment. *Dasein* is, in the first place, spatial; the '*da*' of '*Dasein*' designates a place, a topos. It does not designate a position, characteristic of the enframed worldview, but a relation. Of this relational dimension Heidegger says:

> the 'above' is what is 'on the ceiling', the 'below' is what is 'on the floor', the 'behind' is what is 'at the door', all 'wheres' are discovered and interpreted as we go our way in everyday dealings; they are not ascertained and catalogued by the observational measurement of space. (103)

All space is directional and active, as is all existence. It is always directed at something: right, left, up, down, beneath, behind, in front. When we move, the space we are attentionally attached to moves with us. We, as existence, as '*Dasein*', are always engaged in a transitive, dynamic activity of nearing, of bringing closer or of drawing away and distancing. Our body is itself a site of habits; it is a matrix that 'remembers' past configurations and orientations. It evolves within specific surroundings, becomes familiar with them and is, in this way, itself constituted through sedimentation. Each local situation or experience within a certain environment becomes a part of the body's memory through repetition. Our relationship to space is always, and invariably, personally ours, specific to the *Dasein* that we

are. Pollock's fascination with sand painting, with its patterns, designs and with the half-man/half-beast creatures that populate much of Native American painting – portraits of artists-shamans when transformed into their alter egos, animals – is part of an existential relation. This fascination is not exoticist, however. It is not a white – colonial – man's recycling of native art and knowledge. Rather, Pollock's aspiration to the relationality inherent in the native forms was a form of searching for a mode of existence that unites spatial, temporal, existential and symbolic dimensions. Art historian and philosopher Hubert Damisch (1982) could not be more right when, in an article entitled 'Indians!!??', he says that, for Pollock, the '"Indian example" had less to do with "iconic resonances" or the actual appearance of pictograms than it did with a "laying out" or "marking out" in actions with the trance used in shamanistic rituals' (30). Damisch adds that 'Pollock's procedures move his work into the physical actions of the ritual' (30). In practical terms, this means that Pollock's actions and traces can be likened to the Navajo sand paintings, but only to a degree. Although the beauty of the sand paintings can be breathtaking, their purpose is not aesthetic but relational. Made on the tamped floor of especially built 'song houses', the sand paintings are altars upon which the song man – or shaman – performs the ritual connected with a particular query or petition. If there is a persisting health problem, which is often the reason behind such rituals, the petitioner is placed near the centre of the painting. The purpose of this is to enable the transmission of the power from the shapes created on the floor, produced by the ritual. The painting without the ritual has no power, much like the ritual without the painting has no power. At the end of this transmission, the remaining design is rubbed out and the sand is deposited outside the 'song house'. These rituals form part of a merging of being and image through activated space. The purpose of the Navajo sand paintings is to impregnate the ill person's body with the proximity of the activated space (Foster, 1963: 43). Although Pollock's paintings are not intended as a space of recovery, they nevertheless activate space and the relation between a particular *Dasein's* existence – Pollock's – and the existence of such vast spaces as deserts, mountains, rivers and oceans. In an early twentieth-century report on the relation between pictorial mark and climatic conditions, space and events, anthropologist William Jones analyses the Plains Ojibwa moccasin design. Apart from the connection between the colour of the moccasin beads, such as between white and the light of day, red and the horizon and the limits of the world, blue and the sky, green and plant life on earth, there are shapes by means of which the colours are placed in a graphic relation with the supplication for life-fostering climatic conditions, such as rain

(Jones cited in Phillips, 1991: 95). The moccasins are at the same time something worn during the everyday action of walking or running. This means that it is the smaller spatial action – walking or running – that mobilises the relationship with bigger constellations, as it does in the sha-manistic ritual. It places the concrete action, performed in a delimited environment, as well as in delimited time, walking from A to B, in relation with the mountains, the sky, the stars, animal and plant life, in short, with the world. For Heidegger (1962), to look at 'trees ... mountains, stars' and see them as separate entities is 'pre-phenomenological'; such a view is devoid of all relations with Being; to see them in relation, however, is to see them '*as* Being, is phenomenological' (91, emphasis original). Pollock's action painting is an existential form of non-rational sense-making with a particular focus on matter, space and time. His wife, Lee Krasner, herself a painter, calls Pollock's obligatory movement during painting, 'dance' (Krasner cited in Rose, 1980: np). In the previous chapter we saw that Bergson associated space with staticity and quantifiability. This is largely due to his effort to wrest duration from divisibility and surveyability. But for Heidegger, space, time, the individual existence, *Dasein* and Being are not only enmeshed, they are also in continual movement, the move-ment of revealing. Famous is Heidegger's (1962) concept of 'throwness'; to be human is to be thrown into an already established cultural trad-ition, and into a situation (101). Every single *Dasein* finds itself in this position; none of us asked to be born. Authentic life, however, is a life engaged in 'truthing', in revealing and bringing forth, the ultimate goal of any enquiry being to render the enmeshed-ness of life transparent while, simultaneously, rendering the enquirer transparent to himself or herself. Heidegger's name for such an action is resolute disclosed-ness. It desig-nates the occasion on which the truth-character of *Dasein* is revealed; this makes resolute disclosed-ness a double relation – a relation to one's own relation to existence. It is the only possible authenticity, the authenticity borne of care and what may be called enlightened relationality. When authentically itself, when actively making sense of its daily existence and its life, *Dasein* is not detached from the world; instead, the world discloses itself to *Dasein*, which is why *Dasein* is then in a position to (authen-tically) be with others. 'Resoluteness ... brings the self into solicitous Being with Others' (344). It is because of its emergent ethics, emerging from the *Dasein*'s relation to Being as space, time, matter and action, but which remains related to the authenticity of the enquirer, that many critics and theorists, such as Leo Steinberg, saw Pollock as a 'cause célèbre ... because more than anyone he symbolizes a radical change in the social role of art' (Steinberg cited in O'Connor, 1967: np). In Pollock's case, art was not

a style but a particular *Dasein*'s enquiry into the world despite the fact that he was, as feminist visual theorist Griselda Pollock (no relation of Jackson Pollock's) notes, 'part of the mythic constructions of that decade' which portrayed artists as 'modern', 'American' and 'masculine' (Pollock, 2003: 143); in short, as fearless doers that fitted so well into the American dream. This quest for a distinctly non-instrumental relation to the world, in which the world can be revealed to us in all its richness, through performance, neither as standing reserve nor as representation, can also be found in the work of John Cage and Merce Cunningham, albeit their work is of a very different kind.

Letting be: John Cage and Merce Cunningham

In August 1952, composer John Cage and choreographer Merce Cunningham staged *Untitled Event* (also called *Theater Piece #1*), in the dining hall of the Black Mountain College, near Asheville in North Carolina. Much like Cage's other pieces, this piece is in many ways a prime example of Heidegger's (1966) notion of 'letting be' or *gelassenheit*, which he saw as the antidote to technological, goal-orientated, calculative thought and defined as a 'releasement towards [a meditative merging with] things' (54). Despite the fact that Cage makes no references to Heidegger, he does acknowledge the elaborate history of 'letting be' in Eastern philosophy in many of his lectures, concerts and performances, as does, indeed, Heidegger. Letting be is a form of relinquishing and release in and through which a different, more authentic relation to the world can be established. However, for Cage, the emphasis is not on individual perception of authenticity; what authenticity might mean for the specific human being, situated amidst life as praxis, and within a particular practice, as was the case with the action painters. Instead, Cage sought to move away from personal taste, as well as from the purely aesthetic appreciation. For Heidegger (1977), art was initially a form of 'truthing' but had, through a long history of enframing, 'moved into the purview of aesthetics' and became 'the object of mere subjective experience' (116); the point of a work of art was not to create pleasing sensations by displaying harmonious shapes, colours or rhythms. It was to stage an encounter with Being that underlies all specific forms of being (humans, plants, animals), Being as the drive towards the open and the manifest. Departing from quite different sources, such as Eastern, Chinese and Japanese philosophy, Cage arrives at a similar conclusion: there should be no preordained relation to the work, no overarching, unifying logic, and the work should neither be the result of the composer's or

choreographer's taste, nor should it appeal to a particular audience taste. For Cage, 'we don't live by means of one principle, but by a series of principles which can change according to the situation we find ourselves in'; this is why it is necessary to move from 'giving attention to an object to what we can call environment or process' (Cage cited in Kostelanetz, 2003 [1987]: 56–57). The work should let multiplicity unfold on its own terms. Art historian and performance scholar RoseLee Goldberg (1993 [1979]), describes *Untitled Event* in the following way:

> Spectators took their seats in the square arena forming four triangles created by diagonal aisles, each holding the white cup which had been placed on their chair … From a step-ladder, Cage, in black suit and tie, read a text on 'the relation of music to Zen Buddhism' and excerpts from Meister Eckhart [medieval German mystic]. Then he performed a 'composition with a radio', following the prearranged 'time brackets'. At the same time, Rauschenberg played old records on a hand-wound gramophone and David Tudor played a 'prepared piano'. (126)

The prearranged time brackets were used to determine duration; they were the only instruction given to the various performers who were otherwise free to determine the content of their performance, be it dance, poetry or music. As Mary Caroline Richards, who read some of her poems, notes: '[a]s we came in, we were given a piece of paper that had the time on it – 3'2" or 4'00" – for those of us who were performing, but how I knew what that time was, I can't remember' (Richards cited in Fetterman, 1996: 101). Prepared piano originated with Cage's 1942 *Wonderful Widow of Eighteen Springs*, performed as a percussive action on the outside of the piano. Since then, the phrase 'prepared' refers to the modification of the musical instrument to encompass a greater variety of concrete sounds, sounds that emanate from the concrete 'body' of the instrument, not from the conventional musical vocabulary. Goldberg (1993 [1979]) continues:

> Later Tudor turned to two buckets, pouring water from one to the other while, planted in the audience, Charles Olsen and Mary Caroline Richards read poetry. Cunningham and others danced through the aisles chased by an excited dog, Rauschenberg flashed 'abstract' slides (created by coloured gelatin sandwiched between the glass) and film clips projected onto the ceiling showed first the school cook, and then, as they gradually moved from the ceiling down the wall, the setting sun. (126–127)

But is this what really happened? There is no reason to doubt the accuracy of Goldberg's reporting but, as Martin Duberman (1972), chronicler of the Black Mountain College, shows through interviews with audience members and citations from diaries, *Untitled Event* resisted unified rendering. The reason for this was non-streamlined multiplicity, which was to become the hallmark of both Cage's and Cunningham's work. While some audience members saw girls serving coffee, others saw boys; while some heard a lecture on Zen, others heard a lecture on silence. Yet others were convinced that Cage's lecture was, in fact, on Ralph Waldo Emerson and Henry David Thoreau. Some members of the audience thought that the music Robert Rauschenberg played was Édith Piaf, others opined that it was American popular music from the 1920s and 1930s. Similarly, *Untitled Event* was thought to have gone on for forty-five minutes precisely by some, and for over two hours by others (Duberman, 1972: 11–18). This 'disagreement' over what happened was, of course, related to the multiplicity of focal points present at any given time. Cage's habit of ushering life into the performance area and letting it be precisely what it is, is indebted to Zen Buddhism, the Japanese variant of Chinese Buddhism, called Chan Buddhism, and to Chinese Daoism, also known as Taoism. Cage (1968 [1939]) often spoke about the importance of non-interference:

> It all goes together and doesn't require that we try to improve it or feel our inferiority or superiority to it. Progress is out of the question. But inactivity is not what happens. There is always activity but it is free from compulsion. (140)

The idea of progress has much to do with a linear conception of time, which, although philosophically suspect, as we saw in the previous chapter, has nevertheless persisted. Moreover, it has become entirely naturalised in the productivist era, in which activity is related to motion while passivity is related to stasis, even regress. In Eastern, Chinese and Japanese thought, time is cyclical; instead of stasis and motion, it is seen as a constant interplay of constancy and mutation, in which there is no opposition. 'Letting be' is thus not static or passive. In order to explain this particular, active form of 'letting be', Cage cites D. T. Suzuki, whose classes at Columbia University, New York, he attended from 1949 to 1951. In keeping with the Eastern thought and, in particular, with Zen Buddhism, D. T. Suzuki advocated a conception of reality which is not related to the laws of cause and effect but, instead, to unimpeded-ness and interpenetration. Cage explains these two concepts, which play a crucial part in *Untitled Event*, and in the vast majority of his other works, in the following way:

unimpededness is seeing that in all of time each thing and each human being is at the center and furthermore that each thing and each human being at the center is the most honored of all. Interpenetration means that each one of these most honored ones of all is moving out in all directions penetrating and being penetrated by every other one no matter what the time and the space. So that when one says that there is no cause and effect, what this means is that here are an incalculable infinity of cause and effects and that in fact each and every thing in all of time and space is related to each and every thing in all of time and space. (46)

Within the context of *Untitled Event*, interpenetration means that several mutually unrelated, even jarring activities – movement through space, film footage of the daily life of the dining hall showing students and cooks going about their business, a poetry reading, a theoretical lecture, music coming from the gramophone and music played on the prepared piano – were unfolding in an unimpeded way. In order for this to happen, it was crucial for every unit of action to proceed unencumbered by premeditated relations to other activities or media. As Cunningham suggests, this unfolding can only occur in the absence of any 'classifications which come with a ready-made set of expectations – painting, music, dance'. Instead, the concern is 'with something being exactly what it is in its time and place. ... A thing is just that thing' (Cunningham in Vaughan and Harris, 2004: 86). So, if a black cat crosses the performance space, it is important to notice the shiny smoothness of its fur and its languid walk, rather than to perceive it in the prefabricated 'black cat = ill fate' association where the proverbial cat is substituted for the concrete, alive, unique and beautiful creature crossing the performance area. *Untitled Event* was in many ways inaugurative; Cunningham remained faithful to the principle of multiplicity for the rest of his career. If anything, he strove to increase the distance between the various elements that make up a dance performance instead of unifying them. His dance company, founded shortly after *Untitled Event*, with which he went on to create pieces such as the 1954 *Minutiae*, 1958 *Summerspace* and 1963 *Story*, has always insisted on a fresh encounter with music and visuals. Despite the fact that the pieces were meticulously choreographed and carefully rehearsed, on the first night the dancers came into interaction with the visual and the musical elements for the very first time. Needless to say, some of the interactions were harmonious, but some were jarring and incongruous. Cunningham (1991) writes:

what we have done in our work is to bring together three separate elements in time and space, the music, the dance and the decor,

allowing each one to remain independent. The three arts don't come from a single idea which the dance demonstrates, the music supports and the decor illustrates, but rather they are three separate elements each central to itself. (137)

The centrality of each of the elements invariably means multiple centralities, which intermittently create points of focused intensity and focus-less dissipation. Not only does such an approach not create a unified whole, it does not even create a single event; it creates a multiplicity of events, which, like *Untitled Event*, render the interpenetration of the most varied elements possible as well as transparent. Whereas the authenticity of the action painters remained concerned with human existential relations, the authenticity of Cage's and Cunningham's work was related to rendering transparent the world as continuous change and a continuous interplay of order and disorder. For example, Cage's *Music of Changes*, composed in 1951, used chance procedures derived from the *I Ching*, also called the *Book of Changes*, to determine duration, dynamics, rhythm, pitch and the ordering of events within the composition. *I Ching* is an ancient divination text and a Chinese classic. Resorting to a 'chart' technique, which consisted of grids, each devoted to a single musical constituent – rhythm, pitch – the charts specified a number of musical values, including silence. Each value was chosen by a chance operation, as was the ordering of events and tempo changes. Once this procedure was completed, the composer notated the music in a relatively traditional way and the performer played in a relatively traditional way – by playing what was written in the score. For Cage (1968 [1939]), this method of composing music freed it of 'individual taste and memory (psychology)', of the 'literature and "traditions" of art'; and enabled sounds to 'enter the time-space centered within themselves' (59). Similarly, in *Untitled Event* all events were centred within themselves; they were related to each other only through unexpected convergence in space-time. Dance historian David Vaughan (2004) could not be more right when he says that *Untitled Event* 'crystallized the Cage-Cunningham esthetic – the denial of the center, the structure in terms of time, the creation of what Cage called "a purposeless, anarchic situation which nevertheless is made practical and functions"' (Vaughan and Harris, 2004: 68). Cage insisted on this quality as an emergent form of ethics, as a relation to the world, in which one does not impose a perceptual order but lets be and lets see the processes of constancy and mutation, of order and disorder. Cage (1968 [1939]) asks:

What is the purpose of writing Music? ... the answer must take the form of a paradox; a purposeful purposelessness ... not an attempt to

bring order out of chaos nor to suggest improvements in nature but simply a way of waking up to the very life we're living. (8)

It is in this constantly changing relation, which does not take itself, or anything else, as stable, that a similarity between Heidegger's truthing, the action painters' permanent motion and the switching of perspectives, emerges. Both solicit the intrusion of the everyday: in the case of Pollock, glass, dirt, or whatever happened to be on the floor; in the case of *Untitled Event*, jumping dogs, accidental passers-by, the college cook. What made this piece different for each member of the audience was attention to a specific segment or a specific sequence of events. For Heidegger, who differentiated between attention from which we might 'obtain the primordial memory of thinking' and inattention which makes it impossible for us to understand either time or being, 'attention is that which discloses the world to us' in the very process of 'worlding' (Heidegger cited in Zhang, 2009: 73).

Attention and revealing: Cage's *4'33"*

There is an inextricable relation between the simplicity of everyday occurrences, attention, and the process of revealing, of 'truthing'. The 'truthing' or the revelatory process that occurs in the work is not a once-for-all presentation of a tangible state of affairs; it is a subtle process of emergence, of in-between-ness and emptiness. Crucial in understanding this are Heidegger's comments on ancient Chinese philosopher Laozi's 'Things of Dao', which, according to philosopher Xianglong Zhang (2009), was praised by Heidegger for the exceptionally clear distinction between Being and beings (73). Using the following quotation from Laozi: 'Thirty spokes converge in a hub but the emptiness between them grants the Being of the cart. ... Wall, windows and doors produce the house, But the emptiness between them grants the Being of the house' (Laozi cited in Zhang, 2009: 74), Heidegger proposes that although the between-ness of things, when 'it first appears to us in its extension and duration', 'may look as the null', it is, in fact 'the gathering [of Being]' (Heidegger cited in Zhang, 2009: 74–75). It is when we can see, hear, feel the vibration of existence that we can sense Being; it is precisely this 'between-ness' that makes it possible for us to do so. This is crucial; it is out of emptiness and formlessness that being and form arise, but this disclosing or revealing is predicated on attention. Heidegger's view of the human capacity for deep, full, committed attention was not optimistic, however. Heidegger

asks: 'How do we, the belated-born ones of non-Attention ... learn Attention?' (73). His own response is: 'by looking at unpretentious simplicity, appropriating it more and more primordially' (73). Indeed, the 'unpretentious simplicity of the simple things moves us to ...what we call "Being"' (73). This simplicity was undoubtedly present in what is probably Cage's most famous piece, *4'33"*. Performed for the first time by David Tudor at Woodstock on 29 August 1952, *4'33"* is a textual notation which indicates nothing but duration:

I

TACET

II

TACET

III

TACET

In musical vocabulary, the Latin word 'tacet' refers to the section during which an instrument is not required to play. Here, it directs the performer to remain silent during three movements. Artist Allan Kaprow, whose event-based work will be discussed in the following chapter, present at the second performance of *4'33"* at the Carnegie Recital Hall, describes the experience thus:

> David Tudor ... came out and sat at the piano. ... He adjusted, in the usual manner his seat – I remember this very vividly – because he made a pointed activity out of it. He kept pushing it up, and pushing it down. ... And he opened up the piano lid and put his hands on the keys as if he was going to play some music. What we expected. We were waiting. And nothing happened. Pretty soon you began to hear chairs creaking, people coughing, rustling of clothes, then giggles. And then a police car came by with its siren running, down below. Then I began to hear the elevator in the building. Then the air conditioning going through the ducts. Until one by one all of us, every one of that audience there ... began to say 'Oh. We get it. Ain't no such thing as silence. If you just listen, you'll hear a lot. (Kaprow cited in Leonard, 1995: 188–189)

In 1951 Cage visited the anechoic chamber at Harvard University, designed to absorb sounds, internally and externally soundproofed. He entered the chamber expecting to hear silence but, instead, heard two sounds, one high and one low. When he enquired after the origin of these sounds, he

was told that the 'high sound was his nervous system in operation, the low one his blood in circulation' (Cage cited in Kostelanetz, 2003 [1987]: 244). Although this is, of course, highly pertinent to *4'33"*, 'the absence of activity', in Cage's words, is 'also characteristically Buddhist ... when activity comes to a stop, what is immediately seen is that the rest of the world has not stopped' (70–71). This space of in-between-ness, which calls for attention and provides a time-space for reflection, is crucial; indeed, it is the reason why Cage thought *4'33"* was his 'most important piece' (70). Essentially, by foregrounding the background, Cage exposed Being. This is, of course, related to Cage's rebellion against the culturally formatted notion of music which excludes sounds and noises, an idea vehemently defended by Russolo in his 1913 'The Art of Noises: Futurist Manifesto', mentioned in Chapter 1. Of this relation, Cage (1968 [1939]) says: '[w]herever we are, what we hear is mostly noise. When we ignore it, it disturbs us. When we listen to it, we find it fascinating' (3). This sensitisation to life as such, life unfettered by all the anthropomorphisms grafted on it by taste or tradition, is precisely what art affords. The score for *4'33"* here acts as a temporal framing device for all events in space-time, events that include aural, olfactory, kinaesthetic and visual perception. It accentuates the co-action of becoming and attention. For the Zen Buddhist, the world has no shape. The shape of the world is always predicated on the perceiver's perceptual habits and interests. This is why, in many ways, *4'33"* has ecological significance. Cage (1981) writes:

> We, as a human species, have endangered nature. We acted against it, we have rebelled against its existence. So, our concern today must be to reconstitute it for what it is. And nature is not a separation of water from air, or of the sky from the earth, etc., but a 'working together', or a 'playing together' of those elements. That is what we call ecology. Music, as I conceive it, is ecological. You could go further and say that it IS ecology. (229, emphasis original)

This notion of nature is closely related to the ancient Chinese one, in which the word '*hsing*', which means 'nature', does not refer to mountains, trees or lakes only, but to the given-ness of the world, to the ways of all beings and things – the fact that dolphins live in water and that birds fly (Cheng, 1987: 53). Attention is thus closely related to nature, and nature is, in ancient Chinese thought, as in Heidegger, related to truth, and to revealing. The technological enframing of the world is here contested by means of ecological works of which the Japanese Gutai group is a prime example.

Dwelling in the fourfold: Gutai group and picturing

In war-ravaged Japan, which had suffered the irreparable effects of two atom bomb attacks, on Hiroshima and Nagasaki, in August 1945, the post-war years were riddled with existentialist concerns. How was life to be envisaged after such a tragedy and under American occupation? The call for concreteness, which is the translation of the Japanese word *'gutai'*, voiced by the eponymous group of artists based in Osaka and led by Jiro Yoshihara was not at all concerned with the reconstruction of art but, far more importantly, with the reconstruction of the basic notion of human existence, of the individual, and of all its vital relations to the world. According to the literary critic Hideo Odagiri, this was an effort to 'establish an opposition to the wartime notion of the national body – *kokutai* – and "its hundred million hearts beating as one"', in the form of *kotai* (Odagiri cited in Ming, 2013: 50). Of particular importance is the choice of vocabulary here. The word for individual, as a psycho-physical entity, *kotai*, comprises the Japanese character *tai*, also present in the word *gutai* which stands for *body* in the physical, carnal, spatial and environmental sense of the word (Ming, 2013: 50). This notion is thus concerned with embodied, environmental existence. One of the Gutai's most prominent artists, Kazuo Shiraga, stresses the need for resilience when 'faced with nonhuman forces' (Shiraga cited in Ming, 2013: 5). According to Shiraga, 'intelligence must not be escapist' (5) but engage the environment, which is to say that the real enquiry, as for Heidegger, does not lie in abstract cogitation but in direct engagement with the world. This concrete, embodied, environmental approach was to be seen in Shiraga's famous 1955 *Challenging Mud* and in his 1956 *Please Come In*. In *Challenging Mud*, performed at the First Gutai Art Exhibition at the Ohara Kaikan Hall in Tokyo, Shiraga stripped down to his underwear and jumped into a mound of mud, full of rocks, gravel and sand. As can be seen in Figure 3.2, he wrestled with the resistant matter, whirling, rolling, jumping, diving, kicking and flicking, creating contorted and awkward but also dynamic, even beautiful, shapes in the process.

When he emerged from this battle with the mud, Shiraga was bruised; he even had open wounds. The encounter had obviously left a trace both on the mound of mud and on his body. Shiraga subsequently placed a frame around the mound and posed for a photograph. The same visceral engagement with the environment, in the form of resistant elements, where the body – *tai* – with its physical strength, viscera and vulnerability was shown to be the locus of the self, was seen in *Please Come In*, performed at the *One Day Art Exhibition* on the Imazu Beach, Nishinomiya, which took place between 6 and 8 April 1956. Just as physically demanding as

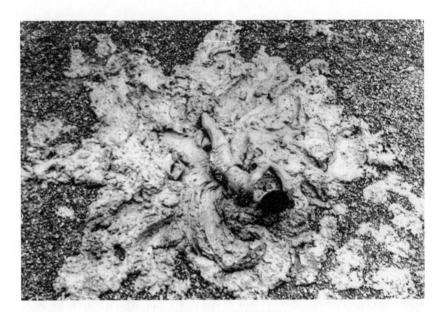

Figure 3.2 Kazuo Shiraga, *Challenging Mud.* **First Gutai Art Exhibition at the Ohara Kaikan Hall in Tokyo, 1955. © Shiraga Fujiko and the former members of Gutai Art Association. Courtesy of Osaka City Museum of Modern Art, Economic Strategy Bureau City of Osaka.**

Challenging Mud, this performance consisted of Shiraga's hacking of the interior of a conical structure made of logs. This process of making a dwelling with the use of natural materials – wood – performed on a beach, with no reliance on machinery or, in fact, any tools other than the axe was witnessed by an audience. After Shiraga had created a precarious dwelling, audience members were asked to come in and feel the kinaesthetic echo of Shiraga's performance.

As Heidegger (1971) explains in 'Building, Dwelling, Thinking', dwelling in the world, which invariably involves the physical, visceral existence, is inextricably entwined with rediscovering existentially important things and a sense of place. This deeply interconnected existential-environmental fabric, which consists of things as well as events, is what Heidegger calls the fourfold – the earth, the sky, the mortals and the divinities (153). He employs the word 'thing', as opposed to 'object', for that which is conducive to creating the fourfold – understood as the interrelation between some or all of the elements of the fourfold. A log, a hut or a bridge, none of which have a single, delimited, strictly utilitarian purpose, are things, not objects. Dwelling is, for Heidegger, a 'way of staying with things' (151). It is a form of being with things and being with the fourfold that cues

an ecological relation to the world. While technology is instrumental and manipulative, and transforms the world into standing reserve, things which cue the fourfold, such as huts and bridges, cue a fuller relation to the world. For example, a hut or a house mediates between the Earth and the sky, the divinities and the mortals (153). The path to the hut/house, the entrance, the garden, the backyard, all emerge as such only when the hut or the house create such a relation. Given that first villages as well as cities were built around graveyards, dwelling is invariably historically associated with the life and passing of other close human beings. A hut/house also weathers the sky and the seasons; it exists in complex relations to physical forces like gravity and affective qualities, like mood. This is the reason why it invokes the sky. Furthermore, a hut/house brings people together; community is created not only in houses but also in new life. Dwelling in the world indicates a mindfulness of these elements, which is the reason why any constructive activity ought to be driven by care for how the fourfold manifests itself, not as four different elements but as a 'oneness with four expressions' (Heidegger, 2000: 188). This is strikingly similar to the Japanese notion of space, which is movement and interaction. As architect Izozaki Arata notes, space includes emplacement, movement, time and the divinities in equal measure; it is capable of receiving *kami* – the spirits – when they descend upon it with their *ki*, which is the Japanese rendition of *chi*, vital energy, as in the term *tai chi*, which, in fact, is the emplacement of the vital energy in a body. As Arata (2012) suggests, this moment, when space is moved and becomes time, has been at the forefront of Japanese art practice for centuries. It is a unique form of spatial perception, related to events that took place in it, as exemplified by Shiraga's *Please Come In*. Initially related to 'the sense of the kami's sudden appearance', it also signifies 'the moment when nature is transformed' such as 'the wilting of flowers ... the shadows cast on water and earth' (350). This is why, Arata goes on to explain, the canonical example of an architectural arrangement in Japan is *gankōi*, which refers to the 'flight pattern of wild geese' and takes the shape of 'several buildings joined in succession along a diagonal axis' (347). Key in this design is that while each part of the building preserves its own sense of emplacement, they are all related to a shifting axis, which is based on the diagonal, dynamic view. In other words, that which is static is always related to motion, the cycles of life and death, the sky and the earth. Shiraga's, and much of the Gutai, work resonates strongly with the notion of dwelling in the world, as simultaneously visceral, spiritual and ecological. At the 1st Gutai Art exhibition, Saburo Murakami dramatically burst through six paper screens. The torn remnants of this performance – entitled *Six Holes* – were left on view as both a residue

of the action and a composition in its own right, as was the case with *Challenging Mud* and *Please Come In*. Although the influence of Jackson Pollock is obvious here, this visceral relation between the body – *tai* – space and change, which includes movement and event-hood, as derived from the *kami*, foregrounds the body in its materiality, as a repository of past spatial relations, experience, contact with the world, and with the divinities. More importantly, it treats it as an ecological component of that world, from which personhood and individuality arise, rather than the other way around. Much Gutai work captured these ecological relations by a single-letter form – *e* – which means picturing. *E* or picturing is as far from the notion of enframed world-as-picture as it can be, however. It consists of creating a picture to be felt aurally or kinaesthetically through performance. As Saburo Murakami suggests, *e* should be understood 'in an expanded manner, such as Shimamoto Shōzō's 1955 *Please Walk on Here*, a work you experience with your whole body, [by following the indicated path], and Tanaka Atsuko's work by sound alone [her 1955 *Bell*]' (Murakami cited in Ming, 2013: 5).

Through this emphasis on environment and on dwelling as a relational concept that includes the weather, the tides, the trees, the lakes, the seas, sand, plants, animals, *e* is not related to 'getting the picture', discussed by Heidegger in *The Question Concerning Technology* and mentioned above. It is related to disclosing the world in all its multifaceted appearances. And, further, like some of the Surrealist practices, such as Salvador Dalí's lecturing, discussed in the previous chapter, which sought to communicate the basic concepts of Surrealism in non-artistic contexts, the Gutai group were committed to practising picturing in every day life, and particularly with children. This was different from the Surrealist interest in children's art as a source of direct contact with an undistorted perception; the Gutai group actively nurtured children's creative abilities as a way of fostering an ecological relationship to the world. Atsuko Tanaka, like Saburo Murakami, wrote in *Kirin*, a journal for children and adults, which addressed existential concerns in an accessible manner. Praising her third-grade niece for assembling various materials, such as bricks, and creating a mobile appendage, Tanaka (2004) encouraged parents to raise children 'without pressure and constraint', allowing them to follow their impulses instead of subjecting them to adult notions of what is appropriate and what should be done (np). The unfettered intimacy with which most children approach the world is what was to be sought and deepened, a tendency present in the works exhibited at the *Challenging the Midsummer Sun* exhibition in Ashiya, which ran from 26 July to 5 August 1955, and at its sequel the following year, in which many works were environmental and interactive.

Engaging the natural forces, such as the sun, the wind and the rain, these works displayed a very specific relation to the viscerality of existence. Such a relation is crucially dependent on performance as interaction between the body and the environment, which cannot be generalised but occurs in a specific moment, when a specific *Dasein* comes into contact with a specific manner of dwelling.

All the practices discussed in this chapter establish a relation between the process of discovering or 'truthing' and the enquirer's own existence. All are deeply concerned with the environment. While Cage, Cunningham and Suzuki place all relationships between humans, animals, plants and minerals in a de-centred constellation where each constituent interacts with all other constituents, all the time, Pollock, the Gutai group and Heidegger (as well as the ancient Chinese philosophers) are concerned with the relationship between human beings and the environment. For none of these artists or philosophers is the human being separate from the world, nor is time separate from space. Space, too, is time, as well as continual interaction between animate and inanimate matter. The explored crossings and interconnections are essentially ecological in that they bear on the interactions of organisms (in this case, humans) and their environment and ecosystems. Essentially, ecosystems consist of the flux of energy in living and non-living environmental components, such as the wind. They are dynamic interactions. This is why ecology is not solely concerned with life processes, with the movement of energy through living communities and with sustaining ecosystems, but also with the interdependence of ideas, concepts, ingrained habits and human life practices, as they all have effects on the environment. Cage brings into focus the dynamic nature of these relationships themselves. The Gutai group stress the dependence of human beings on matter resistance, motion, gravity and velocity. Pollock's action painting brings into focus the simultaneous existence of vast spaces – mountains, rivers, plains – and those domesticated by humans as manifested in the Heideggerian '*da*' of *dasein*. All these performative strategies inaugurate a deeply ecological relation to the world and make ecology an immediate and visceral concern. The reason why performance is crucial to ecology is not as an umbrella term that encompasses tectonic changes over time, natural, learnt and, in some cases, forced forms of behaviour – such as species extinction resulting from the human-inflicted disbalances in ecosystems. It is because performance is transformative in the micro and the macro sense of the word. As Australian critical theorist Elizabeth Grosz (2008) notes in *Chaos, Territory, Art*, scientific and artistic forms of knowledge maintain their 'connections with the infinite' from which they are,

in fact, 'drawn' (8). In the case of science, the purpose is to 'extract something consistent' (8), to create an order out of chaos; in the case of art and performance, it is to mobilise the '[c]osmological imponderables ... temporality, gravity, magnetism ... the invisible, unheard, imperceptible forces of the earth, forces beyond the control of life that animate and extend life beyond itself' (23). It is this connection with life, not life framed by the divisive systems of knowledge but life in all its unsurveyability involving motion, dwelling, sound, rhythm, daily, yearly and tectonic cycles of humans, animals and nature, that ecological performance brings into focus.

Scores:

1 Stretch a canvas or a white sheet on the floor. Collect various materials such as dirt, dust, gravel, mud. Have paint of various colours as well as textures ready. Think of a particular spatial relationship – with a familiar landscape, mountains, meadows, lakes, oceans – think about how your body relates to this space. Begin moving and drip-painting, follow emergent patterns, compositions, think of the bigger space as musically (rhythmically) related to your body and the space of the canvas. Use impressions and imprints of your own body. Let the painting dry. Hang it on the wall.

2 Select a location where a distinct activity is performed – a waiting room, an auditorium, a café or a restaurant. Select at least twelve actions related to performance in a public space – DJ ing, VJ ing, lecturing, Bingo, auctions, fashion shows, dance, ice skating and so on. Allocate strict time durations to each of the twelve events. Let the performance of all twelve events occur simultaneously.

3 Find an outside area – a beach, a forest, a hill. Engage in a kinetic dialogue with the elements found there – sand, pebbles, wind, sea, bushes, trees. If appropriate, construct a temporary dwelling. Use materials such as wood, soil, mud. Let the sculpture/dwelling stand. Ask your audience to put themselves in the appropriate position to feel the vibration/repercussions of your performance.

PART II
The Deconstructive Turn

To deconstruct means to take apart or dismantle an existing structure. Although this term, as it is known today, came into wide use with the publication of French philosopher Jacques Derrida's influential *Of Grammatology* in 1967, its approach was already present in the late 1950s. Deconstruction exposes the effort and the manoeuvring needed to establish, legislate and maintain hierarchical structures in place. Hierarchical structures, equally present in the realm of social life, urban planning, the body politic and gender identity – to name but a few – are structures based on the relation of superiority to inferiority. For example, within an oppressive gender regime, men are seen as superior to women, who are seen as inferior. The necessity for a systematic dismantling of oppressive regimes arose in response to the post–World War II systems of control and new modes of hegemonic operation. By the 1950s, institutions such as the church, the school and the army no longer exercised overt control over individuals' lives. They were replaced by far more diffuse networks in which increasing mediatisation – the use of an ever-growing number of media, such as the television and the radio – was steadily gaining dominance. This not only changed the social and the cultural landscape, it also influenced the economic and biological life. More and more segments of reality were becoming interpenetrated by communicational structures based on persuasion, advertising and the shaping of public consent. In political terms, the period from World War II until the fall of the Berlin Wall in 1989 was one of opposition. It was marked by the Cold War between the countries of the NATO pact – the US and Western Europe – and the countries of the Warsaw pact – the USSR and Eastern Europe. As the years after World War II wore on, however, it became increasingly clear that what French theorist François Lyotard (1984 [1979]) termed 'the grand narratives', which referred chiefly to the disastrous effects of Nazism and communism, were no longer plausible. Lyotard famously associated this 'incredulity towards grand narratives' (6) with postmodernism. In contrast to modernism, postmodernism was marked by a distinct lack of grand plans and designs. Although 'post' does mean 'after', postmodernism is more than the worldview and the practice that came after modernism. Its focus on the concrete, the particular and the local, rather than on the overarching and the totalitarian, is ideological. Postmodernism is purposefully concerned with the small and the particular, with parts rather than wholes. The battles fought in this period were ones of emancipation from increasing consumerism and gender, ethnic and sexual norms.

PART II

The Deconstructive Turn

4 Against Commodity Fetishism

The Society of the spectacle

In 1960, Michèle Bernstein (2004 [1960]), founder member of the Situationists International movement, influenced in equal measure by the theoretical writings of Karl Marx, Dada and Surrealism, described a typical conversation between young people in the following way:

'What exactly are you interested in?'

'Reification' answered Gilles.

'It's serious research' I added.

'Yes' he said.

'It's very serious work, with heavy books and lots of paper spread out across a big table'

'No' said Gilles, 'I go for walks. Mainly, I go for walks.'

(25–26)

How can the study of reification, which, coming from the Latin for 'thing', refers to the process of turning an abstraction into a thing, be replaced by walking? This was the preoccupation of the Situationists International, a group of writers, architects and painters from France, Algeria, Denmark, Holland, Italy and Germany. The group was formally founded in Paris in July 1957, after the unification of the Paris-based Lettrist Internationale, led by French writer and theorist Guy Debord, and the International Movement for an Imaginist Bauhaus, led by Danish painter Asger Jorn. The name is derived from situationism, the practice of creating impromptu situations, which stands opposed to passive consumption, reification and commodification. As Karl Marx (1990 [1976]), whose influence on the Situationists International activist-artistic critique of capitalism cannot be overestimated, explains in *The Capital*, an object becomes a commodity when it acquires exchange value. While use value is a *qualitative expression* of relations involved in the process of production – such as the materials used and the processes applied – and has a 'metabolic relationship' with

the temporal and qualitative dimensions of human labour (130), exchange value is a *quantitative expression* thereof. It is a 'form of appearance of a content distinguishable from itself' (127). That exchange value is a 'form of appearance of a content distinguishable from itself' means that it does not *embody* any form of specific labour but only refers to abstract labour. Abstract labour is therefore the generalised 'equivalent commensurable with all specific labours' (131). Unlike use value, which renders material and human relations transparent, exchange value mystifies them. This makes commodification inseparable from alienation, a state of estrangement of human beings from their actions. Although much used by Marx and the artists and theorists discussed in this chapter – Guy Debord, Raoul Vaneigem, Henri Lefebvre – alienation has its origin in polytheistic religions, more precisely in the concept of idolatry and fetishism. Deriving from the Portuguese *feitiço*, which means 'spell' – the Latin root of the word being *facticius*, 'artificial', and *facere*, 'to make' – fetishism is the attribution of unquestioned value or powers to an artificially constructed object. Human beings thus expend energy, artistic talent, time and affect on constructing objects, which, having been invested with supernatural powers, human appreciation, even worship, and thus accrued value, begin to exercise power over humans.

In capitalism, this relation is called commodity fetishism. In *The Society of the Spectacle*, Guy Debord (1992 [1967]) defines commodity fetishism as 'the domination of society by things … [which] reaches its absolute fulfillment in the spectacle, where the tangible world is replaced by a selection of images which exist above it' (36). First of all, the spectacle refers to the increasing prevalence of watching over any other form of immersion in the world – movement, touch, smell and taste. Second, it arises from representation, not from directly lived experience. Third, the spectacle refers to passive reception rather than to active participation. This means that 'the world at once present and absent which the spectacle makes visible is the world of the commodity dominating all that is lived' (37). The term 'spectacle' does not merely refer to advertising or television; it refers to an entire network of social relations established through and by the circulation of commodities. There are two problems at the heart of commodity fetishism: mystification (alienation) and the basic relations of inequality produced by capitalism. Since capital, the dead past, employs living labour – the power of the living – in an instrumental manner, in the capitalist hierarchy, amassed things have more value than life, action and affect. The person who owns capital commands the person who does not, regardless of the latter's superiority in terms of intellect, talent or ability. The conflict between capital and labour is the conflict between two radically

opposed values: the value of the world of accumulation of things, steeped in inequality and exploitation, and the value of the world of life energies and creativity. To enable the factory or the white-collar worker to endure the mindless drudgery of heteronomic work – work coordinated from the outside by a pre-established organisation that deprives the individual of coordinating their own activities – pacification in the form of instantly gratifying entertainment and commodities is needed. In any productive, spontaneous and creative activity, such as making a meal, playing with a dog or writing a novel, a transformatory experience takes place within the person. This occurs because the experience is both an expression of their life energies and a creator of new energies. In alienated work and the equally alienated passively consumed forms of pleasure, nothing happens. The person has consumed the sitcom the way they would have consumed a hamburger; they have not created or invented anything.

In Marx's time, the mid-nineteenth century, industrialisation was in full swing but the seductive consumerist strategies were not in existence. This is why Marx believed in the possibility of a reversal of positions predicated on enlightened consciousness. He believed that if only the exploited class became aware of their predicament they would rebel against the exploitative conditions of their existence. But consciousness is not something that abides outside the conditions that make up one's life. It is produced through and by these very conditions. While the advertising industry continues to proliferate associations of freedom and sovereignty with commodities – fast cars, beautiful homes, extravagant holidays, all-powerful gadgets – human beings are cast in the role of consumers. Worth noting here is that to 'consume' means to spend wastefully, to do away with; consumption is the archaic name for tuberculosis, an infectious disease that causes the decomposition of the lungs. Such a practice foregrounds commodities and casts humans in the role of 'mere appendages', as Marx and his close collaborator Friedrich Engels repeatedly stressed (Marx and Engels, 1959: 111). In a prescient theorisation of the commodification of human beings, Marxist critical theorist and social psychologist Erich Fromm (1956) argues that the process of commodification has two key characteristics. On the one hand, 'human qualities like friendliness, courtesy, kindness, are transformed into … assets of the personality package' (142), conducive to achieving 'a higher price on the personality market' (142). On the other, authority is no longer 'overt authority, but anonymous, invisible, alienated authority. Nobody makes a demand, neither a person, nor an idea, nor a moral law. Yet we all conform as much or more than people in an intensely authoritarian society would' (152). This invisible conformity is different from the conformity critiqued by Nietzsche and discussed in

Chapter 1. Produced through behavioural structures that make consistent behaviour in recurrent situations possible – in other words, social roles – this form of spectacularised conformity is learnt through socialisation, dictated, to a significant degree, by advertising. This is why Situationists International called for action in the sphere of the social. They felt that life itself, colonised by consumerism, had to be reclaimed. They rejected the idea that the increased income and increased leisure could ever outweigh the psychological impoverishment inflicted by capitalism. In the appropriately titled *Revolution of Everyday Life*, Belgian Situationist writer and philosopher Raoul Vaneigem (2003 [1983]) states:

> The degenerate state of the spectacle, individual experience, collective acts of refusal – these supply the context for the development of practical tactics for dealing with roles. Collectively it is quite possible to abolish roles. The spontaneous creativity and festive atmosphere given free rein in revolutionary moments afford ample evidence of this. When people are overtaken by *joie de vivre* [joy of life] they are lost to leadership and stage-management of any kind. Only by starving the revolutionary masses of joy can one become their master: uncontained, collective pleasure can only go from victory to victory. (149)

Key to the practice of spontaneous creativity are several techniques for averting the public to the commodification of experience imposed by capitalism. They were techniques for creating directly lived experience, as well as fulfilling authentic, not fabricated or imposed, desires: *détournement, la dérive* and symbolic urbanism.

Situationists International: *détournement* or appropriation

Détournement, usually translated as 'appropriation', although the literal translation would be 'diversion', refers to the subversion of signifying processes that make up advertising and televisual communication. This technique, often employed in *Internationale Situationiste*, a collectively edited journal which first appeared in 1958 and continued to appear until 1969, derives its efficacy from 'the double meaning' and 'the enrichment of most of the terms by the co-existence within them of their old senses and their new immediate senses' (Anon. in Knabb, 1981 [1959]: 55). In other words, *détournement* is 'first of all a negation of the value of the previous organisation of expression' while it also denotes 'the search for a

vaster construction' (55). For Asger Jorn, it is 'a game made possible by the capacity of *devaluation*' (Jorn cited in Anon. in Knabb, 1981 [1959]: 55, emphasis original). This means that *détournement*, which does, of course, resemble the Dadaist and Surrealist collage, discussed in Chapters 1 and 2, operates *beyond* negation to include other regions of meaning. The *Internationale Situationiste* journal was filled with reproductions of advertisements, such as the Peace of Mind Fallout Shelter Company, and with comics, Steve Canyon and True Romance, which were given new balloons and made to discuss revolution, alienation and the spectacularisation of the world, as can be seen from the below illustration (Figure 4.1) which appeared in *The Return of the Durutti Column*, a Situationist comic created by André Bertrand in 1966. This comic, whose below text is identical to Bernstein's above-cited text, was distributed to students during the student revolt at the Strasbourg University in France in October 1966.

Figure 4.1 Situationists International détournement, part of *Le Retour de la Colonne Durutti (The Return of the Durutti Column)*, Situationist comic by André Bertrand, given away at Strasbourg University in October 1966.

A good example of a role-related *détournement* – and, importantly, a precursor to the feminist attack on the reductionist portrayal of the female body in the media – is the Situationists International critique of the commodification of desire through the commodification of the female body. In the first issue of *Internationale Situationiste*, three photographs of sexy women appeared: one in the shower, smiling coyly, another wearing a trench coat with nothing underneath, yet another crouching topless on a beach. Similar found photographs of semi-nude women continued to appear in the magazine, their purpose being to critique a very specific and far-reaching form of alienation – desire. Alienation operates on two levels in such photographs: the female body is shown in poses formatted by the commodity market – the usual array of pin-ups which accentuate the breasts and the rear and elongate the legs – the purpose of which is to codify the (oversimplified) perception of the female body; the second level is the conditioning of the viewer to appreciate the selected body parts, depicted in exaggerated poses, while excluding others. This further leads to the perception of women as large-breasted, round-bottomed pouting posers, ever ready to modify their appearance to please the viewer. Importantly, this distorted perception affects men, women, the young, the middle-aged and the elderly alike. Not only does it sell products that help to produce such a body image – high heels, clothes, make-up, dieting regimes – it also sells these particular behavioural structures, or roles. Perhaps the most notable example of a role-related Situationist *détournement* is the image of Marilyn Monroe that appeared in *Internationale Situationiste* 8, in January 1963. The picture showed a pensive, if not distraught Monroe, while the caption stated the date of her suicide, 5 August 1962. Accompanying this caption was the following text: 'the specialisation of the mass spectacle constitutes, in the society of the spectacle, the epicentre of separation and of non-communication' (Anon., 1963: 19). In the economy of the spectacle – whose chief dynamo is the gaze with its judging, comparing, evaluating and denigrating functions – all images, regardless of what they depict, are treated as objects. The spectacle objectifies; it reifies. By exploiting the full extent of Monroe's status of the cultural icon and sex symbol, the Situationists International draw attention to the highly detrimental effect of the spectacle on human psyche. This is not only to say that standardisation and codification of human beings are bad; far more importantly, it is to point to the standardisation of all passion. In advanced capitalism, all human activities associated with affect – dating, eating, dancing, holidaying, walking a dog, giving birth to children – are structured by and through advertising. Not only do consumers desire a particular experience – skiing for

example – because skiing has been suggested by advertising, they also want this experience to have a particular form, the form suggested by advertising. They want to go to St. Moritz, not Bernese Oberland; they want to wear Arc'Teryx, not Falke. For Situationists International, desire has to be unique to the individual expressing it; it has to form part of the subject's personal affective processes; it cannot be the same as everybody else's. According to the anonymous Situationist:

> within the current framework of consumerist propaganda, the fundamental mystification of advertising is to associate ideas of fulfilment with objects (TV, garden furniture, or automobile, etc.) ... this imposed image of fulfilment also constitutes the explicitly terrorist nature of advertising. (Anon. in Knabb, 1981 [1959]: 106–107)

This daily conditioning results in the people becoming more and more used to the idea of associating happiness and well-being with consumption. Of this, Debord and Situationist Pierre Canjuers write:

> capitalist consumption imposes a general reduction of desires by its regular satisfaction of artificial needs which remain needs without ever having been desires – authentic desires being constrained to remain unfulfilled. (Debord and Canjeurs in Knabb, 1981 [1960]: 307)

Henri Lefebvre (1991), Marxist philosopher and sociologist who worked very closely with the Situationists, goes further in associating the spectacularised images of desire and the female body: '[i]mages with a (more or less) erotic meaning, or simply the display of a woman's body, are violently attractive' but they lack 'genuine sensuality, a sensuality which implies beauty or charm' (35). Modern eroticism is, according to Lefebvre, therefore 'weary and wearying, mechanical. There is nothing really sensual in this unbridled sensuality' (35). The purpose of *détournement* is to expose the discrepancy between the codification of human passion, the continual production of conditioned impulses and the fact that passion, because of its relation to the strictly personal, the uncategorisable and the subconscious, cannot be subsumed under the unimaginative but profitable categories dictated by advertising. In other words, *détournement* performatively upsets accrued meaning while simultaneously creating channels for the redeployment of spontaneity that the spectacle denies, but that needs to be, and can be, reclaimed.

Situationists International: re-writing space

Passion and authenticity were given free rein not only through the re-directing of meaning but also through the spontaneous creation of physical situations in daily life. This practice, termed 'symbolic urbanism', consisted of experimental comportment, of the *détournement* of prefabricated aesthetic elements, architecture and urban planning. As early as 1955, members of the Lettrist International, which in 1957 became Situationists International, put forth the following propositions:

> Open the metro at night after the trains stop running. Keep the corridors and tunnels poorly lit by means of weak, intermittently functioning lights. With a careful rearrangement of fire escapes, and the creation of walk-ways where needed, open the roofs of Paris for strolling. Leave the public gardens open at night. Keep them dark ... Put switches on every street lamp; lighting should be at the disposal of the public. (Anon. in McDonough, 2009 [1955]: 69)

In some cases, it was not the addition of new elements or their rearrangement that was called for but, instead, '[k]eep[ing] the railroad stations as they are. Their rather moving ugliness adds to the atmosphere of travel' (70). In other cases, it was the erasure of the existing elements, elements that organise bodies in space, such as the falsification of all information about train departures at a train station. It is easy to see how these playful structures elicit unpredicted intensities, interactions, even tumult and havoc. The same can be said of the proposition to abolish museums and place exhibits in bars where 'spontaneous fraternisation, and high spirits, are frequent as well as contagious' (70). This is opposed to the behaviour elicited by museums where quiet contemplation and non-communication are encouraged. Like no artistic movement before them, the Situationists were painfully aware of the behavioural conditioning produced by architecture and urban planning, as influenced by the capitalist manipulation of needs by vested interests. The managerial approach to architecture, which coincided with the birth of modern architecture, is generally thought to have begun with the publication of Charles-Édouard Jeanneret-Gris's manifesto *Towards a New Architecture* in 1927. Here, the Swiss-born architect, better known as Le Corbusier (1986 [1927]), argued that interwar Europe had only two alternative futures: 'architecture or revolution' (289). The only way to avoid the revolutionary upheaval that loomed at Europe's Eastern doorstep in the years between the two wars, argued Le Corbusier, was to refocus industry to satisfying the needs of the masses.

Housing was at the top of this agenda. The problem, however, was the lack of financial means; sufficient housing could only be produced with the aid of Henry Ford's system of mass production. For Le Corbusier, a house was a machine for 'living in' (264). It had to be produced and designed 'on the same principles as the Ford car' by applying 'standardization, simplicity and mechanization' (264). The association of modern architecture with the admirable faith in the ability of mass-production technologies to bring economic progress to the masses notwithstanding, Le Corbusier's city was a site of alienated labour and passive consumption. In the 'Critique of Urbanism', published in *Internationale Situationiste* 6, in August 1961, an anonymous Situationist describes this sorry state of affairs in the following way:

> The city of Mourenx. 12,000 residents live in the horizontal slabs if they are married, in the towers if they are unmarried. To the right of the picture lies the small neighbourhood of mid-level personnel, composed of identical villas symmetrically divided between two families. (Anon. in McDonough, 2009 [1961]: 24).

In the same issue, Raoul Vaneigem (1961) is even more critical of such drab, purely utilitarian architecture: '[i]f the Nazis had known contemporary urbanists, they would have transformed their concentration camps into subsidized housing' (np).

This impoverished urban form, which was the physical embodiment of hierarchical organisation, where drab ambiances reigned in segregated spaces, also had a decisive effect on the performance of daily actions; sleeping, eating, walking, socialising, shopping. Not only was this life of segregation radically different from the city of the past – a space of social encounter, spontaneous interaction and, in this sense, freedom – it was imposing an alienated, de-humanised, purely utilitarian, 'work, sleep, consume' life on its citizens. For the Situationists, like for the Surrealists before them, *Palais Ideal*, built at the Hauterives in Southeast France in 1912 by Ferdinand Cheval, was the privileged example of architecture, urbanism and personal passion. A postman by profession, Cheval spotted an anomalous but beautiful stone on one of his post delivery rounds and subsequently spent thirty-three years building his 'ideal palace'. In its completed form, *Palais Ideal* resembled a building from dreams. This contrast – *Palais Ideal* and the Le Corbusier–designed suburbs of Paris – was what made Situationist Ivan Chtcheglov (1981 [1953]) formulate the need for a 'symbolic urbanism'. Symbolic urbanism drew as much on the history of art as on humorous and playful constructs such as 'translucent

concrete', 'sports pharmacy', and the division of the city into the 'bizarre quarter', the 'noble, tragic quarter' and the 'sinister quarter' (3–4), all of which were to be used for living, learning, sport, amusement and social-ising. Chtcheglov first produced a series of maps, such as the map of Paris, which he created by superimposing over the city's metro plan cut out segments of North America, China, Afghanistan and Central America. This desire for the wondrous and the unchartered was amply manifested in *la dérive* – the drift – 'a technique of transient passage through varied ambiances' (Debord, 1981 [1956]: 50). This technique of urban wandering, which the Situationists practised with passion, entailed 'playful-constructive behaviour and psychogeographical effects' (50). Psychogeography here refers to the emotional effect of geographical environments, an idea inherited from poet Charles Baudelaire. Baudelaire practised random travels through Parisian quarters as a form of poetic inspiration. For the Situationists, the purpose of *la dérive* was to resuscitate a living, multifaceted relation with one's environment; it was also a form of performative aesthetisation, a re-writing of space. Walking was here chosen as a form of expression which theorist Michel de Certeau, who, too, was concerned with the practice of everyday life, as were Debord, Vaneigem and Lefebvre, equated with speech and writing.

For de Certeau (1988), the relation between the city and the walker is similar to the relation between the speaker and language in that the act of walking in the city resembles the act of linguistic enunciation in a number of ways. First, walking appropriates the topographical system of the city in the same way that speaking appropriates the grammar of the language of which it forms part. Second, walking acts out one or more possibilities of a place in the same way that speech acts out language – by arranging specific words in a specific order and lending them a specific intonation. Third, walking creates differential positions between points – the difference between a 'here' and a 'there' – in the same way that linguistic signs create meaning, by articulating the distance between the signs (91–97). The grammar of the city is thus created through use and practice as much as it is created through urban design. Adult human beings rarely move randomly; most often our movement is guided by habit and the instructions of objects and signs embedded in the environment, such as traffic lights. The repetition of these rhythms results in the conversion of the urban space into a patterned ground, just like particular combinations of words create patterned phrases, such as the 'hello, how are *you*', which, when the emphasis is on '*you*' rather than on '*are*' indicates that the phrase is a form of greeting and not a real question. The practice of place inaugurates a particular social reality. Playing chess, scrabble or cards in a park marks the

park as a place where people gather for social and leisurely reasons. This lends the passage through the park a very particular feel, that of lightness and serenity, and acts as a mnemonic device. It cues particular sensations in the passers-by and recollects other such feelings. For de Certeau, '[m]emory is a sort of anti-museum: it is not localizable', fragments of memory come out in 'the everyday acts of walking, eating, going to bed in which ancient revolutions slumber' (108). It is precisely this marking or inscription of space previously unmarked that the Situationists were looking for since all actions performed in the city are invariably seen and remembered by other people Debord 1981 [1956] writes: 'one or more persons during a certain period, drop their usual motives for movement and action, their relations, their work and leisure activities and let themselves be drawn by the attractions of the terrain' (50). The purpose of this is to erase the customary, ingrained psychophysical map acquired through everyday movements and repetition, and open ourselves up to inspiration, chance, even whim. 'One can *dérive* alone', writes Debord, 'but the most fruitful numerical arrangement consists of small groups of two or three people' (51). The average duration is one day, but it can also last only a few hours or, conversely, go on for days. The use of vehicles, for example taxis, is permitted, too; however, as the ultimate purpose is disorientation, careful choices are recommended in this respect. There is also the possibility of arranging meetings, with one or more people. This is closely related to expectation and projection. For example, a walker is told that another person will be in a certain location. Simultaneously, several people are sent to the same location and given a vague description of the person/people they are to meet there, which entices conversations with random passers-by (53). The resources of the *dérive* are endless and include 'slipping by night into houses undergoing demolition, hitchhiking nonstop and without destination through Paris during a transportation strike in the name of adding to the confusion, wandering in subterranean catacombs forbidden to the public' (53). What the *dérive* does it to reawaken the sensual perception of the animate and inanimate world; things, atmospheres and objects become alive. Calling forth such renewed attentiveness of visceral empathy with place disrupts purely utilitarian environments, which, through their regimes of bodily control, blunt the human ability to perceive. For Lefebvre (1974), '[s]pace has been shaped and molded from historical and natural elements, but this has been a political process. Space is political and ideological' (31). In recognising that space is a product filled with living politics, Lefebvre and the Situationists resuscitate space from its historical status as fixed, dead and inert. Space becomes alive, pulsing with the beliefs, thoughts and actions that shape the walkers. When social relationships are analysed with

respect to the material spaces that contain them, it is clear that spaces are not just cultural products; they are, reciprocally, productive of particular social formations. Part of the domination is also segregation, performing one's daily activities in the designated spaces and in these spaces only. This is why an important part of the Situationist programme consisted of visiting places that do not form part of the walkers' daily routine. In 1955, the Lettrists (1955) demanded:

> free and unlimited access to the prisons for everyone. Allow people to use for vacations. No discrimination between visitors and prisoners (to add humor to life lots could be drawn twelve times in the year, so that visitors might find themselves rounded up and sentenced to real punishment). (np)

It is not a coincidence that the 1950s, the time of accelerated technologisation, mass production and standardisation, which went hand in hand with the impoverishment of the urban environment, was marked by the widespread popularisation of tourism. The 'tourist' with the camera, amassing snapshots, became the symbol of an alienated relationship to the world. By the 1950s the idea of the vacation as 'vacating' one's home and work had spread through all social echelons. A 'real holiday' increasingly required 'getting away' from one's everyday environment. A holiday was thus no longer a 'holy day'; it was a form of compensation for an increasingly regimented life, full of toil and drudgery. For Canjuers and Debord (1981 [1960]), tourism's 'pure, rapid, superficial spectacles' satisfy an artificial desire, rather than the desire 'to live in human and geographical milieus' (308). Important to note is also that tourism maintains the illusion of freedom while simultaneously sustaining social controls based on chronarchic oppression. Coming from *chronos*, which means 'time', and *arkho*, which means 'to rule', chronarchy refers to the rule of time. It also refers to the regimentation of human beings by timekeeping, obligations and schedules, which the above Situationist practices sought to rewrite as much as they sought to rewrite space.

Henri Lefebvre: the moment as festival

For Lefebvre (1991), the mysterious, the sacred and the mystical were all 'lived with intensity' (117) in the times before technological rationality. These 'thoroughly authentic, affective and passionate' forces (117) formed part of the real lives of human beings. With the appearance of rationality,

however, this situation changed drastically. Myth became legend, tale or fable; the marvellous and the supernatural became the bizarre. The human relationship with the universe, which included the inexplicable but nevertheless affective, in other words everything that was 'serious, deep, cosmic', was displaced; it was moved to 'the domain of play or art' where it was treated as 'amusing, ironic or mildly interesting' (117). This process, which Lefebvre calls 'demotion', is concurrent with the internal transformation that takes place; in its demoted variant, ritual is reduced to gesture. Prayer, incantation, song and movement become reduced to a silent wish. Time is flattened into equal duration. For Lefebvre, however:

> there are certain instants, minimal in the passing of time, but extremely important in terms of their plenitude, when the mind breaks through the circle in which it had been enclosed, and begins to contradict itself, to have intuitions, flashes of insight, which, try as one may, cannot be denied afterwards – they really happened. There are masses of times, enormous and stupid in which nothing happens; and short, marvelous moments in which lots of extraordinary events take place. So far no one has ever come up with anything to prove that truth is in proportion to abstract time, that what lasts for a long time is true and that what only lasts for an instant is false. (118)

Another problem is privatised consumption – mod cons and gadgets, symbols of sovereignty and autonomy – consumed in the privacy of one's own home. Since, as already mentioned above, the specialised activities of the modern production process are heteronomic, that is to say, coordinated from the outside, the working individual is deprived of forming cooperative relationships with others. This form of obligatory, predetermined communality demands compensation in the form of strictly individual, private happiness, experienced as the space of freedom. This is why the advertising strategies employed to sell such happiness-promising products designate the buyer as a person different from the masses. Moreover, they create a sense of complicity, suggesting that both the seller and the buyer are following their impulses and their passions, in a way that excludes the rest of the world. Not only does this make the buyer buy exactly the same products as everyone else, as discussed by Fromm and mentioned above, it also deprives them of a connection with the world beyond the world of commodities. For Lefebvre, this division between work and leisure, public, work-related life and privatised consumption, between public occasions and intimate situations, between the fascinating and the drab (into which the everyday has turned), results in a diminished consciousness. Instead of expanding and

embracing the world in all its mystery, this consciousness 'shrinks in upon itself'; the more it shrinks, the more it seems to be 'its own'; thoughts, ideas and feelings are suddenly all seen as 'property', on par with the consumer's furniture, 'his assets' and 'his money' (149). This is the moment in history when 'commodity' no longer refers to objects but begins to encompass all of being, a time when individuals begin to view their entire being as a set of traits to be profitably invested on the job or the leisure market. Crucial, for Lefebvre, is the ability to access the infinitely fascinating expanse that is the universe, through one's daily existence, seen not as confined to drab every-day-ness but as open to the marvellous. This ability is closely related to the notion of the festival. Important to understand, however, is that this word does not refer to the carnival and the carnivalesque inversion, in which the poor and the downtrodden become the king or the queen for a day, only to return to their 'real station' in life the very next day and stay there for the remaining 364 days of the year. For Lefebvre,

> [m]ystics and metaphysicians used to acknowledge that everything in life revolved around exceptional moments. In their view, life found expression and was concentrated in them. These moments were festivals: festivals of the mind or the heart, public or intimate festivals. (250)

Seen from this point of view, reality is not a series of contrasts between ordinary moments and exceptional moments, between the trivial and the magic. Instead, the critique of everyday life, which is what the Situationists, as well as Allan Kaprow and Jean-Jacques Lebel, whose happenings are discussed below, practised, investigates those very relations. This relationship between the ordinary and the magical is closely related to collective aesthetic pursuits that have a ritual dimension. Examples of this range from the Navajo Indian rain dance and the Japanese tea ceremony to folk dancing. With the disappearance of uncommodified activities and their gradual replacement by commodified object relations, this particular way of relating to other people, which is not individual leisure time spent watching television but a socially productive time, has been wiped out of existence. One could say that the economy of collective experience has been entirely absorbed by the market. Or, as Vaneigem (2003 [1983]) puts it:

> [e]veryday life has crumbled into a series of moments as interchangeable as the gadgets which distinguish them: mixers, stereos, contraceptives ... sleeping pills. ... Exchange of nothings, restrictions and prohibitions. Nothing moving, only dead time passing. (81)

One of the artists who addressed this demotion of ritual to gesture, and the demotion of the festival to 'dead time', is Allan Kaprow.

Allan Kaprow's happenings

Although taking place in the US, and thereby in a different cultural climate, Allan Kaprow's work could, in many ways, be seen as combining the Situationist practice of symbolic urbanism and the Lefebvrian notion of the festival. His actions, performed in supermarkets, in the street and in city dumps, amply show this. For example, '[a]t least 3 motionless men are covered from head to toe with chocolate icing by the same number of women. Environments and times: a supermarket, Thursday, Friday, 9 am' (Kaprow, 1966a: 204). Or, '[a] group of at least 15 dogs on leashes are fed tinned dog food by their masters. Environments and Times: a street, Thursday, Friday, 5 pm' (205); 'at least 10 people are packaged up in plastic film and are dumped or delivered by truck. Environments and times: a city dump, Thursday, Friday, 12 pm' (205). These performances, in which the ordinary – place, action, performers – became the extra-ordinary, were the result of Kaprow's reflection on the steadily growing problem of instrumental labour, initially developed by his teacher, Marxist art historian Meyer Schapiro. For Schapiro, the history of modern art was the history of an art encapsulated in the capitalist labour practices. The artists' production of aesthetic objects, manufactured in the privacy of their studios, was a product of capitalism's economic, political and class-based ideology of the 'private', as described above. Contrary to this, the task of the artist was to act in the world. Answering this call, Kaprow's work tackled the repetitive rituals of everyday life as produced by the cap-italist regime. Inspired by John Cage, whose classes at the New School he attended between 1956 and 1958, and during which he came into contact with Cage's and Cunningham's 'total art' performance work, discussed in the previous chapter, Kaprow created his famous *18 happenings in 6 parts* in 1959. Staged at the at the Reuben gallery in New York, this work investi-gated the spatial and temporal fracturing of ordinary events by presenting them in simultaneous mode, and situating them within a participatory aes-thetic. As Kaprow (2003) explains in *Essays on the Blurring of Art and Life*:

> Happenings are events that, put simply, happen. Though the best of them have a decided impact – that is, we feel, 'here is something important' – they appear to go nowhere and do not make any par-ticular literary point ... Their form is open-ended and fluid; nothing

obvious is sought and therefore nothing is won except the certainty of a number of occurrences to which we are more than normally attentive. (16)

Most happenings exist for a single performance only. Although accidental onlookers and audiences are welcome, the focus is on participation, on doing rather than on watching. For Kaprow: 'a Happening has no plot, no obvious "philosophy", and is materialized in an improvisatory fashion, like jazz' (18). Its significance

is not to be found simply in the fresh creative wind now blowing. Happenings are not just another new style. Instead, like American Art of the late 1940s they are a moral act, a human stand of real urgency, whose professional status as art is less a criterion than their certainty as an ultimate existential commitment. (21)

This existential commitment, which makes a clear reference to the action-painting work discussed in the previous chapter, resonates strongly with the Situationist and Lefebvrian valorisation of life's repressed energies and moments, which make the everyday marvellous. 'Commitment' has much to do with the ability – and the will – to resist the allure of com-modities and to look for value in the ordinary (which the world of com-modities denigrates). Although many of Kaprow's happenings valorise as well as celebrate the ordinary, some, such as *Mushroom*, presented at the Walker Arts Center in November 1962, offer an explicit critique of the com-modification of life. Here, around a hundred people assembled in a cave, partitioned into several chambers. In the fore-chamber, televisions, tape recorders, microphones, vacuum cleaners and electric saws were exhibited. Several bowls of mushrooms were also exhibited. The attendants acted as salesmen, continuously attempting to engage the visitors by

delivering rapid-fire pitches about their respective display, while dem-onstrating them frequently. For example, the mushroom salesman dressed as a chef offer[ed] small samples in little paper cups, while the tape-recorder man recorded the voices of those whom he engage[d] in making his pitch. (Kaprow, 1967: 6)

A self-important press crew made regular appearances, asking visitors to move aside so as not to obstruct the view, since the media coverage of the mushroom sales pitch was far more important than the actual gathering in the cave. By setting this happening in a cave and contrasting it with the (then-)state-of-the-art reporting technologies, Kaprow stresses the

dependence of advertising and commodification on myth building. At the same time, he acknowledges the human need for ritual. Although ritual can have other forms, as we shall see in the following chapter, it inflects the uninflected and emphasises the undifferentiated. Many of Kaprow's happenings, such as *Household*, commissioned by Cornell University and presented there on 3 May 1964, marry these two aspects. They are a critique both of commodification and of instrumental labour while they simultaneously inflect the uninflected. In so doing, they haul the marvellous and the extraordinary over from the domain of art, and anchor it firmly in everyday life. Set in the country, the *Household* sequence of events includes men building wooden towers on a rubbish mound and women building nests of samplings and strings on another mound. Women screech from nests, and men cover cars in jam; women lick the jam off the cars – as can be seen in Figure 4.2 – and men destroy their nests. There is a lot of shouting and cursing; men roll on the ground laughing, and women dance to loud rock 'n' roll; men set the rubbish heap on fire. After this, all sit down and eat jam sandwiches. The stereotypical division of the household into men and women, male and female tasks does, of course, have an archaic dimension. However, it also 'blows up' a series of private moments: a household squabble, the dumping of rubbish, the eating of jam sandwiches.

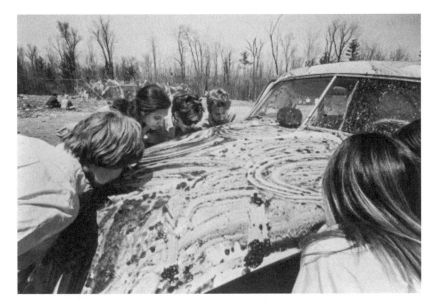

Figure 4.2 Allan Kaprow's 'women licking jam off a car', from happening *Household*, Cornell University, Ithaca, NY, in 1964. Photo by Sol Goldberg. © Estate Sol Goldberg. Getty Research Institute, Los Angeles (980063).

This catapults the selected 'private' moments into a spatially and temporally extraordinary dimension. It also lends the uninflected nature of these actions a communal quality, which rewrites both space and time, while simultaneously acting as a mnemonic device. In other words, it proposes a different comportment and a different relation between the private and the communal, which defies the segregation imposed by capitalist relations. Artist and activist Jean-Jacques Lebel's approach to happenings, albeit very different from Kaprow's, focuses on this segregation, too, but has another element: it engages explicit sexuality.

Jean-Jacques Lebel: exorcising the anal in capitalism

Jean-Jacques Lebel's happenings, staged in Europe and the United States in the 1960s and 1970s, borrowed from Surrealism as well as from Dadaism. For Lebel, the event staged by George Grosz and Franz Mehring at the Berliner Dada Messe in 1919 entitled *Race Between a Sewing Machine and a Typewriter* was the real ancestor of happenings. Here, the Dadaists Richard Huelsenbeck and Raoul Hausmann typed and stitched away at a mourning crepe uninterruptedly for half an hour until George Grosz proclaimed the sewing machine the victor. For Lebel (1998), '[t]hat strange, absurd race had the quality of a dynamite event, which, like a mescaline trip, completely transformed, subjectively, the individual who experienced it' (141). Lebel's happenings were participatory performances with the ability to transform subjectivity, to however small a degree. Not only were they linked to eroticism, as was a lot of Surrealist work, they were also linked to the sexually explicit side of the body. This was, in turn, linked to the exploitation of humans through the manipulations of desire, which served the overarching drive to reify and dominate through capital. In April 1966, Lebel organised the *Festival of Free Expression* in Paris, the main feature of which was a happening entitled *120 Minutes Dedicated to the Divine Marquis*. As Lebel states, the happening was aimed at 'exorcising the anal rituals of merchandise and the authoritarian structure of capitalism' (Lebel cited in Mahon, 2003: 232). Donatien Alphonse François de Sade, also known as Marquis de Sade, who lived in the second half of the eighteenth century and died in 1814, was a French philosopher famous for his propagation of libertine sexuality. Although he has written political tracts and plays, he is best known for his erotic works, such as *Justine* and The *120 Days of Sodom*, both of which depicted wild sexual fantasies as well as violence.

Having spent a large proportion of his life in prisons and insane asylums – despite the fact that he was an aristocrat, de Sade was persecuted by the law and the Catholic Church – he tirelessly propagated extreme freedom, unrestrained by law or religious prohibition. Indeed, de Sade stood for the ability to overcome the factual conditions of one's life (in his case, incarceration and prolonged sojourns at mental asylums) through the use of one's imagination. The allusion to de Sade in Lebel's title situated de Sade's call for freedom from all restrictions within the context of capitalism, which was steadily colonising all walks of life. Lebel had hired Théâtre de la Chimère, situated in Pigalle, the red-light district of Paris, as the venue for his happening. The audience entered the theatre through the stage door on which two shanks of bloody meat hung. After this entry into a womb-like space, flashing strobe lights, jazz music and abstract film projections began to bombard the spectator. Sugar cubes containing LSD were generously distributed, too. Much used in the 1960s and advocated by such people as Harvard professor Timothy Leary for whom liberation from societal constraints and other forms of oppression resided in the field of expanded perception, LSD is a hallucinogenic drug which, in Lebel's case, was used in order to bring about further distanciation from the time-space of capitalist productivity. Among the actions presented to the ambulating audience was spanking, executed by Lebel and Bob Nenamou and followed by a role reversal in which the spanked girls drummed *La Marseillese* (French national anthem) on the naked buttocks of Lebel and Nenamou. Popularly titled *Fessée Marseilleise,* this number engaged 'nationalism and xenophobia' in equal measure and was a 'clear anarchist statement' (Lebel, 2015: np). A soprano was heard singing the French anthem in the background. Whether or not this voice belonged to the woman who appeared above the audience and urinated on them a little later is unclear. However, this unexpected act was followed by the entrance of three nuns wearing the yellow Star of David. The nuns engaged in intimate hygiene while a singer lay on the table covered in cream, her G-string visible and bearing the Star of David as well. At some point during the happening, a transsexual with the Sadean name – Justine – revealed her female breasts and penis to the audience. The repeated references to the Nazi concentration camps and segregationist politics, in the form of the Star of David, mixed with the French national anthem, and other references to French president Charles de Gaulle and the colonial war France waged in Algeria, were interpenetrated by the explicit body and eroticism. This intermingling of signs foregrounded the anal capitalist tendency to amass and dominate

while simultaneously emphasising the unbridled, disorderly and disordering power of eros. For Lebel, despite its increasing harnessing by the market logics, eros remained a force of resistance, the epitome of uncolonised and unpredictable life energies.

The performative strategies discussed in this chapter *change* much of what is usually seen as solid and unchangeable: the printed word, architecture, the layout of the city. Not only do they reveal space as temporal, and imprinted meaning as fluid, they also reveal just how much resistance is needed, in all spheres of life, to de-construct the alienation of work, the alienation of desire, the colonisation of life by chronarchic regimentation and, finally, the disappearance of socially enriching but economically non-productive uses of time, aptly summed up by Debord as the society of the spectacle. Although all of the above practices originate in the fields of art and theory, they are linked to the most widely practised activities, such as walking. This places them in the realm of the everyday, where these performative interventions act as an embodied critique of architecture, of urban planning and, more generally, of the organisation of life. Architecture shapes space and built environments. As such, it cues behaviour, memory and the formation of communal identity. To remember something is to remember it spatially; we tend to remember our childhood through the houses and places we have lived in. There is therefore nothing external about buildings. The built environment is as much a part of us as the food we eat. Many theorists and architects have examined this relationship since the Situationists International. A case in point is French architect and theorist Bernard Cache. That there is no separation between interiority and exteriority is evident in language, too; in many Indo-European languages, the expression for 'outside' comes from the Latin word for 'door', *fores*, which means 'threshold' and from which the French *dehors* and the Italian *fuori* are derived. Outside is therefore not a different region. As Cache (1995) explains in *Earth Moves: the Furnishings of Territories*, both furniture – which, essentially, is body-sized architecture – and architecture proper are the 'primary territory' for the 'urban animals that we are' (30). They are the immediate and only environment for 'our most intimate and most abstract endeavours' (30). Our emotions, thoughts and interactions are shaped through their concavity, convexity, their folding and unfolding. The Situationists' performative interventions, like Kaprow's happenings, accentuate this relationship of place, space, time, built environment, individual and group identity, and cultural memory. They also propose concrete strategies for countering the increasing commodification of life, as does, indeed, Lebel. Performance

is here a strategy for de-commodifying life, one with the explicit aim of impacting social processes, of which architecture is an important part. Although architecture, geography and performance are different disciplines, the above interdisciplinary endeavour, marked by the poetic mobilisation of what is usually perceived as a 'static environment', the ritualisation of the everyday, and the staging of intimate actions in public places, reveals the performed nature of all architecture and, conversely, the situating, architectural nature of all performance.

Scores:

1 Find a cultural text – a comic book, a film or a reality show and *détourn* it with the aid of (a) theoretical text(s). For example, dub a reality show protagonist's lines with lines from Debord, Lefebvre, Hardt or Negri (discussed in Chapter 10).

2 Design a *dérive* in a familiar city. Think of the meeting points, interiors and exteriors, public and private zones – the railway station, the stock market, the city hall, the zoo, the cathedral, the pubs and clubs, the favourite walking/ thinking/kissing spots. Try and run through these environments as quickly as possible, striking impromptu conversations with the passers-by. Include other performative/inscriptive elements, such as singing or leaving words written on bits of paper (or other materials), as a trace.

3 Design a happening in a public space – an airport, a supermarket, a football stadium. Either use the actions usually performed in that space or transpose an action from one space to another, for example from a doctor's waiting room to a football stadium.

5 The Way of the Body

Ritual, sacrifice, the non-utilitarian worldview

The 1960s were a period in which social, cultural and political values were radically rethought. Also referred to as the 'cultural decade' (Barth, 1984 [1967]: 62), which denotes the period roughly from 1963 to 1974, this decade was marked by the student revolts of the 1968, in which many of the artists and theorists discussed in the previous chapter – Michèle Bernstein, Guy Debord, Jean-Jacques Lebel and Raoul Vaneigem – played a prominent part. Counterculture launched a sustained attack on the supposedly unquestionable rationality of the bourgeois morality, in particular, its manifold sexist and racist manifestations. Protests against the Vietnam War raged in Europe and the US; thirty-two African countries were finally liberated from colonial rule. The capitalist utilitarian dogma was under heavy attack, too. This had been broached many times before, among others, by the artists and theorists discussed in the previous chapter; however, it was French philosopher George Bataille who most clearly articulated ideas radically different from those of the classical economy, which propelled capitalism. Developed by Adam Smith and David Ricardo, classical economy was based on the notion of scarcity. In *The Accursed Share*, Bataille (1988a) asks the following question: 'why would it [classical economy] have thought that in the beginning a mode of acquisition such as exchange had not answered the need to acquire, but rather the contrary, the need to lose or squander?' (67). Bataille goes on to argue that excess and transgression are not aberrations but, in fact, logical outcomes of the general economy of which classical economy is only a subcategory. The general economy is based on the concept of the inexhaustible flow of energy, in other words, on surplus, not on scarcity. This surplus of energy can be found everywhere in nature. The sun expends its energy on the earth, but once expended, this energy is not used up; plants imbibe it and generate new energy. A part of the newly produced energy is used for survival; however, like the sun, plants, too, produce an excess of energy which they expend on what appear to be 'useless elements', such as the beauty of their leaves. For Bataille, the same principle extends to all economic phenomena:

> a society always produces more than is necessary for its survival; it has a surplus at its disposal. It is precisely the use it makes of this surplus that determines it. The surplus is the cause of the agitation, of the structural changes and of the entire history of society. But this surplus has more than one outlet, the most common of which is growth. And growth itself has many forms, each one of which eventually comes up against some limit. Thwarted demographic growth becomes military; it is forced to engage in conquest. Once the military limit is reached, the surplus has the sumptuary forms of religion as an outlet, along with games and spectacles that derive therefrom, or personal luxury. (106)

Clearly, in Bataille's view, it is the expenditure of excess energy that matters, not efficient utilisation of resources. Religion, military conquest, art, aesthetics and entertainment are all expressions of this excess energy, or surplus. This realisation is the cornerstone of two important concepts in Bataille: the gift and sacrifice, both of which are directly related to the practices discussed in this chapter – the visceral performances of the Vienna Actionists, the *butoh* of Tatsumi Hijikata and the shamanistic work of Joseph Beuys. All these practices focus on the body, not only on the human body but also on animal bodies and on inter-corporeal and inter-temporal relations, which include exchanges between plants, animals and humans over time. In a rational economy, goods and production are designated to meet the general needs of life, or to aid expansion and growth. Given that all production is designed with the future in mind, all objects are pre-ordained and understood as a means towards an end. This is similar to the Heideggerian conception of technological production discussed in Chapter 3. In sacrifice, however, goods, animals and humans are subtracted from this ordaining towards a future end. They are no longer subordinated to a predetermined system of values and are free of utilitarian domination. Both the sacrificed and the person who offers sacrifice are seen as removed from utilitarian circulation; their existence is free of all constrains. For Bataille, 'the victim is surplus taken from the mass of *useful* wealth' and 'can only be withdrawn from it in order to be consumed profitlessly', in other words, 'utterly destroyed' (59, emphasis original). Once chosen, 'the victim is the *accursed share*. ... But the curse tears him away from the *order of things*; it gives him a recognizable figure, which radiates intimacy, anguish, the profundity of living beings' (59, emphasis original). No longer available for any future, planning or use, the person to be sacrificed becomes a truly sovereign, free subject. As such, it can enter the realm of the sacred, which has nothing to do with the realm of use. Bataille writes: '[t]he world of the subject is the night: that changeable, infinitely suspect night which, in the sleep of reason,

produces monsters. The free "subject," [is] … occupied only with the present' (58, emphasis original). It is only in the present moment that the intimacy and the existential depth can become manifest. A fraction of this exchange can also be felt in gift giving, which, for Bataille, does not belong to the category of rational exchange. Influenced by Marcel Mauss, who, in his famous work, *The Essay on the Gift,* which first appeared in 1954, proposed that in the so-called archaic societies the gift was a carrier of spiritual force, Bataille forged a connection between the excess energy and the potlatch. In Mauss's system, every gift requires a counter-gift to return the inherent power of the gift; a gift places a hold on the receiver and the only way to lift the hold is to return the gift. In the archaic societies, social structures were kept in place through the process of gift giving of which the potlatch, practised by the Haida, Makah, Nuxalk and the Tlingit who inhabit the Pacific coast of Canada and the US, is the most extravagant example. During a potlatch, there is an orgy of gift giving by the person holding the event; the emphasis is on abundance and excess. Economic wealth is regarded with disdain and gifts are often destroyed. However, the destruction of precious objects is not meaningless; it shows just how much the potlatch holder honours his/ her guests, how highly s/he thinks of them, given that s/he is prepared to destroy absolutely everything in their honour. The easiest way to understand this is through love. If a suffering lover is given a car, but if in the same moment the long-lost beloved appears and the lover drives the car into the nearest lamppost to show just how little s/he cares for cars and how much s/he cares for his/her beloved, the gesture will, most likely, not be read as senseless destruction but as a gesture of ultimate love. Something similar occurs in the potlatch where goods are subordinated to the unity of life and living beings. In order to honour life, to be free, one needs to annihilate excess, not to hoard and accumulate. The giving away of the surplus, even in the form of human sacrifice, is therefore an act of existential intimacy. It is an act of moral beauty, which is the reason why it requires the ritual form, found in the work of the Vienna Actionists.

The base materialism of the Vienna Actionists

Much of this relation to the intimacy of existence, intimacy shared by all living beings, is found in the work of Günter Brus, Otto Mühl, Herman Nitsch and Rudolf Schwarzkogler, also referred to as the Vienna Actionists. This name, however, was not originally used by the four artists; it was coined by theorist Peter Weibel and first used as the title of Rudiger Engerth's essay that appeared in *Protokolle* arts journal in 1970. Although trained in painting and

experimental film-making, the Actionists, active between 1960 and 1971, used ritualistic performance as their medium and made frequent references to theatre. In his 'Orgies Mysteries Theatre Manifesto', which was simultaneously a scenario for an action, Nitsch (1999 [1962]) writes:

> on june 4 1962 i shall disembowel, rend and tear apart a dead lamb. this is a manifest act (an 'aesthetic' substitute for the sacrificial act) which [is] both meaningful and necessary. through my artistic pro- duction (a form of life worship) i take upon myself all that appears negative, unsavoury, perverse and obscene, the lust and the resulting sacrificial hysteria, in order to spare YOU the defilement and shame entailed by the descent into the extreme…every agony and lust, combined into a single state of abandoned intoxication, will pervade me and thereby YOU. (132, emphasis original)

First, it is important to note that all animals used in the actionists' events – of which there were many – were procured from slaughterhouses, not killed for the purpose of the event. Second, the word theatre is here used in the archaic sense to signify ritual. In 'Drama and Ritual', performance scholar Rainer Friedrich (1983) offers an interesting interpretation of the much-debated link between Greek tragedy and the song of the goat (i.e. *tragoedia* from *oide* – song, *tragos* – goat), which he locates at the moment of the ritual killing. For Friedrich, ritual killing is an expression of a deeply ambivalent feeling humans have towards slaughtering animals for food. On the one hand, this is needed for survival; on the other, it robs another being of that which the one who kills – the human being – is hoping to sustain through the act of killing, namely life. This unsettling feeling, which, within Bataille's logic, belongs to the existential intimacy of life and the anguish associated with the knowledge that asserting life presup- poses death, was the reason why killing was ritualised, argues Friedrich. The edible parts of the animal were eaten by the congregation present at the ritual killing; the inedible parts – bones, fur, fat – were arranged in such a fashion so as to imitate the animal's shape and presented to the gods. Symbolically, then, the animal was reassembled and sent to the realm of the sacred; it was sacrificed (Friedrich, 1983: 167–169). Any sacrifice is a gift to the gods as well as a gift to those on whose behalf it is performed, those who stay behind. Much like in the potlatch, the gathered company is indebted through and by this act. Nitsch proposes that such an existential intimacy is necessary to reveal the life-to-life, body-to-body relationship, which lies at the heart of all existence. He also proposes to absolve the viewers of all unpleasantness and guilt associated with committing such

a deed. In traditional sacrifice, for example that of the Aztec, the sacrifice restores the spiritual balance; this balance is enjoyed by all. This is why the act has to be performed publicly, and witnessed by an audience. At the same time, a bond is created from excess. But this excess is not monolithic; rather, as Nitsch (1999 [1962]) states, it is riddled with multiple intensities:

> a philosophy of intoxication, ecstasy and rapture demonstrates that the innermost core of the most vital intensity, of frenzied excitement is the orgy, which represents a constellation of being within existence in which joy, pain, death and procreation come together and coalesce. As a consequence of this viewpoint, the sacrifice (abreaction) must be seen as the concern of ecstasy and the zest for life. (132)

The Vienna Actionists strove to convey this coalescence of joy, pain, death and procreation – which is life – in the most direct way, not through (idolatric) art objects. Theirs was the quest to render manifest 'the warmth of life, organic growth within the womb, the extremes of sexual intensity and mysticism, the process of existence in its totality' (133). This intimate yet violent response was at once a reaction against capitalist commodification and a reaction to the repressive climate of post-war Vienna. Key to the so-called economic miracle, in Austria and the rest of central Europe, were discipline, obedience and subordination. The Actionists rebelled violently against the taboos of tradition, passed down from generation to generation, taboos that silenced any explicit concern for the body and made possible the unprecedented slaughter of the World War II, which took place in an organised, even efficient, fashion. Their choice of the body in its explicit form, of animal bodies, and of the various materials associated with blood, secretions and mucus, was not accidental. In the 'Material Action Manifesto' of 1968, Otto Muehl (1999 [1968]) writes:

> freedom for all members of the human and animal body ... from now on, the audience will not be duped by anything. all that exists will be presented directly. coitus, murder, torture, operations, decimation of people and animals and other objects ... people must open their eyes at last ... pornography is a suitable means for healing our society of its genital panic. (110)

The phrase 'genital panic' refers to the eponymous action by the prominent female artist associated with the Viennese group, Valie Export. This action was performed in Munich in 1968; Export entered an art cinema wearing crotchless trousers and a leather shirt, and holding a machine gun.

Her genitals were exposed and the audience gaze was controlled by means of the machine gun. Like this acknowledgement of the subversive power of sexuality, which resembled Lebel's happening discussed in the previous chapter, the Viennese Actionists drew attention to the explicit body. All their actions were performed naked, with frequent incisions, with pain and sometimes with the performance of such private bodily actions as urination. The outrage and the scandal that accompanied the appearance of the naked body in spaces designated for cultural production – galleries, concert halls, universities – brought into focus not only the inexistence of the body within social regulation, but also the manner in which the body – that fabric of existence and part of the general economy – was oppressed by the various disciplinary regimes: legal, social and educational. As art theorist Malcom Green (1999) notes in the introduction to *The Writings of the Vienna Actionists*: '[t]he legal machinery lacked the articles to deal with the actionists' deeds, and in several cases its ruling resorted to serious distortions of the observed fact in order to obtain a conviction' (15). The fact that the law courts had to resort to unlawful means to obtain a conviction says a lot about the problem the Actionists were trying to address: the complete negation of the body in any social or legal definition of a person. To counter this, they created purposefully jarring actions, in which apparent eroticism mingled with physical revulsion or injury. What were the bodily conditions of social respect? Individuals were seen as respectable only if their bodies were appropriately covered and their sweat, triggered by discomfort, fear, panic or, indeed, the operation of their bowels, was safely hidden from view. Inappropriately dressed individuals or individuals in pain were considered an affront to society. Everywhere was one's social existence separate from one's physical existence. This is why the four Actionists repeatedly showed the human body in ways that disturbed the usual, socially validated reactions. Pain was shown alongside beauty, disgust alongside irony, vulnerability alongside excretion. An excerpt from the list of abreaction rites included such delicate things as 'tea-roses sliced on a glass plate with a razor blade' but also pierced, blood-filled pig's bladders, raw meat as well as 'the loudest possible noise through which ecstasies are created' (Nitsch, 1999: 134). This particular constellation of ritual objects and stimuli was designed to produce a 'meditative and prodigiously sensual feeling' in the audience (134). As Bataille (1988c) argues in *Inner Experience*, this is, simply and purely, experience. Experience is superior to all knowledge and comes from non-knowledge, as only non-knowledge can communicate ecstasy and the intensity of life (52). There can be nothing that justifies or attributes meaning or value to experience. Life cannot be comprehended or justified from the

outside, since life is new in every moment. For Bataille, understanding, empathy, attunement, communication and community are all founded in the rupturing of single existence. Communicating with that intangible, intimate part of existence, incomprehensible in its intensity, unpredictability and mutation, is only possible through the witnessing of discomfort and pain. This sort of experience takes individual being to 'the extreme limit of the possible', a limit at which 'everything gives way' (59). This is why the Actionists deliberately embroiled the 'factual', 'physical' and the 'public' body, or, in Brus's words: 'the scandals attributed to Nitsch, Muehl and myself originated in the "outrageous" exposure of "bodily delusions"' (Brus cited in Green, 1999: 16). These delusions consisted in separating the self from the body. As the press report about Brus's February 1968 performance *Sheer Madness*, entitled 'Spectators Turned White Viennese Artist Simulated the Origins of Life' shows:

> Brus, a 30-year-old Viennese, demonstrated for the first time in Germany what he understands by his term 'Direct Art'. This was so direct that at least half a dozen spectators fainted or left the scene of the direct action looking white as sheets. Their stomach were turned by processes that in Vietnam take place in 'reality' and are everyday occurrences. (Anon. cited in Brus, 1999: 54)

Consisting of such actions as tying his left foot to what resembled an umbilical cord, drawing an outline of a womb around himself, placing his head on a plate, spitting and (re)swallowing a raw egg, while stuffing raw meat down his trousers, as well as piercing the meat with scissors and screaming as if his body was being torn to shreds, Brus's action caused violent physical reactions. 'Revolted, they [the audience] watched an act that in Vietnam is the order of the day' (54). Such actions posed the question of experience in a distinctly experiential way: what is it that hurts us all when pain is shown? Where is it? Whose body does it belong to? Who or what is concerned when the body is performed as a force, as matter, as a base, as a threat and/or obstacle, as in the case of illness or imprisonment? When, in the words of Nitsch (1999 [1962]), 'the boundaries of "I" and "you" are transcended, when "the clearly grasped moment" (intoxication of being) precipitates an identification with the essence of creation' (173)? Nitsch goes on to affirm that 'we want to know one another, be in the other, be in all things, your bodies are my body' (173).

By equating Brus's action with what was going on in Vietnam at the time – a very real political reality – the anonymous reviewer points out that if the body is taken into account, rather than the social or legal person, the

carnage occurring on another continent is not distant. On the contrary, it should be the most immediate concern of every single human being. Seen in this light, the helpless, utterly incomprehensible body is political through and through. Important to understand, however, is that the presentation of the explicit body was not only about unlawful actions, degradation or discrimination. The Viennese Actionists also authored numerous performances that had a strangely erotic appeal, where notions of vulnerability, subjugation and tenderness were explored. A case in point is Brus's *Breaking Test* performed at the Aktionsraum 1, in Munich in 1970. Wearing a suspender belt, stockings and underpants, Brus cut into his thighs with a razor blade so that the blood trickled down his thigh in a fine line. He also made an incision in his shaven head and created another fine stream of blood. Thus bleeding, he put his feet in small bathtubs and stumbled about the performance area, like a child or a person inept at walking. He sprawled and gasped on the floor and whipped himself with a leather belt. These actions were interspersed with demonstrations of extreme vulnerability, such as asking for a glass of water or for the window to be closed, in a feeble voice. By employing conventional 'erotic' signifiers, such as suspenders and stockings, which mark and frame the (usually female) body as an object designated for the pleasures of another, while simultaneously invoking pain, albeit in a highly aesthetised manner, Brus, in fact, validates abjectness through eroticism. For Bataille, eroticism bestows value on all forms of existence. In recognising the vulnerability of the human flesh, it represents socially and culturally un-colonised life. It is a form of bodily respect. This is not the same as the socially decreed respect. Eroticism is a form of communication with that reality which is a part of all life; it is life itself.

Tatsumi Hijikata's dark eros

The forefather of what is termed *ankoku butoh*, or the dance of darkness, Japanese dancer and choreographer Tatsumi Hijikata first came into prominence with a 1959 piece entitled *Kinjiki*. Loosely based on novelist Yukio Mishima's *Forbidden Colours*, which related the (then) taboo nature of homosexual erotic love, *Kinjiki* was a form of dance that can, in many ways, be described as the revolt of the body. The latter is also the title of Hijikata's solo performance, created in 1968, which, like *Kinjiki*, foregrounded his conception of the body as a fundamentally transformatory experience, not the body as a medium through which the self has experiences – not a container, despite the fact that the word '*bodig*', from which 'body' is derived, does mean 'container' – but the body as experience. In an interview with

Jean Vial and Nourit Masson-Sekine, Hijikata comments on the fleshliness of our existence and says:

> we are not transparent. Criminal, the body has something in common with the criminal ... it's the practical dimension in man's life, his animal instincts, his primal nature ... We are broken from birth. We are only corpses standing in the shadow of life. (Hijikata cited in Viala and Masson-Sekine, 1991 [1988]: 186–187)

The notion of life awaiting death, of the two being dynamically related, has a different status in the Japanese culture in comparison with the various Christian or post-Christian cultures. While in the latter, death is related to the linearity of time as well as to the last judgement, in many Japanese religions, such as Shintoism and Buddhism, time is not linear and death is only another stage in the constant mutation of matter. One of the first sentences in *Hagakure* or the *Bushido* code, the code of the samurai, is that a samurai is to live as if he were already dead, with no projections, no regrets, but with utmost bravery (Yamamoto, 2006: 1). Likewise, in Bataille's general economy, death is not meaningless waste; on the contrary, it is as important as life.

In *Kinjiki*, Hijikata, who was greatly influenced by Marquis de Sade's taboo-breaking notions of eroticism, as was, indeed, Bataille, who wrote 'The Use Value of D.A.F. de Sade' in 1930, Hijikata touches on several highly contested domains of the body. In this performance, Yoshito Ohno, the son of the famous butoh dancer Kazuo Ohno, performed an action that resembled sodomising a hen. As dance scholars Sondra Fraleigh and Tamah Nakamura (2006) report in *Hijikata Tatsumi and Ohno Kazuo*, drawing on an interview with Nario Goda, present at the performance, 'some audience members attested their release of dark emotions ... while others were disgusted ... The chicken squeezed between Ohno Yoshito's thighs was later sacrificed in the dance' (78). Performance scholar Nanako Kurihara describes the dance as a ritual sacrifice and reports the following sequence of events:

> After the boy [Yoshito Ono] appears on stage, the man [Hijikata], holding a chicken, enters and runs in a circle. The boy stiffens, and walks to a narrow illuminated area center stage, where the man is waiting in the darkness. Breathing hard, they face each other, and the man thrusts the chicken into the light with the white wings fluttering 'stunningly'. The boy accepts the chicken, turns his head, and holds it to this chest. Then placing the chicken between his thighs, he slowly sinks into a squat, squeezing it to death while the man

watches from the darkness (not everyone believes the chicken dies). The boy stands in shock, and the audience is outraged. When they see the chicken lying at the boy's feet, they gasp. Black out. (Kurihara cited in Fraleigh and Nakamura, 2006: 79)

This is followed by the dancers performing in total darkness with only the sounds of breathing and moaning being heard. Fraleigh and Nakamura suggest that in staging a 'totem animal sacrifice, he [Hijikata] proceeded much as shamans have often done, moving toward the dark regions of subconscious life projecting this into visible performance' (79). Although Hijikata was inspired by much of Surrealist work and although he had a close connection with the Japanese religious heritage, his butoh operated beyond the shaman's performance efficacy which brings the invisible into the realm of the visible. He did, of course, acknowledge the impression that his own non-rationalised experiences left on his body:

> The first time I danced my self-portrait, at a dance studio in Nakano, I started sobbing out aloud. I shrieked and eventually foamed at the mouth. That was the first accompaniment to my dance. I apologized to the chicken I held while dancing. (Hijikata, 2000a: 39)

Dance, for Hijkata (2000b), is a means of summoning experiences that never may have entered the conscious mind. This is the reason why butoh is a medium between the 'spirit and impulse', as well as a 'secret ritual' (47). While mirroring the processes of the universe, it transforms the dancing body, itself a process and not a substance. In this sense, butoh is danced for the universe, for the body-spirit and for the witnesses, or the audience. Quoting French writer and playwright Jean Genet, in 'To Prison', Hijikata suggests that 'talent is courtesy with respect to matter; it consists of giving song to what is dumb' (Genet cited in Hijikata, 2000b: 47). Butoh is completely devoid of any system of representation. In this respect it differs vastly from the large majority of Western dance and cannot be discussed within the paradigm of production and reception. Embodying *butoh-fu*, or word images, often used in the practice of butoh and butoh training – the most famous of which are the ash pillar walk, bug ambulation, the floating pollen and the flower's passage from bloom to withering – is a way of comprehending life at an erotic but not sexual level. Here the dancer seeks to embody, not imitate, the multiple processes of transformation, which include plants as well as animals.

For Bataille, eroticism is not limited to relationships between human beings; in the wider sense of the word, the erotic, understood in its broad,

not narrowly sexual sense, is the link between all that lives. Luscious peaches, sweet-smelling flowers, refreshing waterfalls, the warmth of another human being, all these phenomena cradle life. Eros is the simple expenditure of the most diverse energies; it embraces the profane world. Through the embrace of the profane, or even the abject, rejected world, eroticism enters the sphere of the sacred where it negates the body's limitations. In eroticism, the poles of life and death, of being and nothingness, of fullness and emptiness, are one, dissolved much like subject and object are dissolved in the entanglement of all things. This is the Bataillean general economy present in *Kinjiki*, in *The Revolt of the Body*, and, more generally, in butoh. Of this, Hijikata (cited in Fraleigh and Nakamura, 2006) writes:

> In our body history, something is hiding in … our unconscious body, which will appear in each detail of our expression. Here we can rediscover time with an elasticity, sent by the dead. We can find Buto, in the same way we can touch our hidden reality, something can be born, and can appear, living and dying in the moment. (50)

This mysterious relation is the reason why desire exceeds any particular object and is directed at the ungraspable, impossible reality of experience. The body is always in a state of becoming, as is nature, the world and the universe. Drawing on the mind-body philosophies of Hiroshi Ichikawa and Yasuo Yuasa, Japanese theorist Shigenori Nagatomo (1992) describes the process of perpetual becoming of the body, as that of attunement. Here, the body – any body, human, plant or animal – is always already in interaction. It is always modified through interaction with the living ambiance, which is the 'totality of shaped things, beings and phenomena' (179). The body is thus neither a stable concept nor a closed concept. Hijikata's *butoh-fu* make it possible to grasp this inherent transitivity of the body, which occurs through time. This may not necessarily be the time frame readily graspable by humans, but it is precisely in this domain that Hijikata's butoh becomes a form of aesthetic sacrifice exemplified by *The Revolt of the Body*. Carried on to the stage on a ceremonial litter, in this piece, Hijkata was accompanied by a small pig in a child's cradle. In the two-hour-long performance, he danced several ecstatic sequences, almost naked, throwing himself against metal panels suspended from above. As can be seen in Figure 5.1, an elongated golden phallus was strapped around his waist, of the sort usually seen in fertility rites. Halfway through the performance, Hijikata changed into a white girl's dress and danced a transformation from extreme old age to youth, and back again. At the performance's end, he

stood motionless with a fish in his teeth. This transitivity, which encompassed different genders and ages, and included animals, was, in fact, the becoming-ness of being, 'being' that does not refer to a single form but is in constant movement.

Eros, sacrifice and the mirroring of inter-corporeal becoming were all enacted to present a form larger than the individual body, whether human or animal. This domain, which is, in fact, the domain of ecology and includes environmental concerns, albeit not of the sort prevalent today but, rather, inter-species and inter-material knowledge-production, was explored in great detail by German artist Joseph Beuys.

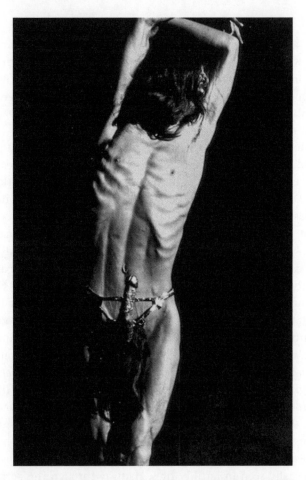

Figure 5.1 Tatsumi Hijikata, *The Revolt of the Body*, 1968. Photo by Ryozen Torii. © Hijikata Tatsumi Archive at Keio University Art Center. Courtesy of Keio University Art Center.

Joseph Beuys and the return to archaic thought

To Beuys, the Western system of representation, in which everything had to be classified, used and manipulated, was ultimately a disaster. Science – the privileged source of knowledge – was far too specialised, and, for this reason, in Beuys's own words, 'dead' (Beuys cited in Leeber, 1980: 176). Instead of contributing to an inter-temporal and inter-corporeal understanding of the world, contemporary science reduced it 'to a mass of details amid which men are lost' (Beuys et al., 1988: 128). For an artist influenced by Rudolf Steiner, an Austrian polymath who propagated biodynamic farming – one of the first forms of sustainable agriculture, based on the use of compost, not chemicals – and anthroposophic medicine, which, like Chinese medicine, took a holistic approach to the body, and made much use of homeopathic medicine, massage and exercise, it was already apparent in the 1960s that the world's energies had been exhausted through division. The reason for this was that matter had, for centuries, been seen as quantifiable and calculable, not as an energetic vibration, despite the fact that it had been occasionally theorised as such, for example by Bergson, discussed in Chapter 2. For Beuys, as for Bataille, the archaic peoples, with their seemingly irrational practices, such as the above-described potlatch, understood the importance of elevating ordinary perception to a different, extraordinary level through ritual. As a survivor of several crashes as a Luftwaffe pilot during World War II, Beuys saw the need for articulating the knowledge and the practice of healing. He was shot down over the frozen wasteland of the Crimea, near Znamianka, then Freiberg, where he was discovered unconscious by a nomadic Tartar tribe. In Beuys's words, they covered his 'body in fat to help it regenerate warmth, and wrapped it in felt as an insulator to keep warmth in' (Beuys cited in Tisdall, 1981: 17). In his later work, which consisted of actions and installations, the elements of fat and fur, combined with such materials as minerals, turf and honey, became important symbols, and, Beuys believed, instigators of healing and regeneration. In order to entice these substances and objects into operation, Beuys made extensive use of ritual. As anthropologist Victor Turner (1982) suggests, a ritual is 'a time and place lodged between all times and places' (84). Many of Beuys's early performances made a clear reference to his life-changing experience at the Crimean front. In *The Chief*, performed in the basement of the René Block Gallery in Berlin in 1964, he lay on the ground for nine hours, wrapped in a felt blanket, emitting inarticulate fragments of speech, surrounded by copper, felt and fat. Likewise, in *Twenty-four hours … and in Us … under Us … Landunder*, performed at the Düsseldorf Academy in 1965, Beuys confined himself to a box for twenty-four hours, without touching the ground with

his feet or his hands, his head leaning towards a heap of fat as if listening to it. He only left this position to try to reach for objects, most of which were not within his reach, without moving from the box. In this performance, whose focus was on simple objects, present in every human environment, action was emphasised in relation to time and human will.

For Turner, all ritual has 'an abyss in it'; Beuys's actions often opened onto this 'infinite depth' in which one acknowledges the abyss and accepts 'the sacrificial plunge into possibility' (83–84). Letting go of the familiar grid of knowledge is key here. For Beuys, nothing is inert; this is why the materials used in his actions ranged from organic substances to electricity and magnetic fluids. Fat, wax, honey and gelatin were often used for their unstable qualities. Heat is assimilated into the circulation of energies while cold testifies to the slowing down of exchanges between matter and its environment: the more fixed a form is, the more insulated and the colder it grows. In *How to Explain Pictures to a Dead Hare*, performed in 1965 at the Galerie Schmela in Düsseldorf, Beuys's head was covered with honey and gold leaf. The invited audience arrived at the gallery to find the doors locked. Through the glass front they saw Beuys sitting in a chair, cradling a dead hare in his arms. Slowly he got up and wandered around the exhibition of his own works, mostly graphics, explaining each work to the hare in an invented language. The calorific character of honey, which, according to Steiner, is expansive and life-giving, as well as regarded as a spiritual substance in mythology, metaphorically awakened thinking processes (Steiner, 1998: np). By covering his head with gold and honey, Beuys also cited an alchemical gesture. In alchemy, the character of honey is mercurial, and mercury is the essential catalyst of change. According to Beuys (cited in Tisdall, 1981), this made it possible for the hare to 'cross freely from one level of existence to another' (21). For Beuys, the human body is a magnet; the head is the positive pole through which the ethereal substance flows; it is linked to energies by the negative pole – the feet. This makes the human body a relay in the electromagnetic flow that governs the entire planet and is simultaneously the reason why Beuys often uses copper as an electric vector which intensifies 'the conducting potential of the human body as an antenna or transmitter' (Tisdall, 1981: 34). In *How to Explain Pictures to a Dead Hare*, Beuys denies biological death as an end. He claims that death is a 'passage of energy through matter that liberates new powers' and that a 'higher level exists for thinking through the liberation of death' (Beuys cited in Tisdall, 1981: 30). The hare – mercurial animal circulating 'freely from one level of existence to another' (21) – embodies this. The bone pierced with electric wires and placed under Beuys's stool in the static moments of *How to Explain Pictures to a Dead Hare* conjures up similar associations.

Bones are often present in Beuys's work, an advocate for a return to matter as intrinsically transformational, a return 'to the real meaning of Materia, with its root in MATER' (mother, as in 'Mother Earth') (105, emphasis original). This thinking was later to be seen in his famous 1974 *I Like America and America Likes Me* in which Beuys spent a week in a cage with a coyote, using felt and a staff. He first used a staff in the 1967 *Eurasian Staff* action, which began with the production of wedges of fat, used to smooth the sharp angles of the performance space. This is because angles:

> symbolize the most mechanistic tendency of the human mind the cornerstone of our present society as manifested in our square rooms, square buildings and square cities, all built on combinations of the right angle. In its extended meaning the right angle represents the mineralized coordinating system of our culture, science and of our living processes. (73–74)

Greasing the space was a ritual which associated the particular space Beuys was working in with the possibility of change, or reversal. He also used felt, which, Beuys believed, was receptive to invisible energies. The purpose of ritually marking the space was to create a receptacle of sorts where a different sort of receptivity might occur, where the invisible might become visible and palpable. Beuys's actions explicitly sought to 'destroy the physical source of time' (62). The purpose of bringing about another kind of temporality was to sensitise the viewer to time as a source of creativity, and, a sort of whirlpool through which the viewer could connect with other temporal layers. In *Eurasian Staff*, Beuys also brandished a copper rod towards the sky. The rod was enshrouded in felt, which reinforced the impetus of the collecting energy; it also aided the circulation of energy between East and West, hence the title *Eurasian Staff*. All of Beuys's objects, in combining the various substances, were transformed into 'energetic tools' (Tisdall, 1981: 21).

In *I like America*, Beuys was flown into New York and taken to the René Block Gallery on Broadway in an ambulance car, lying on a stretcher. When he arrived at the gallery, he was taken to a space where a coyote awaited him. The coyote is an important totemic animal for a number of Native Americans, the Kruk, Maidu, Tongya, Ohlone, Miwok and Pomo. The choice of coyote in a performance entitled *I Like America* was significant, particularly when read against the fact that Beuys's feet never touched the American soil. Beuys spent eight hours a day with the coyote, wrapped in grey felt. His only tools were a shepherd's staff, a felt blanket and straw he used for lying down on. Beuys engaged in literal and symbolic communication with the coyote; indeed, he could come very close to the coyote

without being attacked or bitten. After three days Beuys was taken to the airport and left in exactly the same way he came. For Bataille (2006 [1989]), nature lies by definition outside the human domain. The term 'nature' does not refer to plants and trees but is the condition of unbroken, unconscious continuity between the individual being and its environment. In the *Theory of Religion*, Bataille uses the term 'animality' to refer to immediacy (23). The animal is not a separate consciousness defining itself in opposition to the world but is, rather, Bataille insists, fully continuous with the world. Each animal is in the world like water inside of water (24–25). This state of indivisibility is most clearly seen when one animal eats another. The indivisibility of the animal world is such that violence and death are no disruption to it. Rather, they are stages through which indivisible oneness passes. Bataille claims that there is no hierarchy in the animal world, either; a lion devouring other animals is not a 'king', their hierarchical superior. In the movement of the waters, a lion is only a slightly bigger wave, over-turning other, smaller ones. Bataille writes: 'the animal opens before me a depth which attracts me and which is familiar to me. In a sense, I know this depth: it is my own' (22). Yet the undifferentiated continuity glimpsed in the animal is also 'that which is farthest removed from me ... *which is unfathomable to me* (22, emphasis original). The emergence of a subject-object relationship between the human being and the world signifies, for Bataille, the end of the intimacy which envelops and dissolves the animal in its environment. The rupture in our intimacy with the world is consum-mated and made irrevocable by the human use of tools. The tool forces the subject/object split and indicates the end of the 'indistinct continuity of the animal realm' (32). The particular status of the tool which does not have any value in itself but whose value is derived from the expected result, the use to which it is put, transformed human existence in a radical manner. More and more objects, actions and beings come to be perceived as instruments, entities which possess no inherent value but are to be used, manipulated as means to end beyond themselves. The reifying approach spreads like contagion through the world of experience. For Bataille, out of the relationship to the tool grew a social order which is the order of utility. In this order, materials, time and human beings all become tools in a never-ending chain of production. For Bataille, the nostalgia for the state of animal haunts human beings forced to exist under the order of utility. This yearning lies at the heart of the religious impulse. The sacred, which humans always perceive with a mixture of fascination and horror, can be seen as that in which the power of the continuity of being becomes manifest, throwing into relief the 'poverty' of the profane realm which is the domain of work and utility (35). Bataille stresses again and again that

that which is sacred attracts and possesses incomparable value, but that it might appear dangerous to the profane world. Beuys's work performs interconnectedness; in particular, it foregrounds the transformatory power of all matter and all energy. By helping us sense and/or visualise the multiple exchange networks that operate across species and across time, it addresses highly relevant ecological concerns rooted in epistemology.

The sacrificial and ritualistic performance strategies discussed in this chapter address embodied and embedded knowledge (knowledge embedded in the environment). While the previous chapter concerned itself with the sociological relevance of built environment, the practices here discussed situate the body – as carrier of knowledge that cannot be displaced, divided or rationalised – within not only the phenomenological but also the economic arena. With the increasing technologisation of life and human experience, the value of embodied knowledge has dwindled. It has been placed in a subordinate relation to the rapidly expanding process of commodification. The different strategies of the Vienna Actionists, Hijikata and Beuys – namely, the explicit body, the body in pain, the sexualised body, the body performing its replenishing/discharging functions, the environmental body and the trans-temporal body, which, through its use of materials and symbols, establishes connections with past times and past knowledges – place the body at the centre of concern. Although the practices of the Gutai group, Pollock and Cage discussed in the previous chapter were ecological, the Vienna actionists', Hijikata's and Beuys's uses of performance addresses ecological concerns through ritual. In so doing they inaugurate – as well as resurrect and recombine – the ancient relations between the body and the universe. All major religions have doctrines that prescribe the relationship of the body to the wider world. The very word religion, which, coming from the Latin *religare*, means to bind the body through ritual, amply shows this. In a world no longer governed by religious belief (or, governed by religious belief to a far lesser degree), Bataille proposes a theory of economy that consists of the sacred but has no God. Here again, our present understanding of the word 'economy' is impoverished, concerned as it is with the production and distribution of wealth and the management of resources. The ancient Greek word, by contrast, encompassed the environment as well as the universe. Here, the realm of the sacred ascribed a non-utilitarian value to all life, through eros. Not only do the above-discussed performative strategies dismantle the difference between the sacred and the profane – and, in fact, sanctify the profane – they also viscerally critique reductionist knowledge. With its cerebral, divisive and insulating processes, reductionist knowledge stands in the way

of embodied, intuitive, sensorial, carnal, embedded knowledge. But there is also another link between performance and knowledge. As theorist of science William R. Newman (2011) suggests in an appraisal of the recent historiography of alchemy, medieval and early modern alchemy was not only 'art in action', in the sense that it could 'genuinely reproduce, recombine nature' instead of 'making mere ersatz replacements of natural products' (314). It was also a form of experimental philosophy. Although within the Christian tradition, such thinkers as Thomas Aquinas insisted that a given substance 'can have only one substantial form, which is necessarily destroyed and replaced by another substantial form during its generation or mixture' (Aquinas cited in Newman, 2011: 2016) – an idea coextensive with the notion of God the creator – the pre-Christian tradition presupposed the mutability of all matter. It also justified learning from interventions in nature by means of performance and experimentation. In this sense, medieval and early modern alchemy excavated, through performance, the interdisciplinary intersection of the natural sciences – physics, chemistry – and philosophy, which prevailed in ancient Greece, much like Beuys's use of performance resurrected anthroposophy and biodynamics. In both cases, performance regroups and reassembles historically divided disciplines. Enlightenment disqualified the ancient Greek, mostly Aristotelian, natural philosophy. Likewise, the early twentieth-century technologisation of science disqualified anthroposophic ideas. Given that they could not be mapped against the criteria of either the natural or the social sciences, or, for that matter, divinity, they were seen as insufficiently scientific. By reclaiming past knowledges, performance here restructures the credible, the feasible and the true.

Scores:

1 Design a ritual. Think of the transmutation of matter, of the cycles of coming into being and decomposition, of the cultural status of the body's liquids and viscera, blood, sweat, urine, semen, milk. Also think of what constitutes a body – bones, teeth, nails, hair, skin, bunions, tendons. Think of the abject and the profane body. Elevate it to the status of the sacred through a formalised ritual consisting of repeated movements, song, vocal utterances and symbolic objects.

2 Consider the earthly processes of transformation – winds, floods, day, night – as they occur in human and tectonic time. Create a *butoh-fu* for yourself. This can include anything from a sugar cube dissolving in a cup of tea to sea storms and global cataclysms. Dance these processes of transformation. Dance the wind, dance the ants, dance the sugar cube dissolving.

3 Research alchemy and the logic of relations between the various energies (those of the sun, the different plants, animals, mountains, water, gold, mercury). Design a performance using trans-temporal, inter-species, inter-objects communication. Reflect on the transmission of practice and knowledge.

6 Resisting Determination, Resisting Interpretation

Interventions and undecidables: Zero Jigen and Hi Red Center

In the works discussed in the previous chapter, as well as in Bataille's general economy, the temporal and spatial ordering of ritual had a unifying effect. Despite the fact that Brus's, Nitsch's, Hijikata's and Beuys's actions dismantled social and epistemological dogmas, they nevertheless enabled the viewer to establish overarching connections between human life, matter, the processes of birth, death, assembly and disassembly, as well as between the different temporal dimensions, such as sacred time and the archaic past. The absurd, interventionist rituals performed by Zero Jigen, which, in Japanese, means Zero Dimension, in 1960s and 1970s Japan, had an altogether different effect. Here, ritual, or *gishiki*, caused disruption as well as cohesion. It was simultaneously strange, incomprehensible, ridiculous and performatively efficacious. The very name – Zero Dimension – reflected the cultural vacuum characteristic of the post-Hiroshima period in Japan. Indeed, cultural theorist and art critic Tono Yoshiaki goes as far as to name the entire generation the 'post-Hiroshima generation' (Yoshiaki cited in Fernandès, 2011: 10), thus pointing to the manifold and lasting social consequences of the A-bomb. The notion of going back to zero, which was also related to the US rule over Japan, lasting until 1952, and to the so-called progressive, but, in fact, technocratic tendencies, which, while adhering to scientific justifications caused unprecedented pollution, overgrowth and a social crisis, was already present in Gutai's work, discussed in Chapter 3. As art historian as art historian Charles Merewether (2007) notes, the search for the 'aesthetics of freedom', which characterised the Gutai work, was already evident in the fact that Kazuo Shiraga and Saburo Murakami had named themselves 'Zero Society', prior to joining Gutai (7). The need for a clean slate was emphatically present in post-war Japan; in literal translation, 'zero jigen' means 'the next thing that appears after zero' (Kuroda, 2003: 35). But what might that be? Clearly, the purpose of such a name was to exercise the imagination of the enquirer. Although initially founded by Kotaro Kawaguchi in 1960,

the group's leadership is usually associated with Yoshishiro Kato. Kato was a businessman, not an artist, and the group's members included activists, students or, indeed, anybody who cared to participate in a given *gishiki*, the participant numbers ranging from two to several dozen. The notion of going back to zero was certainly present in the physical vocabulary the *gishiki* relied on, such as *haizuri*, which meant performing infant actions of rolling and crawling, but without imitating an infant. As Japanese art historian Raiji Kuroda (2003) notes, the Zero Jigen repertory of actions, performed in public spaces, in Nagoya until 1963, and in Tokyo between 1963 and 1972, on the street, in squares, parks, cemeteries, public baths, spas, cabarets, universities and film studios, consisted of lining up and walking slowly with one hand raised as in a military salute, walking backwards and falling on top of each other, or walking on all fours (33). Often seen was also the 'shark-back walk', usually performed with men lying on the ground and with women walking on their backs (33). *Imomushi koro-koro*, or roll over caterpillar, was also often used; here a dozen or more people lined up on the ground and rolled over each other in sequence, thus producing a movement reminiscent of a cater-pillar's. Although costumes such as business suits and tails, with a tie and a round silk hat, were sometimes worn, with or without a gas mask, which was among the most used accessories, and a clear reference to Hiroshima and Nagasaki, most of the *gishiki* – of which there were over 300 in the ten years of Zero Jigen's existence – were performed naked (33–34). In Kato's words, nudity had a special effect in the city space, which, as we have seen in the Situationists' practice, is not an architectural given, but a performative structure:

> When the naked mass started to run, the entire city in pursuit of high economic growth – cars, people and buildings – gradually stopped its moves like a slow-motion movie, startled at the sight of the beautiful human bodies. My body looked straight into those spectators. When we ran, everything in the city also exposed its naked face. In fact, the truth is, 'Zero Jigen' became 'naked' because of its urge to see the real side of Tokyo in those very 'eyes' of the 'city of Tokyo' staring at our bodies. It was the urge to 'sightsee' the true side of Tokyo. (Kato cited in Kuroda, 2003: 32)

This is directly related to the specific disciplining of the body that took place in Japan during the time of its astonishing economic growth. The traditional Japanese practices of self-cultivation, all of which include the body, had, to a significant degree, been overwritten by the Fordist-Taylorist regime discussed in Chapter 3. This regime potentialised efficiency and the

economic use of the body, which not only limited the body's repertoire of movements but also confined it to repetition while simultaneously disabling the body's attunement to the environment, as theorised by Nagatomo and mentioned in the previous chapter. In providing a different, deeper way of seeing – Kato speaks of 'true' bodily schemes – not to mention the shock value, Zero Jigen's *gishiki* did have a clear effect on the passers-by. In that sense, the *gishiki* could be seen as performatively efficacious.

Carrying or wearing objects on one's body was routine practice, too; for example life-sized dolls, Japanese *furoshiki* (wrapping cloth), bandages and luggage labels. Futon was one of the much-used objects, often carried by four performers as a travelling rectangle, and placed on the ground/floor of a train station, gallery, or a public bath, and used as an accentuated performance space. In addition, the Zero Jigen performers used objects employed in traditional Japanese ritual or performing arts, such as red and white ropes, candles and fireworks that marked Buddhist altars and festivals, Japanese *sensu* (folding fan) with the *hinomaru* (rising sun) motif, often used in traditional Japanese theatre forms such as Kabuki and Noh. They also had a taste for containers and objects used for medical purposes, such as plastic tubes, hoses and disposable gloves. Crucially important in understanding the *gishiki* was the performers' unannounced, 'out-of-the-blue' appearance in a public space. In a *gishiki* performed in Meguro, Tokyo, in 1964, a man in business suit walked down the road with a white cloth over the upper part of his body, covered in burning incense stick. Both his hair and the white cloth were full of what seemed like wooden holders in which several long incense sticks were burning. The man walked down the road in such a manner as to keep the incense sticks burning, which necessitated bending, crouching, twisting, kneeling, even sprawling on the floor, after which he got up again as if nothing had happened and continued to walk in a straight line. Similarly puzzling was the *Buck Naked Ass World gishiki* performed at the Kashima Jinja Shrine in Tokyo 1964. Here, a dozen naked men lay on the shrine stairs, turning intermittently left and right. In a 1967 performance, part of the Kuro Hata's (Black Flag group) *National Memorial Ritual* for the late Chunoshin Yui in Shinjuku, Tokyo, a long row of men in suits and gas masks marched down the road saluting the passers-by. Protesting against Japan's involvement in the Vietnam War, Yui self-immolated earlier that year in front of the prime minister's residence. The *National Memorial Ritual* consisted of a procession carrying a framed photograph of Yui, of the Kuro Hata performers carrying large effigies, and the Zero Jigen in gas masks and dark suits.

Apart from often shocking accidental or intentional witnesses with incongruent combinations of action and costume, these abrupt appearances

had both a disorientating, dissipative effect and a cohesive one. To be more precise, the incoherence, in fact, destabilised the very purpose and efficacy it seemed to target. As performance scholar Peter Eckersall (2013) notes in *Performativity and Event in 1960s Japan*:

> As ceremonial and ritual practices, *gishiki* are also ideological and play an important role in establishing and maintaining social practices, while at the same time opening up questions of class and gender politics and theories and practices of nationalism and identity formation. A factor common to all rituals then is that they must be performed and must be seen to be performed, and in that moment of enactment a vested ideological or political position is solemnised and reiterated. (21)

Indeed, the subversion occurs precisely at the level of insistence on the ritual form displayed in the public space, since within the public context, ritual forms usually serve military, state or religious purposes. In serving these purposes they propagate a clear ideology. Affirming the confused reception of Zero Jigen's *gishiki*, Kuroda (2003) notes that numerous articles and photographs of these interventionist activities appeared in newspapers and magazines. However, there was neither 'empathy nor understanding' for the activities variously labelled 'ero-guro-nansensu' (the erotic, the grotesque and the nonsensical), 'orgy under the Tokyo skies' and 'the aggressive salesmanship of today' (32) since it remained entirely unclear whether the group's purpose was ritualistic, propagandistic or purely anarchic. As art historian Doryun Chong (2012) notes, the group's events 'looked strange when reflected against each other' since 'the sacred seemed vulgar while the vulgar transformed into something sacred' (68).

The work of Zero Jigen, as well as the work of two other groups discussed in this chapter, Hi Red Center and Fluxus, forms part of what French philosopher Jacques Derrida has termed undecidables. Deriving from Austrian mathematician Kurt Gödel's famous 1931 incompleteness theorems, which postulate that no consistent system of axioms can either conclusively prove or, for that matter, refute all the arithmetic truths, an undecidable is a phenomenon, occurrence or concept that belongs to what seem like two opposed categories at once (Berto, 2010). In philosophy, this concerns binary oppositions in particular. A binary opposition is a pair of contrasted terms, each of which depends on the other for its meaning, such as sacred–vulgar, true–false, good–evil, inside–outside, positive–negative, male–female, civilised–primitive. These oppositions form a conceptual order by classifying objects, events and relations. Within this order, it becomes

impossible to imagine how something might be both useful and useless, both sacred and vulgar, or how a master can also be a slave and vice versa. In 'Plato's Pharmacy', Derrida (1981) questions this conceptual order by focusing on classical Greek philosopher Plato's famous work *Phaedrus*. In this work, Plato debates his teacher Socrates's uncertainty about the merits of writing. Important to note here is that Socrates was a founder of Western philosophy. However, Socrates debates the merits of writing in relation to Egyptian *mythology*, not philosophy, in other words, to the realm of human activity associated with fables and imagination, not with sound reasoning. In this debate Socrates uses the word *pharmakon*. In Greek, *pharmakon* means both a remedy and poison; it is a particularly ambiguous word. The debate centres on whether writing could be seen as aiding memory or making it redundant, whether it is a reliable transmission of speech and thus also of the presence of reason, or a mere appearance thereof. Would students coming into contact with their teachers' writing come into contact with mere appearance or would they come into contact with reality? After a long discussion of the Egyptian mythological entities' – Theuth's and Thamus's – points of view, Socrates concludes that writing is a mere appearance and that it is, for this reason, harmful (125–127). Important, in Derrida's view, is Socrates's and Plato's acknowledgement of the fact that writing can be a cure as well as poison. For example, if we write something down so as not to forget it and are able to go back to it later, writing can certainly be seen as a memory aid. It stores information and thoughts and makes them available at a later point in time. But writing can also be seen as that which aids the loss of memory. Suffice it to ask: how many frequently used phone numbers can we remember? Most likely, not very many, since this information is stored in our mobile phones and we do not *need* to remember it.

By pointing out the undecidability of writing, Derrida shows three things: that there can be no definitive answer to this question as excessive reliance on memory aids does, in fact, cause memory to deteriorate; that Plato's reasoning remains imprisoned by a set of oppositions – true/false, essence/appearance; and, most importantly, that what is presented as a rational argument – *Phaedrus* is one of the foundational texts of Western philosophy – depends on myth. An undecidable is a forever oscillating paradox; it keeps moving between two opposing poles of the spectrum without properly inhabiting either. Although Derrida's insights were truly revolutionary within the framework of Western philosophy, similar insights had existed for many centuries within Zen Buddhism, albeit in a different form. For example, the already mentioned D. T. Suzuki (1953), who was a great influence on John Cage and, via Cage, on the Fluxus artists, discussed

below, explains that since everything is always in the process of transformation, it is also in the process of becoming its other. The thing called 'night' is not taken away in order for the thing called 'day' to be ushered in. Night becomes day through a series of imperceptible transformations, the last of which is dawn. Suzuki explains the process of everything becoming its other by citing a Zen monk Ummon, who says: '[k]nock at the emptiness of space and you hear a voice; strike a piece of wood and there is no sound' (Ummon cited in Suzuki, 1953: 34). Naturally, the logical way to speak of this would be to say 'knock at the emptiness of space and you hear nothing; strike a piece of wood and there is a sound', but this is also a static and, in Zen terms, erroneous way of interpreting reality. Zen is a non-rational, misologist philosophy as well as a branch of Buddhism. That it is misologist means that it is distrustful of reasoning and logical argumentation; this is why its highly intuitive approach makes it unsuitable for logical explanations. Derrida, on the other hand, provides a clear alternative to the limiting system of binary oppositions. He also validates paradox and undecidability. From this point of view, Zero Jigen's physical, aural and aesthetic interventions into public space can be seen as a form of sculpting space. Not only by introducing unusual elements but by politicising social conventions, while including the body, the sacred, the vulgar, the humorous, the disturbing, and in this way drawing attention to, in Zero Jigen scholar Bruno Fernandès's (2014) words, the 'underlying violence of the civil society', which was 'just as murderous and stupid under its optimistic, pacifist and progressive guise, as were the more openly violent societies before it' (11). Equally provoking were the public interventions of Hi Red Center, a group name for artists Jiro Takamatsu, Genpei Akasegawa and Natsuyaki Nakanishi. Hi Red Center was derived from the first kanji (characters) of the artists' surnames: 'taka' (in Takamatsu), meaning high; 'aka' (in Akasegawa), meaning red; and 'naka' (in Nakanishi), meaning centre.

Contemporaries (and, some of them, collaborators) of Tatsumi Hijikata, discussed in the previous chapter, Hi Red Center's work had a similar political flavour; it often intervened in the public space through undecidable, semi-ritualistic performance. A case in point is their *Cleaning Event* performed in Tokyo on 6 October 1964. Here, group members dressed in white coats, reminiscent of medical staff, cleaned a street in the affluent Ginza district of Tokyo with toothbrushes, cotton wool, cleansers, tweezers and other hygienic and cosmetic utensils. On the one hand, this event was a poignant critique of the Westernisation of Japan, symbolised by the frantic preparations for the Olympic games, which took place in Tokyo in 1964. On the other hand, it was an incongruous mimicry of an action usually performed on the human body, or in sterilised environments, rendered utterly absurd

by the sheer square footage that such cleaning utensils could clearly not clean. In the invitation-only event *Shelter Plan*, performed at the Imperial Hotel in Hibaya, Tokyo, on 26 and 27 January 1964, the artists performed puzzling measuring rituals on participants. The purpose of this was to build tailor-made one-person bomb shelters. Guests had the following measured: head volume, mouth capacity, difference between shoe and foot length, finger strength, saliva production, distance between nipples, circumference of body at key points – neck, shoulders, chest, waist, hips, knees, elbows, wrists – amount of air filling a balloon as inhaled and exhaled in one breath, amount of liquid swallowed in one draught. These measurements were then brought into complex mathematical relations with the option to purchase half-size, quarter-size, one-tenth-size or full-size shelters. This sense of absurdity reflected the control exerted by the Japanese state on its population in an increasingly controlled society. Key to the Hi Red Center's practice was ambivalence, the reversal of proportions and, importantly, parasitism. They used the hitherto existent means and modes of communication, public spaces, everyday actions and participation that resembled everyday forms of interaction, such as going to the doctor's. They produced undecidables within and through the everyday. This had much to do with the concept of anti-art, which not only Zero Jigen and Hi Red Center but also Fluxus wholeheartedly embraced. This concept rose to prominence in the 1960s and 1970s, and proposed artistic activities fully submerged in everyday life. Unlike the Dadaists and the Surrealists, who disrupted existing realities by proposing other forms of practice, much of the anti-artistic work was predicated on parasitism. It was through parasitic activity that it exposed paradox. In this sense, it resembled Derrida's chief method – deconstruction – which sought to disorder but also to re-arrange through displacement and derailment.

Jacques Derrida's disordering and re-arrangement

Although all the tendencies discussed in Part II of this book are deconstructive in that they dismantle dominant structures and reveal other, hitherto repressed possibilities, Derrida's notion of deconstruction deserves particular mention. In his early writings, Derrida adapted the German *Destruktion*, which he borrowed from Heidegger. However, as 'destruction' referred to demolition and eradication, he introduced the word 'deconstruction' to denote not only disassembly but also *reassembly*. In Derrida's view, the main principle of truth seeking up to that point had been logocentric. Coming from the Greek *logos*, which means 'reason' as well as 'word',

logocentrism grounds truth in a single point, seen as the ultimate origin. Supporting this operation is the structure of binary oppositions. Here, the entire perceptual and conceptual content of the world is divided into binary categories, of which one is superior and the other inferior. This means that presence–absence, cause–effect, mind–body, centre–periphery and male–female are not neutral binaries. They are binaries in which the first term is positive, the second negative or derivative. Female is that which is not male, the amorphous mass of the not-male. Derrida tackled the fundamental problem of the universe divided into the positive–negative polarity, through two important traditions of thought, phenomenology and structuralism. While phenomenology, of which Heidegger, discussed in Chapter 3, was an important proponent, views the world through immediate experience, structuralism is the study of human language, culture and society. The reason why Derrida used two such disparate approaches is to critique the notion of a fixed meaning. From the phenomenological point of view, meaning resides in inner consciousness; from the structuralist point of view, meaning arises from the relations between the various elements of language. Departing from the basic division of language into signifiers and signifieds (where 'signifer' is the word used to refer to the 'signified' such as the word 'cat' which refers to a furry mammal that emits meowing sounds), and in reference to Swiss linguist Ferdinand de Saussure, Derrida (1982) concludes in *The Margins of Philosophy* that there are no ideas, or sounds, that existed before the linguistic system (11). This means that there is nothing intrinsic in the word 'cat' that signifies the furry meowing mammal. Indeed, in other languages, this word is *'chat'* (in French) or *'gatto'* (in Italian). Rather, it is the relation between the word 'cat' and all the other words available within the system – dog, lamp, cake, vacuum cleaner – that produces the meaning. In the phenomenological account of meaning, Derrida contests the idea that the meaning-making process resides in the subject's interiority, independently of the sensible world, which, in the phenomenological account, is depicted as awaiting signification by the subject. In *Speech and Phenomena*, Derrida (1973) objects to the privilege granted to the inner consciousness over the world arguing that such thinking is a remnant of a theological worldview. According to this view, God is the ultimate point of origin. Human consciousness, made by God, remains bound to this ultimate source of being through the concepts of self-presence and self-identity (42–43). For Derrida, there can be no such opposition, between presence and non-presence, meaningfulness and meaningless, much like there can be no single or ultimate source. Rather, everything is always produced through relations. Relations, in turn, are 'woven' of interaction, they are created through tracing which is a form of play and a form of slippage; it is an inherent instability that implies

unpredictability. This is why Derrida's deconstructive texts do not exist in the form of yet another system whose purpose it is to disprove the current system/s. Instead, they operate in the margins of other texts, by undoing their structure and proposing a field of multiplicity. They are parasitic. Derrida does not simply reject or oppose the texts he critiques; he carefully undoes their presuppositions and brings their underlying levels into play by exposing the already-existing paradoxes, as in the above example of the *pharmakon*. Indeterminacy and slippages are always at work in any system of thought or any pragmatic knowledge. For Derrida, the fact that there are no stable categories also means that there are no definite differences. Rather, everything is always produced through multiplicitous interactions; everything is always in-relationship. These multiplicities, traces and their endless possibilities of recombination were particularly fruitfully explored by Fluxus, a loosely knit association of artists from the most varied disciplines – music, painting, sculpture, architecture, art history, but also chemistry and economics – whose approach to performance was distinctly intermedial.

Fluxus intermedia

Active predominantly in the 1960s and 1970s, in Europe, the US and Japan, Fluxus activities consisted of concerts, performances, sight-seeing tours, films, gadgets, instruments, furniture, mail order centres and education initiatives. However, the group, which, apart from chemists (George Brecht) and economists (Robert Filliou) also included such artists as Ay-O, Dick Higgins, Ken Friedman, Alison Knowles, George Maciunas, Nam June Paik, Yoko Ono, Takako Saito, Mieko Shiomi and Robert Watts, to mention but a few, was, and still is, most notable for its invention of intermedia. Process, participation, performativity were all the order of the day in the 1960s and 1970s. But there was something radically different, paradoxical and undecidable in the Fluxus works, something that defied all forms of classification, much like it defied commodification.

Intermedia, a term first used by Dick Higgins (2001 [1966]) and already mentioned in the Introduction, although initially coined by Samuel Taylor Coleridge, refers to 'works that fall conceptually between media as well as between the general area of art media and life media' (49). The emphasis on the latter is of crucial importance here. Much like Derrida used other texts in a parasitic way and performed his deconstruction in their margins, the Fluxus works used much of what was already present in the perceptual and social world as ready-mades. There are three notable Fluxus intermedia – the *event score*, the *Fluxkit* and *Flux-Sports*. The *event score* is

essentially a performative ready-made, an observed fragment of reality turned into a score, which, like a musical score, can be performed by anyone, anywhere, at any time. The *Fluxkit* is a portable performative score in the form of objects assembled in a briefcase to entice performance – bicycle horns, stopwatches, catapults, bits of rope, marbles, wax. *Flux-Sports* are ludic ready-mades, which utilise the existing structure of a game, or sport – chess, football – as a ready-made. Both the *event score* and *Flux-Sports* can be traced to the expanded sense of music advocated by John Cage, whose 1958–1959 classes in Experimental Composition at the New School in New York many of the Fluxus artists – George Brecht, Dick Higgins, Al Hansen and La Monte Young – attended. However, using the already-existing performative structures as ready-mades could be seen as arising from the concept of concretism, which, too, is associated with music.

In his 1962 essay 'Neo-Dada in Music, Theatre, Poetry, Art', George Maciunas, principal Fluxus organiser, suggests:

> A material or concrete sound is considered one that has close affinity to the sound producing material – thus a note sounded on a piano keyboard or a bel-canto voice is largely immaterial, abstract and artificial since the sound does not clearly indicate its true source or material reality – common action of string, wood, metal, felt, voice, lips, tongue, mouth, etc. A sound, for instance, produced by striking the same piano itself with a hammer or kicking its underside is more material and concrete since it indicates in a much clearer manner the hardness of hammer, hollowness of the piano sound box and resonance of string. (Maciunas cited in Hendricks and Phillpot, 1988: 27)

This approach, which can, of course, be traced to John Cage's prepared piano as well as to *musique concrète*, developed in the late 1940s by Pierre Schaeffer and Pierre Henry who recorded everyday sounds – rain, trains, footsteps – and subsequently ran them backwards at different speeds, thus creating playful compositions, could be seen in a number of Fluxus concerts. The first took place in Wiesbaden in 1962 and consisted of such pieces as Brecht's 1962 *Drip Music* in which water was poured from a jug into a glass. Similarly, Nam June Paik's 1962 *One for Violin Solo* consisted of a single violin action; the violin was first ritualistically lowered to the table in front of the performer, then smashed to pieces. In George Maciunas's 1964 piece entitled *Piano Piece No. 13 for Nam June Paik*, piano keys were nailed with a hammer. On a more poetic note, Yoko Ono's 1965 *Sky Piece to Jesus Christ*, performed by the Fluxorchestra at the Carnegie Hall in New York City, together with *Pieces for Orchestra to La Monte Young* and pictured in Figure 6.1, consisted of an entire orchestra being bandaged up as they were playing.

Figure 6.1 Yoko Ono *Sky Piece to Jesus Christ* and *Pieces for Orchestra to La Monte Young*, simultaneous performance at Carnegie Recital Hall, New York, 1965. Photo by Peter Moore. Photo © Barbara Moore/ Licensed by VAGA, New York, NY.

The fascination with undecidability and indeterminacy, which formed a significant part of the Fluxus work, acquired a novel form, form different from Cage's, in Brecht's early works, like his 1961 *Two Durations*:

- Red
- Green

Two Durations could be performed in any number of ways. For example, by preparing and eating a meal that consists of red and green food such as tomatoes and peppers; by walking or driving through as many sets of traffic lights as possible; or by wearing red and green clothes for a day, a week or a month.

Similarly, Dick Higgins's *Danger Music Number Fifteen*
(for the Dance)
Work with butter and eggs for a time
May 1962

Could be performed in such a way as to make an omelette or create an abstract painting with eggs and butter as material. His

Danger Music Number Twenty-Nine
Get a job for its own sake.
March 1963

included an even wider set of possibilities: actions, durations and experiences. Although all these scores are related to music in the expanded sense of the word, which, as we have seen from Cage's *4'33"*, discussed in Chapter 3, include all elements in sound space, Brecht (1978) felt that: 'Cage was a great liberator, but he remained a musician, a composer ... life is much larger than music. Afterwards I tried to develop the ideas that I'd had during Cage's course and that's where my "events" came from. ... Events are an extension of music' (83–84). Brecht's, as well as numerous other Fluxus artists' scores were a way of *notating* life; they were a way of observing and scoring life. As Higgins (1976) suggests, Fluxus works accept 'reality as a found object, enfolding it by the edges, so to speak, without trying to distort it (artistically of otherwise) in its depiction' (6). This is why the above scores consist of everyday objects and actions – butter, eggs, hammers, gauze, colours. However, these works also have another prominent characteristic: in-between-ness. In 'Statement on Intermedia', Higgins (1993 [1966]) points out that the transitive sense of medium – or intermedium – which arose in the latter part of the 1950s as a response to the advent of what were then the new media – television and radio – triggered an 'intermedial dialectic' (172). This dialectic, where one form enters into a dialogue with another, was created by applying the perceptual lens traditionally associated with music to the properties of other media, such as colour, shape, texture and movement. The *event score* scores phenomena and events seen and experienced in life by articulating them in an explicitly transitive way. There is therefore a strong similarity between the practice of the *event score* – a scored fragment of reality – and Derrida's method. Both are concerned with the seemingly insignificant, both operate in and from the margins of a given situation; in Derrida's case, this is the host text/theory, in Brecht's, Higgins's and other Fluxus artists' case: life. Important in this respect is that the Fluxus events, performed as part of the Fluxus concerts, were also sent to friends and acquaintances in written form, as telegraphic notations, simultaneously pictures, poems and performance instructions. This was done to circumvent not only reification but also community. Whereas Kaprow's and Lebel's happenings, discussed in Chapter 4, bestowed a definite value on group performance, and thus also community, Zero Jigen's *gishiki* proposed a different form of mediation, one operating in the very margins of sociality. Fluxus *event scores*, for their part, operated (and still operate) in the margins of performance. They also explicitly invite different performative interpretations. For example, La Monte Young's famous:

Composition 1960 No. 10
Draw a straight line and follow it

was first performed by Nam June Paik at the Fluxus Internationale Festspiele Neuster Musik in Wiesbaden in 1962. In this performance, Paik dipped his head in a bucket of ink and painted a straight line on a sheet of paper extended on the floor. Similarly, George Brecht's 1962 *Piano Piece,* which consisted of a single instruction: 'center', was performed by Brecht (1978) in the following way: 'with my two index fingers I began to play the notes of the piano starting from the two ends until I found the note in the centre' (85). The journalist Irmeline Lebeer reports performing the score by 'pushing the piano into the centre of the room' (Lebeer in Brecht, 1978: 85). This means that every performance is a re-arrangement, and a re-interpretation of the score. As such, it exposes the working of the Derridian tracing on several levels and in several frames of exchange: medial interpretation – which medium or combination of art media or life media to use; duration – how long to perform the score for, a few minutes, a day or a month; and finally, interaction – whether or not to involve other people, and, if so, how and at what point in the performance. This performative multiplicity is further expanded in *Flux-Sports* where it is combined with continuous indeterminacy.

Flux-Sports and blind tactics

Takako Saito's *Flux Chess* series, which included *Sound Chess* – played with identically shaped boxes filled with powder, grains, pins, pebbles and stones – and *Grinder Chess* – played with red and blue grinders with differently shaped tops placed in a grid of peg holes – is a good example of this; it is concretist, intermedial and indeterminate. The most notable of the chess series was perhaps *Smell Chess* whose inherent indeterminacy subverted chess, as it is usually played, on a chequered board with sixteen hierarchically related pieces. Chess, in its original variant, is a game whose object – to checkmate the opponent's king – is carried out through a series of strategic manoeuvres. The hierarchy of the pieces is clearly indicated by their shape, size and their position on the board as well as their assigned directionality of movement. In keeping with the game's object, the game relies primarily on optical per-ception. Saito's *Smell Chess* follows the same rules; however, the pieces consist of identically shaped vials filled with different spices. The white pawns are made of cinnamon, the white knights of ginger, the bishops are made of clove, the king is made of cardamom. The black pawns are made of black pepper, the black rooks are made of coriander, the queen is made of cayenne pepper. In contrast to the purely symbolic value of

the traditional chess pieces, Saito's *Smell Chess* pieces reinstate the concreteness of their 'material' existence. Once four or more vials have been opened, their smells fuse and hang in the air, creating an undifferentiated continuum which makes it next to impossible for the players to identify the pieces, let alone decide on the position they ought to occupy on the board. The habitual goal of the game and its contemplative manner of unfolding is here thwarted by a series of concrete interferences. In this sense, *Smell Chess*, like Cage's prepared piano or Ono's *Sky Piece to Jesus Christ*, upsets the purely instrumental connection in which a particular key is struck in order to produce a targeted sound, a particular partition played by a particular instrument in order to create a predetermined effect within a larger work (a symphony, for example), or a particular chess piece moved to a particular position in order to produce a targeted strategic effect. This new relationship gives rise to unpredictability of a very specific kind. Instead of operating within a fixed hierarchical structure in which move A results in effect B, concretism in *Smell Chess* creates an unpredictable variety of reactions in the players, not as a side effect but as a constituent part of the game. Needless to say, this has a direct effect on the players' ability to gauge the symbolic value of the pieces. This de-centredness in which each of the multiple elements of the game enters into an equivalent relationship with any other element – the smell of coriander with the action of check-mating one's opponent – is crucial to understanding how *Flux-Sports* operate. Like the Duchampian ready-made, they resonate in two parallel registers: the aesthetic and the functional. The entire playing field, the game's resources and the players' relationship to the goal of the game are here reconfigured by the use of concrete game elements which influence every move the players make. The interrelation of these factors is produced through and by 'blind tactics'. A Derridian term, blind tactics exposes the endless play of differences and multiplicities and prevents reduction to an ultimate meaning or an ultimate position. In preventing the formation of a definite and stable structure, it operates without a final goal and without a governing agent. In Derrida's (1982) own words, it is simultaneously 'strategic and adventurous' (7). Blind tactics is strategic because there is no organising principle above it; it is '[a]dventurous because this strategy is not a simple strategy in the sense that strategy orients tactics to a final goal' but is 'the unity of chance and necessity' (7).

This unity of chance and necessity can, of course, be traced to Duchamp's as well as Cage's practice, since both artists sought to dissolve the hierarchical supremacy of structure over non-structure, albeit in different ways.

As discussed in Chapter 2, Duchamp's famous *Bride Stripped Bare By Her Bachelors, Even (The Large Glass)* was created through a series of chance operations involving a toy cannon that shot paint-dipped matches at the glass and in this way determined the positions of the malic moulds. These mechanical chance operations, unaffected by artistic inspiration, or skill, served to deconstruct the usual 'structure' of artistic creation. However, Duchamp's mechanical chance operations were rigorously defined and thus themselves a structure. In similar fashion, John Cage's *4'33"* dissolves the structure of what Cage terms 'old music', which 'has to do with *conceptions* and their *communication*' (Cage cited in Nyman, 1974: 20, emphasis original). This makes 'old music' different from 'new music', which has to do with '*perception* and the arousing of it in us' (20, emphasis original). However, like Duchamp's *Large Glass*, *4'33"* is not entirely structureless. It depends on clearly delineated movements and repeated actions, such as the opening and closing of the piano lid. *Flux-Sports* follow closely in the footsteps of Duchamp and Cage in the sense that they collapse 'old', ingrained structures. Indeed, the traditional opposition between art and participatory entertainment in the form of games and sports is none other than the opposition between meaningfulness and meaninglessness, which Derrida was so vehemently against. The prerequisite for art is originality and innovation; the prerequisite for games and sports is traditionalism and imitation. Art is unique, created by a qualified and gifted professional; games and sports are a general matrix, practicable by all. *Flux-Sports* dissolve this basic structure and in its stead propose the non-structure of play. Operating on the assumption that art is a way of doing, a way of behaving as a member of society, *Flux-Sports* propose a simultaneously aesthetic and social experience.

Organised for the first time at Rutgers University, New Brunswick, in 1970, *Flux-Sports* consist of a variety of athletic disciplines and ball games such as Larry Miller's *100 Yard Run* (in which runners proceed to the fiftieth yard taking three steps forwards and two steps backwards and from the fiftieth-yard mark three steps backwards and two forwards); *220 Yard Candle Dash* (in which each runner carries a lighted candle and is obliged to stop to light it if it goes out); and *220 Yard Balloon Dash* (in which the contestants run with as many inflated balloons as possible attached to their body). Among other contributors were Bici Hendricks with her *Stilt Soccer* (soccer played on stilts) and Maciunas with a variety of disciplines ranging from *Team Ski Run* (in which four runners have their left foot tied to one ski-like board and their right foot to another) and *Boxing* (performed with giant inflated musical gloves) to *Blow Soccer*

(played with a ping pong ball and long tubes). Like much of the performance work discussed above, *Flux-Sports* are paradoxical activities, which, in the words of art historian Kristine Stiles (1993), 'perplex the player and confound the body requiring its realignment with conceptually implausible behavior' (86). Modelled on and bearing reference to well known sports whose rules are common physically ingrained knowledge, *Flux-Sports* engage the player in a clash of opposites by asking him/her to pursue the goal of the game in ways and by means that are either nonsensical or entirely counterproductive. In doing so they disrupt the hierarchical divide between the means of the game – the boxing gloves, the ball – and its ends – knocking's one's opponent out or scoring a goal. Although *Stilt Soccer* is a game just like ordinary football in so far as it consists of a set of rules by which the players agree to abide for the duration of the game, as well as of clearly defined roles, it proposes a structural reconfiguration of the relationships inherent in the game. According to the French game theorist Roger Caillois's (1971[1961]) classification of games, which differentiates between *agon*, *alea*, *mimicry* and *ilinx*, in other words, between competition, chance, simulation and vertigo, football, like chess, boxing, jousting or a 100-yard race, belongs primarily to the category of *agon* (17–18). *Agon* refers to competition and rivalry and requires an artificial equality of chances and resources at the start of the game so that any prospective advancement may be attributed solely to the adversaries' or teams' strength, speed, skill or stamina. *Alea* designates chance and is deployed independently of the players' strength, speed, skill or stamina. *Mimicry* refers to children's play, imitation and acting where the pleasure is derived from pretending to be or to do what one is very obviously not or cannot do. Mimicry relies on the participants' suspension of disbelief. *Ilinx* is defined by Caillois as rooted in the pursuit of vertigo, chaos and tumult (26), found in physical activities that provoke the sensations of disequilibrium, falling or vertigo, such as whirling or trampoline jumping. The main difference between ordinary football and *Stilt Soccer* is that whilst the former relies mainly on *agon*, although it certainly comprises occasional, albeit proportionately smaller elements of *alea* and *ilinx*, *Stilt Soccer* mobilises all four categories of play in equal measure, without privileging any single one. In other words, it does not allow a governing principle to emerge. *Stilt Soccer* mobilises *agon* because it adheres to the usual rules of scoring goals in order to win the game; it mobilises *alea* on account of the players' lack of skill, since running on stilts is a demanding task for the unaccustomed player, not to mention trying to hit the ball without losing one's balance.

It mobilises *mimicry* since the players pretend to be playing a game they both understand and know how to play – the game of football. Finally, it creates *ilinx* because of the dizziness, panic and the accompanying thrill caused by chasing the ball on stilts. In *Stilt Soccer*, attempts at strategic organisation are perpetually thwarted by the use of stilts, thus creating euphoric and panicked tumult. But the tumult never quite takes over as it is precisely amidst the shrieking and the falling on top of each other that the players discover a new strategically useful move, such as holding onto each other for balance while trying to hit the ball. In doing so the game explodes the full gamut of play elements, none of which prevail for long enough to constitute a stable frame of reference. Whether playing or watching, it is impossible to decide whether *Stilt Soccer* is a childish make-believe game in which the players pretend to be playing football but are not 'really' playing football, or a group improvisation on stilts, which resembles a dance, or a competitive game in which winners and losers will be determined, regardless of how the game is played. This fundamental undecidability, produced by blind tactics, echoes Duchamp's, Cage's and numerous Fluxus artists' chance operations in which rules are used with the explicit intention of maximising the aleatory potential of the situation.

The crucial difference between Duchamp's and Cage's work and *Flux-Sports*, however, is that whilst the former engage the interplay of chance and structure in a *consecutive* manner, the latter do so in a *simultaneous* manner. This further expands the working of blind tactics to the entire domain of the social. The expression 'the rules of the game' is often used in work, social, educational or marital situations, to mention but a few. In all these contexts, it refers to a relational structure, which can be explicit or implicit, and which needs to be adhered to, the underlying assumption being fair play. Football is, in this sense, representative of any social organisation. In football, every player has a clearly designated position and a clear repertoire of moves. He or she is expected to aid the primarily agonistic goal of the game – scoring as many goals as possible and winning the game – while adhering to both the rules of the game and the relational structure. This means coordinating with other players in a pre-scripted fashion as well as using one's own initiative where appropriate but not at the expense of other players. However, *Stilt Soccer* disrupts the established positions and moves, and subverts the notion of a pre-imposed social structure. Instead, it proposes structured improvisation where other, unpredictable possibilities may come into play. Unless one is a trained stilt walker, it is impossible to predict one's own behaviour on the field,

let alone that of other players. This further means that it is impossible to form any idea of the development of the game prior to becoming involved in it and that the only useful tactics is, indeed, the non-strategic, 'blind' kind. Like many other *Flux-Sports*, such as Miller's *100 Yard Candle Dash* or *Balloon Dash*, *Stilt Soccer* restores playfulness to sport while also creating new possibilities of cooperation as well as new relationships between the given elements. For example, the players may find that the only way to hit the ball is to form threesomes in which two players provide support to the shooter in order for her or him to be able to kick the ball with sufficient vehemence. Or, they may find that holding the shooter in the air with her or his legs/stilts slightly off the ground is an even better position for shooting. Whatever the case, the point here is non-adherence to a predetermined structure which renders all other elements – the field, the ball, the player – instrumental to the overarching goal – winning the game. Like any sport, *Stilt Soccer* is a practice. As such, it conditions physical and psychological behaviour. It also creates novel forms of sociality. To try and run a race while being lifted off the ground by dozens of large inflated balloons provokes uncontrollable fits of laughter, in the runners and in the audience alike. In so doing, it disrupts and temporarily annihilates the goal-oriented, time-efficient logic of meritorious achievement which features as 'common sense' in the habitual practice of running. Equally, applauding the winner of the *100 Yard Candle Dash* implies applauding altogether different values than those ingrained in the 'common sense' practice of running, such as maximum exertion in one direction only, highly selective energy investment and a 'mind over matter' attitude to the world, namely evenly spread attention and a care for a very-small-scale, 'insignificant', almost laughable version of the Olympic flame. It is thus on account of their concretism, which refers equally to the playing field, the game's resources, the players, and the audience, that *Flux-Sports* exemplify 'blind tactics'. In this sense, *Flux-Sports* function as extended undecidables: undecidables in running time, with a particular focus on interaction.

All performative strategies discussed in this chapter destabilise the existing hierarchies, much like they destablise assigned, determined meaning, in highly absurd as well as poetic ways. While Zero Jigen and Hi Red Center focus on interventions in the public space, in an exhaustive sense of the word – the space of passage (metro stations), the space of relaxation (public baths, spas), the space of gathering (the

city square), the space of learning (universities) – Fluxus focus on inter-actional structures that take place in-between the art and the life media. The specifically Fluxus intermedia sidestep established norms of artistic production as well as forms of experience design. In their stead, they create new channels of communication – the endlessly (re)-performable *event score*, for example. Important, however, is that they do not seek to replace one much-used cultural form with another but purposefully seek in-between-ness not only in terms of content but also in terms of the individual-group, producer-recipient relationship. As art historian Lucy Lippard (1973) has famously argued in *Six Years: the Dematerialization of the Art Object from 1966 to 1972*, the 1960s and 1970s were, in the visual arts, a period of the de-materialisation of the object. Many artists sought to de-commodify their work, to make it non-saleable, which is why they resorted to (immaterial) performance. Where the Fluxus artists went further is in the de-materialisation of the work to the point of a performative instruction, itself a fragment of 'scored' reality, not a 'work of art' created by an 'author'. This method is exactly the same as Derrida's deconstruction, which is not a self-standing theory but oper-ates parasitically, by attaching itself to other texts – 'hosts'. The interface with ludology, present in *Flux-Sports*, which creates playful worlds firmly entrenched in non-serious reality, is a potent way of reflecting on the relationship between social rules and practices. 'Game' usually refers to a clearly delineated universe where different, ludic rules apply. However, this expression is also used in the social world, to indicate the rules of the game within any given practice – how one behaves on the job, what the unwritten rules of courtship are. For French sociologist and philosopher Jacques Ellul (1966) who has vehemently argued against the division of social reality into 'serious' and 'ludic', rules are, in fact, arbitrary. They are commonplaces. Echoing Nietzsche's argument mentioned in Chapter 1, for Ellul, commonplaces are truly 'common' because they do not 'tolerate any fundamental discussion' but serve 'everyone as a touchstone, an instrument of recognition' (13). In other words, the rules of the game are not there because they are the most intel-ligent, succinct, sophisticated expressions of profoundly reflected-upon experience. On the contrary, they are arbitrary linguistic and social struc-tures. Undecidability, in this context, is not just a fancy mathematical pattern. It is a condition that underlies all human action, interaction and rapport.

Scores:

1 Research the current formal and informal rituals: behaviour seen in banks, airports, restaurants, saunas. Also think about the wedding and funeral ceremonies as well as of the informal rituals practised in clubs, for example binge drinking. Design and perform short, paradoxical and undecidable rituals in public spaces, pubs, beaches, metro stations, zoos, universities.

2 Observe and score a fragment of life. Perform the score in as many variations and as many times as possible. Send the score to the people you know and ask them to perform it, then send you a short description of their performance/s.

3 Find a game – or a sport – for two or more players. Embroil the game's/sport's elements, goals and means, using the game/sport as a ready-made. Play the game.

7 Biopower and Female Writing

Phallocentrism and the oppression of the female 'other'

Phallocentrism, which comes from *phallus*, Latin for penis, is a term used to describe a genderised, maculinist and patriarchal agenda that depends on an elaborate practice of 'othering' for survival. 'Othering' is a process by which all that is different from the dominant binary, as seen in the previous chapter, is turned into deficient and lacking. In the case of men and women, men have, for centuries, been seen as the positive term, as that which has identity. By contrast, women have been seen as that which lacks identity. In her influential book *This Sex which is not One*, the Belgian-born French feminist, philosopher and psychoanalyst Luce Irigaray, who belongs to what is usually called the second wave of feminism, traces the phallocentric view to the Freudian interpretation of penis envy. The first wave of feminism took place in the late nineteenth and early twentieth centuries as a result of urban industrialism and socialist politics. It focused mainly on suffrage. The second wave took place in the late 1960s and 1970s, alongside numerous other movements, such as the civil rights movement, the anti-Vietnam War movement, and the Black Power movement, which demanded equal rights for African Americans. In this phase, feminists protested not only against the unequal nature of male-female relations, such as pay and property rights, but also against the overt and covert strategies of domination. Among these strategies was, of course, commodification through beauty ideals and their effect on social norms, discussed in Chapter 4. Although women could nominally behave in any way they liked – there was no law prohibiting non-ladylike behaviour – the tacit social consensus was that 'proper women' were dainty creatures who spoke softly, stayed slim, sat with closed legs and took the passive role in decision-making processes, much like they did in (heterosexual) copulation. These 'self-evident truths' were perpetuated through a meshwork of social programmes and technologies, as theorised by Michel Foucault and mentioned in the Introduction. For Foucault (2003), the formation of the norm as discourse – a set of authoritative statements about a thing or a phenomenon – is inseparable from

the technical operations which effect or correct this normativity. In post-modern times, as already discussed in Chapter 4 with reference to Fromm, disciplining is no longer achieved through the use of force, in such institutions as the school, the prison, the hospital or the army. Overtly disciplinary strategies dictating how a body should behave, what it should do, have been replaced by what Foucault has termed 'biopower'. 'Biopower' governs life and the living through a set of binary categorisations, by establishing an 'us' against a 'them', the 'normal' against the 'abnormal' and mapping these categories onto the 'dispositif of security' (242). Such a 'dispositif' – which includes knowledge structures and micro-technologies of power – acts preventively by associating life and the right to live with the 'normal' and dissociating it from the 'abnormal'. This occurs in the realm of physical and mental health, race, ethnicity, sexuality and gender alike. The technologies needed to achieve a certain state of 'normality' – in the case of gender these include tight bodices, uncomfortable shoes, dieting regimes and a constant preoccupation with one's appearance – are what regulates gender. This is why a series of protests was organised in the late 1960s, such as the protest against the Miss America pageant in Atlantic City in 1968 in which feminists parodied what they thought to be a degrading cattle parade and destroyed objects symbolic of this oppression – bras, suspenders, high heels and false eyelashes. Theorists like Irigaray investigated the roots of this inequality by analysing the dominant binaries – mind/body, rational/emotional, man/woman, civilised/savage – as articulated by Derrida and Foucault and rooted in the dominant social and psychoanalytic ideas. As a psychoanalyst, Irigaray takes issue with Freud, for whom female subjectivities are defined in relation to the phallus, which is associated with visibility and the sense of sight. Woman, by contrast, according to Irigaray (1985):

> takes pleasure more from touching than from looking, and her entry into a dominant scopic economy signifies, again, her consignment to passivity: she is to be the beautiful object of contemplation. While her body finds itself thus eroticized, and called to a double movement of exhibition and of chaste retreat in order to stimulate the drives of the 'subject', her sexual organ represents the horror of nothing to see. A defect in the systematics of representation and desire. (26)

This passage raises two important points. First, that the phallocentric discourse rests on optical logic. The female sexual organ is therefore perceived not as radically different, but as a lack. The key Freudian example of this is the little boy who sees female genitals for the first time

and 'realises' that there is nothing there. This is why the little boy fears castration, the underlying assumption being that masculine power goes hand in hand with a penis. The little boy is afraid that, if he does not obey his father's orders, he, too, will be reduced to this 'lack', which, as numerous feminist scholars have argued, Jane Marie Todd (1986) among them, cues feelings of '*das unheimliche*' or the uncanny (521). Associated with the unfamiliar and the strange, the uncanny opens onto the existential abyss, the inexplicable horror of being, which remains associated with women, while simultaneously assigning 'normalcy' to men. The second point, for Irigaray, is that the female sense is the sense of touch; the female sexual organ consists of the double labia, which are continually in contact. Parts of a woman's body thus touch other parts without any intervention from the outside. Phallocentrism suppresses this possibility. The sense of touch is not intelligible to the 'rational' logic based on sight, which, in privileging the visible, the divisible and the easily definable, disqualifies the invisible, the indivisible and the indefinable. Irigaray (1985) writes:

> This organ which has nothing to show for itself also lacks a form of its own. And if woman takes pleasure precisely from this incompleteness of form which allows her organ to touch itself over and over again, indefinitely, by itself, that pleasure is denied by a civilization that privileges phallomorphism [the tendency to shape things into phallus-like things]. The value granted to the only definable form excludes the one that is in play in female autoeroticism. (26)

Disregarding this entire realm, Freud proposes that a penis is 'naturally' associated with sexual and social advantages, such as autonomy, freedom and power. Being deprived of this, a woman can only feel resentment and envy. Not only does she not possess a penis, but this symbol of 'autonomy' has excluded her from the political, social and cultural realm for the past twenty centuries. Irigaray (1985) argues that the dominance of such thinking, based on closed circuits of meaning, has engendered the oppressive 'economy of the Same' which reduces all differences between the sexes 'in systems that are self-representative of a "masculine subject"' (74). These 'self-representative' systems mean that the speaking subject is associated with the masculine subject while women are denied the right to a mind and an opinion. Irigaray points out to what extent this is rooted in Freudian interpretation of sexuality and reproduction. The female sexual function is, for Freud, largely related to the reproductive function. The purpose and goal of the woman's libidinal evolution is the desire to give birth.

The desire to obtain the penis from the father is replaced by the desire to have a child, this latter becoming, in an equivalence that Freud analyzes, *the penis substitute*. We must add here that the woman's happiness is complete only if the newborn child is a boy, bearer of the longed-for-penis. In this way the woman is compensated, through the child she brings into the world, for the narcissistic humiliation inevitably associated with the feminine condition. (41, emphasis original)

Furthermore, 'becoming *the mother of a son*, the woman will be able to [here Irigaray cites Freud] "transfer to her son all the ambition which she has been obliged to suppress in herself"; as the lack of a penis loses none of its motivating power, [citing Freud again] "a mother is brought unlimited satisfaction by her relation to a son"' (42, emphasis original). Since the focus of all relations is solely on the male sexual organ, and the male condition, the nature of female sexuality and the female condition is not only omitted from equation but made subservient to the male condition in more than one way. In a culture that wants to count and 'number everything by units', 'inventory everything as individualities' as 'ones' (26), woman, which is *'neither one nor two'* (26, emphasis original) cannot be comprehended. As a result, she is denied the right of existence as a subject; her natural milieu is the domestic one; the behind-the-scenes work needed to uphold the subjectivities of those with a penis – men and male children. Taking issue with Freud's justification of the male aggressive activity and the female passivity as, supposedly, based on 'anatomical-physiological imperatives' (71), Irigaray reflects on the Foucauldian relationship of discourse to science. She observes the astounding slowness with which other ways of comprehending the world, ways not based on sameness, on individuality, on definite discernibility from other forms, such as the theory of fluids, have been adopted: 'if every psychic economy is organized around the phallus (or Phallus), we may ask what this primacy owes to a teleology of reabsorption of fluid in a solidified form' (110). The study of fluids – liquids, gases and plasmas – is a branch of physics that privileges non-solid forms. Irigaray's argument is that the all-pervasive patriarchal discourse is so absorbed in a particular form of representation and that this representation is naturalised to such a degree that even in science such logical routes as fluidity and the interplay of non-definable forces, have been neglected. Although the 1970s and 1980s saw a proliferation of feminist politics through such works as Suzanne Lacy's, Judy Chicago's, Lynda Montano's, as well as the work of the choreographer Yvonne Rainer, all of whom worked with female roles and body representations, of particular importance in articulating the above issues, albeit in very different ways, are Carolee Schneemann, ORLAN and Bobby Baker.

Carolee Schneemann and biopower

Trained as a visual artist, who in the 1960s collaborated extensively with the Judson Church choreographers in New York, such as Yvonne Rainer, Anna Halprin and Simone Forti, Carolee Schneemann's work has often been compared to the Viennese Actionists'. Without a doubt this has much to do with the work's visceral nature and Schneemann's extensive use of her own body. Her early work, such as the famous *Meat Joy* dating from 1964, provides a prescient reflection on the fluid approach described by Irigaray. *Meat Joy*, shown for the first time at the *Festival of Free Expression* in Paris, organized by Jean-Jacques Lebel whose transgressive work, discussed in Chapter 5, had much in common with Schneemann's questioning of censorship, is of crucial importance to understanding her landmark 1975 work *Interior Scroll*. In *Meat Joy*, the eros of womanhood is shown as polymorphous and inextricably entwined with all other things and beings that inhabit the world.

As Schneemann (1979) states in *More than Meat Joy*, the work developed from her 'sensory orientation' and 'the release from random memory fragments' of textures, sounds and climatic conditions (63). The body's perception of the world, the impressions the world had made on the body were sought largely through improvisations.

> My body streamed with currents of imagery: the interior directives varied from furtive to persistent: either veiling or so intensely illuminating ordinary situations that continually felt dissolved, exploded, permeated by objects, events, persons. (63)

Meat Joy, during which Schneemann (1991) was attacked by a man who came onstage, pushed her against the wall and tried to strangle her (31), resembled an erotic rite: it was indulgent, a celebration of flesh as material including raw fish, chickens, sausages and feathers. It was also a celebration of the sensorial apprehension of matter – of wet paint, transparent plastic or paper scrap. In this performance, a group of men and women, stripped to their underwear, danced and writhed around with each other on plastic sheeting; they danced with, rubbed and threw raw fish, chicken, sausage, and wet paint onto their own and other performers' bodies. *Meat Joy* was highly sensual; feeling, smelling, hearing, seeing and even tasting were all equally foregrounded; the work was a celebration of the flesh but also of tactile sexuality. As Schneemann (2003 [1995]) notes, '[p]hysical equivalences are enacted as a psychic and imagistic stream in which the layered elements mesh and gain intensity by the energy complement of the

audience' (253). The focus is here not on individual bodies or entities, on the 'one', of which Irigaray speaks, but on the materials, flesh and actions which relied, to a significant extent, on the sense of touch. This is where a 'certain tenderness (or empathy) comes from ... [tenderness] pervasive – even to the most violent actions: say, cutting, chopping, throwing chickens' (253).

In Irigaray's (1985) view, the female self-hood, based on the sense of touch, is inextricably entwined with otherness, because woman 'finds pleasure almost anywhere. Even if we refrain from invoking the hystericisation of her entire body [a reference to Freud's theory of [female] hysteria], the geography of her pleasure is far more diversified, more multiple, in its differences, more complex, more subtle ... "She" is indefinitely other in herself' (28). A part of this physical empathy has to do with the fact that the sense of touch has no locality, like all other senses – hearing, sight, taste, smell – but includes the entire body. Further, it has to do with this sense's particular manner of understanding – of grasping – that which it comes into contact with, even in what seem like violent encounters, through one's entire body. On 19 August 1975, Schneemann performed *Interior Scroll* at a mini festival called *Women here and Now* in East Hampton. This piece, in which Schneemann extracts a scroll of text from her vagina, arose from a considerable period of research into the symbolism of the female body, including sculptures, wood carvings, ancient religions and mythological accounts of womanhood. First, as Schneemann (1991) notes in 'Obscene Body/Politic', the importance of the female body had been systematically erased from patriarchal Western representation; the perception of the female body had therefore been 'deformed' (28). This deformation, achieved through systematic justification via discourse, as theorised by Foucault and Irigaray, appears in Western creation myths as 'Athena [the Greek goddess of war] emerging from Zeus's head, as the birth of Dionysus from his father's thigh – which circumvents women altogether – and as the birth of Jesus from a virgin mother' (28). All these myths conspicuously deny the very existence of a womb and the female sexual and reproductive organs. Schneemann (2003 [1995]) writes:

> I thought of the vagina in many ways – physically, conceptually as a sculptural form, an architectural referent, the source of sacred knowledge, ecstasy, birth passage, transformation. I saw vagina as a translucent chamber of which the serpent was an outward model: enlivened by its passage from the visible to the invisible, a spiraled coil ringed with the shape of desire and generative mysteries, attributes of both female and male sexual organs. (234)

Moreover, Schneemann relates this organ to 'primary knowledge', an expression she uses to replace the term 'primitive', which is unnecessarily hierarchical and treats primary knowledge with disdain. For Schneemann, primary knowledge consists of 'strokes and cuts on bone and rock by which I believe my ancestor measured her menstrual cycles, pregnancies, lunar observations, agricultural notations – the origins of time factoring, of mathematical equivalences, of abstract relation' (234). Explicitly playing on such mythic and metaphoric connections as 'Mother Earth', as well as on Gustave Courbet's famous 1866 painting *Origin of the World*, which offers a close-up view of the female genitals, Schneemann establishes a connection between the 'visual-mythic transmutation of self-knowledge' and the 'experience and complexity' of the personal body of the cosmic Mother, seen as the 'source of conceptualizing, of inter-acting with material, of imagining the world and composing its images' (234). In so doing, Schneemann provides a positive re-formulation of the concept of biopower, the power to give and sustain life through direct bodily knowledge. Of further importance here are two sources of inspiration, Sharon Hennessey's video *What I Want* in which Hennessey reads from an unfolding scroll, what she, as a woman, but without any personification, wants. Very much in the vein of female 'self-otherness' discussed by Irigaray, this monologue consists of entirely different, contradictory wishes and observations. Indeed, it foregrounds the 'whimsical, incomprehensible, capricious state, in which '"she" sets off in all directions leaving "him" unable to discern the coherence of any meaning' (Irigaray 1985: 28–29). Being always already multiple, through her associations with all things of the world – with which she merges – the woman's speech is multiple, too. It follows numerous simultaneous paths and directions. However, this is not to say that it is nonsensical, only that it *appears* disorderly from the above-described point of view which foregrounds 'one-ness'. The other source of inspiration for Schneemann was Anne Severson's 1971 film *Near the Big Chakra*, in which several dozen vaginas, belonging to women from three months to sixty-three years of age are filmed in 'close focus in an effort to stage visibility' (MacDonald et al., 1991: 22) and therefore recognition for that which is not normally in full sight, and is, for this reason, the object of mystification. In the East Hampton performance of *Interior Scroll*, Schneemann placed a long table under the spotlights, in a space consisting largely of women. She then undressed, wrapped herself in a sheet and announced that she would read from her book *Cezanne, She was a Great Painter*. She painted large strokes defining the contours of her body and face, dropped the sheet and started reading while simultaneously adopting a series of life model 'action poses'. After this, she slowly extracted a scroll from her vagina, inch by inch. As Schneemann (1991) notes:

The need to see, to confront sexual shibboleths was an underlying motive for *Interior Scroll* ... I didn't want to pull a scroll out of my vagina and read it in public, but the culture's terror of my making overt what it wished to suppress, it was essential to demonstrate this lived action about 'vulvic space' against the abstraction of the female body and its loss of meanings. (3)

She read the following text from the scroll:

I met a happy man, a structuralist filmmaker ... he said we are fond of you, you are charming, but don't ask us to look at your films. We cannot, there are certain films we cannot look at, the personal clutter, the persistence of feelings, the hand-touch sensibility, the diaristic indulgence. (Schneemann, 2003 [1995]: 238)

This description of female art, which is supposedly incomprehensible and consists of devalued emotions as well as of insufficiently mastered techniques, reveals a modality of being that Irigaray identifies as fundamentally destabilising. The reason for this is that this seemingly disorganised – and, importantly, *disorganising* logic – 'puts into question all prevailing economies' (Irigaray, 1985: 31). By this, Irigaray means 'male, patriarchal economies' (31). The interpenetration of woman and the environment is particularly confusing to this logic; it is too close, too intimate, and therefore invalid, as the 'structuralist filmmaker' from Schneemann's monologue seems to suggest. Schneemann's (2003 [1995]) response to the filmmaker's comments is as follows: 'it's true, I said, when I watch your films my mind wanders freely ... during the half hour of pulsing dots I compose letters, dream of my lover, write a grocery list, rummage in the trunk for a missing sweater' (239). Making a humorous comment about structuralist film-making, whose point of interest are the various structures, their transformations and dissipation, in this case 'pulsating dots', Schneemann appropriates the multiplicitous condition of her reception. This reception should not be confused with distraction or a lack of focus, but seen as an ability to think along multiple tracks simultaneously. Impersonating the structuralist filmmaker's reaction, Schneemann retorts: 'you are unable to appreciate, the system, the grid, the numerical rational' (239). Then, in her own voice: 'He told me he had lived with a "sculptress". I asked "does that make me a 'film-makeress'"? Oh no, he said, we think of you as a dancer' (239). By juxtaposing the male view of the woman and the frivolity associated with such stereotypical gender roles, to the interior, bodily, fleshly knowledge, Schneemann critiques the entire structure of representation. Included in this critique is the rational opinion based on rationally

organised observation – the grid, the procedures – as well as orderly presentation, which presupposes a single point of view and refers to 'one-ness' and the 'economy of the Same', discussed by Irigaray, not to the 'clutter' the structuralist filmmaker from Schneemann's monologue refers to. By extracting this dialogue from her vagina, Schneemann reverses the (patriarchal) hierarchy. She places the filmmaker's opinion, firmly entrenched in the discursive-psychoanalytic-scientific system of representation (Irigaray), in a subordinate position to bodily knowledge. More specifically, she places it in a subordinate position to what might be termed the origin of knowledge, because it is, in Coubert's words, the 'origin of the world'. In so doing, Schneemann also problematises the visibility of the female body, specifically the visibility of its taboo organ – the vagina – usually relegated to the domain of pornography. Schneemann (1991) writes:

> Censorship and pornography are blood brothers ... If my photographs, films and enacted works have been judged obscene, the question arises: is this because I use the body in its actuality – without contrivance, fetishization, displacement? Is this because my photographic works are usually self-shot, without an external, controlling eye? And are these works obscene because I posit my female body as a locus of autonomy, pleasure, desire; and insist that as an artist I can be both image and image maker, merging two aspects of a self deeply fractured in the contemporary imagination? (33)

Schneemann's work is highly relevant precisely because it refuses to surrender to split subjectivities, predicated on sight and the gaze as the dominant categories and dominating strategies, in which the observed and the observing are never the same. It also refuses to be censored, censorship being yet another observing and disciplining category.

ORLAN: the commodification of the female body and the myth of beauty

ORLAN is the name the French artist Mireille Porte adopted in an act of self-naming. In patriarchal society a daughter does not have her own name, nor does she take her mother's name; she is first 'marked' as belonging to the father and subsequently 'marked' as belonging to the husband. When a woman 'changes hands' in patriarchal society, in other words, when she is 'given away' to the husband by the father in a wedding ceremony, she is traditionally dressed in white. Although this colour is the colour of mourning in the Islamic world, in the Western world white signifies intactness and blankness. Like a screen, which is blank, white and without inscription, the better

to reflect projection, the whiteness of the bridal dress can be seen as a screen on which patriarchal relations are inscribed. Once a wife and a mother, the woman becomes the carrier of the name which is her husband's, not her own. This lack of identity, and this lack of economic freedom, is closely related to the lack of libidinal freedom. In her analysis of this condition, Irigaray cites Friedrich Engels, a close collaborator of Karl Marx:

> the first class opposition that appears in history coincides with the development of the antagonism between man and woman in mon-ogamous marriage and the first class oppression coincides with that of the female sex by the male. (Engels cited in Irigaray, 1985: 82)

Irigaray's argument is that the patriarchal order is, indeed, a latent form of slavery because it turns the woman into property. After all, women have traditionally been provided with a dowry. Since a woman is considered economically unproductive, the husband is compensated for keeping her. Irigaray (1985) writes:

> the patriarchal order is indeed the one that functions as the *organ-ization and monopolization of private property to the benefit of the head of the family*. It is his proper name, the name of the father that deter-mines ownership for the family, including the wife and children. And what is required of them – for the wife, monogamy; for the children, the precedence of the male line and specifically of the eldest son who bears the name – is also required so as to ensure [Irigaray cites Engels here] 'the concentration of considerable wealth in the hands of a single individual – a man' and to 'bequeath this wealth to the children of that man and of no other' which, of course, does not 'in any way interfere with open or concealed polygamy on the part of the man' How, then, can the analysis of women's exploitation be dissociated from the analysis of modes of appropriation? (83, emphasis original)

Not only has the woman been kept from the public sphere and confined to the seclusion of her home, her body matter has also been exploited. A woman is thus an object of consumption and exchange. ORLAN's work is concerned chiefly with the terms of the patriarchal appropriation and com-modification of the female body, for example the medical practice, beauty norms, Christianity and art history. Her first venture into the territories of male domination was a work entitled *ORLAN Gives Birth to Herself*, realised in 1964. Consisting of a photograph in which naked ORLAN gives birth to an androgynous mannequin, this action was staged on traditional trous-seau sheets. Forming part of the bride's-to-be dowry, the trousseau, which a

mother hands down to her daughter/s, consists of linen, which the-bride-to-be embroiders in preparation for married life. While the groom-to-be prepares for a life in the public sphere, the bride-to-be prepares for a life designed to support the public life of her husband. By giving birth to herself on the trousseau sheets, ORLAN critiques the property laws implied in the custom of exhibiting the blood-stained sheets after the first marital night so as to prove the bride's virginity, her status of an intact, unused good. ORLAN's self-birth cuts through this complex network of social relations rooted in commodification. ORLAN further explored commodification of the female body in *Le baiser de l'artiste, The Kiss of the Artist*. Performed during the international *Contemporary Art Fair* (*FIAC*) at the Grand Palais in Paris in October 1977, this installation, set up at the entrance, consisted of a life-size photograph of ORLAN's naked torso shaped like a slot machine, as shown in Figure 7.1.

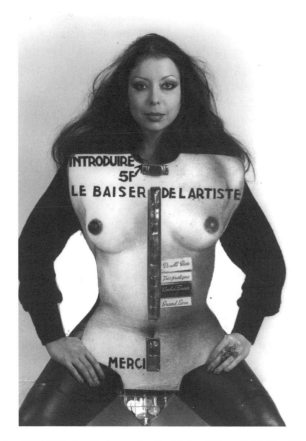

Figure 7.1 ORLAN *Le baiser de l'artiste* (*The Artist's Kiss*), Foire Internationale d'Art Contemporain, Grand Palais, Paris, 1977. © ORLAN. Courtesy of ORLAN Studio.

ORLAN stood behind the photograph and invited the passers-by to insert five francs into the slot between her breasts, thus referencing easy and instant consumption of the commodified object. Once inserted, the coin could be heard travelling all the way to ORLAN's groin where it finally settled. The kiss had a musical accompaniment – Bach's *Toccata in B Minor*. A siren signalled the end of the kiss, thus acting as a cue for the passer-by to disengage from the kissing machine. In the background was a life-size cardboard cut-out of ORLAN as the Virgin, draped in cloth but with exposed breasts. In 'Facing a Society of Mothers and Merchants' ORLAN reflects on this dual role of the woman as a virgin and a use object, devoid of all subjectivity, catering solely for male desire. ORLAN points out that the Christian values are steeped in commodification, since the relationship of 'Mary and Mary Magdalene, virgin and prostitute … duty and pleasure, respect and disdain' (ORLAN cited in Kerejeta, 2002: 206) makes it possible for men to use and abuse real women and still remain respectful of a God who creates women from Adam's rib. The reason for this is that, in Christian religion, women are derivative. Another layer of ORLAN's critique is directed at the art world, consisting mostly of male artists, curators, critics and the various board directors, whose attitude to female artists, as portrayed by Schneemann in *Interior Scroll*, is demeaning. In the work entitled *Art and Prostitution*, presented in the same year in Nice, ORLAN invited gallery owners and art dealers to have sex with her on her trousseau sheets. The soiled sheets – the remnant of the performance, and of the commercial transaction in which the female artists traded sexual favours for the right of entrance into the art world – were to be exhibited in the gallery as an artefact and as a *corpus delicti*. Although, unsurprisingly, the gallery owners declined – such transactions are, after all, performed in secret, while inclusive, non-sexist attitudes are paraded in public – the portrayal of the artist as a woman who has no other choice but to sleep her way into the male establishment was very poignant, indeed. As ORLAN states: 'I have only one choice: to sell myself. One has to face up to this situation … I go to the meeting with Mr. Untel [French for: 'Mr. Such-and-Such'] [and] offer him my body while I show him my work' (207). This sort of explicit articulation of the commodification of the female body can be traced to the work of Valie Export, mentioned in Chapter 5. Export was born Waltraud Lehner. Like ORLAN's, her change of name expresses her unwillingness to bear the name of the father. It simultaneously associates women with commercial goods, Export being a famous brand of cigarettes as well a form of trade. Apart from *Genital Panic*, performed in 1969, Valie Export produced *Body, Sign, Action* in 1970, a series of photographs of herself as the protagonist with a garter tattooed onto her thigh.

Export aligned herself with Viennese Actionism of a distinctly feminist kind, suggesting that Viennese Actionism sought to 'transform the object of male natural history, the material "woman", subjugated and enslaved by the male creator, into an independent actor and creator, object of her own history' (Export cited in Mueller, 1994: 29). She explains *Body, Sign Action* in the following way:

> The garter is used as a sign of past enslavement, as a symbol of repressed sexuality. The garter as the sign of belonging to a class that demands conditioned behaviour becomes a reminiscence that keeps awake the problem of self-determination and/or determination of others of femininity ... the body becomes a battle field on which the struggle for self-determination takes place. (33–34)

Her tattooed thigh was accompanied by a text:

> Woman is forced to represent herself through jewelry, make-up, personality and as bearer of fixed sexual symbols which are signs of a phallocratic society in a way that does not correspond to her personal needs. Based on the system of biological differences, a sociological system of repression was erected, which women can escape only by rejecting the body defined in the manner as feminine. (33–34)

Similar work on commodification was carried out by Hannah Wilke, and in the same medium – photographs. In her 1974 *Starification Object Series*, Wilke poses for the male gaze in a series of twenty-eight photographs where she mimics postures of a model. But her body is not only starified, it is also scarified. Dispersed in random patterns on her skin are small bubble-gum vulva-like forms. The pictures, which feature bare-breasted Wilke with her legs spread, sitting provocatively on a chair, posing in a pin up position, with her hand on her crotch, dressing and undressing, touching up her make-up, laughing with abandon, looking innocent, surprised, defiant, sleepy, sexy, in other words, using the full gamut of manufactured images of beauty, offer the constructed image of femininity. The bubble-gum sculptures look like a disease, however. Like Schneemann's work, they draw attention to the *interior* of the body, albeit in a different way. Continuing from her 1970s and 1980s work, in which ORLAN used her body to explore the intersection between the male gaze in religious iconography and the medical gaze, to which the body is, in fact, already dead, ORLAN often presented herself as the Madonna. Connections with transmutations of the body, the pain and the scarification that saints often endure, were further

explored in her carnal art, defined in ORLAN's (2014) *Carnal Manifesto* as 'self-portraiture in the classical sense, but realised through the possibility of technology' (np). Self-portraiture here oscillates between de-figuration and re-figuration. Its inscription in the flesh is a function of our age, in which the body is – or can be – seen as a ready-made. However, ORLAN clarifies that the necessary component of self-modification through technology, and often surgery, namely pain, should not be seen as 'redemptive or as a source of purification. Carnal Art is not interested in the plastic-surgery result, but in the process of surgery, the spectacle and discourse of the modified body which has become the place of a public debate' (np). In 'From Carnal Art to the Artist's Kiss', ORLAN comments on the beginnings of what was to become a long series of operations, which discuss commodification through surgery. Expressing dismay at how 'over-adapted' artists have grown to commodification – as an example ORLAN cites her Beaux Arts de Dijon students' repeated requests for recipes for creating successful, in other words, saleable artistic work – ORLAN (1997b) reasserts that art belongs to resistance, that the task of art is to 'shake the viewer, upset her thought patterns' which is the reason why all artistic endeavour has to remain 'outside the norm' (36). The series of surgeries under the name *The Reincarnation of St. Orlan*, the first of which took place in 1990, were radically outside the norm, not because they used surgery but because they used and manipulated the face as a collage. Preparations for this work began in late 1980 when ORLAN created a composite image (via morphing computer software) of her own face. This was combined with the face of Leonardo's *Mona Lisa*, anonymous School of Fontainebleau sculpture of *Diana*, Gustave Moreau's *Europa*, Botticelli's *The Birth of Venus* and F.P.S. Gerard's *Psyche*. All of these are prototypical representations of women. The *Mona Lisa* was chosen because this is, in fact, a self-portrait of Leonardo, hiding beneath La Giaconda; ORLAN took the forehead and temples of Mona Lisa. Diana, the goddess of hunt was chosen because she did not submit to men; ORLAN used her nose. *Europe* looked to another continent and into an unknown future. From her image ORLAN appropriated the mouth. From the image of Venus, goddess of love, fertility, and creativity, Orlan took the chin; from *Psyche* she took the eyes. ORLAN (1996) states:

> I constructed my self-portrait by mixing representation of goddesses from Greek mythology: chosen not for the canons of beauty they are supposed to represent but for their histories…These representation of feminine personages have served as an inspiration to me and are there deep beneath my work in a symbolic manner. In this way, their images resurface in works that I produce, with regard to their histories. (88–89)

However, the purpose of these operations is not the final result; it is the performance of surgery, of opening the operating theatre to the public, and debating, once again, the status of the body. ORLAN's (1997b) body is 'the privileged material of her work' (35). This is particularly polemical in relation to plastic surgery, which, apart from in cases where surgery is highly necessary, brings people closer to the widely accepted beauty ideal. It may thus be argued that *The Reincarnation of St. ORLAN* is a dis-appropriation, not an appropriation of the body, as were ORLAN's earlier performances. In this series, surgeries are transmitted via live streaming. The audience can see ORLAN's face being marked for incision, they can see a needle being inserted into her body, the scalpels slicing along the marked lines, the surgeon lifting the skin and revealing the inner layers of her flesh, not to mention the swelling and bruising that accompanies the incisions. As ORLAN is only under partial, not general, anaesthesia, her communications with the surgeon are also transmitted. The reason for the performance is not masochism or sacrifice, as ORLAN clearly articulates in the Carnal Art manifesto. She does not want a 'definite and definitive identity, but multiple, moving 'nomadic identities' (42). As theorist Ulla Karttune notes, 'Orlan is not only an artist, she is also an art critic, and she uses better methods – raw flesh – than mere intellectual criticizing. Orlan shows how the conception of pure visibility is built upon real flesh: the flesh of women abandoning their own will or pleasure' (Karttune in Orlan, 1997a: 11). ORLAN's surgeries are, of course, a logical continuation of her previous work but, as Karttune notes, her method – performance – is of crucial importance to the commodification discourse precisely because it inscribes and re-inscribes the debate about commodification and about femaleness on the female body.

Hélène Cixous's feminine, white writing

Contrary to ORLAN's method of inscription, which could be seen as tool- and technology-related, and therefore, masculine – although such a division would be dualistic – French philosopher and writer Hélène Cixous proposes a radically different approach. Like ORLAN, whose 1978 work *Documentary Study: The Head of Medusa*, a film of ORLAN's vagina, shot in response to Freud's above-mentioned equation between the female genitalia and monstrosity, Cixous's famous text bears the title 'The Laugh of the Medusa'. Originating in Greek mythology, Medusa is a monster. She has venomous serpents in place of hair and can turn everyone who looks her directly in the eyes, into stone. Cixous (1976) writes:

> As a woman, I've been clouded over by the great shadow of the scepter [the phallus] and been told: idolize it, that which you cannot brandish. But at the same time, man has been handed that grotesque and scarcely enviable destiny (just imagine) of being reduced to a single idol with clay balls. And consumed, as Freud and his followers note, by a fear of being a woman! (884)

In thinking through this predicament, Cixous calls for feminine writing, which she calls white, like the mother's milk. Although she suggests that feminine writing does not necessarily mean the exclusion of men, she believes that women are closer to feminine economy than men are, for cultural reasons (884–886). The linear, suspense-driven, result-orientated, rational writing can be countered through the inscription of rhythms and articulations of the mother's body. These rhythms and articulations continue to influence the adult self, and affect the subject's relationship to language, him/herself, others and the world. Key to this writing is that it does not seek to subsume difference in order to appropriate the position of mastery, but exists alongside it. Moreover, it brings into existence alternative forms of perception, expression and thus also relation. In *The Newly Born Woman*, Cixous (1986) writes:

> Feminine writing is a place ... which is not economically or politically indebted to all the vileness and compromise. That is not obliged to reproduce the system ... If there is a somewhere else that can escape the internal repetition, it lies in that direction, where it writes itself, where it dreams, where it invents new worlds. (72)

What does it mean to be politically indebted? Ultimately, Cixous's notion of writing encompasses all that creates a new subjectivity, a feminine, but not necessarily female, subjectivity, as Cixous does not exclude men from this subjectivity. Instead of focusing on the body as a commodified object, this writing focuses on the body as a source of life and creation. For Cixous,

> it is not only a question of the feminine body's extra resource, this specific power to produce some thing living of which her flesh is the locus, nor only a question of a transformation rhythms, exchanges, of relationship to space, of the whole perceptive system ... It is also the experience of a "bond" with the other, all that comes through in the metaphor of bringing into the world. (90)

What this writing seeks to bring into focus, the threads that it seeks to knot together is a bond between several aspects of femininity. These are

the woman's libidinal economy, the feminine imaginary and the particular way of self-constructing a subjectivity, as related to the materiality of the female body. The female ability to bring new beings into the world exonerates feminine writing from the political indebtedness to the Western discourse: the clarity of thought, the single-mindedness of logical pursuits. It also creates a possibility for re-evaluating what has often been called, pejoratively perhaps, the 'female domain'.

Bobby Baker: motherhood and the 'female domain'

British artist Bobby Baker draws on many of the already discussed traditions, such as action painting, found life structures and the ritual marking of a moment, a state or a transition. However, Baker's work is also radically new in its treatment of the neglected domains of domestic life where invisible violence and denigration are exercised across societal levels. Much of the domestic work needed for the basic survival of a family – cooking, cleaning, washing, mopping, dusting – has traditionally gone unrecognised and unpaid. While men who left the house in the morning and came back in the evening were regarded as bread-winners, women, without whose work life itself would have been impossible, were regarded as the ones who did not work. There are artists who, like American Karen Finley, brought the overt violence into focus. In a 1989 piece *We Keep our Victims Ready*, Finley (2000) smeared her body in chocolate because, in her own words, 'I'm a woman, and women are usually treated like shit' (84). Narrating the following segment of the performance she explains:

> Then I cover myself with red candy hearts – because, after a woman is treated like shit, she becomes more lovable. After the hearts, I cover myself with bean sprouts, which smelled like semen and looked like semen – because, after a woman is treated like shit, and loved for it, she is jacked off on. Then I spread tinsel all over my body, like a Cher dress – because, no matter how badly a woman is treated, she'll still get it together to dress for dinner. (84)

This was inspired by the story of Tawana Brawley, a sixteen-year-old African American girl who was found 'dazed and semi-conscious in a trash bag in an apartment complex … covered in human excrement. She said she was raped by a group of white police officers. Brawley was accused of faking the whole thing' (84). Baker's work could not

be further removed from this despite the fact that it uses food. Unlike Finley's work, it focuses on hidden and implicit violence. This sort of violence is fully ratified by the social system of which we are part. In what is perhaps her most famous piece, *Drawing on a Mother's Experience*, first presented in 1988 at the ICA, in London, and depicted in Figure 7.2, Baker tells the story of her pregnancy, the birth of her child and her postnatal depression while marking the white canvas stretched on the floor, Pollock-style, although this time in a literal performance area, with an audience present.

Her material, and her language in this performance was food. While chatting to the audience in a friendly manner, which combined humour with self-effacement, Baker dexterously wove themes associated with the female domain with constant reference to situations in which we customarily see women in adverts for toilet cleanliness or the ingenious management of the household budget. As performance scholar Eliane Aston (2000) notes in '"Transforming" Women's Lives: Bobby Baker's Performances of "Daily Life"', this performance came out at a time when the 'conflict for women

Figure 7.2 Bobby Baker *Drawing on a Mother's Experience*, ICA, London, 1990. © Bobby Baker. Courtesy of Daily Life Ltd.

between the roles of mother and worker' was particularly poignant, in the Thatcherite 1980s, which 'prompted the myth of the Superwoman – the working mother who could "successfully" combine professional life with family life' (17). In *Drawing on a Mother's Experience*, Baker (2007) says:

> I'm going to do this drawing for you out of food. I'm a very experi-
> enced mother and the one thing I've learnt is that you should always
> think ahead and avoid unnecessary mess, whenever possible. (Baker
> starts laying out plastic sheet on the floor) ... I'm going to do my
> drawing for you on a sheet, a white double sheet. (Baker starts laying
> out white sheet on top of the plastic.) The wonderful thing about
> doing drawings on sheets is that when you've finished it you can
> wash them and then either use the sheet again for a bed, you know,
> or for another drawing. It is quite difficult to get the stains out. It
> takes quite a lot of boiling and soaking but it's worth it. I've actually
> drawn four times on this sheet and you'd never know, would you,
> as there isn't a mark on it. I always buy these sheets, as I'm an expe-
> rienced mother, in the sales at my favourite department store and
> thereby I save just a little money. (149)

The things, occurrences and objects Baker makes reference to belong to the domestic side of life only: preparing dinners, shopping and looking out for bargains, moving house, reminiscing about borrowed/lent objects such as the mixer Baker's mother had lent her but which she no longer wanted to give back. These minute and entertaining descriptions are combined with the process of drawing and are interspersed with short reflections on the states usually ascribed to women. Baker: 'Whew! Now I'm quite hot and bothered! I'm going to start at the very beginning with the birth of my first child nearly ten years ago. Don't worry. I'm not going to embarrass you with any nasty details' (150). Baker recounts the birth of her baby girl, while marking the sheet with what she calls 'sensitive marks, delicate impressions' (150) made with the aid of cold roast beef. At the same time, she reassures the audience that no ingredients will be wasted since she will either feed the non-durable ingredients, such as beef, to the cats, or freeze them. While continually reminding the audience of what a good housewife, she is and thus mimicking some of the traditional husband-wife dialogues, in which the husband had the right to enquire about the household management in an authoritarian and disciplinary way, Baker recounts some of the, in her words, more embarrassing parts of her preg-nancy, namely her postnatal depression. Baker:

> I went into hospital a couple of times but it didn't help at all except for people assuming it was my nerves. I spent about five months in bed and it's really terrible with a small child and your husband is trying to cope with everything, but it was the only thing to do. (152)

At this point Baker lies down in the middle of the drawing. While continually using the neutralising technique which makes the described events less serious by referring to such frivolous things as the Boudoir biscuits her mother used to bring her while she was bedridden, Baker moves on to discuss the reasons behind her depression.

> My theory, that no professional has queried, is that depression is connected to anger and I was certainly very angry by this stage. That's why I love this bit. I think it's my best bit! I want to make these really strong marks with the black treacle. (152)

Here Baker starts pouring treacle from a tin. Continually combining the everyday – although not the banal – with bigger issues, Baker construes both a poignant critique of the patriarchal repression, which, typically, does not want to know about messy female emotions, and a poetic universe. At the end of the performance, she wraps herself up in the sheet she had been using for painting/marking experience and comments on the fact that she looks like a Swiss roll. In *Rootprints Memory and Life Writing*, Cixous (2005) proposes that 'what is most true is poetic. What is most true is naked life' (Cixous and Calle-Gruber, 2005: 3). Baker's performative writing, while playing off the prejudicial material around women in a humorous way, does not mimic what Cixous (1986) calls 'the system to which it is indebted' (72) nor does it fight against it in the manner that ORLAN and Finley do. This everydayness, which permeates all of Baker's work, and can be seen in the marking of gestures employed in her 1991 *The Kitchen Show*, opens onto a space of difference. This poetic space, which, importantly, is rooted in the seemingly prosaic, like the snippets of polite dialogue in which the perfect hostess attempts to find out whether her visitor would rather have tea of coffee, or the binding – marking – of the hand after having stirred the pot, is a form of feminine writing. This white writing does not signify, in the strong sense of the word. Rather, it includes. It brings customs, movements, glances, words and phrases, small, insignificant occurrences into view without arranging them into a linear chain of signification and without removing them from their continuous existence in the realm of the everyday. Thus although Baker's work could be compared to Pollock's, it is not as contained as Pollock's. Rather, it is in continuous interaction

with everydayness. For Cixous (2005), '[w]hat is most true is poetic because it is not stopped-stoppable. All that is stopped, grasped, all that is subjugated ... is caged. Each object is in reality a small virtual volcano. There is a continuity in the living' (Cixous and Calle-Gruber, 2005: 3). Baker's work captures this living and life-giving multiplicity exquisitely.

In the practices discussed in this chapter, performance intersects the already-encountered forms of painting and writing. However, it also introduces a different form of writing, on and in the flesh, with the aid of surgical instruments, as used by ORLAN. It also includes capturing performance, action, spontaneous behaviour in mid-flight, as in Baker's practice of marking movement through bandaging. Apart from shedding light on the long history of male domination – evident in the various representational practices which construct what women should and should not do, what counts as knowledge and, importantly, whose knowledge – the writing that emerges from the interior of the body and the writing on the body inform the question of inscription, heritage and tradition. Coming from the Latin *tradere*, which means to deliver, to hand over, tradition is a relay of particular – authoritative, thus invariably patriarchal – information by way of inscription. The particular forms of inscription examined in this chapter address the alliances of the various discourses such as the medical conceptualisation of the body, as always already dead, political economy, which foregrounds property, and art history which transmits, through millennia, particular aesthetic standards of female beauty. A discourse is a relation between the programmatic and the technological – a relation between the content of the inscription and its methodology. However, discourse is also formed through repetition and appropriation of certain behaviours. As Foucault (1988) notes in 'The Technologies of the Self', a critique of the disciplinary split between social history, which describes 'how people act', and the history of ideas, which describes 'how people think': 'the way people act or react is linked to a way of thinking, and of course, thinking is related to tradition' (14). In this context, performance accentuates the close relation of the two disciplinary modalities which never should have been separated in the first place. The value of the above-discussed practices resides in their problematisation of the very process of institution – the 'becoming-norm' of performance. In re-writing a number of traditionally female practices – posing as a painter's model, undergoing plastic surgery, cooking, serving food, cleaning – these performative strategies shed light on the coordinated working of a number of technologies of domination while simultaneously proposing a different inscription, aptly termed by Cixous 'white' writing.

Scores:

1 Think about the ways in which your body is inscribed with the various personal experiences through cuts, scars, scratches and stretch marks. Think about social inscription. What is the relationship between the interiority of your body and your hair, nails, eyebrows, eyelashes, facial hair? If a woman, think about your menstrual cycle and how this inscribes your body. Over a period of one month, sample the various body products. Parallel to this, study other forms of knowledge, ancient or alternative. After two months, make a performance in which knowledge of a specific manner of being – being a mother, being a virgin, being ill – is addressed.

2 Consider the tacit agreements that form part of the libidinal economy: the trade-offs between the younger and the older members of a couple, between the attractive and the plain, between the experienced and the naïve. Think about the traces, mannerisms and forms of behaviour such a libidinal economy creates. Think about the effects this has on the gendered body. Create an installation that captures these relations.

3 Work with food. Stretch a canvas or a sheet on the floor. Collect a variety of foods of different textures, consistency, colour and smell. Think about the cultural and symbolic meaning of the different ingredients (mustard is different from egg yolk although both are yellow). Go back to a memorable and perhaps tragic moment in your life; relate the story to the audience using food as a form of writing.

8 Identity Politics

Who or what is the subject?

An entity capable of thought, a subject has unique experiences and a unique consciousness; it relates to the world in two chief ways: as one subject to another, and as a subject to an object. Relations with inanimate matter aside, a subject can relate to other subjects in an object-like way. This ability, or tendency, of the subject to objectify, to place in a subjugated position, is, however, dependent on the processes of the subject's own coming into being. In *The Psychic Life of Power*, Jewish-American philosopher Judith Butler (1997b), who was influenced by Foucault, discussed in the previous chapter, suggests that the very constitution of subjects is, in fact, based on subjection. Subjection formerly referred to a monarch's or other sovereign's recognition of the subject in the spatial and legal sphere of the monarch's rule and power. Since the abolition of monarchies, subjection has referred to being under the dominion of another. Butler (1997b) writes:

> To be dominated by a power external to oneself is a familiar and agonizing form power takes. To find, however, that what 'one' is, one's very formation as a subject, is in some sense dependent upon that very power is quite another ... if we understand power as forming the subject as well, as providing the very condition of its existence and the trajectory of its desire, then power is not simply what we oppose but also, in a strong sense, what we depend on for our existence and what we harbor and preserve in the beings that we are ... the 'we' who accept such terms are fundamentally dependent on those terms for 'our' existence. ... Subjection consists precisely in this fundamental dependency on a discourse we never chose. (2)

When we come into this world, as helpless infants, we are dependent on our parents or our carers for survival. Since our cognitive faculties are not developed yet, since we have no experience, no habits to fall back on, and since we cannot even understand such basics of life as where and how to get food, we are dependent on our parents or carers. We learn to speak

their language/s and adopt their expressions and gestures. We are formed through and by their emotions, attitudes and habits. A child growing in a family where everybody is always shouting will appropriate shouting as a form of communication; in the initial stages of their development, prior to socialisation, they will communicate with other children in the same way. This particular form of communication may cause fear and distress in other children, thus making the shouting child into an unwitting bully. Although such behaviour may be seen as seeking to overpower and subordinate other children, all the shouting child has done is to employ the only forms of behaviour he or she knows. As human beings, we are formed by others, who were themselves formed by others. This sedimentation of customs and forms of behaviour we have neither chosen nor can get sufficient distance from, lies at the heart of sociality. Hence the need to think through subject constitution, social interaction, particularly language, and the 'pull' it exercises on individuals. This particular condition, this 'pull' has been termed 'interpellation' by French theorist Louis Althusser (1977). When a person of authority, a policeman, for example, hails the passer-by with 'hey you there' the one who recognises himself or herself and responds to the call, which, very often, is almost everyone, does not pre-exist the call but is summoned into existence in that very moment (170). The law-abiding citizen comes into being as a result of interpellation, of calling and summoning, he or she does not pre-exist the hailing. Interpellation is thus, according to Butler's (1997a) reading of Althusser, not an 'act of recognition but an act of constitution' (3). If such and similar interpellations are enacted every day, in the public sphere, in schools and universities, at work and through advertising, as is invariably the case, they come to form identities. They shape acceptable as well as unacceptable identities. Acceptable identities – whereby the word 'identity' refers to one's unique being but also to one's race, ethnicity and sexual orientation – are those that are affirmed as identities; others are socially disregarded and denigrated. As Foucault (2003) has argued, once otherness is constituted as a threat to the accepted forms of identity, acceptable identities – white, heterosexual, tax-paying individuals, as opposed to the immigrants, the homeless or transsexuals – learn to desire, even demand, their exclusion from the sphere of civic rights and moral obligations (243). In *Gender Trouble*, Butler takes issue with one of the core aspects of identity and subjecthood, namely gender. She argues that gender is not a given but is socially construed. This is very different from what is claimed by biological essentialism, which is that sex and gender are one and the same, and that, in the face of these 'universal genetic dispositions' as biological essentialist E. O. Wilson (1979) calls them, there are only three choices: 'to exaggerate them, to fight them

or to accept them' (132). This sort of thinking, which welds gender to heter-
onormative practices – practices that prescribe heterosexuality as natural
and homosexuality as deviant – comes from a problem present, once again,
in Freud. As numerous theorists, such as the Danish-American author of
The Freudian Subject, Mikkel Borsch-Jacobsen (1988), have argued, for Freud,
gendered identity is a linear development. It begins with the child's primary
identification, with his or her mother. This is followed by secondary identi-
fications, produced by the child's relationship to its siblings. The male child
appropriates male gender identity by identifying as not-the-mother-figure.
This is a primary identification. Therefore, in secondary identification, the
male child begins to desire the opposite gender. Conversely, the female
child identifies with the mother figure and acquires female gender identity.
This makes her desire the opposite gender – men. For Freud, this acquisition
of gender identity is natural. His explanation of any deviance from this
binary system of oppositions, such as homosexuality, is also rooted in bina-
rism. If a woman desires a woman, it is because she identifies with men and
consequently desires the binary opposite of male gender (183–184). Butler
(1990) rejects this narrow binary opposition on two counts: first, gender is
not a fixed aspect of identity; it is a performance. Second, it consists of an
infinite number of variants:

> If the sexes appear to be unproblematically binary in their con-
> stitution, there is no reason to assume that genders ought also to
> remain as two ... When the constructed status of gender is theorized
> as radically independent of sex, gender itself becomes a free-floating
> artifice, with the consequence that man and masculine might just as
> easily signify a female body as a male one, and woman and feminine
> a male body as easily as a female one. (6)

There are plentiful examples of non-binary divisions of genders in other
cultures. As sociologist Michael S. Kimmel (2008 [2004]) notes in *The
Gendered Society*, biology is not destiny. In fact, it is no more than a culture-
specific construct. The Mohave, a Native American culture, recognise four
genders: male, female *alypha* and *hwame*. A boy who shows preferences for
feminine clothing or toys undergoes different initiation rites at puberty;
he becomes an *alypha* by adopting a female name, painting his face the
way women do, and marrying a man. Equally, if a girl shows preferences
for male clothing and toys, she undergoes an initiation rite and becomes
a *hwame*. She goes on to live as a man, hunting, farming and assuming
paternal responsibility for children (69–70). Anchoring gender in sex is but a
cultural choice, one among many. As Butler (1990) notes, gender 'is neither

the causal result of sex nor seemingly fixed on sex' (6). Instead, it is a performance, created with, through and for another or a collectivity of others. We are all familiar with the experience of suddenly feeling short when in the company of extremely tall people, such as a basketball team. Likewise, when in the company of people much shorter than us, we will, quite likely, look for ways of making ourselves shorter than we are, by bending over or sitting down. This 'feeling' is exactly the same when applied to femininity or masculinity. There are people who make us feel more or less feminine or masculine. All these oscillations mean that 'the universal conception of a person is displaced' since, relationally, what a person 'is' and, indeed, what gender 'is' is always 'relative to the constructed relations in which it is determined' (10). This is why Butler uses the example of drag, which stands for gender performance as such. Citing Esther Newton, who in *Female Impersonators in America* proposes that drag is a 'double inversion that says "appearance is an illusion" in the sense that "my outside" appearance is feminine, but my essence "inside" is masculine', while it, at the same time, symbolises the opposite inversion; 'my appearance "outside" is masculine but my essence "inside" is feminine' (Newton cited in Butler, 1990: 137), Butler proposes that there are multiple relations of sex to gender and that there is no such thing as a 'unified woman' (Butler, 1990: 137). Rather, it is the performance, as in drag, that creates a unified picture of 'woman' or 'man'. The idea that gender is not fixed, essentialist, but performed, as well as the implications this has for identity politics at large, was explored by many artists, among which Adrian Piper, Tim Miller and Vaginal Davis.

Adrian Piper's *Mythic Being*, an anti-essentialist gender performance

A conceptual artist and philosopher of African descent, Adrian Piper is a biological female. Between 1973 and 1975, she adopted the male form in a life performance entitled *Mythic Being*. As noted in the previous chapter, the 1970s were a time of rebellion against patriarchy and heteronormative rules. Identity politics, as well as life performance – performance that did not take place on a stage with an auditorium or in a gallery but in life – was very much the order of the day. These performances often incorporated personal experience as well as fiction and mythology. For example, in 1972, Linda Montano started performing her *Chicken Woman* in the streets of San Francisco. This was followed by a number of male personas, among which the moustached man, Lenny. At the same time Eleanor Antin could be seen in the streets of San Diego as the King of Solano Beach, a seventeenth-century nobleman who made regular appearances acting as if this area of

San Diego were his kingdom. Waving benevolently, the King enquired about his subjects' health and life conditions, even allowed them to kiss his hand. Lynn Hershman, whose work will be discussed in the following chapter, created a persona called Roberta Breitmore. Breitmore existed as a physical as well as a legal entity; she joined gyms and consumer clubs; she had bank accounts and medical records. Although Suzanne Lacy's work in this area took place a little later, in 1977, her *Bag Lady*, performed in the streets as well as around San Francisco's De Yong Museum, thematised the less acknowledged forms of identity – the homeless and the elderly who are often perceived in negative terms – as not having a social identity because they do not have a home and cannot find work. Like these performances, Adrian Piper's *Mythic Being* created a platform for a visceral critique of unified gender as a norm. As Butler (2004) notes in *Undoing Gender*:

> A norm is not the same as a rule ... A norm operates within social practices as the implicit standard of *normalization*. ... Norms may or may not be explicit, and when they operate as the normalizing principle in social practice, they usually remain implicit, difficult to read, discernible most clearly and dramatically in the effects they produce. (41)

One of the ways in which Piper's *Mythic Being* disturbed gender norms – both male and female – was through a series of appearances in a widely read newspaper, *The Village Voice*. In the advertisement section of the September 1973 issue, a photo of a moustached man with a big Afro appeared. In the 1970s the Afro was a hairstyle with an iconic significance. Having been popularised by the Black Panthers in the 1960s, it was a sign of radical politics, youth culture and anti-consumerism. Wearing a turtleneck and sunglasses and posing with a cigar, the *Mythic Being*'s photograph was accompanied by a thought balloon, of the sort usually found in comic books: 'Today was the first day of school. The only decent boys in my class are Robbie and Clyde. I think I like Clyde. 9-21-61' (Piper, 1996: 103). Another such advertisement, which appeared on 3 January 1974 read: 'No matter how much I ask my mother to stop buying crackers, cookies and things, she does anyway, and says it's for her, even if I always eat it. So I've decided to fast. 12-12-64' (110). Whereas the context of the first advertisement seems to be in contrast with the cool persona of the person apparently thinking it, the second is even more confusing. The man with an Afro and a cigar may well have suffered from weight-related problems and body consciousness in his adolescence, but would he have placed an advertisement in the *Village Voice* to draw our attention to this? Still more

confusing were texts with relational overtones: 'I told him we were just platonic friends, so he said he'd never jump on me unless I jumped on him first. Well, that's all right. When I'm ready to jump on him, I will. 1-9-65' (110). These texts were fragments of Piper's adolescent diary, transplanted into the thoughts and mouth of, in Piper's own words, 'a third-world, working-class, overtly hostile-male' (147; 263). Being a Harvard-educated middle-class female, this persona was far removed from Piper, in terms of not only gender but also class. Since *Mythic Being*, shown in Figure 8.1, was performed in public environments, on buses and on the subway, in parks, at concerts and exhibition openings, the bubble texts were used as 'mantras' in multiple live settings, too.

The criteria for the mantras, as Piper calls it, was their shortness, containing 'the term and be[ing] about an "I"', and dealing with important events, or relationships in Piper's life (103). In these settings, the mantras were sometimes used as communicational devices, which, needless to say, had a jarring effect. The reason for this is that identity is a semiotic system, based on naturalised norms. Piper recalls the experience of dancing with abandon in a club, then catching a glimpse of the dancing figure in the mirror, which brought about two realisations: that the figure in the mirror

Figure 8.1 Adrian Piper, *The Mythic Being*, New York, 1973. Video, 00:08:00. Excerpted segment from the film *Other Than Art's Sake* by Peter Kennedy. Detail: Still #2. Collection of the APRA Foundation Berlin. © APRA Foundation Berlin.

was how people perceived her, and that this was the person she 'performed' (97). We are all familiar with performing the good son or daughter to meet our parents' expectations. Once a fixed image of a person has been created, it functions as a form of Althusserian interpellation; it binds the person to it. By performing a person radically different from herself, Piper exposes this infinitely malleable territory that is the performance of identity in relation to (often implicit) social norms. She re-inscribes her experiences into a different gender and class. But Piper also exposes another territory as well as system of inscription. She describes her persona as:

> a fictitious or abstract personality that is generally part of a story of folktale used to explain or sanctify social or legal institutions or natural phenomena. The 'mythic' persona is a personality who is at the same time not an individual but nevertheless has a personal history and experiences. (108–109)

In Butler's discussion of Irigaray's notion of the female 'lack', the male subject is abstract and disembodied; its subjecthood resides precisely in the negation of the body. Maleness is thus stereotypically associated with thought, idea and the realm of the spirit. Butler (1990) writes:

> The subject is abstract to the extent that it disavows its socially marked embodiment and, further, projects that disavowed and disparaged embodiment on to the feminine sphere, effectively renaming the body as female. This association of the body with the female works along magical relations of reciprocity whereby the female sex becomes restricted to its body, and the male body, fully disavowed, becomes, paradoxically, the incorporeal instrument. (11)

Piper's *Mythic Being* is thus abstract, non-specific and male in the Butlerian sense of the word. It uses the female body as a form of appearance, since Piper's body, despite the guise, is and remains female. *Mythic Being* is also abstract in the sense that it is vaguely reminiscent of the Black Panthers, as well as of Che Guevara and Fidel Castro, both of whom were very often photographed with cigars in their hands and who were iconic figures of the time. And yet, through this abstraction, another identitarian non-place is indicated – that of black women. As Audre Lorde (1979), a black feminist theorist, suggests, black women were seen as 'neither women nor black' (31) by the dominant gender/race fighter groups, namely white women and black men. One of the few possibilities of articulating their concerns in the public domain was to consciously blur the distinction between being

a man and a woman. Lorde called this 'acting like a man to perform anger as a way of representing some of myself as a woman that I am reluctant to acknowledge or explore' (31). This particular male form, which according to Piper (1996) is an 'emblem of confrontation', having been appropriated, 'hostility, fear, anxiety, estrangement' could be expressed in the public space (138). However, as Piper soon realised, this freedom came with a toll, too, related to the implicit perceptions of the various identities. Piper admits that when she dressed as the *Mythic Being*, 'people reacted to me [her] as though I were a black male, and that's incredibly unpleasant. White women would clutch their purses and go into neighboring cars in the subway – the usual bag of tricks' (Piper cited in Shatz, 1998: 46). This is why she potentialised such ideas, as in the part of the *Mythic Being* performance she referred to as *Getting Back*, performed with David Auerbach in 1975. This performance consisted of Piper loitering on the sidewalk and reading a newspaper, with Auerbach leaning over her shoulder trying to catch a glimpse of what she was reading. To this, *Mythic Being* reacted with 'violent, barely suppressed anger, then proceed[ed] to mug him [Auerbach] and steal his money' (Piper, 1996: 147). Piper's persona was affirmed through her participation in the public context of New York City and through 'being given recognition as a separate being by people on the street, in stores and in subways' (147). However, Piper also played with received images and prejudices, such as that mugging people is a 'natural' thing to do for black men. Essentially, *Mythic Being* is a performative meditation on the Butlerian forging of identity, which occurs in-interaction with others, since it is through recognition – categorisation as well as prejudice – that opinions about who one is, one's habits, one's very modalities of being are created. These modalities concern not only gender and race but also sexual orientation, which was poignantly explored by Tim Miller.

Tim Miller: queer performance as politics

Dancer and performance artist Tim Miller's approach to identity, and the formation of identity, is very different in that it solicits as well as facilitates public affirmation. In an article entitled 'Preaching to the Converted', co-authored with David Román, Tim Miller (1995) discusses frequent criticisms his performances, in particular, *My Queer Body*, have received. In a nutshell, these criticisms state that this performance, which consisted of autobiographical material, derived through the body, a queer body, at a time when the AIDS epidemic decimated not only the homosexual population but the entire population, was nothing but 'preaching to the

converted' (173). This phrase has a derogatory as well as smug meaning. In the artistic context, it means that the work has nothing new to offer, and that the support it enjoys from predictable audiences is sub-standard, since it is not the quality of the work but the cheap fraternising with the audience that sustains attendance. This is because of the long history of regarding aesthetic contemplation – art conceived as 'high culture' discussed in Chapter 6 – as something entirely separate from the world, a privileged bubble from which 'mundane' things are excluded. Audiences gather in venues segregated from the rest of life – in theatres, concert halls, exhibition spaces – to imagine a better, more ideal form of social life, beyond the grim reality, but without any reference to the specific, the local and the concretely problematic. The condition for this con-templation is that the ideal reality be removed from any specific, local, concrete reality. By contrast, Miller's work proposes direct action which relies heavily on what can be termed affirmative interpellation, an open hailing and thus drawing of attention to issues that need to be addressed collectively. As Miller notes in an interview with dance scholar Sally Banes, from the very beginning, from his early collaborations with such choreographers as Steve Paxton at New York's P.S.122, he was looking for ways of integrating 'basic issues of community [reactions to injustice and oppression] with "participation" and ritual' (Miller in Banes, 2001: 111). Miller states: 'I wanted to be performing in an ongoing process ... more like real life ... like going to a church ... like *real* research' (112, emphasis original). Miller's work is often autobiographical, but, as Banes (2001) suggests, 'his autobiography resonates with the events he has felt compelled to witness or to cull from collective memory' (110). In the por-trayal of these events, his life and body 'become the arena where images of war, revolution, depression, and other political disasters' are acted out (110). Miller (1995) describes *My Queer Body* as 'a journey through the most intimate pleasures and pains of being in our bodies in these difficult times' (169). At a point in the piece, Miller wanders naked out in the audience. In his own words,

> I look them in the eye and acknowledge them as the community occupying that theatre for that evening ... I sit on one of the audience members laps and look in their eyes. My butt naked on their laps. I try to speak clearly to them: 'I'm sitting here with you now. I see your eyes. I see myself in your eyes. I could try to tell you some more sweet or scary stories like I was doing up on stage in those big red theatrical lights. But it wouldn't really matter what I did. Cause, right now sitting with you, whatever I do is gonna be wetter and

messier and more human and more complicated than when I stand
up there on the stage and think I'm gonna take you nice people into
a volcano.' (169)

This particular gesture is a performative inauguration of a single, unified
social body, through Miller's own body, which is both very real and a
symbol of vulnerable human flesh in danger. While sitting on the audience
member's lap, he talks about all the people who are 'really sick right now'
(170) and about the need to cross the border imposed by the skin, within
whose confines a single, individual body resides. Here, a direct connec-
tion between an individual body and the social body is sought, which can,
indeed, occur through performance. Performance is here used to create a
communal identity, a communal recognition, within which the present
individuals may situate their specific concerns, some of which are created
directly by the lack of visibility and lack of recognition. As soon as the per-
formance is over, Miller comes back to the stage and invites the audience to
climb up and talk to him or to each other. This literal touching and direct
communication after the performance is something that is often seen in
religious ritual, for example in gospel. The pronouncement of the words
which seek to connect or heal here inaugurate a new state, a state of cama-
raderie and understanding. This form of address can be seen as a positive
interpellation. In *The Psychic Life of Power*, Butler (1997b) discusses the
Althuserian interpellation in relation to God's word. She proposes that the
reason why address produces the desired state in the addressee is because,
in some way, the addressor has the power over the addressee. Butler writes:

> Baptism exemplifies the linguistic means by which the subject is
> compelled into social being. God names 'Peter' and this address
> establishes God as the origin of Peter; the name remains attached to
> Peter permanently by virtue of the implied and continuous presence
> in the name of the one who names him. (111)

In religious sermons it is the priest, the intermediary between God and the
faithful, that directs the prayer to God or, as in the Catholic confession,
pronounces the subject absolved. The church has, in its many forms, kept
this direct, unambiguous interpellation by which the priest calls worlds
into being, through speech and through ritual. Miller's reliance on a simi-
larly direct link between the actions performed and the words used is
directly interpellative. It makes not only possible but also *actual* a very
different world from the homophobic climate of the times. Miller's idea
of forging a community, however tentative, rests on the assumptions that

community is a political necessity and a viable possibility. Such a direct approach has much to do with the fact that in the current society, modes of behaviour and identities are not controlled through direct repression. Instead, the ruling groups work to establish hegemony. According to cultural theorists John Clark, Stuart Hall and others (Clark et al., 1976), this means that they work to 'contain opportunities, to win and shape consent, so that the granting of legitimacy to the dominant classes appears not only 'spontaneous' but natural and normal' (38). An important part of this supposedly transparent legitimacy is gained in the cultural sphere, where specific ideas are placed in the public imagination. Here, they appeal to the supposedly universal human spirit, because of the above-mentioned association of culture with disinterested contemplation. In reality, they are places where consent is engineered. By watching only heterosexual relations and representations thereof in the theatre, art and film, heterosexuality is implicitly affirmed as a norm, which makes other forms of sexuality deviant. The clearest example of the way that political forces shape the content shown in art venues is the famous de-funding of Tim Miller, Holly Hughes, John Fleck and the already mentioned Karen Finley. The National Endowment for the Arts in the United States, chaired by John Frohnmeyer, withdrew funding from the 'de-funded four' – as they came to be known – in June 1990. The reason for this was obscenity. Not unimportant is the fact that three of these artists, all but Finley, are homosexuals whose work openly addresses non-heterosexual content. As for the consent-engineering aspect of the affair, the four artists sued the National Endowment for the Arts, won, and received their funding in 1993. However, as Miller (1991) notes in 'An Anarchic, Subversive, Erotic Soul', his work was henceforth nevertheless seen as obscene: 'Every review referred to my work as "pornographic", a word that I don't think had even been used in a review before'; audiences 'were there with a clicker noticing what might be problematic or objectionable' (Durland and Miller, 1991: 171). It is for this reason – the ease with which, in the public domain, stigmatisation is accepted and unacceptable identities are forged – that positive interpellation through performance, such as that of *My Queer Body*, is necessary, not as a form of 'preaching to the converted' but as a form of resistance.

Disidentification: Marga Gomez and Vaginal Davis

In her 1991 performance *Marga Gomez is Pretty, Witty and Gay*, Marga Gomez, a Puerto Rican/Cuban-American performer and writer, recounts the process of early adolescent identification. Humorously, this is triggered

by a talk show, called *Open End*. The episode in which disguised female homosexuals appear is presented by Gomez (cited in Muñoz, 1999) thus:

> I sat next to my mother on the sofa. I made sure to put that homo-phobic expression on my face. So my mother wouldn't think I was mesmerized by the lady homosexuals and riveted to every word that fell from their lips ... All disguised in raincoats, dark glasses and wigs. It was the wigs that made me want to be one. (3)

She then imitates the lesbian interviewees: 'Mr. Suskind, I want to thank you for having the courage to present Cherene and Millie and me on your program. Cherene and Millie and me, those aren't our real names. ... We must cloak ourselves in a veil of secrecy or risk losing our employment as truck drivers' (3). Gomez here plays on the often only semi-successful public concealment of blatantly obvious facts which only emphasise the obsoleteness of such pretences. While ridiculing the need for secrecy – the wigs, the supposedly false names – she also portrays the very serious problem of representation from which lesbians are often excluded. In this sense, Gomez's work functions like Miller's, in that it, in the words of per-formance scholar Jose Esteban Muñoz (1999), 'permits the spectator, often a queer who has been locked out of the halls of representation or rendered a static caricature there, to imagine a world where queer lives, politics, and possibilities are representable in their complexity' (1). However, the problem with representation, particularly for individuals who are doubly minori-tarian in relation to heteronormative identity politics – both in terms of sexuality and in terms of ethnicity – is the impossibility of an easy, mono-lithic identification. Much like the position of women discussed in the pre-vious chapter is synonymous with lack, deficiency and/or ineptitude, the position of the minoritarian subject is a negative one. It is seen in relation to the majoritarian subject, where it is *not* like the majoritarian subject. Muñoz offers two important accounts of identification in order to explain the process of disidentification through which a tenable identity position can be created. The first definition of identification is derived from French psychoanalysts Jean Laplanche and Jean-Bertrand Pontalis (cited in Muñoz, 1999), who propose that identification is a 'psychological process whereby the subject assimilates an aspect, property or attribute of the other and is transformed, wholly or partially, after the model the other provides' (7). This seemingly simple and straightforward definition is supplemented by another, more nuanced one, provided by Jewish-American critical theorist Eve Kosofsky Sedgwick:

Identification always includes multiple processes of identifying with. It also involves identification as against ... Identifying with an object, person, lifestyle, history, political ideology, religious orientation and so on, means also simultaneously and partially counteridentifying. (Sedgwick cited in Muñoz, 1999: 8)

What Sedgwick is proposing here is that identification is not only positive – accepting and appropriating somebody else's ways – it is also negative in the sense that it clearly marks that which the subject does not want to be in order to arrive at what the subject wants to be. Counteridentifying is identifying with the opposite of what is offered as a model in any given context. However, disidentification is not the same as counteridentification. For Butler, disidentification is a failure of identification, a point at which the subject says: 'I am not and cannot be like this'. But it is also a politically productive failure, which can serve as 'the point of departure for a more democratizing affirmation of internal difference' (Butler cited in Muñoz, 1999: 12). In other words, while La Planche, Pontalis and Sedgwick stress the nuanced nature of identification, and the simultaneous counteridentification, for Butler, the failure to identify with what is presented strengthens the individual's specific internal identification. Since identity is not monolithic, but consists of many identifications with various political, cultural, social, familial, erotic, and aesthetic facets of the world, and the people who inhabit it, it is important to be aware of an entire spectrum of possibilities present in any given cultural form. This wealth of possibilities calls for skilful navigation. Disidentification, in Muñoz's view, is precisely that micro-tactics that can be used to expose or oppose the norm. In *The Psychic Life of Power*, Butler discusses the relationship between the external norm, its internalised form and the subject's consciousness. Butler (1997b) writes:

Conscience is the means by which a subject becomes an object for itself, reflecting on itself, establishing itself as reflective ... The 'I' is not simply one who thinks about him- or herself; it is defined by this capacity for reflective self-relation ... In order to curb desire, one makes of oneself an object for reflection. (22)

If, however, one has desires that one's conscience does not approve of – and we will remember from Chapter 1 that Nietzsche's interpretation of consciousness, to which Butler makes a reference, is that of coagulated clichés, inherited from others – one will, in fact, begin to subjugate oneself. This is why it is important to understand the enmeshed-ness of subject and social

environment and, within this context, the importance of representing not only other identities but also entire processes of identification as well as disidentification. Exemplary in this context is the work of Vaginal Davis, African-American composer, singer, performance artist and activist, and, in particular, his work *The White to be Angry*. While his name is an homage to and an anagram of Angela Davis's name – a political activist involved with the Black Panthers – *The White to be Angry* was a live club performance and a CD produced by a musical group called Pedro, Muriel and Esther. Davis lucidly describes some of the phases of the minoritarian subject's identity formation in the following way:

> When you come home from the inner city and you're Black you go through a stage when you try to fit the dominant culture, you kinda want to the white at first – it would be easier if you were white. Everything that's negrified or Black – you don't want to be associated with that. That's what I call the snow period – I just felt like if I had some cheap white boyfriend, my life could be perfect ... I could feel myself projected through some white person, and have all the privileges that white people get – validation through association' ... Then there was a conscious shift, being that I was the first one in my family to go to college – I got militant. That's when I started reading about Angela and the Panthers, and that's when Vaginal emerged as a filtering of Angela through humor. (Davis cited in Muñoz, 1999: 97)

The White to be Angry performance consists of a band and Vaginal Davis's performance of two characters: a naïve black girl who declares that she finds white supremacist militiamen attractive to such a degree that she herself has had both a race and a gender reassignment and is now a white supremacist militiaman called Clarence. Davis's (consecutive) performance of the two characters – the naïve black girl and the white militiaman, whose name, Clarence, is, in fact, Vaginal Davis's real name – is relevant to the way disidentification relates to identification. Clarence is dressed in a military outfit, his face is painted white and he sports dark glasses, a hat and a long beard. He sings a number entitled '*Sawed-off Shotgun*':

> I don't need a 'zooka
>
> Or a Ms. 38
>
> I feel safer in New York
>
> Than I do in L.A ...

My shotgun is so warm it

Keeps me safe in the city

I need it at the ATM

Or when I'm looking purdy

In its convenient carrying case

Graven, initialed on the face

Sawed-off shotgun … (105)

Performing his militiaman identity, Davis plays heavily on the associ-ation of the weapon and male genitals, while commenting on the need to protect white rights in cosmopolitan cities where whites feel threatened by the various minorities, threatened by, in the first place, difference, which they often do not understand, do not want to understand and therefore dislike, and threatened by the possibility of losing their position of priv-ilege. Another one of Clarence's songs tackles a similar paranoid obsession:

A homosexual

Is a criminal

I'm a sociopath, a pathologic liar

Bring your children near me

I'll make them walk through the fire

I have killed before and I will kill again

You can tell my friend by my satanic grin

A homosexual is a criminal. (107)

This is the point in the performance when a striptease begins, the white supremacist personality is shed away and a black female appears. This transformation from a 'white supremacist' to a black woman, who is, in fact, a man, embroils the supposedly tidy race and gender categories. The white supremacist is defiled through his association with blackness and homosexuality, while black subjects are portrayed as desiring precisely that which oppresses them. This is the self-subjection Butler speaks of, the cycles of consciousness produced through self-reflexivity, which is both formed by the norm and reproduces the norm. Furthermore, it is rare that a human being desires or desires to be something they have never seen or been in contact with. Far more often, they will desire to occupy subject positions that are depicted as worthy and dignified. In offering the above

kaleidoscopic view of identity as connected through sexual desire as well as through the desire to be acknowledged, to be visible, Davis shatters the notion of a unified identity of any kind. At the same time, his performance undermines the very possibility of dominance, since one is here asked to reflect on the interdependent formation of all identities. What a subject will (want to) identify with or disidentify from is always dependent on the already existing relationships that have always already shaped and determined these desires. Davis's performance of the white supremacist is also a performance of a position of power, which, however wrong, can be, and, in fact, is desired by disempowered and marginalised subjects precisely because it is a position which makes a troubled life considerably easier.

Guillermo Gómez-Peña and Coco Fusco: injurious deeds, injurious words

In March 1992, performance artist Guillermo Gómez-Peña and writer and artist Coco Fusco performed *Two Undiscovered Amerindians*, also called *The Couple in the Cage* at Irvine. Staged in a cage and exhibited in a museum, this performance consisted of presenting the supposedly aboriginal inhabitants of an island off the Gulf of Mexico, overlooked by Columbus, to the general public. The aboriginal inhabitants (Gómez-Peña and Fusco) were placed in a cage so that their rituals of 'authentic' daily life could be observed. As Fusco (1995) recounts in *English is Broken Here: Notes on Cultural Fusion in the Americas*:

> We called our homeland Guatinau, and ourselves Guatinauis. We performed our 'traditional tasks', which ranged from sewing voodoo dolls and lifting weights to watching television and working on a laptop computer. A donation box in front of the cage indicated that, for a small fee [one dollar] I would dance (rap music), Guillermo would tell authentic Ameridian stories (in a nonsensical language) and we would pose for Polaroids with visitors. Two "zoo guards" would be on hand to speak to visitors (since we could not understand them), take us to the bathroom on leashes, and feed us sandwiches and fruit. At the Whitney Museum in New York we added sex to our spectacle, offering a peek at authentic Guatinaui male genitals for $5. A chronology with highlights from the history of exhibiting non-Western peoples was on one didactic panel and a simulated Encyclopedia Britannica entry with a fake map of the Gulf of Mexico showing our island was on another. (39)

The entire performance was a sustained interpellation of the Althusserian kind, as can be seen in Figure 8.2; it used authoritative ways of communicating information and well-established modes of representation: the eighteenth-, nineteenth- and early twentieth-century habit of exhibiting peoples which colonial, Eurocentric regimes labelled as 'savage'; a location legitimated through cultural practice – a museum – with its personnel, strict entry and behavioural rules (no touching of the exhibits, no ice-cream, in some museums even a prohibition on wearing shorts); and a legitimate medium of knowledge dissemination – Encyclopedia Britannica. In addition, 'experts' with an 'Ask Me' sign were available to explain the natives' dress, habits and origins.

This is, in many ways, the opposite of Davis's work as Gómez-Peña and Fusco's performance exposes, and questions, the very tools of legitimation, precisely because they are presented in a legitimate and *legitimising* way. As Fusco notes in an interview for the BOMB magazine:

> When we created this piece, our original intent was not to convince people that the fiction of our being Amerindians was a reality. We understood it to be a satirical commentary both on the Quincentenary celebrations and on the history of this practice of exhibiting human

Figure 8.2 Coco Fusco and Guillermo Gómez-Peña, *The Couple in the Cage or Two Undiscovered Amerindians*, Madrid, 1992. Photo by Nancy Lytle. © Coco Fusco and Guillermo Gómez-Peña. Courtesy of Coco Fusco.

beings from Africa, Asia, and Latin America in Europe and the United States in zoos, theaters, and museums. (Johnson, 1993: np)

However, many people did, indeed, think Fusco and Gómez-Peña were Amerindians; they even believed they understood the invented language. According to Fusco, 'one man in London translated Guillermo's story for another visitor' (np). Many of the visitors also related to them in a sexual manner and openly asked to see Fusco's breasts; apparently, a woman at Irvine 'asked for a rubber glove in order to touch Guillermo and started to fondle him in a sexual manner' (np). Interesting to observe here is that in many cases viewers behaved in ways suggested by the 'tradition' of exhibiting human beings in such shameless ways. In other words, they seemed to be hailed by the authoritative citation. It is hard to imagine audiences behaving like this outside the colonial frame, for example in a space with no cage, Encyclopedia Britannica, and no ritual of being escorted to the toilet on a leash. However, all these citations provided interpretative parameters, much like the actions of the viewers when seen and repeated by others. In *Excitable Speech*, Butler (1997a) proposes that 'one is brought into social location and time through being named. And one is dependent upon another for one's name, for the designation that is supposed to confer singularity' (29). The fact that Gómez-Peña and Fusco have named themselves as those who have been overlooked but are now discovered, which puts them in a voiceless position, since the aboriginal is not supposed to have an opinion or, even, the ability to articulate his or her thoughts (which is the reason why the white coloniser has to speak for and on behalf of the colonised subject), others treated them as such. In this way, the 'savage' reaffirms the cultural supremacy and authority of the acculturated subject, that is to say, the colonising subject. It also traces the process of counteridentification. The viewing subject appropriates the superior position, derived form the 'savage' subject's inferior position. In fact, the focus of this performance was, as Fusco (1995) notes, 'less on what we did than on how people interacted with us and interpreted our actions ... We intended to create a surprise or "uncanny" encounter, one in which audiences had to undergo their own process of reflection' (40). A documentary film, entitled *The Couple in the Cage: Guatianaui Odyssey* (1993) was also made of the performance where the numerous viewer interactions, which were, in fact, the main focus of the film, were shown. The film was made by Fusco and Paula Heredia; they interjected footage representing the daily rituals of the 'natives' with the interviews conducted with audience members. When the film was released, many of the interviewed viewers were displeased with having been duped. However, as performance scholar Diana Taylor

(1998) aptly points out: 'The Guatinauis, linguistically derived from "what now", demanded incredulity. Fusco and Heredia parodied Western stereotypes of what "primitive" people do. Every stereotype was exaggerated and contested – the sunglasses offset the body paint, the "traditional tasks" included working on a computer. When paid to dance, Fusco performed a highly unritualistic dance to rap' (167). Taylor goes on to ask, 'how could people believe and also feel so angry about having believed?' (167). Although unpalatable, the answer to this question may lie in the processes of identification and counteridentification. Modes of representation are at the same time modes of legitimation. What is presented is seen as 'true', because it is presented as 'true'. Other people affirm it as true – attendants, guards, other viewers – regardless of how unbelievable this 'truth' is. Not only that, but, as Sedgwick notes above, identity is derived through counteridentification. A person can therefore see themselves as civilised and non-savage when contrasted with the identity portrayed in the cage. Indeed, much like the law-obeying citizen comes into being as a result of interpellation, the civilised and therefore 'superior' citizen comes into being through the interpellatory process. This does not exonerate the audience, however. Rather, it points to the extraordinarily powerful effect legitimising props and acts – the encyclopedia, the attendants, the cage, the fact that the performers were taken to the toilet on a leash – have on the creation of what is taken to be reality. However fleetingly, a person can gain value, which they may feel they do not otherwise possess, through seeing themselves as not-the-presented savage. If the authoritative signs are not questioned but taken for granted, an identity is already constituted for the viewer – that of a benevolent observer of anthropological trends and discoveries, or even that of an enlightened viewer who 'understands' the language of the Guatinauis. All this affirms that identity constitution – how subjects come into being – is highly dependent on institutionalised roles, symbols and communication media.

The performative modes discussed in this chapter use a variety of methods and forms: cross-medial life performance in the case of Piper, ritual utterance in the case of Miller, club culture in the case of Vaginal Davis, interventions into museums in the case of Fusco and Gómez-Peña. They all deal with the way in which gender, sexual, race and social identities are formed in a variety of locales: in the street, in cultural institutions – galleries, museums, theatres – in the newspapers and other media, in clubs and through popular songs. The particular strategies employed rely heavily on performativity, whether of a linguistic, gestural, pictorial or musical kind. The one thing they all have in common is that

they deconstruct, or lay bare, the process of identification. This is done in several ways: through the bending of gender norms as well as abstraction (Piper), through affirmative identification (Miller), through disidentification (Davis) and through false identification (Fusco and Gómez-Peña). In other words, these performative strategies utilise the full array of channels and practices in which identity is produced in everyday life. In this sense, they build on everyday performance discussed in the previous two chapters and use precisely those performative modes that belong to the processes they seek to deconstruct, either through formal means (Piper), affirmation (Miller) or parody (Fusco and Gómez-Peña). In doing so they reflect on the process of socialisation responsible for the creation of social institutions, understood as systems of expected behaviour in given circumstances. Social institutions are mediating activities which regulate norms. They also conserve relationships and provide continuity over time, and in so doing constitute social roles and scripts. While roles are determined by the norms of the society they pertain to, scripts encapsulate established procedures by which people are accustomed to act in a recurrent situation. Exposing the essential performativity at the heart of all social roles, procedures and institutions demystifies not only sociality but, more importantly, the relation between sociality and biopolitics. Initially formulated by Foucault and mentioned in Chapter 7, this concept has been given a more radical turn by Italian philosopher Giorgio Agamben. For Agamben, biopolitics separates bare life – the physical life of a human being – from its political existence through the politics of exclusion. Biopolitics, which, for Agamben, includes all social and political processes, precisely because it decides what legitimacy is, controls the deepest dimension of all human beings. Homosexuals, transsexuals, immigrants, the undocumented and the homeless have all been, and still are, treated as criminals and denied basic human rights, such as health care. This does not have to do with legislation only but also with the circulation of ideas about normalcy in the public sphere. Famously arguing for a trans-temporal character of biopolitics, Agamben (1998) believes Auschwitz is the ultimate example of such political erasure: '[i]nsofar as its inhabitants were stripped of every political status and wholly reduced to bare life, the camp was also the most absolute biopolitical space ever to have been realized, in which power confronts nothing but pure life, without any mediation' (171). This was made possible through the legal constitution of the state of exception, which placed the camp outside the zone of civil jurisdiction. However, this legislation was itself made possible by manifold – social, medical, epistemological, ideological – practices of exclusion, all of which ratified and normalised exclusion. The above-discussed practices, which foreground everyday

identity production, are not to be compared with Auschwitz. Rather, as in Agamben, this comparison is used to calibrate the discussion about exclusion since what separates the 'normal' and the legitimate from the 'abnormal' and the illegitimate is not just (or, in many cases, no longer) the law. Instead, the law is the end product of an entire series of subtle hegemonic practices that consist of glances, postures and reactions to one's hair texture, grooming or dressing habits, and which, by the same token, lend these performative minutiae political urgency.

Scores:

1 Keep a gender diary for a couple of months. If you have one, use the diary you kept as a child/adolescent. How have you – the specific person that you are – performed your gender as a child/adolescent/adult? Think about the precise circumstances, people, places, actions and reactions. Map those experiences onto a different gender – a man, woman, a third gender person. Take pictures and/or make a short film about your other-gendered self. Perform this gender in the street, in bars, in cafés, shops, museums, cinemas.

2 Analyse your own identity in terms of ethnicity, class, cultural background, gender and sexual orientation. Have you sought refuge in your cultural or religious heritage, your class, social status, skin colour, ethnic origin, sexual orientation? Or, have your counteridentified, and, if so, how and why? Make an autobiographical performance that deals with these issues.

3 Think about how your ethnic, gender, social, cultural or religious identity is stereotypically perceived. Choose several of these stereotypical perceptions and exoticise them further, then turn them into an anthropological exhibit. Mount this exhibition in a public space – a zoo, a museum, a lecture hall.

PART III
The Digital Turn

The last decade of the twentieth century and the first decade of the twenty-first century were marked by the rise of the personal computer and the rapid growth of digital networks. This was the time when new technologies radically altered notions of space and time, both of which were compressed. Linear, consecutive time needed to cover physical distances gave way to instantaneous access to the most distant locations. French theorist Paul Virilio (2005) termed this condition the 'implosion of space and time', since 'journeying requires no displacement' but occurs in 'a *now* stripped of any here' (120, emphasis original). The end of the twentieth century was also the time of expansive globalisation. Although globalisation represents an intensification of certain aspects of capitalism – the structure of international finance, increased economic instability, the role of speculation – it is largely indebted to the rise of digital communications and to the dissolution of the nation state. A state is a geopolitical entity, while a nation is a cultural and ethnic one. With the radical alterations in the speed of access to data afforded by virtual communication, globalisation integrated national economies and cultures through the global network of trade, immigration and transportation. Virtuality came to occupy an important place in the conception of reality. Seen as the 'ability to work from a conceptual model, rather than actual experience' but 'act as if the actual experience had occurred', as theorised by American philosopher Charles Sanders Peirce (1960: 261), virtual reality signalled a radical change in the logic of originals and copies. In the actual world, an object, a pen for example, cannot be in two locations at once. If you are using it, I cannot use it at the same time. In the virtual world, however, individual possession is not an issue. The virtual world is based on access, not on possession. The process of digitisation has influenced not only notions of possession, individual and group, but also the way we perceive reality, knowledge and being. In the initial phase of digitisation, analogue materials, such as films and tape recordings, were digitised. This was followed by the promotion of new, digital working practices in all spheres of life, work and knowledge production, social networking included. The most recent phase seeks to re-conceptualise old, human-centred approaches to knowledge. This phase is also marked by the increasing hybridity seen, among other areas, in genetic engineering. In 1997, the first cloned animal – Dolly the sheep – was born. Although the life sciences and technology have been in close collaboration since the 1970s, accelerated technological development has radically changed both.

PART III
The Digital Turn

9 Mixing Reality

Donna Haraway's cyborg and Lynn Hershman's multiples

In the famous 'Cyborg Manifesto: Science, Technology, and Socialist Feminism in the Late Twentieth Century', American critical theorist and historian of science Donna Haraway (1991) suggests that all individuals in contemporary society have become cyborgs in their interaction with technologies. She uses the term 'cyborg' to refer to 'a hybrid of machine and organism, a creature of social reality as well as a creature of fiction' (149). However, important to stress is that Haraway's cyborg is not the science-fiction human–machine warrior derived through the military-entertainment complex. It is a figure that challenges assumptions about the human–nonhuman divide, which includes machines as well as animals, much like it challenges assumptions about the nature-culture divide. Numerous examples of this can be seen in multimedia artist's Lynn Hershman's work, dating back to her 1988–1990 series of black and white photographs entitled *The Phantom Limb Photographs*. Consisting of human bodies with cameras, monitors and cathode-ray tubes in place of limbs, all of which belong to the category of 'reproductive machinery', this series points to, in Hershman's (2005a) own words,

> the invasive nature of mass media and the ingestion of images that ultimately alter the projections of collective identity. Robotic append-ages further dehumanize the bodies, referencing a society evolving toward techno-human existence. (64)

Here Hershman implicitly includes Marshal McLuhan's famous theor-isation of the media, and technology in general, as extensions of human beings. In McLuhan's view, explained in his 1964 book *Understanding Media: The Extension of Man*, a medium is a form of prosthesis. When a blind person uses a stick, the stick is the extension of his or her hand as well as a replacement for the sense of sight; it serves to feel and understand the lay of the territory ahead. This is similar to the use of the telephone, which helps us to 'cross' the distance that separates us from the person we

want to communicate with. The telephone is an extension or a prosthesis. But apart from extending human reach, these extensions, or technologies, also require very specific modes of attention as well as afford different actions. McLuhan (1964) claims that it is not the content of the media that matters – whether we are watching a children's show or the news – but the medium itself. In McLuhan's famous phrase, 'the medium is the message' (7) the medium *modifies* human behaviour. For example, if we are talking to somebody on a mobile phone, we will be able to move around and touch objects. If we are watching television – not on our mobile phone but on a standard, static television screen – we will not be able to walk around and touch objects that are not in our immediate environment. Our physical stance and posture, our activity and our mode of attention are therefore influenced by the medium. Hershman's point is that the increasing use of an increasing number of media cannot *not* have an effect on the way we perceive the world around us, ourselves and others. Implicit in the *Phantom Limb* series, an example of which is Figure 9.1, is also the production of identity through the media.

Figure 9.1 Lynn Hershman, *What's Up?*, 1985. *Phantom Limb Series*, 1985–1987. © Lynn Hershman. Courtesy of Lynn Hershman.

Hershman's signature practice of merging technological and human iden-
tities, as well as processes, dates back to 1955, the year when she made her
first drawings. Here, she transformed female bodies by crumpling paper
and photocopying it. This highlighted the parallel between the techno-
logical reproduction and human reproduction. Human-technological
interfaces do, of course, have a long history; however, it was the intensive
technologisation of the last decades of the twentieth century that rendered
this interface politically increasingly relevant. Haraway's (1991) famous
phrase 'we are all chimeras, theorized and fabricated hybrids of machine
and organism ... The cyborg ... gives us our politics' (150) should be under-
stood in two key contexts. First, it should be understood in the context
of medical, professional and financial records, all of which are digitally
processed. Second, it should be understood in the context of the century-
long domination, exploitation and alienation. It should not be forgotten
that the reproduction of the self from the other, which counts as 'the one',
normatively incarnated in the figure of the white, heterosexual, entrepre-
neurially minded male, as discussed in Chapter 7, is also part of this trad-
ition. The politics of the cyborg therefore lie in amalgamating imagination
and action. The cyborg can imagine, create and communicate a world
without social, gender and racial normativity, but also without anarchy.
Haraway writes: 'the cyborg has no origin story in the Western sense – a
"final" irony since the cyborg is also the awful apocalyptic telos of the
West's escalating dominations of abstract individuation, an ultimate self
untied at last from all dependency, a man in space' (150–151). As Haraway
(1995) repeatedly stresses, the term 'cyborg' derives from the context of
space travel, where its key function was to adapt to, and learn to co-exist
with other environments (xv).

Surpassing all origin stories which depend on the myth of original unity,
divine presence and the ultimate point of origin – as theorised by Derrida
and discussed in Chapter 6 – but which continue to oppress the human
race through the narratives of the fall,

> the cyborg is resolutely committed to partiality, irony, intimacy, and
> perversity. It is oppositional, utopian, and completely without inno-
> cence. No longer structured by the polarity of public and private,
> the cyborg defines a technological polis [city] based partly on a revo-
> lution of social relations. (151)

The idea of a perfect unity, of the male and female uniting in a perfect
couple, of the nuclear family, or, of leaving this world, after death,
to unite with one's maker and become part of a bigger whole, are all

questioned by the cyborg, who, in Haraway's words, is 'wary of holism but needy for connection' (151). The reason for this is that there are no longer any clear connections between the progenitor and offspring, such as between the divine presence and the human race and, therefore, implicitly, between wholes and parts. Instead, there is the enmeshedness of flesh, prosthetics and media. Haraway's contention is that this augmented relationship to the environment has crucial implications for the concept of identity:

> Gender, race or class consciousness is an achievement forced on us by the terrible historical experience of the contradictory social realities of patriarchy, colonialism and capitalism. And who counts as 'us' in my rhetoric? Which identities are available to ground such a potent political myth called 'us', and what could motivate enlistment in this collectivity? (155)

Gender, class and race consciousness is, of course, necessary, but this consciousness is developed as a reaction to patriarchy, colonialism and capitalism. It is thus always already pre-formed by these very conditions to which it is a mere reaction. Once these exploitative concepts are taken away, Haraway argues, we are not stable, oppositional identities but multiple, hybrid selves depending on the context we find ourselves in as well as on other bodies and nonhuman entities (animals, machines) which form part of this context. Here, again, Hershman's work is prescient as well as comparable to Cage's simultaneous multiplicity, discussed in Chapter 3. As mentioned in the previous chapter, between 1971 and 1978 Hershman performed *Roberta Breitmore*, later to become *CybeRoberta*, a telerobotic doll through which the viewers could spy on the world by looking at it through the doll's eyes via an internet connection. Although *Roberta Breitmore* was performed in the actual, not in the virtual, world, she had the characteristics of an avatar. Coming from the Sanskrit word for 'spirit', as well as incarnation, avatars are graphic representations of physical people. Similarly, *Breitmore*, who was impersonated in the first instance by Hershman and subsequently multiplied and impersonated by three other women (the already mentioned art historian Kristine Stiles, Michelle Larsen, and Helen Dannenberg), was an avatar in the actual world. She wore a distinct costume and a blonde wig. She opened bank accounts, had regular health check ups, went to the gym and joined consumer clubs. All Breitmore multiples had two postal addresses: one for themselves, one for Breitmore. Each interacted with the world both as herself and as Breitmore, thus simultaneously inhabiting two identities. This is, of course, common practice on the internet, in

particular, in game worlds where avatars have names, costumes and entire invented histories. Interesting in Hershman's prescient practice, which, as we shall see below, was to shape her future work, was the notion of a physically distributed identity, identity produced in multiple contexts – legal, social – and (physical) sites at once: the gym, the dentist's, the consumer club. This highlights Haraway's point about identity not being welded to a single body but, instead, co-produced in, through and with multiple contexts. It simultaneously references Duchamp's Rrose Sélavy, Clair's and Picabia's medial displacements, and the practices discussed in the previous chapter while highlighting that identity is invariably fractured and plural from the very start.

Lynn Hershman: fractured identities

The key element in the creation of such distributed identities is interaction. In 1983–1984, Hershman produced the first tele-interactive work in the form of a video disc, entitled *Lorna*. Here, the viewers could make choices for the protagonist, Lorna, an agoraphobic woman, afraid of open spaces. Unable to leave her apartment, Lorna lived without any contact with the outside world. She was confused and had problems making choices for herself. The choice-making mechanism was thus also the interactive as well as the performative mechanism; by means of the choice menu, the viewer helped Lorna live her life. The interactive disc consisted of pre-recorded sequences; all objects in Lorna's apartment had numbers. When the viewer pressed an object, a video and sound files started playing. The content of these files were Lorna's fears and dreams, either directly related to the object, the hair brush, the shoes or the television set for example, or merely triggered by this object. The narrative structure was not linear. Each part of the story could be combined with a number of other parts to form different content. This structure was modelled on Argentine writer Jorge Luis Borges's famous 1941 story 'The Garden of Forking Paths', which consists of numerous characters, locales and periods whose mutual relationship is intertextual. Intertextuality refers to the ability of allusions and references not forming part of the initial story to influence the course of events within the story. For example, if a character in a sitcom makes a reference to a well-known actor, this reference is intertextual, since it refers to a world outside the world of the sitcom. In the case of interactive content, it means that any given choice leads to a specific sequence of events, whereas a different choice would have led to an entirely different sequence of events. There are segments of the

Lorna disc that can be viewed backwards or forwards, in slow motion, as well as from several perspectives. Although there are only seventeen minutes of moving footage on the disc, the thirty-six chapters can be differently sequenced; their meanings shift radically when placed in different contexts. Likewise, the video segments have multiple endings: Lorna may shoot her television set, commit suicide or move to Los Angeles. It is up to the viewers/interactants to find a logic in a labyrinth of possibilities; this openness, however, simultaneously reflects the protagonist's existential predicament. In fact, the illogical jumps and breaks in the action and sequences accentuate Lorna's psychological state. The fact that we, as interactants, trigger specific events and not others creates a sense of shared authorship. In many ways, *Lorna* is an extension of ideas explored by Duchamp, Cage and Fluxus concerning the relationship between rules and chance and discussed in Chapters 1, 3 and 6. However, *Lorna* also takes a fresh look at the passive-active divide. Lorna's passivity, caused by her being controlled by media, is a counterpoint to the direct action of the player. As Hershman (2005a) suggests, '[a]s the branching path is deconstructed, the player becomes aware of the subtle yet powerful effects of fear caused by media and becomes more empowered (active) through this perception' (78). This means that, apart from exercising agency, the viewer/interactant becomes progressively more aware of the agency of the media he or she is using. This introduces a third element into the active-passive dualism, which, in a pre-cyborgian universe, formed part of the male-dominated discourse. Although it is, of course, possible to see the technology as merely instrumental, we will recall Heidegger's theorisation of technology as a complex system of challenging forth, and not a mere means, as discussed in Chapter 3. If we also include Haraway's notion of human–machine enmeshed-ness with no clear divide, questions such as 'how can anything but a human being exercise agency?' soon become obsolete. As many digital communication theorists, such as Erkki Huhtamo (1995), suggest, interaction is related to an entire interactional configuration. It is related to temporality as well as to causality. Why something happens and the time frame it happens in are inseparable in the sense that the cause and the time are experienced as chief characteristics of an event, both in 'closed' and 'open' interaction.

In what Russian-American media theorist Lev Manovich (2000) terms 'closed' interaction, the participant plays an active role in 'determining the order in which already generated elements are accessed' (42), while in open interactivity 'both the elements and the structure of the whole object are either modified or generated on the fly' (42) in response to the participant's input. But if, as in the case of *Lorna*, the interactant's and

media actions have a clear effect on the protagonist, the merely 'manipulating' aspect is far less transparent to the viewer/interactant. Rather, it seems that both the viewer's and the protagonist's actions are shaped by the temporal-causal nature of their interaction. This is what is meant by Haraway's notion of an unstable and unfinished identity. This particular theme, expanded to include multiple identities without a single source, was further explored by Hershman in *Agent Ruby*, initiated in 1993 but finally realised in 1998. Here, the protagonist is an intelligent web agent whose identity, knowledge and relationships are shaped by her encounters with participants/interactants. This makes Ruby inhabit the actual and the virtual world simultaneously. While talking to participants/interactants, she remembers/stores their questions; if they come back, she recognises their voices, remembers their names and can even make references to former conversations. She herself appears in several forms. According to Hershman (2005a),

> Agent Ruby was designed to have a four-part life cycle: the website: the hub from which users communicate with Ruby via text messages. Beaming/breeding stations: Stations that allow users to replicate Ruby on their Palm handheld computers. Speech synthesis and mood swings: Speech synthesis enables Ruby to speak directly to users' typed responses; Ruby reacts with different moods. Voice recognition and dynamic processing of current events: Ruby understands spoken language; she comments on current events via real-time data culled from the Internet. (94)

Haraway's idea of cyborgs as beings with no origin can be seen in the entire *Agent Ruby* project, in particular, Hershman's 2002 film *Teknolust* in which Agent Ruby makes an appearance, too. In the film, a researcher named Rosetta Stone uses her own DNA to create three Self Replicating Automatons – Ruby, Marine and Olive – thus echoing the self-creation theme present in ORLAN's and Valie Export's work discussed in Chapter 7. The three automatons are named after the red, blue and green pixels used to create colour on computers. Ruby's role is that of an e-dream hostess in a portal where she teaches her visitors to dream and, more generally, talks to them about their emotional life. When as interactants we meet Ruby, we see the face of actress Tilda Swinton, who is Ruby, but also Marine and Olive. On the website, however, her features are overexposed, which makes her look less like a human being. Her facial mimic is over-accentuated, thus reminding the interactant that Ruby is not human but has merely borrowed human features. Of Ruby's performative dimension Hershman says:

> Once the counterfeit representations of life involved 'actors', 'per-
> sonae', or 'robots'; now the terminology includes 'avatars' and
> cyborgs'... These pixilated essences of virtual identity link into an
> archeology of networks that create a collective, connective ethnog-
> raphy of information. Data represents the coded spine of our evolving
> cyborgian posture. (69)

Although as human beings we are never static but in a permanent process
of change – as well as in a permanent process of learning – this is not how
we actively perceive ourselves, or each other. We do not perceive others as
knowing little about Iceland's ecological problems at the moment but on
the way to becoming leading experts on ecology in Iceland. Rather, we see
them as 'knowing little about Iceland full stop'. *Agent Ruby*, however, is pred-
icated on visible knowledge as well as on visible information-acquisition,
and brings a crucial human characteristic to light. In Hershman's words,
Agent Ruby is 'an Internet-bred construction of identity that develops
through cumulative virtual use, reflecting the global choices of internet
users. Agent Ruby evokes questions about the potential of networked con-
sciousness, identity ... and interaction' (92). At times intelligent and witty,
at other times sensitive and kind, Ruby is as vulnerable as a human being.
But she is also downloadable to Palm Pilot and can accompany the inter-
actant wherever he or she goes.

This shape-shifting is, of course, cyborgian but has another purpose,
too: it makes Ruby mobile and alters the fixation on sight at the
expense of other senses, something the digital world is, prone to do. In
'The Promises of Monsters: A Regenerative Politics for Inappropriate/d
Others', Haraway (1992), echoing Irigaray, whose work we discussed in
Chapter 7, speaks of the need for a re-appropriation of the sense of sight
effectively, in practice:

> Sight is the sense made to realize the fantasies of the phallocrats.
> I think sight can be remade for the activists and advocates engaged in
> fitting political filters to see the world in the hues of red, green, and
> ultraviolet, i.e. from the perspectives of a still possible socialism, fem-
> inist and anti-racist environmentalism. (295–296)

Haraway is right to note that the dominance of any given sense is political;
it shapes our experiences and our understanding of the world. However,
despite the fact that the digital turn is often associated with the dominance
of the sense of sight, in some practices, such Paul Sermon's, the cyborg
re-conceptualises the sense of sight.

Vision into touch: Paul Sermon's telematics

British artist Paul Sermon pioneered telematic work in the early 1990s and continued to make significant works – such as the 1992 *Telematic Dreaming*, the 1993 *Telematic Vision* and the 1996 *Telematic Encounter* – throughout the 1990s. The word 'telematic' refers to the conjunction of computers and telecommunications that Roy Ascott, British pioneer of networked art, first started applying to art in 1983. Crucial to his theory and practice of telematics was the transformation of the viewer into an active participator who collaborates in creating the work. The work is never a static product but remains in process throughout its duration. For Ascott, as for Haraway and Hershman, digital communication is radically different from its non-digital variant in that it is intrinsically networked; it is 'net thinking'. Ascott (2004) writes:

> the flow between my internal associations and my hypertracking is seamless. If I were not always on, umbilicaly connected to the Net – when I am reading, on the phone, mobile-texting or in face-to-face seminar mode – I would lose half of my imaginative thinking capacity... A new kind of romantic revival is at work here, not the romanticism of self-expression but that of self-navigation, of connec-tivism, a liberated, open-ended routing through the mind. (195)

Sermon's work, much like Ascott's, is based on this intrinsic connect-ivity, or 'connectivism' as Ascott calls it, which does, indeed, give onto an expanded consciousness, since the large proportion of the works are, in fact, the participants. A telematic connection consists of an internet phone line that connects two remote sites. This can be used in any setting, the basic principle being that two physical locations have something to sit or lie on: a chair, a sofa and a large monitor with a video camera. The video images captured at each site are simultaneously superimposed on both monitors so that people sitting on the chair or sofa at site A see themselves sitting on the chair or sofa with people at site B, and vice versa. Sermon's famous work *Telematic Dreaming*, which has been performed many times since its initial creation in June 1992, originally produced for the Koti exhibition at the Kajaani Gallery in Finland, went further in that it intro-duced a space usually thought to be strictly private – the bed. As Sermon recalls, the piece was produced in response to *The Ecstasy of Communication*, an influential book by French cultural theorist Jean Baudrillard whose work will be discussed in the following chapter. In order to explain the precise nature of this connection, Sermon cites Baudrillard:

The celibacy of the machine brings about the celibacy of 'Telematic Man'. Exactly as he grants himself the spectacle of his brain and of his intelligence as he sits in front of the computer or word-processor, the 'Telematic Man' gives himself the spectacle of his fantasies and of a virtual 'jouissance' [enjoyment, pleasure] as he sits in front of his 'minitel rose' [minitel was a pre-World Wide Web online service accessible through phone lines]. The Other, the sexual or cognitive interlocutor, is never really aimed at ... The screen itself is targeted as the point of interface. The machine (the interactive screen) trans-forms the process of communication, the relation from one to the other, into a process of commutation ... from the same to the same. The secret of the interface is that the Other is within it virtually the Same – otherness being surreptitiously confiscated by the machine. (Baudrillard cited in Sermon, nd).

In disagreement with Baudrillard, Sermon made *Telematic Dreaming* in order to show that the presence of a screen does not imply sameness or narcissistic self-absorption but, in fact, connectivity of an expanded kind. In two separate locations, two interfaces and with two double beds were set up. One of the beds was in a dark space, the other in a brightly illuminated space, with a camera above the bed sending a live image of the bed and the person lying on it – person A – to the dark bed in the other location, location B, where person B was lying. Another camera sent a video image of the projection of person A with person B back to a series of monitors that surrounded the bed and person A in the illuminated location. As Sermon notes, the 'telepresent image functions like a mirror that reflects one person within another person's reflection' (nd). In other words, it func-tions like superimposed film footage in which both images are visible. The presence of the bed was a direct response to Baudrillard's comment about bland sameness and the lack of eros; not only sleeping and dreaming but also erotic connotations were here brought into play. Susan Kozel (1994), the dancer who took part in *Telematic Dreaming*, discusses the version performed at *I + the Other: dignity for all, reflections on humanity* in 1994 in Amsterdam, in an article entitled 'Spacemaking'. After a series of observa-tions about the interactions between the cyber-body and the fleshly body, she concludes that 'virtuality is the new materiality' (np). There are several reasons for this. Both Kozel's movement and the movement of the visitor/ interactant occurred in real time. However, the space in which the inter-action occurred was entirely technologically mediated and could be seen by the audience. In improvisation, as in everyday life, people often spon-taneously create and follow patterns; when two people are in agreement

their body language is synchronised, their movements begin to follow the same rhythm and they often have the same directionality. Kozel recounts the many improvisatory sessions she had with different visitors/interactants in the following way:

> Movement usually began in a hesitant way with hand contact taking on excessive importance. The impact of slow and small movement became enormous. Great care and concentration was required to make intricate web patterns with the fingers of a stranger, or to cause one fleshly finger meet up with one video finger. When the movement progressed from these early stages to a sort of full body choreography the piece became an emotional investment which shocked and sometimes disturbed people. Some people simply froze, and fled the installation once they realised what it was about. (np)

Telematics amplifies the virtual aspect of any relation. When touching an actual person, a person we care about, in a non-telematic situation, we simultaneously touch them in a virtual, emotional way; that is, our movement is always invested with our perception of the person. Whether we touch them with caution, trepidation, tenderness, devotion or passion depends on our relationship with the person in question. In the case of a first time encounter, the quality of our touch depends on our past relationships with other people. A telematic relation magnifies this aspect; although there is something distant about touching a person via a screen, as opposed to touching them physically, which is clearly Baudrillard's point of comparison, this touch is also in many ways closer. As Kozel suggests, many audience members went a lot further than they might have done in a live but non-telematic situation. 'Some felt protective toward me, or stayed on the bed because they didn't want me to be alone in my virtual world. Others claimed to have been "changed" by the experience' (np).

These experiences were not always positive, however. A viewer took out a knife and brandished it – although, clearly, the knife could do no harm to Kozel's actual body, only to the bed – while another participant hit her. A part of the violent behaviour may have had to do with the challenge to perform, to do something memorable, something extraordinary, which interactants, aware of being watched by other members of the audience, sometimes felt. But it was also related to the fact that a telematic contact lies outside the normative arena of social behaviour predicated on physical proximity, and, for this very reason, affords intimacy. Comparable to the unexpected levels of intimacy experienced in confessional conversations with perfect strangers on flights to locations we are unlikely to visit ever

again, which can be far more intimate than the conversations with our nearest and dearest, precisely because both parties know that they will never see each other again, the closeness of telematic contact is predicated on physical distance. However, this intimacy is dependent on movement. As Kozel notes, 'when in movement, people take on an alternative materiality, while objects become immaterial in their inertia' (np). This is a very important point. As haptic theorist Laura Marks (2002) notes in *Touch Sensuous Theory and Multisensory Media*, the one thing that the digital age is certainly doing is making people very good at communicating through symbols, shorthand style, rather than attempting to communicate about things for which 'there are no readily available categories' (xi). Needless to say, this is problematic because it imposes ready-made frames and thought patterns. The more such categories, frames and patterns there are, the harder it becomes to talk about anything for which there are no ready-made categories. At the same time, it could be argued that these non-defined, non-categorisable things are the most important to talk about. Touching, however, is diametrically opposed to categorisation. The sense of touch is not reductive; touch does not master. On the contrary, it merges with that which it touches. Although Kozel and the interactant are not touching each other's actual bodies but, instead, superimposed images of each other's bodies, they are communicating in a way that is not reductive. As anybody who has ever tried putting on make-up or shaving via a video camera (a process in which the left and the right side of the face are interchanged) knows, this sort of mediated touch is anything but reductive and mastering. After the initial disorientation, the interactant learns through the process of embodied translation, which involves proprioception, the body's sense of balance, and kinaesthetics, the sense of movement.

This haptic – touching – relation to the world is a close relation; it has nothing of the removed, judging, evaluative, controlling sense of sight, of which Haraway speaks. And yet telematics is predicated on sight, since it communicates through cameras and screens. Telematic touch is thus precisely that cyborgian relation that arises from the digital but does not succumb to the reductive and controlling frameworks. Instead, *Telematic Dreaming* offers a virtual closeness, a haptics in which the performers melt into movement, an (usually) uninterrupted series of patterns, which result in sensations. There is a possibility here for what Marks calls 'amoeba-like' contact, that is, neither subject-subject nor subject-object contact, but non-divisionary contact (xvi). The simultaneous closeness and distance overrides the social problematics that might arise from a physical situation; and yet there is nothing disembodied, distant and objectifying about this sort of

contact. In a reference to Frederick Brooks, virtual reality researcher, Kozel (1994) notes that 'intelligence amplification (IA) is more interesting than artificial intelligence (AI)' (np), that creating networked, amplified human intelligence is more interesting than translating human intelligence into artificial intelligence. This, indeed, is Haraway's mode of thought, too. The aim of the cyborg is not to create a more powerful but simultaneously more removed, more regimented, thinking machine, which excludes the body altogether. Instead, it is to augment sensorial intelligence and the ability to engage in a productive encounter with enmeshed-ness and the body, not with pure categories, to which AI does, of course, belong. As Kozel suggests, in *Telematic Dreaming*, her body was always:

> [t]he ultimate ground for the image, it was the final reference point and the source of meaning. Like the difference between three-dimensionality and four-dimensionality, the image provided my body with another dimension rather than rendering it obsolete. Initially I was disoriented in virtual space ... My disorientation was a symptom of how moving was entirely mediated by my sense of sight. The way I overcame this was by drawing my attention back to the pattern of my body in physical space ... In this sense my electric body was an extension of my physical body, it could do things which the latter could not, such as map itself onto another or disappear, yet it could not exist independently. (np)

Although initially disorientated because reliant on sight, Kozel's kinaesthetic sense did regain its scope and was, in fact, augmented by telematics. In other words, a different logic of interaction was here allowed to emerge. Clearly, mediated contact has a significant impact on the sphere of the social.

Interconnection as a posthuman condition: Katherine Hayles

Interaction, co-authorship and digital co-creation all belong to a broader theoretical outlook called posthumanism. Posthumanism is not only what comes after humanism, which is what 'post' would generally indicate, but is radically different from humanism's basic assumptions. In *How We Became Posthuman*, American cultural theorist and theorist of science N. Katherine Hayles (1999) suggests that this difference is chiefly related to the notion which she, after political scientist C. B. Macpherson, calls 'possessive individualism'. Citing Macpherson, Hayles suggests the following: that possessive individualism's 'possessive quality' stems from

the 'conception of the individual as essentially the proprietor of his own person or capacities, owing nothing to society' (Macpherson cited in Hayles, 1999: 2). In this conception, the human essence is described as 'freedom from the wills of others', and freedom is described as 'a function of possession' (2). From this separationist view, Hayles extrapolates the relationship between the phrase 'owing nothing to society' and arguments about what was in the world before market relations. Hayles argues that because ownership of oneself was thought to be the logical condition on which market relations were built, it was taken for granted that ownership of oneself existed prior to market relations. However, much like sex can be said to be the product of gender, as we saw in the previous two chapters, this liberal self-owning and, consequently, the notion of a self-sufficient individual could also be seen as the *product* of the market relations discourse, not as its origin or foundation. The problem of what was there before individualism remains difficult to solve, since, in the Western world, this notion is related to religion. God, the sources of all being, made individuals – in Latin, the word *in-dividu* means that which cannot be further divided – in his image. Individuals are thus the smallest possible denomination of the divine presence; within this concept, they are only separate from this presence while living an earthly existence. Upon death, they reunite with their maker. In other words, both the overarching system – God – and discussions about what was there before and after are one and the same.

Economics, with its concern for market relations, appeared in the nineteenth century, after the bankruptcy of religious institutions. However, as Austrian-French social philosopher André Gorz (1989) notes in *Critique of Economic Reason*, regardless of the difference in content, economics nevertheless continued to rely on exactly the same logic, the logic of neatly fitting parts and wholes, as evident in the economic whole of production, reproduction and distribution of wealth (12). It is therefore not surprising that the individual, too, is explained within economic discourse, as intrinsically forming part of the discourse centred on market relations. Hayles's (1999) claim is that this problem is resolved in the posthuman, since posthumanism does away with the 'natural' self. 'The posthuman subject is ... a material-informational entity whose boundaries undergo continuous construction and reconstruction' (2). This condition, in which, like in Haraway's cyborg, there is no wholeness but a continually changing collection of (different) parts is produced by the 'privileging of informational pattern over material instantiation, so that embodiment in a biological substrate is seen as an accident of history rather than an inevitability of life' (2). Here Hayles goes beyond Haraway

in theorising the digital, non-individualist condition. She proposes that the body is not originary, natural, but, in fact, 'the original prosthesis we all learn to manipulate, so that extending or replacing the body with other prostheses becomes a continuation of a process that began before we were born' (2). This different, posthumanist view of the subject – which seems to extend McLuhan's above-mentioned concept of extensions and prostheses – is closely related to the difference in the notions of ownership. In the digital age, ownership is replaced by access, which resonates with many practices discussed in the previous chapters, notably those of Cage, discussed in Chapter 3, the Situationists International, discussed in Chapter 4, and Fluxus discussed in Chapter 6, all of whom propagated free use and free exchange in place of the limiting concept of ownership. The fact that, in the digital age, there is access rather than ownership has important implications for the notion of self as well as society. Information is neither mine nor yours; and yet, as posthumans, we are interpenetrated with information. This means that, according to Hayles, we are 'articulated through the performative dimension' (6), not through 'what is', which is the substantive dimension, but through 'what we do' (6). Being informationally and digitally extended, as well as networked, is of huge importance to the way we perceive social action. In reference to Derrida's deconstructive theorisation of the presence-absence binary whose importance Hayles fully acknowledges, but also relegates to the non-digital age, she stresses that:

> [o]ne feels lack only if presence is posited or assumed; one is driven by desire only if the object of desire is conceptualized as something to be possessed. ... By contrast, pattern/randomness is underlaid by a very different set of assumptions. In this dialectic, meaning is not front-loaded into the system, and the origin does not act to ground signification. Complexity evolves from highly recursive processes being applied to simple rules. Rather than proceeding along a trajectory toward a known end, such systems evolve toward an open future marked by contingency and unpredictability. (285)

This is important because although Derrida protested vehemently against dualisms as cultural repositories of power and oppression, digital interconnection foregrounds new relations, primarily through access and complexity. Although open, unpredictable (for example, chance-operated) work has been much discussed so far, the digitally interactive works, such as those of Blast Theory, create an entirely new host of ludic-social relationships, based on access and complexity.

The game worlds of Blast Theory

A British interdisciplinary arts collective, consisting of Matt Adams, a theatre maker, Ju Row-Farr, a visual artist, and Nick Tandavanitj, a polymath, Blast Theory was formed in 1991. Radically committed to activism as well as to technology, which for Blast Theory is a mode of enquiry, the group's early work, such as *Stampede*, realised in 1994, and performed in clubs, concentrated on modes of action and interaction. *Stampede*, a performance about the energetics and cohesion of rioting crowds and the implementation of mind-control techniques, was made in the wake of Reclaim the Streets, a radical form of protest begun in London in 1991. Influenced in large part by the boom of rave culture, RTS rearranged the rules of dissent by introducing DJs, dancing, wild costumes and, more generally, pleasure to radical politics in the streets. *Stampede* used a system of pressure pads that allowed the dancing audience to trigger video recordings, which utilised complex information input as well as randomness. This was followed by numerous pieces such as *Kidnap* and *Desert Rain*. In 1998's *Kidnap*, a trailer appeared in cinemas around England and Wales advertising a kidnap as a lottery. The two winners were abducted on a prearranged date, blindfolded, put in a van and taken to a safehouse constructed so to allow for constant monitoring. The live web broadcast allowed for remote viewing, and there was an online chat room where viewers could exchange impressions. A constructed 'situation', which bears a strong relation to the practices of the Situationists International, both because it is an impromptu situation and because it directly addresses Debord's critique of the society of the spectacle, discussed in Chapter 4, but raised to an entirely new level through digital connectivity and internet viewing (Adams, 2007: np), *Kidnap* was an arena of common enquiry where a maze of spectatorial relationships was created. The relationships between the remote viewers and the kidnappees, between the kidnappers and the kidnappees, between the wider public (who followed the project through the media) and the kidnappees, between the journalists at the press conference and the kidnappers and kidnappees, were all used as a magnifying glass to focus on the question: what relationships are produced in these sites, and how? How do these relationships influence the creation of further relations? How are situations, opinions and views formed through mediation? The complexity of this constant weaving of relations was further investigated in Blast Theory's 2001 game *Can You See Me Now?*, a playful exploration of the notions of 'space' as established by the interplay of presence and absence, which, in mixed reality – which refers to the parallel and interwoven existence of actuality and virtuality – is very different from actuality alone. *CYSMN?* is a mobile chase game,

realised in collaboration with Mixed Reality Lab, in which up to twenty online players are chased by five runners – professional performers – who are running through the actual city streets. Playing from anywhere in the world, the online players are chased by the runners through a virtual model of the city containing not only existing buildings but also those currently under construction or even buildings still in the phase of planning: situated somewhere between the present and the future. The players have a bird's eye view and can zoom into closer map views. However, the dynamics of the city – the movement of its population and traffic – are absent from the model. In this sense, the city carries some of the ghostly emptiness of a city that has been evacuated (usually for some life-threatening reason) or the newness of a city not yet populated. The players move through the virtual city by navigating their avatars. As can be seen in Figure 9.2, the runners in the actual city streets are equipped with handheld computers that enable them to see the positions of online players and receive text messages, Global Positioning System (GPS) receivers which track their positions in the city and transmit them online, and walkie-talkies which enable them to talk to each other.

The walkie-talkie communication is streamed to the online players who can thus eavesdrop on the real and 'staged' dialogues of the runners. The live streaming also relays the soundscape of the city – the traffic and the sirens as well as the weather conditions – the wind, the rain and the

Figure 9.2 Blast Theory, *Can You See Me Now?*, Dutch Electronic Arts Festival 2003. Photo by Blast Theory 2003. © Blast Theory. Courtesy of Blast Theory.

texture of the terrain the runner may be struggling with, such as gravel or mud. In order to deliberately confuse the online players, the runners exchange rehearsed or improvised dialogues based on descriptions of false whereabouts, or engage passers-by in conversations that can provide false clues as to what is going on. They also use tactics such as hiding in places where their GPS receivers have no reception in order to appear invisible on the city model. *CYSMN?* is orchestrated in such a way as to allow for context ambiguity, defined by Human–Computer Interaction designer William Gaver (2003) as a 'mingling of discourses which disrupts easy interpretation' (Gaver et al., 2003: np). However, one of the main goals of the game, in the words of computer scientist Steve Benford (2004b), is to 'encourage online players to experience the city through another person, tuning into their audio descriptions of the actual city streets ... hearing when they are tired and out of breath and finally, realizing that their online actions are having a remote physical effect' (Benford et al., 2004b: np). As a player from Seattle reports: 'I had a definite heart stopping moment when my concerns suddenly switched from desperately trying to escape, to desperately hoping that the runner chasing me had not been run over by a reversing truck (that's what it sounded like had happened)' (Blast Theory, 2003: np).

Another important aesthetic layer of the game is that when the online players register to play, they are asked to enter the name of a person they haven't seen for a while but still think of. Most people enter names of long-lost friends, unrequited teenage loves, family members who have passed on, or ex-partners. When they are caught, the runners shout out both the name of the player and the name of the person whose name they entered. While some players run with the person from their past from the very start, others get so engrossed in the game as to forget all about them. A player from Dublin reports:

> The first time I played, I entered the name of my last partner ... When I was caught, I heard my own name read out – which was fun to hear, but this was then followed by my last partner's name. I was suddenly filled with emotion and confusion. Was she playing the game as well, did she know I was there, would I try to say hello. The absence of this person from my life was suddenly converted into a palpable presence through the dynamic physical and mental responses of my body to the emotions which came from hearing her name. (Russell, 2007: np)

Like that of the runners, whose live-streamed voices testify to their presence while at the same time underlining their absence, the 'virtual' companions'

presence is framed by their absence. The virtual companion with whom the players enter *CYSMN?* is the mental image which conjures up the memory of that person. Whether the players 'run with' their named person throughout the game or not, the moment they are caught and hear the name of their 'virtual' companion uttered next to their own name lends the person a strange materiality. Much like a voice message left on the answering machine by person who has left, for a determinate or indeterminate period of time, or has even passed away, the presence of 'material signifiers' amplifies the absence of the person. In the era of information technology, virtuality, defined by Katherine Hayles (1999) as the 'cultural perception that material objects are interpenetrated by information patterns' (13), does not operate on the basis of the presence/absence dialectic but that of pattern/randomness. Information, which has no materiality or dimension, is a pattern, not a presence. Information theorists distinguish between message and signal, and assert that what is sent is a signal and never a message. In order to 'appear materially', a message needs to be encoded in a signal for transmission through a medium such as letters and words printed in a book. Hayles compares humans to books in so far as they both have a resistant materiality which has enabled the durable inscription of books and the durable inscription of experiences on human beings. She concludes that

> the contemporary pressure toward dematerialization, understood as an epistemic shift towards pattern/randomness and away from presence / absence, affects human bodies and textual bodies on two levels at once, as a change in the body (the material substrate) and as a change in the message (the codes of representation). (28)

Can You See Me Now? is a complex investigation into the nature of precisely this shift. The question is: how can we understand these differences emotionally? On the one hand, the game creates a visceral connection between a runner on the streets of an existing city and a player who could be hundreds of miles away, by means of an avatar. On the other, it creates a connection between the player's 'virtual' companion's absence and his or her sudden presence when he or she is summoned up by her name in a city that could be a hundred miles away from where she is, or ever has been. Furthermore, a 'space' is created on the virtual model of the city by the players' 'practice' of running, and this stands in umbilical connection to the 'space' created by the runners' 'practice' on the actual streets. The deployment of interactivity in *CYSMN?* is the network through which complex relations are created. As such, it requires extensive orchestration.

Not only is pre-programmed content combined with content generated on the fly from the outset (the runners' improvisations with passers-by), but the very structure of the game remains open to change, due to its fast-moving presence in multiple locations in the city. In 'Coping With Uncertainty in a Location-Based Game', Steve Benford et al. (2004a) examine the possible ramifications of uncertainty, and thus unpredictability, caused by the sporadic inability of the GPS to report the location, failures in networking or delays in relaying messages. For example, 'GPS inaccuracy' (caused by variable connectivity or networking failure) 'could cause players to appear in impossible places (inside virtual buildings). It could result in noticeable unfeasible movements (sudden jumps) or, could even result in false sightings, where a runner would suddenly jump close to a player, see them and then jump away again' (np). While pointing to the obvious strategies, such as reducing or hiding uncertainty, the authors also stress the semantic advantage of exploiting it. The direct weaving of uncertainty into game-play, for example by 'requiring participants to actively seek out regions of good connectivity and GPS in order to gain visibility or acquire "energy"' (np), adds an extra semantic layer to the conceptualisation of presence and absence. Can an avatar, just like a human being, be physically present but invisible to others because of its absence of mind (energy)? What does that say about the thinking tools and maps we have at our disposal? This game makes it possible to run with those who have passed on. The complexity of the various levels and textures of presence and absence, amplified through visual and aural cues, makes palpable Hayles's notion of interpenetration of humans and information. It also removes notions of randomness from the randomness-intentionality binary since random operation can be programmed, with variables, so as to bypass human intention all together.

The modes of performance discussed in this chapter effectively rewrite many of the old assumptions about either/or demarcations. Not only does digital performance expand the field of human action by taking space and time limitations out of the equation, it creates new modes of interaction. In the first place, it de-centralises identity. It dissolves the connection between identity and a single body, as seen in Hershman's work, thus effectively creating cyborgian, multi-locational, unstable identities that inhabit many shapes simultaneously. In the second place, it introduces new forms of sensorial interaction – such as those derived through telematics, which create entirely new haptic but also conceptual possibilities where the emotional nearness-distance boundary is surpassed. In the third place, it makes palpable a complex connectivity of patterns and events, which radically

changes ideas about knowledge, perception and consciousness. Although digital information processing is, of course, dependent on symbolisation, and therefore formal logical representation, and is, in this sense, very different from human information processing (which is embodied and contextual), the fact that the formerly purely imaginary – or virtual – things, beings and spaces have become a part of the commonly perceptible reality has remarkable consequences. Knowledge has always been networked, both dependent on other people and the environment. When paying with cash and in a currency we frequently use, our ability to work out which coins to select is as dependent on their shape and weight as it is on their denomination, if not more. Likewise, reproducing a movement routine is much easier in space and with others, relationally, than on one's own, or cerebrally. And yet, human memory is limited by focus. There are millions of fragments of life that are permanently stored in our memory but that never come to the surface. Apart from bringing the imagined into the actually perceptible world, digital mediation brings those moments to the forefront of consciousness, as in Blast Theory's work, or in Hershman's *Agent Ruby* in which mnemonic traces are rendered visible in the very operation of the project. The interface with computer science is significant because it offers a focus on the structures that underlie representation and information processing. Combining information encoded as bits in computer memory and information encoded in biological cells – plant, animal and human – it poses complex questions about the nature of knowledge. It also poses questions about Haraway's cyborgian identities, the precise nature of posthumanism, all of which offer new alternatives for the forging of reality. Computer science does, of course, rest on a set of assumptions about abstract, disembodied reason and the body which operates like a machine, as American philosopher of psychology Hubert Dreyfus (1994) has persuasively argued. The most problematic is the assumption that all knowledge can be formalised and categorised and that 'everything essential to the production of intelligent behavior, must in principle be analyzable as a set of situation-free determinate elements' (156). Not dissimilar to Marks's argument mentioned above, Dreyfus's point is that computer science aids the long-standing tradition which seeks to 'eliminate uncertainty: moral, intellectual, practical' demanding that 'knowledge be expressed in terms of rules or definitions which can be applied without the risk of interpretation' (211). While this is certainly true, digital performance offers more than the increasingly efficient models of symbolisation, namely the creation of imaginary worlds that do not have a fleeting or immaterial relationship to reality. In digital performance, imaginary worlds are augmented and amplified; however, they are also anchored and matrixed, that is to say, behaviourally inscribed.

Scores:

1 Create a digital performance in which your avatar appears in different forms and on different digital platforms. Invent a mechanism by which the avatar absorbs information, interacts with the 'users' and is transformed by the information it receives. Think about how this knowledge accumulation is manifested. Does it change the avatar in any way?

2 Set up a telematic connection between two remote places. Ensure the locales afford similar positions – for example standing, sitting, lying. Work with two performers. Place them in different environments, a surgery as opposed to a living room sofa. Think about the different meanings the same movement has in different places.

3 Design a game using easily accessible servers, simple symbolisation (avatars/game elements) and widely available interactive technology – Skype, for example. Make two of the ingredients found in all games – space and time (whether actual or virtual) – the thematic focus of the game.

10 Ludic (H)activism

The problem with simulation: Jean Baudrillard

French social critic and theorist Jean Baudrillard's unique theorisation of the new modes of communication and their impact on the increasing mediatisation of the world was of paramount importance to artists working in the field of new media, such as Paul Sermon and Blast Theory, discussed in the previous chapter, who made works in direct response to Baudrillard's influential theories. For Baudrillard, the new modes of communication were inextricably entwined with the flow of capital and the political-military-informational complex, both of which were marred in simulation, as he explains in *Simulacra and Simulation*. According to Baudrillard (1994), key to understanding the currently topical notion of the simulacrum – Latin for imitation – is the historical development of the four successive phases of the image. In the first phase, the image is the reflection of a profound reality; in the second phase, the image masks and denatures this profound reality; in the third phase, the image masks the absence of a profound reality; in the fourth phase (the phase of the end of the twentieth and the beginning of the twenty-first century), the image no longer bears any relation to reality whatsoever (2–6). The first phase belongs to the pre-industrial period in which signs corresponded to the factual state of affairs. For example, much like there was a concordance between a blacksmith's or a dressmaker's professional activity and the sign outside their shop – a hammer, a chisel, scissors, thread or needle – other signs in social circulation reflected an existing reality, too. People dressed and behaved in ways that corresponded to their position in life: peasants dressed and behaved like peasants, nobility dressed and behaved like nobility. The second phase corresponds to the period of industrialisation, characterised by the rapid development of new modes of production, and by the rise of a new class – the bourgeoisie. Here, simulacra appears with the increasing detachment of industrial processes of production from natural processes. In this phase, members of the bourgeoisie mark their appurtenance to this class by behaving and dressing in particular ways as well as through ostentatious possession of objects. This behaviour does not reflect a profound reality but masks this very reality while, simultaneously, inaugurating a new reality

through speech, performance and the use of symbols. For Baudrillard, the first and the second phase of the image have a truth value; the first corresponds to reality and is therefore true, the second does not correspond to reality and is therefore false. The third phase, however, bears no relation to truth or falsehood; it is entirely fabricated and no longer 'anchored' in reality. Disneyland, a 'play of illusions and phantasms' (6) is Baudrillard's example of choice. But his point is not that there is no correspondence between Disneyland and a prior reality; clearly, Disneyland is an imaginary land. Rather, his point is that Disneyland is 'presented as imaginary in order to make us believe that the rest is real' (12). Referring to the advertising-saturated mode of social and economic production, in which products are made entirely from models, and where the possession of choice objects has become the dominant mode of communication, Baudrillard proposes that 'the America that surrounds it [Disneyland] is no longer real, but belongs to the order of simulation. It is no longer a question of a false representation of reality (ideology) but of concealing the fact that the real is no longer real' (12–13). In this order of simulation, the individual receives his or her identity through the signs he or she displays and consumes, a form of identity production reliant on the signs already in circulation.

Given that the circulation of signs has an increasing potential to reach all areas of human lives – after all, advertising went from sporadic appearances in a static medium, television, to ceaseless appearances on all mobile devices all the time – it has the power to create what Baudrillard has called the 'code' (79). The code is a unified name for the communicational structure, or the structure of representation produced by the fourth phase of the image, in which there is no relation to any reality whatsoever. It refers to the modelling, reproduction and influencing of social relations across different spheres. In subordinating existence to a particular system of representation, the code resembles, and is an extension of, Guy Debord's theory of the spectacle, discussed in Chapter 4. Despite the fact that, for Baudrillard, the world as we know it is already entirely subsumed by the code since communication occurs between the various media, which only further perpetrate simulation, the easiest way to understand this concept is to compare it to a computer game. *Halo III* is a closed universe whose logic, rules, self-evident values, script and modes of behaviour form a seamless semantic whole without having much in common with reality. Like a computer game, the fourth phase of the image is a profoundly manipulated universe. However, Baudrillard's contention is not the lack of truth: simulacrum is neither a lie nor a fiction; it does not present the imagined as the real. Far more disturbingly, it undermines any mode of resistance because it absorbs the real within its system of representation. The very basis of the capitalist economy,

which commodifies absolutely everything, requires a communicational mode similar to monetary currency, that is, a universally applicable mode of communication that will keep the movement of capital in motion. The fascination with 'the code' as a mode of communication lies in its 'flawlessness and manageability', programmable 'infallibility', 'maximum security … that today controls the spread of the social' (34). In other words, 'the code' is comparable to a map that no longer corresponds to an existing territory but maps a non-existing one. Like a map, it has no depth. For Baudrillard, both depth and meaning are lost behind the increasing circulation of signs, which, because of the obsession with living an easily manageable life, creates empty, floating, interchangeable communication. Baudrillard's contention is that in the informational age, information does not produce meaning but, in fact, destroys it (78–79). Much like the thirty-seven brands of peanut butter in the supermarket create more confusion than satisfaction, the forty television channels and the thirteen kinds of social media do not make for more profound and meaningful communication. If anything, they make for more superficial, but more 'efficient', communication. This is why information and meaning 'implode' (79).

Acknowledging McLuhan's theorisation of the media, Baudrillard concludes that the media produce technological effects, not social consciousness in the individual through meaningful information. Being thoroughly acculturated to incessant media communication, we become a screen for the various networks of influence. This domination of the simulacric, and the ultimately flat, has 'overbidding' as a result (36). In 'overbidding', the individual rebels not by protesting against the system and the code but by becoming more passive than the passivity suggested by the media that render him or her passive. This is Baudrillard's explanation for the growing onslaught of depression, cancer and obesity, which he views as overbidding in three different ways: implosion, the organism's self-annihilation and inertia. The work of the American (h)activists and culture jammers The Yes Men can, indeed, be seen as a form of overbidding, albeit of a very specific kind. While following Baudrillardian suit and countering simulation with simulation, or, to be more precise, countering simulation with the overproduction of simulation, The Yes Men affirm what Baudrillard negates, namely that active resistance is possible.

The Yes Men and the practice of identity correction

In November 1999, the World Trade Organization, a forum for the international government negotiation of trade regulations and the settling of trade disputes, found that their website had been directed to www.gatt.org.

Here, individuals unknown to the WTO officials, but posing as the WTO officials, enumerated instances of the WTO's abuse of corporate power. The 'impostors' were Jacques Servin, aka Andy Bichlbaum, and Igor Vamos, aka Michael Bonanno, better known as The Yes Men, a culture-jamming (h)activist corporation formed after the 1999 WTO protests in Seattle. Having much in common with the Situationist *détournement* as well as with critical theory, which provides alternative views to mainstream, institutional science (social and natural), culture jamming is a practical critique of existing social, economic and political practices. (H)activism is derived from 'hacker' and 'activism'; it resorts to digital tools and methods to expose systems of domination. When the WTO found out about the misappropriation of their name and the fake website, they issued a press release in an attempt to denounce the impostors. But the timing was not on their side. Thirty thousand people were heading to Seattle, where an anti-globalisation protest was taking place at the WTO Ministerial conference. The protest was staged not only against the WTO but also against the International Monetary Fund and the World Bank, all of which were involved in the drafting of new global trade laws that facilitated insufficiently remunerated immigrant labour at the expense of the local work force, and lifted trade-restrictive laws which protected the environment. As numerous political theorists have argued, Martin Orr (2007) among them, the triumph of globalisation in the 1990s was in fact, the culmination of the post–World War II *pax Americana* (which included the rule over Japan mentioned in Chapters 3 and 6) and the international dominance of neo-liberalism (made possible by the fall of the Berlin Wall in 1989 and the dissolution of the Soviet Union in 1991). Under the 'promise of a "global village" in which all humanity would share in the benefits of the "information age"' (106), organisations like the WTO and the World Bank were instrumental in what after the attacks of 11 September 2001 became an 'overt imperial intervention' to establish 'the US control over its rivals' access to oil' (105). The Seattle protests thus in many ways marked the failure of neoliberal globalisation.

The increased web traffic resulted in many search engines picking up the fake website, which, in turn, resulted in misdirected conference invitations, intended for the real WTO, but which Servin and Vamos gladly accepted, making landmark appearances at conferences in Salzburg, Sydney, Tampere and Philadelphia. Both Servin and Vamos were founder members of RTMark, a corporation whose name is derived from 'registered trademark' and which specialises in subversive activities through the exploitation of a legal paradox. In the US, corporations have the same legal rights as natural persons. Dating back to the 1886 *Santa Clara Country v. Southern Pacific*

Railroad court case, which dealt with the taxation of railroad properties, and in which the Supreme Court ruled that corporations were protected under the Fourteenth Amendment – the very same amendment that had been written to protect the rights of free slaves – US corporations have limited legal responsibility. If a corporation causes health damage to one or more individuals, through the distribution of, say, insufficiently tested products, corporate executives will not be personally liable. Rather, the corporation will assume liability as a legal entity, which in many cases leads to the exoneration of individuals responsible for the situation. RTMark, who already had a record of subverting corporate products – in 1993 they swapped Barbie's and G. I. Joe's voiceboxes and placed the dolls on the market, while in 1997 they inserted homoerotic images into a Sims computer game – merely applied these subversive methods to performance. Inaugurative as it is of new realities, particularly when witnessed, and thus ratified, by authoritative members of a group, performance disrupts simulation, precisely because it layers it with new simulacric information. The world trade executives, who negotiate the world trade agreements, are a prime example of this; they behave as if there was a direct correspondence between the legal maneouvres of a small group of representatives of the world's most powerful countries and the economic realities of the rest of the world. Representing the WTO, Servin, aka Dr Andreas Bichlbaum, gave an inspiring speech on the need to privatise democracy at the Salzburg conference in October 2000. Using diagrams, he showed how easily this could be done: 'by allowing corporations to bid on votes directly – to pay citizens to vote directly for candidates they wanted rather than go through campaign finance mechanisms' (Bilchbaum cited in Smith, 2014: np). In an attempt to find out what the reactions to such a speech might have been, an impostor journalist (part of The Yes Men crew) came to inform the audience that Dr Bichlbaum had been pied after the conference. The journalist asked the audience whether they could remember anything about the lecture that may have caused such an attack. Throwing pie 'in the face of economic fascism' (The Biotic Baking Brigade cited in Thompson and Sholette, 2004: 70) is the signature practice of another group of worldwide activists, The Biotic Baking Brigade, whose targets are politicians, economists, tycoons and magnates, such as the Nobel laureate economist Milton Friedman, or Bill Gates, all of whom have been pied. The answer to the 'impartial journalist's' question was negative, however. No one in the audience could remember anything odd about Dr Bichlbaum's lecture. This means that Servin's use of language, his use of rhetoric style and of diagrammatic visuals, had a simulacric performance efficacy. The gathered representatives did not notice anything unusual.

At a textiles conference in Tampere, Finland, in 2001, Hank Hardy Unruh, aka Servin, gave a lecture on the inefficiency of the Civil War. He explained that since slave labour had led to remote sweatshop labour, the legacy of the Civil War – making slavery illegal – was clearly an erroneous decision. Towards the end of the lecture, Unruh tore off his business suit to reveal 'the management leisure suit', a golden leotard with an inflatable three-foot phallus, which had a video interface system that allowed surveillance of employees, and a device whose purpose was to deliver electric shocks to lazy workers, as shown in Figure 10.1.

In similar fashion, at a Wharton Business School conference on business in Africa, in November 2006 in Philadelphia, Hanniford Schmidt (Servin) announced the WTO initiative for full private stewardry of labour. Pointing out how privatisation had been successfully applied to transport, energy, water and even to the human genome, the WTO proposed to 'extend these successes to the (re)privatisation of humans themselves' (The Yes Men, 2006: np). Although the programme of full, untrammelled stewardry was similar in many ways to slavery, Schmidt explained that 'just as "compassionate conservatism" had polished the rough edges on labor relations in industrialized countries, full stewardry, or "compassionate slavery," could be a similar

Figure 10.1 The Yes Men Management Leisure Suit, Tempere, 2001. © The Yes Men. Courtesy of The Yes Men.

boon to developing ones' (np). As The Yes Men suggest, the purpose of such sustained interventionist work is to disrupt 'normal flows of capital and power' (Servin and Vamos cited in Thompson and Sholette, 2004: 106). Essentially, this means deconstructing the simulacrum by means of simulation, that is to say, by staying firmly within hyperreality. Hyperreality is Baudrillard's term for the *social reality* created through the code. Globalisation itself, which at the beginning of the new millennium was rapidly turning all life worlds and all cultures into abstract exchange value, is an example of hyperreality. The corporate universe generated from models and abstract points of reference, based on schematic forms of representation, is another such example.

Importantly, the term 'hyperreality' has implications of 'too much reality' – in the sense of everything being on the surface, plain to see, even overexposed. However, it also has connotations of 'para-reality', reality with an extra layer laid over – or instead of – reality. Much of the corporate knowledge production and communication has an irrational rationality about it, the targets, the percentages seemingly providing indubitable precision and accuracy. This was insightfully analysed by the Baudrillard-influenced American social theorist George Ritzer (1993) in *The McDonaldization of Society*. Focusing on the fast-food industry but implying the entire corporate world, Ritzer developed a theory of profoundly irrational rationality – a mode of calculation which replaced thinking with a series of means-to-an-end, cost-benefit analyses, whose sole parameters were efficiency, calculability, predictability and control. In employing these parameters, the McDonalised logic managed not only to sell nutritionally noxious food at a great profit, it also exercised social control by substituting systematic, schematic, self-serving irrationality for rationality. To Baudrillard's thinking, it is precisely this extra justificatory effort over and above what is self-evident – the schematic, dogmatic and self-serving analyses and calculations – that is the alibi for the non-existent reality. It is that which creates hyperreality. Baudrillard (1988) writes:

> A possible definition of the real is: *that for which it is possible to provide an equivalent representation.* At the conclusion of this process of reproduction, the real becomes not only that which can be reproduced, but that which is always already reproduced: the hyperreal. But this does not mean that reality and art are in some sense extinguished through total absorption in one another. Hyperrealism is something like their mutual fulfillment and overflowing into one another through an exchange at the level of simulation. ... The secret of surrealism was that the most banal reality could become surreal, but only at privileged moments, which still derived from art and the imaginary. Now

the whole of everyday political, social, historical, economic reality is incorporated into the simulative dimension of hyperrealism. (145–146, emphasis original)

This is why simulation such as the creation of the gatt.org website is crucial to exposing the system of corporate power, which has always relied on creating realities through image and product lines, as well as through symbols that act as affective condensations and are performatively extremely efficacious. The radical politics and cultural activism of RTMark could not function in the way it did had it not had the form and legal status of a corporation. This simulative mimicry, which facilitated the legal framework around such works as www.GWbush.com, a fake website in which Servin and Vamos commented on Bush's inadequacy for a presidential role, to which Bush allegedly responded with a compromising statement, namely that 'there ought to be limits to freedom' (Bush cited in Meikle, 2002: 113), is the only way to salvage and expose reality in the vortex of the hyperreal. Crucial to The Yes Men's resistance is their understanding of the simulacric working of networks and information. Although information is often seen as neutral, as Swedish cultural critics Alexandar Bard and Jan Söderqvist (2002) suggest in *Netocracy*, the Latin root reveals two definitions: on the one hand, 'representation' and 'depiction', on the other, 'interpretation'. In the initial uses of the word, such as those by Cicero, Roman politician, philosopher and orator, 'information' referred to 'giving something a form, or to 'bringing matter to life with an active vision' (75). In other words, it referred to a sophisticated mental activity of one or more individuals, not to raw material. Bard and Söderqvist could not be more right when they say that the '[t]echnological information' is the 'very essence of society today around which the entire economy revolves' (76). Baudrillard's point about the meaninglessness of the overload of information one is faced with is entwined with the overexposed – or hyperreal – manner in which information is presented. But, as Bard and Söderqvist point out, information appears as a meaningless overload only to those on the receiving end, which they name the 'consumteriat', after 'proletariat' (140). In electronic colonialism, a digital form of colonialism, netocracy replaces aristocracy and technocracy, in that it rules the networks and manipulates information. Since life in the digital era is seen as 'a question of the dispersal of information' (154), control, claim Bard and Söderqvist, is exercised over the streamlining of information. Through (h)activism, whose chief aim is to disrupt and redirect the flow of information, The Yes Men manage to construct an oasis of the Baudrillardian 'real' within the hyperreal. However, they do so through simulation, since, in this order of simulacra, the real no longer exists. As Servin, aka Bichlbaum, notes:

[We give] the journalists ... a way to communicate things that they wouldn't normally be able to communicate. Recently we helped an activist group do a parody of the NYPD's stop-and-frisk program— their press release said the cops were collaborating with McDonald's to reward citizens who were frisked multiple times, like frequent flyers. ABC's news anchor, understanding that it was all fake, did a very funny little news piece about it. The anchor was clearly sympathetic to the cause but he needed the material – and we gave it to him. (Bichlbaum in Smith, 2014: np)

Understanding the netocratic, hyperreal element, based on a closed universe in which the self-same signs circulate, The Yes Men do not stage overt opposition. They do not even explicitly draw attention to the closed nature of the semantic communication. Aware that everything has long been assimilated into entertainment – news, weather, politics, education – they seek to impact the real from the simulacrum while remaining entertaining. To The Yes Men's initial surprise, the corporate functionaries present at the numerous conferences were quite prepared to believe their simulation was real, precisely because it was carefully crafted from the already available elements: forms of address, forms of analysis, the existing conceptual and performative grid. But there were many occasions when simulation did impact the actual socio-political situation. A case in point is The Yes Men's 2007 CNN appearance in which they impersonated Dow Chemical executives, promising a significant financial compensation to all those who had suffered irreparable damage in the Bhopal gas leak tragedy. The Bhopal tragedy occurred in 1984 at the pesticide plant in Bhopal, Madhya Pradesh, India, when over 500,000 people were exposed to methyl isocyanate, a highly toxic substance which caused death and/or permanent injury but for which Dow Chemical had not taken responsibility. The media hype that ensued from the CNN appearance, the thousands of emails and queries addressed to Dow Chemical, did make the company take responsibility, albeit belatedly. In this sense, identities – what people believe in, support and identify with – are 'corrected' through simulacric performances at conferences, on television and in the streets.

etoy: new modes of (symbolic) exchange

Founded in 1994 by Gino Esposto, Michel Zai, Daniel Udanty, Martin Kubli, Marky Goldstein, Fabio Gramazio and Hans Berhnards, etoy, too, are a corporation. They engage in participatory artistic-(h)activist practice

by playing with such corporate components as the brand image, the brand name and corporate shares, which, while not recognised by stock markets, do fluctuate in value. As etoy state on their website:

> etoy.CORPORATION SA is a registered shareholder company because the etoy.SHARE, issued as certificate, allows (1) shared authorship and ownership, (2) access to intangible cultural value, (3) broad participation, (4) artificial limitation, and (5) visual documentation. The price of the etoy.SHARE is negotiated among investors and based on supply and demand. (nd)

The shared ownership and authorship aids the company's chief goal, which is to engage in the production of 'social, cultural and financial value' by blurring art, identity, nations, fashion, politics, technology, social engineering, music, power and business to 'create massive impacts on global markets and digital culture' (np). Like The Yes Men, etoy operate from within the simulacrum. However, while The Yes Men's corporate aesthetic seeks to blend in with the existent corporate aesthetic, etoy's emphasis on fashion is directly related to their exploitation of a brand as a product in itself. etoy agents (as members of the company call themselves) have specially designed uniforms; their actions are documented in such a way as to portray people on a mission. This accentuates the performative element of a corporation, a social body whose various segments are strategically organised and synchronised to produce maximum effect in the shortest possible time. The global, multinational activity of the company is also symbolised by fashionable containers, called 'tanks', a word that conjures up continual innovation, accumulation and transition (np). Twelve- and six-metre-long shipping containers – which could be seen as a symbol of globalisation, since in the globalised economy, containers are used to ship goods worldwide – are multifunctional, simultaneously an office, a studio, a hotel and a conference room. The tanks are orange. This particular emphasis on design and fashion, on the aesthetisation of all activities, could be seen as an extension of the effort to overcome the art-life divide, of highlighting everyday activities, which many of the practices discussed thus far – Kaprow in Chapter 4, Fluxus in Chapter 6 – have attempted to do.

But it could also be seen as a deliberate focus on the abstract production of value. As Baudrillard (1993) notes in *Symbolic Exchange and Death*, fashion is a 'universalisable sign system which takes possession of all others, just as the market eliminates all other modes of exchange' (92). Referring to the exchange value in economic terms, which makes other forms of exchange, such as the various forms of barter, obsolete, Baudrillard proposes that

fashion is its own progenitor as well as purpose. It is an arbitrarily produced value, with no correspondence in any sort of usefulness. Instead, it is that which dictates the formation of other social and cultural signs. Fashion is therefore its own system of reference, much like a brand is. Although most brands are related to specific products – Nike, Apple, Jeep – their ultimate goal is a branded way of life that encompasses the whole of life in a simulacric way. A Nike lifestyle thus centres on particular practices – exercising, eating healthy food – but it also implies a particular ethos – an active, environmentally aware go-getter's attitude to life. Apart from exposing the abstract, closed universe of corporate signification, etoy are well known for their effective actions, which debunk popular myths about the freedom of information. Much like The Yes Men, they utilise virtual networks to impact actuality, a case in point being the 1996 digital hijack and the 1999–2000 toy war, in which RTMark also participated. Although consciously operating in the field of hyperreality, etoy make repeated references to the limitations of hyperreality, as well as to its immense violence. In digital hijack, etoy hijacked all internet users who typed in words like 'playboy' or 'Madonna' into a search engine. The unwitting users were taken to a site entitled hijack.org where they were trapped. A notification appeared: 'You have been digitally hijacked by the organization etoy. Don't fucking move' (etoy cited in Baumgärtel, 2001: 218–219). This simple action demonstrated how easy it is to control and restrict the user's access to content in a medium which boasts both easy access to and freedom of information. In 1999, eToys, the web's leading toy retailer, which sold Pokémon cards and Harry Potter books, sued etoy for infringement of its trademark rights even though etoy's address was registered several years prior to the eToys address. In response to this, etoy migrated to another site but simultaneously alerted a number of lists and received support from over 2,000 'etoy agents', worldwide participants, who expressed their support in various disruptive ways. The ensuing toywar was purposefully depicted as a game – as a simulacrum – by etoy, despite the fact that the legal stakes were, in fact, real. Although eToys kept offering more money to etoy to remove their site from the internet – the initial $160,000 having gone up to $520,000 – the two companies went to court. Since eToys lost the lawsuit, they had to reimburse etoy for legal fees. Apart from these early works, which demonstrated the need for a different approach to resistance, etoy are significant for engaging in participatory explorations of the other-worldly elements of the digital technology, such as *Mission Eternity*. According to the company:

> etoy. CORPORATION digitally sends M∞ PILOTS across the ultimate boundary to investigate afterlife, the most virtual of all worlds.

Currently 2,760 registered users build a community of the living and the dead that reconfigures the way information society deals with memory (conservation / loss), time (future / present / past) and death. (etoy, 2007: 11, emphasis original)

The augmented use of information technology, which leaves numerous traces behind – for example, on the internet, where many people continue to exist in the form of posts and social networks long after their deaths – have drastically changed the position of the dead. The dead now exist palpably as traces in the global memory: in governmental databases, in professional records, not only in the memory of individuals. This is why the company proposes that

[a]t the heart of MISSION ETERNITY stands the creation and ultra-long-term conservation of M°ARCANUM CAPSULES, interactive portraits and digital communication systems for human beings facing death (M°PILOTS). The M°ARCANUM CAPSULES contain digital fragments of the life, knowledge and soul of the users and enable them to design an active presence post mortem: as infinite data particles they forever circulate the global info sphere – hosted in the shared memory of thousands of networked computers. (11)

Proposing to investigate the impact of the digital media on non-immediate future, scheduled to last for several decades, and thus to ensure presence, performance and interaction well beyond death, *Mission Eternity* not only creates a bridge between life and beyond, it also seeks to increase the value of '[s]trong social and emotional links between the involved people (family ties, friendship, personal or public interest) [and] digital storage technology' (13). Much like the virtual world has, in many ways, actualised the imaginary, this project seeks to actualise what Baudrillard has termed, after Bataille, symbolic exchange. Unrelated to the utilitarian or consumptive system of values, but to a personal, even idiosyncratic one, symbolic exchange has as its goal intersubjective value, value assigned to an object – or an event – by a subject, which includes the dead. Baudrillard (1993) writes:

at the very core of the 'rationality' of our culture ... is an exclusion that precedes every other, more radical than the exclusion of madmen, children or 'inferior races', an inclusion preceding all these and serving as their model: the exclusion of the dead and of death ... [T]here is an irreversible evolution from 'savage' societies to our own:

little by little, the dead cease to exist. They are thrown out of the group's symbolic circulation. They are no longer beings with a full role to play, worthy partners in exchange. (126)

Echoing Bataille's general economy, discussed in Chapter 5, in which the animate and the inanimate, the dead and the alive, form part of the same world, which includes the circulation of energy and value, Baudrillard articulates the need for a system of values that includes the dead. Needless to say, in a society obsessed with accumulation and consumption, death, which is the ultimate consumption, puts an end to all teleology (all purpose and all purpose-related organisation, as well as explanation, of reality). This is the reason why the dead no longer form part of the exchange cycle. Combining McLuhan's notion of the technological extension of man with the steadily growing number of traces technological communication leaves behind, *Mission Eternity* reflects on the possibility of actualised symbolic exchange: the eternity capsules are a form of coded information. The project is also important in another sense. It proves the possibility of a poetic resistance to the sameness (and closedness) of the simulacrum while simultaneously relegating the virtual world to its initial difference, to its status of mysterious otherness. Like Paul Sermon's work discussed in the previous chapter, *Mission Eternity* wrests virtuality from the socio-political, even military, teleology and places it in a productive dialogue with poetics. In doing so, etoy, like The Yes Men, both of which operate as a platform for artistic-activist work, with thousands of participants who propose projects and methods of action, also operate as cellular organisations, which enables them to operate politically.

Michael Hardt and Antonio Negri: the politics of cellular self-organisation

The Yes Men and etoy's use of particular networks, and particular modalities of action, is concomitant with the Marxian philosophers Antonio Negri and Michael Hardt's views of the nature of social relations in the digital age. In a society, which they, after Gilles Deleuze, term the 'society of control', old forms of opposition are no longer possible, not only because of the increasing abstraction of semantic universes but also because the individual no longer stands opposed to the unified 'people'. Instead of possessive individuality on the one hand (as discussed by Hayles in the previous chapter) and unity on the other, Hardt and Negri (2004)

propose the terms 'singularity' and 'multitude'. Singularity is a 'social subject whose difference cannot be reduced to sameness', not even the sameness of indivisibility, which, as mentioned in the previous chapter, is the Latin root of the word 'in-dividual' (99). Likewise, the multitude is not unified but remains plural and multiple. Unlike the masses, whose differences collapse into 'the indifference of the whole' (100), the multitude is an 'internally different, active social subject whose constitution is not based on identity, unity or indifference but is always in the process of transformation' (100). This particular form of sociality can form non-identitarian groups, on an ad hoc basis, like the participatory practices of Lynn Hershman, Blast Theory, The Yes Men, etoy, and the Critical Art Ensemble, discussed below. Not only can ad hoc, non-identitarian groups be more effective because they are mobilistic, but it is through the formation of such groups that institutions are outgrown, left behind and vacated. According to Hardt and Negri, faith in monolithic institutions such as the government, the health system or even large corporations is waning; these institutions appear to be change-resistant. This lack of faith in unity and wholeness is reflected in spectatorial practices, too, the majority of which no longer seek to engage the viewer en masse – a tendency already present in Futurist work, discussed in chapter 1 – but in multiple networks which facilitate peer-to-peer interaction and exchange. The politics of fleeing institutions is inseparable from cellular self-organisation; the need for both arises from two conditions. First, unlike in the overtly disciplinarian society, in which institutions such as the school, the army, the hospital, the prison prescribed what is normal and stigmatised what is deviant, society of control is a society whose mechanisms of command are increasingly more dissolved in the social field, and thus increasingly invisible. For Hardt and Negri:

> The behaviors of social integration and exclusion proper to rule are … increasingly interiorized within the subjects themselves. Power is now exercised through machines that directly organize the brains (in communication systems, information networks, etc.) and bodies (in welfare systems, monitored activities, etc.) toward a state of autonomous alienation from the sense of life and the desire for creativity. The society of control might thus be characterised by an intensification and generalization of the normalizing apparatuses of disciplinarity that internally animate our common and daily practices, but in contrast to discipline, this control extends well outside the structured sites of social institutions through flexible and fluctuating networks. (23)

Of crucial importance is the organisation of physical actions and thinking that occurs through widespread digital networks: the procedures and practices, even the physical stance – hunched over a mobile device, with a narrow focus that excludes most of the environment, trying to manipulate increasingly smaller icons – which inculcate behaviours and attitudes. In addition, there is the need for simplification and transparency, for more efficient communication and for an increased production of affect, due to the increasing frequency and multi-modality of communication as well as the increasing number of people one communicates with. This is why the concept of biopower, or the regulation of social behaviour from inside, has acquired importance in the digital age. As Hardt and Negri note:

> The great industrial and financial powers thus produce not only commodities but also subjectivities. They produce agentic subjectivities within the biopolitical context: they produce needs, social relations, bodies and minds. (32)

Since communication is not only a social but also a biopolitical factor – in Hardt and Negri's view, unlike in Foucault's and Agamben's, discussed in Chapters 7 and 8, this has a positive dimension – creating cellular, self-organised modes of communication can allow for the distributed intelligence to emerge. This is particularly important since non-identitarian groups are also isolated; although digital communication is pervasive, a person staring at a computer screen is, in a sense, the epitome of isolation. As media theorist Eugene Thacker (2004) notes, distributed intelligence can best be understood through the biological example of a swarm, which is 'an organization of multiple, individuated units with some relation to one another ... a collectivity that is defined by relationality ... a whole that is more than the sum of its parts, but it is also a heterogeneous whole' (np). Cellular organisation, seen in the works discussed above, seeks to remain heterogeneous, a multitude. The reason for this is that the various forms of digital communication, portals and networking sites, require very specific procedures and very specific data, which has a homogenising effect. While The Yes Men and etoy, who have, over the past two decades, involved thousands of people in the most diverse projects, continue to create new forms of sociality as well as, in fact, new forms of labour, they remain wary of universality, of united fronts and common causes. Theirs, like the Critical Art Ensemble's, is a quest to make a (few) concrete changes in singularities (individuals), which can further cause a difference in opinion, further to be spread through the particular singularity's contact with others.

Critical Art Ensemble's approach to cellular action

Critical Art Ensemble (CAE) is a collective of five tactical media artists who work in the domain of art, political activism, technology and critical theory. As media theorists David Garcia and Geert Lovink (1997) suggest, '"tactical media" occurs whenever cheap "do it yourself" media, made possible by the revolution in consumer electronics and expanded forms of distribution (from public access cable to the internet), are exploited by groups and individuals who feel aggrieved by, or excluded from, the wider culture' (np). But what does it mean to be excluded from the wider culture? As Steve Kurz, CAE's chief spokesman, suggests in an interview with performance scholars Jon McKenzie and Rebecca Schneider:

> Culture is a diplomatic word for the symbolic order or for semiotic regimes. The military period of globalization (colonization) is fundamentally over. Now domination is predominantly exercised through global market mechanisms interconnected with a global communication and information apparatus. (McKenzie, Schneider and CAE, 2000: 137)

Symbolic order, as mentioned in the Introduction, is a term used in anthropology to denote the overarching system of meaning, beyond the arguable and the interpretable. Being the very basis of meaning, the symbolic order is itself not negotiable. For example, in certain cultures certain animals are not eaten; this is related to their symbolic meaning within a religious, mythological or other inherited system, and is neither changeable nor negotiable. There are many examples of tactical media work carried out by CAE that destabilise precisely this ingrained, non-negotiable and often prejudicial side of culture. In fact, all their work is prototypical of the Hardt-and-Negrian cellular action, but there are three particularly relevant examples. In 1998 CAE set up a biolab in a bar in Brussels as part of *Flesh Machine* project, part of Art and Science Collision. Here, the bar clientele could take part in the CAE biotechnological demonstrations and ask questions about the proposed experiments, methodologies and results. As Kurz affirms:

> Without the academic or corporate architecture to act as a frame of capital/power, science as authority became less legitimate, and hence, could be questioned. Once the participants were skeptical about the underlying authority of the various processes, documents, gestures, and people, the once transparent, normalised authoritarian givenness of the eugenic substrata of reprotech was staring the audience in the face. (143)

Questioning what seems like the monolithic credibility and thereby also authority of the biotech industry, and science as such, has been on the CAE agenda since 1997. Indeed, many of their performances seem to deconstruct the famous 1963 Stanley Milgram experiment, which set out to test not only the limits of obedience to authority but also to a very specific kind of authority – scientific authority. In our day and age, no longer dominated by religiously determined symbolic orders, science has become that uncontestable realm where all non-scientific arguments fail. Baffled by the unfathomable nature of blind obedience to authority structures, as witnessed in World War II, Milgram designed an experiment whose real purpose was to test the extent to which participants were prepared to follow the orders of authority figures. Participants were told they were helping in a scientific experiment the purpose of which was to determine the effects of the supposedly beneficial influence of electric shocks on human memory. Masterminded by 'scientists' – actors dressed in white lab coats, with an array of impressive titles pinned to their lapels – the 'experiment' consisted in the participants administering electric shocks to 'experimentees', who, too, were actors. Located in a separate space, they were 'electrocuted' every time they failed to provide the correct answer. The real purpose of the experiment was to see how far the experiment participants would go despite the fact that they were obviously inflicting pain on the 'experimentees'.

Whereas in the Milgram experiment the performance world was closed off to the participant but staged for his or her benefit, the explicit purpose being deception, in the CAE work, the context is dislodged with the purpose of providing the participant with an insight into the discrepancies and the fissures between what is presented, how it is presented and who presents the content. According to Kurz:

> Experiencing the material effects of the real hyperreal as a means to understand its politics in a lived way is at the heart of our performances ... Baudrillard is undersold. He's too often misunderstood as claiming that simulacral culture does not have material effects. It's not just a cynical ploy on his part to say that we're lost in the hyperreal. (142)

But what precisely is the meaning of the hyperreal in this context, so closely related to the symbolic order, which, in the current culture, is science? Science is the privileged site of knowledge production not only in terms of subject matter but also in terms of method. Whereas dreams or divine communication are obviously discredited as forms of knowledge

production, the CAE (2000) claim that, in the West, science is the authority that has taken over from Christianity and is, in fact, 'a key mythmaker within society, thus defining for the general population the structure and dynamics of the cosmos and the origins and makings of life, or, in other words, defining nature itself' (167). It is therefore important that the questioning of this very order, this form of knowledge production, take place in a number of ways, which, while fitting the cellular model of action, nevertheless mimic the canonical forms of communication – published books, public talks and seminars.

In 2001 CAE produced *Digital Resistance*, in which electronic civil disobedience is an inversion of the model of civil disobedience. In the classic model of civil disobedience, masses of people gather in a location with a unified purpose, such as the Seattle WTO protest of 1999 mentioned above. Instead of such mass public congregations of objectors, CAE (2001) suggest a 'decentralized flow of particularized micro-organisations (cells) that produce multiple currents and trajectories to slow the velocity of capitalist political economy' (14). This approach is very different from the 'people united approach' which for CAE, like for Hardt and Negri, is not only outdated but also flawed since such a system creates a monolithic 'semiotic regimes that cannot represent or act on behalf of the diverse desires and needs of individuals within complex and hybridizing social segments' (15). In order to draw attention to the uselessness of such universalising myths about social formation as well as about science, CAE staged a project entitled the *Cult of the New Eve* in 1999. This work arose from the observation that

> scientists involved in new biotechnological developments are pitching their work to the public in very theological terms, offering promises of new universalism, the end of aging, even perhaps immortality, miracle cures, and more. New universalism is the idea that if all DNA is part of every living creature and if it is all compatible, then the essential link between all living creatures has been discovered. The DNA can replace the soul. (CAE, 2000: 169)

The tactic deployed was similar to the one in the bar in Brussels, only more overtly critical of the scientific enterprise. In the Brussels bar, the discourse was merely de-contextualised; in the *Cult of the New Eve*, it was moved to the context directly opposed to science, that of a cult. The performance operated on two levels, the actual and the virtual; in both worlds, the cult had its rituals, relics, its sacred texts and prophesies. The project drew on the fact that, in the Human Genome project, the sample of blood, which

was at the heart of the project, was taken from a female donor in Buffalo, New York. This woman had, for the purposes of CAE's performance, become the New Eve. Like Jesus, the New Eve performed the rite of communion in which the participants were given a host and a beer, both of which were made of yeast containing Eve's genome. In a similar manner, but in on a less parodic note, CAE performed *GenTerra* between 2001 and 2003.

A transgenic company, *GenTerra* produces new hybrid organisms from one or more genes, and from one or more already existing organisms. Products created through this process, such as the widely spread transgenically modified foods, have caused many controversies, such as tomatoes that smell of fish. *GenTerra*, however, claims to produce organisms that help solve ecological and/or social problems. Staged in a tent, which looks like a lab (as can be seen in Figure 10.2) and equipped with computer stations on which the company's profile and projects may be viewed, the *GenTerra* project offers an encounter with a bacteria release machine. Within this setting, the participants are invited to discuss transgenics with the members of CAE who are present, dressed in white coats, and who can even offer assistance with making transgenic bacteria, which the participants are invited to do.

Figure 10.2 Critical Art Ensemble and Beatriz da Costa, *GenTerra*, 2001–2003. Participants manipulate transgenic bacteria. © Critical Art Ensemble. Courtesy of Critical Art Ensemble.

One of the main issues at play in this interaction is risk assessment. Having engaged in discussions of transgenic bacteria, the participants are asked to make a decision about whether or not to release the bacteria from one of the twelve petri dishes of the release machine. They are told that eleven dishes contain non-transgenic bacteria but that one contains transgenic bacteria. When the participants ask what will happen if they release the transgenic bacteria, they are told that the bacteria are benign and that labs do this routinely. Unlike in the Milgram experiment where the 'scientists' in white lab coats gave clear directions, the 'scientists' in the *GenTerra* project highlight the participants' personal or group responsibility. Dealing with all things new that do not have a clear record of feasibility – a clear set of consequences – demands an ethical appraisal. Given that the company is profit-driven, the participants are faced with a complex dilemma, made even more difficult by the fact that it is impossible to link any course of action to a clear result with no risk. Questions like 'what will happen if I release the transgenic bacteria?' and 'to whom will it happen?' are an explicit part of the project whose purpose is to charter singular itineraries through material that appears to be confusing. Not because there is not enough information, but because there is too much conflicting information. Like The Yes Men and etoy, CAE work with complex networks of information; all three companies are concerned with biopower, which, as defined by Hardt and Negri (2000), is 'at the heart of the production and reproduction of life itself' (24). They also highlight the unintelligibility of information, aggravated by its constant multiplication, information that remains in the hands of power complexes of the scientific-military kind.

Key to media performance – the maintenance of particular universes, and particular beliefs, the belief in the all-powerful status of science, for example – as well as to the performance of branding, as created by The Yes Men, etoy and Critical Art Ensemble, is cellular organisation. Since the values of capitalism are now being inscribed on the body – human, animal, plant – through genetic manipulation and bioengineering, entirely different modes of resistance are needed. This resistance needs to be rooted in the understanding of the simulacric universe, and the logic of informational networks, which are rhizomatic – irregular, asymmetric – and which do not consist of wholes and parts. In many ways, the notion of a closed, simulacric universe, in which only the existing signs circulate, thus continually creating new simulacra, is opposed to the democratic, liberating visions put forth by Haraway and Hayles and discussed in the previous chapter. Although Baudrillard has been criticised, by Dennis Dutton (1990) for example, for what was considered to be an apocalyptic vision of the

world, many of the simulacric insular systems – such as the financial world whose vortex of abstraction resulted in the 2008 stock market crash – do, indeed, testify to its existence. The modes of performance employed by the three companies use digital performativity (Hayles) to deploy clear tactics (Derrida, de Certeau) for debunking the simulacrum and making it possible to catch a glimpse of the (invisible) power operations at play. This belongs to what Belgian-born French political theorist Chantal Mouffe (2007) calls the agonistic approach (2). Discussed in Chapter 6, *agon* denotes contest, competition or struggle. While the dominant neoliberal practice is that of consensus, which, like economics, presupposes a coherent whole, Mouffe states that '[p]roperly political questions always involve decisions which require us to make a choice between conflicting alternatives' (2). In fact, for Mouffe, 'the incapacity to think politically is to a large extent due to the uncontested hegemony of liberalism' (2) precisely because of the neoliberal emphasis on consensus and compromise. Given that the political invariably forms part of 'the symbolic ordering of social relations' (4), technical solutions and (supposedly) rational debate cannot hope to change deeply flawed social systems. Rather, agonistic struggle – or activism – has no choice but to penetrate, albeit not in an overt but in a simulacric way, the very formation of such political-symbolic orders.

Scores:

1 Find a segment of life – a corporate, trade, tax, institutional practice you deeply disagree with. Research how this company operates. Intervene in its operation through digital hijacks but without committing identity theft or engaging in any illegal activity.

2 Set up an online performance company. Use simulacric methodologies to blur the distinction between corporation and performance: focus on branding, on the logo, on the production procedures. Create a company that produces nothing.

3 Research one of the genetically modified food producers. Pay attention to the way they package their information. Place this information in a different setting – a metro station, a bank – and engage passers-by in an interactive performance. Ask them to make a decision about the production of potentially harmful food or insufficiently tested medication. Analyse the ways in which the displacement of information (through the venue, costumes, performative strategies, the way the information is presented) influences the way it is received. Vary the theme by varying the context.

11 Beyond the Human–
Non-Human Divide

Biotechnology and Bruno Latour's appraisal of science

As could be seen from the discussions of the previous chapter, and the work of Critical Art Ensemble, the implications inherent in genetically modified products – alimentary or otherwise – are far from innocuous. This is not to say that biotechnology, including bioengineering, does not have positive sides, however. By harnessing biomolecular processes, bio-technology reduces the rates of infectious diseases and furthers diagnostics of human, animal and plant malfunctions. But biotechnology also *uses* living systems and organisms to develop new products which serve human purposes through the exploitation of any source of biomass by means of biochemical engineering. Essentially, bioengineering applies the principle of engineering to tissues, cells and molecules. As American social theorist Jeremy Rifkin (1998) notes in *The Biotech Century*, it includes anything from the injection of porcine islet cells, widely used to cure diabetes in humans, to the creation of headless donor frogs, pigs and other host bodies, to be used as living storage spaces for replacement human organs. The ultimate goal of biotechnology, according to Rifkin, is self-serving; it is to 'reduce all biological organisms and ecosystems to information', then use this infor-mation to advance technology (217). Together with the rapid rise of bio-informatics and bioengineering, and the seemingly unlimited growth of the digital-military-biotechnological complex, there appeared the urgent need for a reassessment of ethics, bioethics and, more generally, of scien-tific practice. Philosophers like Peter Singer have been adamant about the need to abandon speciesism – a prejudice against species difference, similar to racism and sexism. In 'Speciesism and Moral Status', Singer (2009) argues that scientists ought to formulate a sentient, not a 'rational', hierarchy of life, which is human-biased. Numerous 'human' characteristics such as a propensity to love and a defined social order can be found in animals, par-ticularly in the lower primates, all of which are, argues Singer, absent from persons with severe cerebral malfunctions (572–573). Without suggesting that humans with cerebral malfunctions be sacrificed on the altar of experi-mental science, Singer proposes that consideration for the sentience of all

beings replace speciesism. This is one of the important concerns of the works discussed in this chapter – those of Eduardo Kac, Oron Catts, Ionat Zurr and Helen Pynor – and, in particular, their relation to the practice of science. Key to understanding the practice of science is the work of French sociologist of science Bruno Latour, more specifically, his discussion of the politics, influences and interests that make up what is usually perceived as a monolithic term. For Latour, the common myth that has persisted in Western sciences from the seventeenth century onwards is that science is beyond social influences. This perception is detrimental in all respects. The cultural and legal decrees and practices which have helped to combat the various forms of discrimination, such as racism or sexism, have remained confined to the sphere of the social. As a result, they have remained outside of the non-socio-cultural construct called 'nature'. Conversely, only qualified experts have had access to the domain of the natural sciences, as well as science as such, which has precluded the broader public from participating in the relevant debates.

Traditionally, the scientific findings have been beyond dispute. While there are many, sometimes even contradictory interpretations of cultural events, scientific accounts proceed in a linear and progressive fashion. There can be only one accepted account of physics – Isaac Newton's laws of motion, for example. When this account is found faulty or insufficiently comprehensive, it is refuted and replaced by a more comprehensive account, for example by Albert Einstein's theory of relativity. This has much to do with the absolutistic nature of scientific discoveries, with the methodologies used but also with the manner in which science is construed, claims Latour. The chief problem here, just like in the sphere of the social and the cultural proper, are exclusionary binaries which segregate the social from the scientific, the political from the natural, and assigned, construed value from 'hard facts'. According to Latour (2004 [1999]), these binaries render 'ordinary, political life impotent through the threat of incontestable nature' (10). Latour contests these binaries methodologically and contextually, in two key works: *Laboratory Life*, co-authored with Steve Woolgar, and *The Pasteurization of France*. *Laboratory Life* is the result of onsite research where routine laboratory behaviour and the supposedly insignificant occurrences in laboratory life were closely observed. Here, Latour and Woolgar (1979) showed that the practice of science 'widely regarded by outsiders as well organised, logical and coherent, in fact consists of a disordered array of observations with which scientists struggle to produce order' (36). Laboratory life was shown to be a mixture of the social, the political and the technical, the divide between which was instituted later, in the reconstruction of the scientific process in the form of scientific writing. An

even more poignant critique of science, as firmly grounded in truth, and, in this sense, a hegemonic enterprise, took place in Latour's *The Pasteurization of France*. Here, the scientific claims to truth, which work in terms of predecessors and successors, were deconstructed through Latour's systematic study of what was thought to be Louis Pasteur's genius. In Latour's account, Pasteur is no longer the heroic discoverer of the microbial transmission of disease in the mid-nineteenth century but a shrewd strategist who combines scientific findings with many different interests. In order for his theory to win, Pasteur combines a set of interests that include farmers, army doctors, hygienists, the press, French nationalism, cows, industrialists, popular journals, transport experts and the French Academy, as well as the microbes themselves. In a later account of a more contemporary phenomenon – mad cow disease – Latour resorts to the same, seemingly chaotic combination of elements, strategies and events – the European Union, the beef market, politicians, vegetarians, public confidence and farmers – to explain the outbreak. 'Does this list sound heterogeneous?' Latour asks. 'Too bad – it is indeed this power to establish a hierarchy among incommensurable positions for which the collective must now take responsibility' (Latour, 2004 [1999]: 113). Just what is this 'responsibility' and where, in what realm, might it take place? As Latour (1987) suggests, large-scale technoscience 'is part of a war machine and should be studied as such' (172). Science is therefore successful not because it isolates itself from society but because it creates networks and connections, and can, according to Latour, be assessed through 'the number of points linked, the strength and length of the linkage' (201). This does not include only the funds needed, but the entire network of social, political and cultural relations. Eduardo Kac's pioneering work can be seen as the study of this complex meshwork of relations and, above all, of responsibility, because it engages the manifold discourses present in cross-breeding and in creating entirely new, heretofore non-existent organisms.

Eduardo Kac's transgenic art as a bio-socio-political network

Latour's (1987) notion of science as thoroughly socialised and produced through 'heterogeneous chains of association' (100) is amply explored by the Brazilian artist Eduardo Kac. Famous for *Edunia* and *GFP Bunny*, among numerous other works, Kac's transgenic art resonates in the anthropological, botanic, biological, social and political registers. As genetic artist and flower breeder George Gessert (1993) points out, transgenic art has existed not for centuries but for millennia, since '[e]xotic orchids [and] hairless

Chihuahuas … developed for aesthetic reasons constitute a vast unacknow-
ledged genetic folk art' (205). Indeed, although Kac's work is by all means
poetic, it is not aesthetic in the way that, for example, Luxembourgian artist
and curator Edward Steichen's was. After twenty-six years of experimen-
tation, Edward Steichen put on an exhibition at the Museum of Modern
Art in New York in 1936 where he displayed flowers of gigantic size and
colours never seen before. Steichen had applied the drug he was taking for
his gout, colchicine, to plants, and in this way doubled their chromosome
count. By using this method, Steichen was able to 'accelerate the nature's
progress' and create 'supernatural growth in delphiniums' (Gedrim, 1993:
356). Although the much-used argument goes that genetic of plants and
animals is really no more than a continuation of genetic folk art and
cross-breeding that had produced such breeds as the Pekinese dogs, it is
important to separate the instrumentalist approach from an investigative
and poietic one. Genetic manipulation, in allowing for biological steps to
be skipped in ways unimaginable within the system of natural selection,
and in crossing plants and animals that could never breed together – for
example the human/cow embryos developed in the search for off-the-rack
human organs, or tomatoes that carry the gene of a deep-water cod fish
to make them less susceptible to freezing – poses hitherto nonexistent
ethical questions. Not only is the question of what should be bred with
what and how of paramount importance, but all life (plant, animal or
human) is composed of the same genetic alphabet – the chemical bases
adenine, guanine, cytosine and thymine. This has direct and profound
implications for all other organisms. Cross-bred organisms are not one-
offs; they will replicate their singularity through further breeding. In con-
trast to the popular mindset of the past decade and half, in which plants
and animals are discussed as if they were particular arrangements of data
to be re-arranged and patented, Kac's transgenics takes a far more com-
prehensive, non-instrumentalist view of cross-breeding. As his 'Natural
History of the Enigma', whose chief focus is a plantimal – a hybrid between
a plant and an animal, christened Edunia – shows, a non-hierarchical rela-
tionship to transgenics is key. *Edunia*, whose development took five years,
from 2003 to 2008, and which was exhibited at the Weisman Art Museum
in Minneapolis in 2009, is a genetically engineered flower that is a hybrid
of Kac and Petunia. The new flower has red veins and whitish pink petals.
As Kac (2009) notes:

> a gene of mine is expressed on every cell of its red veins … The gene
> was isolated and sequenced from my blood. The petal's pink back-
> ground, against which the red veins are seen, is evocative of my own

pinkish white skin tone. The result of this molecular manipulation is a bloom that creates the living image of human blood rushing through the veins of a flower. (np)

Importantly, the gene Kac selected for cross-breeding is normally responsible for the identification of foreign bodies, bodies that, in some cases, can be harmful to the organism in question, in this case Kac's. It is thus precisely this 'guarding' or 'policing' gene that Kac wanted to integrate into another organism, in order to create a 'new kind of self that is partially flower and partially human' (np). A piece of DNA can be extracted from a human, or an animal, and made to perform its function inside bacteria and vice versa. In fact, this interchangeability has been one of the driving forces of all evolution. Once the DNA has deciphered the code, as it were, the code for creating blood cells, for instance, all future organisms adapted and further refined this code; they did not have to reinvent it. This ability of the DNA from one organism to interface smoothly with another, which, essentially, means that all life is interrelated, is at the heart of Kac's project. This is not only an aesthetic point, but far more importantly, an ethical point, as it involves care and responsibility. *Edunia* is an example of bringing not one-off otherness but continuous otherness into the world. Every time Edunia procreates through seeds, Kac's gene will be a part of that procreation. It will be continued in the new flowers. In fact, Kac created a limited edition of *Edunia* seed packs, as he suggests, 'in anticipation of a future in which Edunias can be distributed socially and planted everywhere' (np). In addition to the seed pack, Kac also produced *Edunia* seed pack studies, with the information about the plant's blooming habits, the weather and nutritional requirements. Accompanying these instructions are photographs and watercolours in which Kac explores the relationship between life and communication. This holistic approach, which includes a concern for *Edunia's* future breeding possibilities, as well as a concern for her hybrid status, shows that *Edunia* was not created as an amusing novelty but as an opportunity to highlight the interwovenness of all life. First, this has much to do with non-identitarian groups discussed in the previous chapter. The basis for association has, for centuries, been identity – whether ethnic, gender, class, social or even species identity. The form of association proposed by Kac does not use any common denominator, not even that of a similar shape or habitat. Humans and plants are as different as they can be. And yet, *Edunia* is presented as a plantimal, not simply an aesthetically enhanced plant. Second, the complex cycles of decomposition and reassembly, which occur on Earth, do, in fact, bring human remains in contact with plants. One of the chief Buddhist ideas – reincarnation – and

the accompanying respect for all sentient beings, comes from this interwo-venness. It comes from the fact that within the present time frame, I am a human being, but in fifty years' time, I will be food for microbes, plants and animals. These microbes, plants and animals will, in time, decompose and become part of other microbes, plants and animals.

The same holistic approach can be seen in what is perhaps Kac's most famous work, *GFP Bunny*, a bunny that glows in the dark. Both works are a prominent example of what Latour (1999b) terms the actor-network theory, with a particular focus on the network which consists of several loops. The five important loops are the following: (1) the mobilisation of the world, which is a complex set of processes for transporting objects from the real world into the scientific discourse; (2) autonomisation, which consists of the experimental work of the discipline or sub-discipline, which gains legit-imacy by forming its own criteria; (3) the forming of alliances, including stakeholders and sponsors; (4) representation and public appearances; and (5) the work itself, which, according to Latour, is the most difficult to study, since it is 'a very tight knot at the center of a net' (106). Kac's *Edunia* mobilises all parts of the network. It is a hybrid artistic-scientific object, which extends the concepts of biodiversity and evolution through genomics. It establishes an intersection at the threshold of science, biology, philosophy, aesthetics and literature where notions of normalcy, purity, hybridity and otherness may be discussed. It also gives this discussion a spe-cific name: transgenics. It includes cultural institutions and, more generally, the artistic and the intellectual network. Furthermore, it includes the press, the various cultural forums and the various formats in which *Edunia* has been exhibited and written about, for example in Kac's drawings and paint-ings. Finally, *Edunia* ushers a fascinating, sentient (art)work into the world.

For Latour, a network is not a static grid but a dynamic, processually forged and, essentially, unfinished structure. This is why there can be no fixed explanation, social or cultural, of what the network does; the rela-tionship between the various loops is multifaceted and simultaneous, rather than consecutive. Besides, the very term 'social' binds together the scientific, the political, the cultural and the economic, and cannot be a category that contains them all. In *GFP Bunny*, a fluorescent rabbit that continues to be at the heart of a number of serial works, Kac explores these intersections. Kac (2000) describes the first encounter with the *GFP Bunny* in the following way:

> I will never forget the moment when I first held her in my arms, in Jouy-en-Josas, France, on April 29, 2000. My apprehensive antici-pation was replaced by joy and excitement. Alba – the name given

her by my wife, my daughter, and I – was lovable and affectionate and an absolute delight to play with. As I cradled her, she playfully tucked her head between my body and my left arm, finding at last a comfortable position to rest and enjoy my gentle strokes. She immediately awoke in me a strong and urgent sense of responsibility for her well-being. (np)

An albino rabbit that glows in the dark, Alba is a chimerical animal in all three senses of the word. In mythology, the classical Chimera was the fire-spouting monster with the head of a lion and the tail of the serpent. 'Chimerical' also denotes improbability, chimera being an illusion or a fabrication of the mind. In the scientific sense, 'chimera' refers to any organism that incorporates discrete populations of cells with different genomes. However, Alba is not overtly different. She has no skin pigment; she is an albino rabbit, which means that under ordinary lights she is white. She only glows when placed under blue light. This is when Alba becomes green. This ambiguity is essential to the project, which is not concerned with aesthetics or, indeed, purity but operates at a number of thresholds. The first is the possibility of communicating with Alba; the second is the possibility of communicating about Alba, communicating about the relationship of engineer-progenitor and product-offspring; the third is the sharing of genetic material across species boundaries. As a transgenic animal, Alba brings the question of animal agency into play. This is why Kac (2005) emphasises the necessity to 'think rabbit agency without anthropomorphizing it' (273), without giving it human motives or characteristics. The different stages which form part of the project emphasise this: the birth of Alba, the first public announcement of her birth in the context of the Planet Work Conference in San Francisco on 14 May 2000; a series of public interventions in Rio de Janeiro realised during 'Rabbit Remix', Kac's solo exhibition at Laura Marsiaj Arte Contemporânea gallery in Rio de Janeiro, in September and October 2004, entitled *Rabbit in Rio*; an enamelled steel street plate 'Boulevard Alba' created in 2006, on which the following sentence stood: 'France pays homage to the green bunny in recognition of her exceptional contribution to the defense of the rights of new living beings'; a 2008 artist's book 'It's not easy being green!', which contains public responses to Alba, a montage of images, children's emails, TV broadcasts and webpostings (Kac, 2009: np). Furthermore, in 2009, the Lepus Constellation Suite was created – five engraved and painted steel discs, on which lagoglyphic (a form of rabbit language invented by Kac) interstellar messages were engraved and transmitted from Cape Canaveral in Florida to the Lepus constellation of 13 March 2009. As Kac explains:

'[b]ased upon its stellar characteristics and distance from Earth, Gamma Leporis (part of the constellation Lepus) is considered a high-priority target for NASA's Terrestrial Planet Finder mission. The transmission was accomplished through satellite broadcasting equipment and a parabolic dish antenna. Lepus Constellation [Gamma Leporis star] is 29 light-years from Earth' (np). This means that Kac's messages will arrive in 2038. Such a cross-species as well as interstellar engagement highlights the fact that transgenic art, of the sort practised by Kac, is a reminder that communication and interaction between sentient and non-sentient actants lies at the core of what we call life. It also acts as a reminder of the fact that ideas about what life is have varied throughout history. With the current advances in bio-technology – which are both awe-inspiring and terrifying – it is important to take a comprehensive, ethically informed view of the diverse forms life can take, and leave the segregationist binaries which institute firm borders between 'alive' and 'dead' behind.

Semi-living bioart: Oron Catts and Ionat Zurr

The term 'bioart', coined by Eduardo Kac in 1997 in an attempt to describe *Time Capsule* (a project in which he implanted a microchip into his ankle), has been considerably expanded by Oron Catts and Ionat Zurr. Working initially within the Tissue Culture and Art Project, which came into existence in 1996, Catts and Zurr founded SymbioticA in 2000. SymbioticA is a bioart laboratory that hosts the work of artists and scientists; it is located at the University of Western Australia and acts as a 'porous membrane in which art and bio-medical sciences can mingle' (Catts cited in Quaranta, 2004: 158). Since 2000 it has been home to Catts and Zurr's tissue-engineering project entitled *Semi-Living Worry Dolls*. The tiny dolls, which, as the title of the work suggests, were neither entirely living nor entirely dead, were created from living cells seeded onto degradable polymers, or macromolecules. They were further placed within a bioreactor which acted as a surrogate body enabling the semi-living dolls to grow. Although associated with an ancient children's story, the *Semi-Living Worry Dolls* are a reflection on the anxieties created by the accelerated expansion of corporate bio-technologies and the widespread practice of eugenics. For Catts and Zurr (2002a), who started growing semi-living sculptures in 1996, the

> goal of these works is to culture and sustain tissue constructs of varying geometrical complexity and size for long periods, and by that process to create a new artistic palette to focus attention on and

challenge perceptions regarding the utilization of new biological knowledge. (67)

Given that experiments at the border of life and death invariably conjure up associations with magic, alchemy and the occult sciences, Catts and Zurr chose to accept rather than ignore these associations. In preparation for the project, they purchased a pack of Guatemalan worry dolls from a shop in Boston. Attached to the dolls was the following note:

> The Guatemalan Indians teach their children an old story. When you have worries you tell them to your dolls. At bedtime children are told to take one doll from the box for each worry & share their worry with the doll. Overnight, the doll will solve their worries. Remember, since there are only six dolls per box, you are only allowed six worries per day. (Anon. cited in Catts and Zurr, 2002c: 368)

Not quite heeding the last sentence, Catts and Zurr grew seven dolls whose genderless appearance, in the words of the artists, represents 'the current stage of cultural limbo, characterized by childlike innocence and a mixture of wonder and fear of technology' (368). Each of the seven dolls was assigned a letter of the alphabet and a worry, although viewers and followers of the project were encouraged to name their own worries and post them to the website which accompanied the project. Doll A stood for a worry about '[a]bsolute Truths and people who think they hold them'; B was for 'biotechnology and the forces that drive it'; C was for '[c]apitalism and [c]orporations'; D for '[d]emagogy [appealing to public emotions and prejudices in order to gain power]' and 'possible Destruction'; E stood for '[e]ugenics and the people who think that they are superior enough to practice it'; F was for the 'fear of Fear itself'; G was not 'a discrete doll as Genes are present in all semi-living dolls'; and, finally, H stood for the 'fear of Hope' (368). All the possible fears associated with creating a new class of beings, which straddles what in the rational, scientific, post-religious climate is the ultimate divide – that between life and death – are enumerated here. The list includes both the most infamous experiments, such as the Nazi eugenics (biological improvement of the Aryan race, seen as the master race, accompanied by the simultaneous annihilation of other races), and the most dangerous ones – eugenics motivated by corporate interests as well as, ultimately, profit. As American sociologist Dorothy Nelkin and legal theorist Lori Andrews (1998) observe in 'Homo Economicus: the Commercialization of Body Tissue in the Age of Biotechnology', 'snippets of life such as genes, haplotypes, human tissue and immortalized cells lines

created by the biotech industry through corporate alliances' are manipulated and 'marketed as biological objects', in other words, as 'biocapital' (33–34). This commodification of the human body is further exacerbated by such expressions as 'biobanking' and 'bioinvestment', which are routinely used in such enterprises and which clearly identify the danger associated with profit-driven bioengineering (33–34).

Catts and Zurr (2002b) acknowledge this introduction of a new class of being in the continuum of life, within the current bioengineering climate, in the following way: 'the Semi-Living are sculpted from living and non-living materials, and are new entities located at the fuzzy border between the living/non-living, grown/constructed, born/manufactured, and object/subject' (5). Located between these categories, and pictured in Figure 11.1, semi-living beings require a particular form of care; they rely on the 'vet/mechanic', 'farmer/artist' or 'nurturer/constructor' (5).

This also means that a new relationship needs to be constructed since the 'new class of being' is both similar to former selectively bred plants and animals, and dissimilar: their form as well as their status is non-descript.

Figure 11.1 Oron Catts and Ionat Zurr, *Semi-Living Worry Dolls*, The Tissue Culture & Art Project. Medium: living cells, biodegradable/bioabsorbable Polymers and Surgical Sutures. Dimensions of Original: 2 cm × 1.5 cm × 1 cm each. From the Tissue Culture & Art Project Retrospective Crude Life (Laznia Centre for Contemporary Art, Gdansk, Poland) 2012. © Oron Catts and Ionat Zurr. Courtesy of Oron Catts and Ionat Zurr.

For Catts and Zurr, the semi-living are 'evocative objects' (5) in that they serve to re-evaluate 'our perceptions of what is life and our treatment of other forms of life' (5). 'Evocative objects' are, for theorist of technology Sherry Turkle, 'objects that ignite human perceptions' (Turkle cited Catts and Zurr, 2002a: 64–65). Turkle uses the example of the psychological relationship children have with smart toys that help them to engage with such questions as what qualifies as alive and what does not. However, it also places the semi-living in the domain of 'objects', subordinated to 'subjects'. In the case of Catts and Zurr's project, the relationship to the semi-living dolls was defined by their basic needs; they required sterile conditions and a constant immersion in nutrient media at a temperature adapted to mammalian tissue of 37 degrees. They also needed to be fed on a regular basis. This meant that the laboratory had to be part of the installation wherever the *Semi-Living Worry Dolls* were shown; their engineered habitat was shown together with the dolls. The feeding ritual, which involved the replacement of the nutrient solution in which the dolls resided, was performed in front of the audience to make 'the commitment and responsibilities' (Catts and Zurr, 2002b: 6) to a living system transparent and palpable. Apart from an enclosure area, this needed a sterile hood, a bioreactor and laboratory consumables. The ritual thus had a clearly defined procedure, time, place and equipment. The 'killing ritual' (6), as Catts and Zurr call it, was made transparent and palpable to the audience, too. Catts and Zurr explain:

> Transferring living material through borders is difficult and not always possible, and as there is usually no one who is willing to 'adopt' the Semi-Living entities and care for them daily (under sterile conditions), we have to kill them. The killing is done by taking the Semi-Living sculptures out of their containment and letting the audience touch (and be touched by) the sculptures. The fungi and bacteria which exist in the air and on our hands are much more potent than the cells. As a result the cells get contaminated and die. (6)

At this point we may think that bio-artists merely use the living organisms they created and discard them when they are no longer needed. But the 'artists killing their work of art' metaphor here is not accidental, nor is it frivolous. On the contrary – it raises questions about responsibility that is always already there in all life, not only in bioengineering, a responsibility which involves what appear to be 'dead objects', as they are actants and thus contributors to the development of life, too. For Latour, to say that objects have agency – even when these objects are entirely dead, not

semi-living – is not to grant them mystical power. When Latour writes 'you discriminate between the human and the inhuman. I do not hold this bias but see only actants – some human, some nonhuman, some skilled some unskilled – that exchange their properties' (Latour cited in Johnson, 1988: 303), he refers to the widest range of 'actants' possible. For Latour, even such definitely inanimate things as doorstops, speed cameras and lying policemen are actants and have agency (303). They exercise agency given to them, the agency they are programmed with. However, this is not a case of merely imbuing a specific object with agency; it is an infinitely more complex process. Latour is adamant about the fact that things do not suddenly materialise in the universe, either from society or nature, but are the result of a long process of negotiation between the material world, the various historical associations and human beings. Human beings give these processes names and by doing so organise them. The problem with the 'modern' organisation of knowledge and information, however, unlike that of the pre-moderns, is that it insists on pure – or purified – categories.

Echoing Foucault in *We Have Never Been Modern*, Latour (1993) recounts that modernity works obsessively at categorising the world according to a binary that separates humans from nonhumans, subjects from objects. The key problem here is the violent politics that emerges from this. Nature is to be dominated; other cultures, cultures that refuse this progressive and linear categorisation and the violent disciplining that comes with it are to be dominated, too, since they also are a part of nature, which is seen as inferior to culture. Pre-modern people, however, mix myth, superstitions, the social and the natural indiscriminately while modern science separates these spheres. For Latour:

> Modernisation consists in continually exiting from an obscure age that mingled the needs of society with scientific truth in order to enter into a new age that will finally distinguish clearly what belongs to atemporal nature and what comes from humans. (71)

But nature and culture are constantly co-produced; their dialogue is one of ceaseless mediation. Commenting on the recent developments in which hybrid objects/phenomena proliferate with great speed – allergy epidemics, global warming, ozone holes – it is clear, Latour argues, that there can be no talk of separate cultural, human and non-human processes. Suffice it to look at global warming where 'scientific facts' have been intermingled with industrial, political and ecological interests. For Latour (2004 [1999]), hybrid objects have no clear boundaries; there is no separation between their own hard kernel and their environment: '[t]hey

first appear as matters of concern, as new entities that provoke perplexity and thus speech in those who gather around them, and argue over them' (24). Although *Semi-Living Worry Dolls* are heretofore unseen entities that provoke perplexity, their presentation, like that of Kac's *Edunia* and *GFP Bunny*, is confined to a carefully chosen context. This context allows for a more comprehensive consideration of the multiple states of in-between-ness, not the cataloguing or ordering described by Latour and Woolgar in *Laboratory Life* and mentioned above. As Latour (1993) repeatedly empha-sises, the fuzzy areas are of key interest here, that is to say, the space of 'nonseparability of quasi-objects and quasi-subjects' (139). Careful of not using words like 'objects' and 'subjects' for fear of granting such an absolutistic and limiting division authority, Latour's crucial point is not that the debate about whether something is a subject or an object needs to continue, but that it might be time to 'speak of democracy again, but of a democracy extended to things themselves' (141). By situating *Semi-Living Worry Dolls* within a context where objects of affective pres-ence are usually displayed, objects whose presence has been imbued with subject-value – a gallery is a space where objects of cherished cultural value selected by qualified subjects are shown – and by treating them as living beings through the feeding ritual, as well as by further drawing attention to their living status by christening the killing ritual, 'killing ritual', Catts and Zurr emphasise the 'nonseparability of quasi-objects and quasi-subjects' through performance. In so doing, they also draw attention to the performativity embedded in the semi-living worry dolls, which, as actants, create new frameworks, new contexts and, finally, new networks. Catts and Zurr's exploration of this enmeshed-ness of actants and networks extends to a hybridity that has a less emotional and more alimentary, physical impact, as investigated in *Disembodied Cuisine*. A per-formative installation, *Disembodied Cuisine* thematises meat production without victimisation. Here, Catts and Zurr cultivated edible semi-living sculptures out of isolated muscle cells from frogs in bioreactors. The cells were fed for a period of eight weeks at the Lieu Unique in Nantes, France, in 2003, as part of the *Art Biotech* exhibition curated by Jens Hauser. After this period, a dinner was presented. The animals spared from slaughter, as a direct result of the artificially grown meat, were also shown in this space shaped like an igloo. The laboratory facility was hidden under black plastic, and circular portholes were the only windows through which visi-tors could see what was going on inside the laboratory. The dinner was served in a rectangular space sealed off with transparent plastic where vic-timless steaks were eaten by the audience, which included local farmers. As Jens Hauser (2005) reports:

The tough tidbits were difficult to cut even with a scalpel and their taste was questionable to say the least … one of the guests paid a high price for this dubious pleasure in the form of an allergy suffered for weeks afterwards – ironically, not a reaction to the ersatz meat but rather to its polymer structural skeleton, and thus to the techno-logical avatar that was meant, in this artistic context, as a symbolic means of saving animal life. (np)

In France, where the artificially created frog-steak dinner took place, frogs are part of the national cuisine. However, the uneasiness that persists around bioengineered food – as opposed to the Futurist culinary and, indeed, nutri-tionist aesthetics – has much to do with the deeply ingrained taboos on what is to be eaten and what is not. Only one other taboo has been historically as definitive and as non-negotiable, and that is the incest taboo. There is, of course, a century-long as well as transcultural association of food and eating practices with sacrificial rituals and the communion with the divine. A table was originally a sacrificial altar; since gods inhabited a celestial world, the offerings had to be placed high up. In fact, to this day, the French expression 'la table dressée' refers both to an elevated table and a table that has been laid. On a different level, eating is closely associated with love and represents a mystical union with the loved one, of human or divine nature. When eating, one becomes one with the food one eats. This is why eating delicious food is seen as a form of celebrating life in most cultures. However, which food is seen as delicious and which is not is highly dependent on cultural markers and various systems of belief, whether religious or scientific. In the present age, wrought with campaigns against genetically modified food, particularly food modified for profit purposes – to look bigger, shinier, better-shaped, to stay fresh longer – technologically produced food is seen as less nutri-tious, in some cases even disgusting. Eating such food requires a configur-ation of consciousness and, in fact, a rethinking of deeply ingrained taboos. According to Latour (2004 [1999]), the compulsive need of the moderns to segregate and purify does not need to be entirely dissolved, but the non-modernist acts and performances of valuing, that foreground diverse assem-blages, such as *Disembodied Cuisine*, ought be acknowledged, since

we shall always go from the mixed to the still more mixed, from the complicated to the still more complicated … We no longer expect from the future that it will emancipate us from all our attachments; on the contrary we expect that it will attach us with tighter bonds to the more numerous crowds of aliens who have become fully-fledged members of the collective. (191)

For Latour, nonhuman voices have to be 'added to the discussion' which 'can only be conceived if it can freely traverse the border between science and politics' (69). In probing the area that formerly belonged to the occult sciences and alchemy, and staging interactive works that elicit performance, Catts and Zurr also pose important questions about the performativity of life. Life as 'dispersed information', to use Bard and Söderqvist's (2002) phrase discussed in the previous chapter (75), but also life as a sentient process, where notions of pain and suffering are inextricably entwined with those of birth and death, assembly and disassembly, and composition and decomposition.

Helen Pynor: reflections on intersomativity and interspeciesism

Focusing on the somatic experience of life and the interconnection between the various parts of soma – the body – with the compositional and de-compositional processes of the Earth, Australian artist Helen Pynor's work investigates both new and old assemblages. For two decades, her projects have investigated the life-death boundary, as well as what Latour has termed inter-agentivity. In his definition of inter-agentivity – the coordinated action or interaction of several agents – Latour draws on two sources: Donna Haraway, discussed in Chapter 9, in particular, her book *Companion Species Manifesto*, and Eduardo Kohn's *How Forests Think*. In *Companion Species Manifesto*, Haraway (2003) proposes that 'interspecies cyborgs … bring together the human and the non-human, the organic and technological, carbon and silicon, freedom and structure, history and myth … diversity and depletion … nature and culture in unexpected ways' (4). Focusing on dogs in particular, but implying all domesticated species, Haraway introduces the notion of 'metaplasm', which is 'the remodeling of dog and human flesh, remolding the codes of life, in the history of companion-species relating' (20). It is a mode of relationality in which relationship creates modes of behaviour and habits, for example games, which grown dogs teach their offspring, where the ethics of communication, based on concern and care, is key. The other source, Kohn, examines how forests co-act with other forest inhabitants. He terms this process 'thinking', which imbues trees and plants with a very specific kind of agency. Derived from Haraway and Kohn, inter-agentivity is, for Latour (2013), 'the capacity of relating agencies with one another without passing every time through the obligatory passage point of the Object-Subject' which produces 'lines of agreement and dissent totally different from what would have been expected from a Nature-versus-Culture frame' (5). The

subject-object in this case is not only the difference between the human subject and the (inanimate) object, but the difference between two knowledge alternatives that can be summed up thus: 'are you subjective, that is probably meaningful but unreal?' or, 'are you objective, that is, material, that is, real?' (5).

Helen Pynor's work tackles relationships between humans and their environment through the body's interior – one's own interior, the interior of other people and the interior of other beings. In this sense, her work is related to the subject-object, alive-dead divide, like Catts's and Zurr's work. However, it is also related to the meaningful-material divide, as theorised by Latour. 'Meaningful' here refers to exclusively human modes of meaning-production based on discourse and imagination, for example characteristics attributed to certain body parts. In a 2006 exhibition entitled *Breathing Shadows*, Pynor articulates the ambiguous status of hair, as both dead and alive. Hair was here used to knit seemingly randomly combined bodied shapes and garments – a shirt with a pair of hands. The unfamiliar and unsettling quality of the work emphasises hair's ambiguous materiality: even when attached to a scalp, hair is simultaneously dead and alive; it is an object and a part of the subject. It can be entirely shaved off without causing any pain to the organism, which cannot be said of fingernails, albeit their status is quite similar. Unlike fingernails, however, which are rarely kept when cut off, hair is often regarded as a keepsake as well as used to make wigs. In many ways, hair could be seen as the limit of the subject body, which is the reason why using hair to knit human limbs – hands, for example – as well as human garments – shirts, underwear – has much poignancy. Many of Pynor's works include the pairing of internal organs – liver, heart, kidneys – with clothes, such as shirts and dresses.

Ruminations on the subject-object status of our own organs, and the ultimate un-realness of the interior of the body, which we know exists as an 'object' (we know it through scientific discourse), but which we fail to sense in a meaningful way, unless a disturbance occurs, were further extended in Pynor's collaboration with Australian artist Peta Clancy, which produced a performative bio-art installation entitled *The Body is a Big Place*. Although the work began in 2009, it was first shown in its entirety at the Performance Space in Sydney in November 2011. In five floor-to-ceiling film projections, human beings with an experience of organ transplantation – recipients, donors and donor kin – were shown roaming vast underwater spaces. They were seen walking, standing, sitting on chairs, looking at each other as well as occasionally floating up to the surface for a breath of air. A gentle aqueous soundscape permeated the underworldly ambiance of the exhibition space, which, apart from the semicircular screens also had a

Figure 11.2 Helen Pynor and Peta Clancy, *The Body is a Big Place*, Science Gallery Dublin, 2012. Left to right: Noreen Boyle, Helen Pynor, Michael Shattock. © Helen Pynor and Peta Clancy. Courtesy of Helen Pynor and Peta Clancy.

bio-sculptural heart perfusion system. This system, depicted in Figure 11.2, was used for re-animating pig hearts. In a live performance of unintended but nevertheless ritualistic, almost shamanistic connotations, two fresh pig hearts were brought back to life.

For several minutes the hearts beat – expanding, contracting and pumping blood – only to trail off into eternal silence one more time. Like the organ transplantation recipients, donors and donor kin pictured in the projections, the visitors were here drawn into a world of slippery boundaries, not only those between life and death, memory and oblivion, but also those between humanity and animality. As Clancy and Pynor (2012) explain, the aim of these performances, of which there were two during the three-week run at Performance Space in Sydney, was to appeal to the 'viewers' somatic, kinaesthetic, visual, and aural senses and foster their identification with the hearts they were watching, opening up the possibility of a deeper cognisance and connection with viewers' own interiors' (np). The one thing that the majority of the participants in the project, particularly those whose organs – or ex-organs in the case of non-vital organ donors, such as kidneys – had traversed vast distances, testify to is a lasting sense of openness; they no longer experience their interior as separate from

those of others (np). Finding the right match between the donor organ and the recipient is often a lengthy process wrought with uncertainty and fears of life-threatening immunological reactions. This process is not only lengthy in terms of time but the organs often come from thousands of miles away. Patients often abandon notions of firm self-hood and mineness during this process, since the long tolerance-induction regimens, and the frequent immunological failures, shatter the illusion of bodily integrity.

As French philosopher Jean-Luc Nancy (2000), himself a recipient of a heart transplant, suggests, this is less the result of having been opened up than of the fact this 'gaping open cannot be closed' (10). In Clancy and Pynor's installation, this interconnection with other bodies could be sensed in the movement the donors, recipients and the donor kin performed in the Melbourne City Baths. Entirely submerged in water, they moved involuntarily as a result of a single person's movement, since in water it is impossible not to react to the kinaesthetic impulse. Every small movement had a large kinaesthetic echo which shifted the entire visual constellation and drew attention to the sequence of action and reaction. As Clancy and Pynor (2012) note, the water 'acted both as a metaphor for the interior of the body, and an ambiguous space where various types of exchanges might take place' (np). Situated within this context, the reanimation of two pig hearts can be seen as a citation of a much-used medical procedure – heart transplantation – and, as such, as referring to humans only. However, pig hearts could also be seen for what they are. Given the widespread shortage of same-species transplants, foreign-body transplantation of cells, tissues and organs is increasingly seen as an alternative (Tisato and Cozzi, 2012: 1–3). The chief argument here is that animal donors are available well before the transplant. This 'availability' is, of course, based on the century-long practice of overactive animal reproduction, mostly for the consumption of meat. The fact that donor animals can be bred as well as genetically engineered increases the opportunity for conditioning both the donor and the recipient. Needless to say, animal rights regularly appear at the very bottom of the list of bioethical considerations. Although biomedical science is rife with contradictions, the closest match for foreign-body transplantation are precisely those animals which have been most demonised by all three dominant religions – Christianity, Judaism and Islam – for being scavengers and, as such, 'impure'. However, genetically engineered porcine donors are bred to secure organs for human patients. This narrative is, of course, speciesist, as is all anthropocentrically motivated interspecies or foreign-body transplantation. Indeed, *The Body is a Big Place* poses some very painful questions about intersomativity – the exchange of body parts – as well as about interspecies intersomativity – the exchange of body parts with other

species. Bringing into play Haraway's 'metaplasm', and Latour's 'inter-agentivity', it interrogates not only the moral and ethical background of breeding living beings to service human organ failure, but also the unpredictable sequences of intersomatic interactions.

According to Lori Andrews (2001), '[t]here is probably not a single condition [or] physiological change that doesn't result in profound changes in cell or gene expression' (118). While it is certain that change will occur in intersomatic combinations, whether of the same species or interspecies type, the future repercussions of these changes are impossible to predict. In many transplantation narratives, bacteria that have lain recumbent for generations, or even for entire evolutionary phases, suddenly come to life (Sharp, 2001: 115–116). This lends cellular performativity, as well as the performance of microbes, bacteria and organs, an entirely different focus. The performance of those elements which are or might become part of the human body, but are beyond direct human cognisance, is a mysterious and quite likely disastrous process. While signalling this danger in no uncertain terms, Clancy and Pynor's work sheds light not only on the interconnectedness of all life and matter, but also on inter-agentivity, on interaction with consequences for all those involved.

In the practices discussed in this chapter, performance is entirely bereft of its immaterial, ephemeral connotations. On the contrary, performance here brings to light the continuity of its material inscription for generations to come, beyond time frames imaginable by humans. It renders visible the interconnectedness between the human body – and human subjectivity – and the bodies of other sentient beings, the wider environmental cycles included. Apart from bringing into focus the immense violence which continues to be committed against all sentient beings in the name of science, a protected category beyond debate, it also questions the position of humans in a non-speciesist world. Performance practices operating at the border of art and medical science pose questions not only about the nature of being alive but also about the value of life as well as whose life. Might it be possible to envision a world in which a human donates an organ to a pet in need? Or, are the relations of power that have hitherto enslaved people of colour, women, non-heterosexuals, the poor and the mentally ill merely going to be transferred to robots and animals bred for the supply of human organs? The politics of biotechnology negate the processes of life destruction, the selective gene research and the reduction of the role of the environment to inertia. What alternatives are there and who can implement them? Since the performance of life is displaced – no longer attached to a whole organism – but can easily interface with other

organisms and genetic materials, who (and how) can monitor its prolifer-ation? It is the apparent incompatibility between performance – as imma-terial – and the digital-biotechnological complex – as material in a strong sense, genetically and historically inscriptive – that calls for a re-evaluation of performance in terms of epigenetics. Epigenetics refers to the dynamic alterations in the way DNA information is transcribed from generation to generation. Its basic tenet is heredity as influenced by the daily occurrences in a cell's or an organism's life. In a series of studies and experiments carried out between 1986 and 2006, Swedish geneticist Lars Olov Bygren and British geneticist Markus Pembrey conclusively proved that environmental factors like diet, stress, danger and, in fact, habit of any kind, for example smoking, make an imprint on genes. These imprints are created by the epigenome, which is lodged above the genome and governs its behaviour. In studies ranging from the effects of famine in Sweden to the effects of teenage smoking in the twenty-first century Britain, Pembrey et al. (2006) concluded that the environmental pressures and social changes of the industrial and post-industrial ages exercise an *accelerated effect* on evolution. In other words, they found that contrary to the widely accepted Darwinian ideas, change did not occur gradually, over millennia, but in several decades (163–166). Clearly, this places an entirely different emphasis on behav-ioural ecology. Not only does it add gravitas to Latour's thesis about the continuity between biology and sociology, but it creates an ethically urgent link between (any sort of) performance and heredity. The interdisciplinary intersection between biotechnology, art and performance is here epistemo-logically revealing, more so than any other interdisciplinary intersection. It brings into focus the relation between everyday practice and permanent, genetically inscribed and therefore reproducible damage.

Scores:

1 Choose two unlikely or even incompatible plants – for example, flowers and vegetables or fruit and weed. Cross-breed them. Use a part of your body that contains your DNA – such as your hair or nails – and inject it into the stalk, the leaves or the buds. Water the plant regularly. Give it a name. Create a series of presentations around this plantartwork in a venue and in the media.

2 Go to an animal shelter or a vet's office. Ask for a sample of shed or moulted fur. Attach it to your body, but without hurting yourself. Keep this part of the animal's body on your body for as long possible. Make a performance that addresses this union. Use mixed media.

Epilogue

What is the purpose of performative critique? Of thinking by doing and of appraising through showing? One of the purposes is certainly the re-education of perception. While written and spoken critique often produces verdicts of praise and disapproval, performative critique improves discrimination for the re-education of perception. Perception is, of course, related to culture and to the ordering of the perceptive faculties – sight, hearing, smell, touch, taste, movement. However, it is also related to habit and focus. By asking audiences or participants to turn a questioning eye/ear to what usually goes unnoticed precisely because it has become naturalised, but nevertheless forms part of an oppressive social practice, the examined performance strategies re-format reality by modifying perception. They create an interruption in the ingrained ways of seeing and usher new forms of thinking-doing into social, cultural and political life. The institution of society has always sought to produce a web of meaning that orders what are, essentially, random patterns of life. This web of meaning has served the dominant interests. Implicit rules about how to behave in public make it impossible to revolt against these rules without appearing out of order. And appearing out of order immediately devalues what one is trying to say. Likewise, implicit rules about rationality and 'civilised' behaviour have successfully kept women, minoritarian ethnic groups and homosexuals out of public life for centuries. While progress, expansion, industrial and technological advancement were all overtly propagated in the pre–World War II years, in the post–World War II era these ideas went undercover. To be sure, some grand narratives, such as the national-racial and the panhuman unity (the ideological motivators behind Nazism and communism), did recede into obsolescence. But the grandest narrative of them all – the imperative of economic growth – is more alive today than ever. One could say, as did American theorist Frederic Jameson (1991), that postmodernity has merely 'transformed the historical past into a series of commodifiable stylizations' (x). Indeed, it is difficult to deny that products, objects, services, gadgets, lifestyles and people have all become commodified. In fact, spectacularisation has surpassed the most pessimistic of Guy Debord's predictions, much like technologisation has surpassed the most pessimistic of Martin Heidegger's predictions. Difficult to deny is also Giorgio Agamben's (2013 [1993]) claim that the social classes have 'dissolved into a planetary petty

bourgeoisie' (63), ridden with status anxiety and addicted to affluence. But the purpose of the practices and theories examined in this book is not to state that many people have, indeed, 'told us so'. Rather, it is to high-light the need for a continual dismantling of the knowledge-power nexus as, in the twenty-first century, commodification occurs in the sphere of knowledge proper. Aided by the digital revolution, cognitive capitalism – as Antonio Negri (2008) has called it – works at 'capturing, within a gener-alized social activity, the innovative elements that produce value' and transforming them into commercial gain (64). If this seems far-fetched, a glance at the UK's National Endowment for Science, Technology and the Arts's website will show that the purpose of interdisciplinarity, which has been our concern here, is, apparently, to 'implement a commercial exploit-ation of new ideas, technologies and processes to create, develop and sell products and services' (Nesta, nd). This relationship to knowledge, which subsumes it under the imperative of economic growth, goes hand in hand with the relegation of politics to the domain of 'technical expertise', as Chantal Mouffe (2007) has argued (2). It also goes hand in hand with the relegation of philosophical thinking to the pre-digital era, as Byung-Chul Han (2015) has argued (90). What we are left with are government agencies and various scientific and knowledge-transfer committees whose purpose is to aid the functioning of the neoliberal economy by engineering com-petition and making entrepreneurship an integral part of all areas of life, including areas traditionally opposed to the (reductionist) economic way of thinking: art and theory. Amidst this crisis, the practices examined in this book are not only historically but also very much currently relevant, as they foreground the necessity of bringing non-hegemonic ways of thinking-doing into the perceptual-performative arena. By extracting a scroll from her vagina, Carolee Schneemann not only offers a conception of knowledge radically different from the patriarchal one, she also points to the instability of any given idea about what should constitute know-ledge. By creating semi-living dolls, Catts and Zurr draw attention to the shifting boundary between life and death while simultaneously exposing the instability of these very notions. Knowledge is neither stable nor chart-able and can, for this reason, not be subsumed under an overarching system of meaning. The practices here discussed solicit the viewer's creative and critical participation (whether implied or literal) in the *no man's land that is the world*. The fact that life consists of random patterns means that nothing is fixed or definite and that *things could always be otherwise*. In the current neoliberal climate, it is customary to think that significant social trans-formation is illusory; only economic prosperity can save us. The idea that radical artistic practices and critical theory could ever hope to bring about

significant changes is seen as belonging largely to the past. At the same time, this idea – that we have now reached a point in history from which we can oversee everything (time, the world, ecology, humanity, animality) and rid ourselves of all past delusions – is no other than the idea of progress as overarching meaning/order, characteristic of the many disastrous tendencies the practices discussed in this book so vehemently critique. The idea of progress is *the* most delusional of all ideas. It subordinates all other considerations, particularly ethical considerations, to the unstoppable drive which changes guise – the most recent being cognitive and ecological capitalism – but essentially remains the same as well as harmful. Due to the performed nature of reality, however, new and beautiful worlds can always be brought into the archive of knowledge (as in Surrealism), toxic identities can be corrected (as in The Yes Men's work) and intersomatic exchanges can be negotiated (as in Pynor and Clancy's work). This is why the practices and theories here examined remain as relevant today as they were when they first appeared. They are relevant for the simple reason that they reconfigure frameworks of perception and horizons of thought.

Bibliography

Adams, David (1992) 'Joseph Beuys: Pioneer of a Radical Ecology', *Art Journal*, vol. 51, Art and Ecology (Summer, 1992), pp. 26–34.

Adams, Matt (2007) Interview with the Author, Author's private archive, 2/7/2007.

Agamben, Giorgio (1998) *Homo Sacer: Sovereign Power and Bare Life*, trans. Daniel Heller–Roazen (Stanford: Stanford University Press).

Agamben, Giorgio (2013 [1993]) *The Coming Community*, trans. Michael Hardt (Minneapolis and London: Minnesota Press).

Althusser, Louis (1977) *Lenin and Philosophy and Other Essays* (London: New Left Books).

Andrews, Lori (2001) *Future Perfect* (New York: Columbia University Press).

Anonymous Situationist International (1959) 'Detournement as Negation and Prelude', *Situationists International Anthology* (1981), ed. Ken Knabb (Berkeley: Bureau of Public Secrets), pp. 55–56.

Anonymous Situationist International (1963) 'L'Avant–Garde de la presence', *Internationale Situationiste*, no. 8, January 1963, Centre George Pompidou.

Apollonio, Umbro (1973 [1970]) *Futurist Manifestos*, trans Robert Brain et al. (New York: The Viking Press).

Aragon, Louis (1994 [1926]) *Paris Peasant* (Boston: Exact Change).

Arata, Isozaki (2012) 'The Originality of Architecture and Design in Japan', *From Postwar to Postmodern Art in Japan 1945–1989*, eds Doryun Chong et al. (New York: The Museum of Modern Art).

Ascott, Roy (2004) 'Orai, or How the Text Got Pleated: A Genealogy of La Plissure du Texte: A Planetary Fairytale', *Leonardo*,vol. 37, no. 3 (2004), pp.195–200.

Aston, Eliane (2000) '"Transforming" Women's Lives: Bobby Baker's Performances of "Daily Life"', *New Theatre Quarterly*, vol. 16, issue 01, February 2000, pp. 17–25.

Austin, J. L. (1962) *How to Do Things With Words* (London: Oxford University Press).

Aydin, Cian (2007) 'Nietzsche on Reality as Will to Power: Toward an "Organixation–Struggle" Model', *Journal of Nietzsche Studies*, issue 33, pp. 25–45.

Baker, Bobby (2007) 'Drawing on a Mother's Experience', *Bobby Baker: Redeeming Features of Daily Life*, eds Michèle Barrett and Bobby Baker (London and New York: Routledge), pp.149–153.

Balakian, Anna (1971) *Andre Breton: Magus of Surrealism* (New York: Oxford University Press).

Banes, Sally (2001 [1998]) *Subversive Expectations: Performance Art and Paratheater in New York 1976–1985* (Ann Arbor: University of Michigan).

Bard, Alexander and Söderqvist, Jan (2002) *Netocracy* (Harlow: Pearson Education Ltd).

Barrett, Michèle and Baker, Bobby (eds) (2007) *Bobby Baker: Redeeming Features of Daily Life* (London and New York: Routledge).

Barth, John (1984 [1967]) 'The Literature of Exhaustion', *The Friday Book: Essays and Other Non-Fiction* (London: The Hopkins University Press), pp. 62–76.

Bataille, Georges (1988a) *The Accursed Share*, vol. I, trans. Robert Hurely (New York: Urzone, Inc).

Bataille, Georges (1988b) *The Accursed Share*, vol. I, trans. Robert Hurely (New York: Urzone, Inc).

Bataille, Georges (1988c) *Inner Experience*, trans. Leslie Anne Boldt (New York: State University of New York).

Bataille, Georges (1992) *On Nietzsche*, trans. Bruce Book (New York: Paragon House).

Bataille, Georges (2006 [1989]) *Theory of Religion*, trans. Robert Hurley (New York: Zone Books).

Baudrillard, Jean (1988) *Selected Writings*, ed. Mark Poster (Cambridge: Polity Press).

Baudrillard, Jean (1991) *La guerre du Golfe n'a pas eu lieu* (Paris: Editions Galilée).

Baudrillard, Jean (1993) *Symbolic Exchange and Death*, trans. I. Hamilton Grant (London: Sage).

Baudrillard, Jean (1994) *Simulacra and Simulation*, trans. Sheila Faria Glaser (Ann Arbor: University of Michigan Press).

Bäumler, Alfred (1931) Nietzsche, der Philosoph und Politiker (Leipzig: Reclam).

Baumgärtel, Tilo (2001) *net.art 2.0: Neue Materialen zur Netzkunst* (Nürnberg: Verlag für moderne kunst Nürnberg).

Benford, Steve et al. (2004a) 'Coping with Uncertainty in a Location–based Game', www.mrl.nott.ac.uk (last accessed 21/5/2013).

Benford, Steve et al. (2004b) 'Provoking Reflection through Artistic Games', www.mrl.nott.ac.uk (last accessed 16/5/2013.

Bergson, Henri (1911) *Laughter: An Essay on the Meaning of the Comic*, trans Cloudesley Brereton and Fred Rothwell (New York: Macmillan).

Bergson, Henri (1921) *Time and Free Will*, trans. F. L. Pogson (London: George Allen & Unwin Ltd New York Macmillan).

Bergson, Henri (1939) *Matière et mémoire* (Paris: Les Presses universitaires de France).

Bergson, Henri (1944) *Creative Evolution*, trans. Arthur Mitchell (New York: Random House).

Bernstein, Michèle (2004 [1960]) *Tous les chevaux du roi* (Paris: Editions Allia).

Berto, Francesco (2010) *There's something about Gödel: The Complete Guide to the Incompeteness Theorem* (New York: John Wiley and Sons).

Beuys, Joseph (1974) *The Secret Block for a Secret Person in Ireland* (Oxford: Museum of Modern Art).

Beuys, Joseph (1988) *Par la Présente, je n'appartiens plus à l'art* (Paris: Editions l'Arche).

Beuys, Joseph et al. (1988) *Bâtissons une cathédrale* (Paris: Editions L'Arche).

Blast Theory (2003) 'Can You See Me Now?', www.blasttheory.co.uk/projects/can-you-see-me-now/ (last accessed 2/6/2014).

Bon, Laurent de (2006) *Dada: catalogue publié à l'occasion de l'exposition DADA présentée au Centre Pompidou, Galerie 1, du 5 Octobre 2005 au 9 Janvier 2006* (Paris: Editions du Centre Pompidou).

Bonnet, Marguerite (1987) *L'affaire Barrès* (Paris: José Corti).

Borsch–Jacobsen, Mikkel (1988) *The Freudian Subject* (Stanford: Stanford University Press).

Bosquet, Alain (1969) *Conversations with Dali* (New York: E. P. Dutton).

Bowles, John, P. (2007) '"Acting like a Man": Adrian Piper's Mythic Being and Black Feminism in the 1970s', *Signs*, vol. 32, no. 3 (Spring 2007), pp. 621–647.

Brecht, George (1978) 'An Interview with George Brecht by Irmeline Leeber', *Introduction to George Brecht's Book of the tumbler on Fire* (Milan: Multhipla Edizioni), pp. 83–90.

Breton, André (1924) *Les pas perdus* (Paris: Editions de la Nouvelle Revue Française).

Breton, André (1936) *What is Surrealism*, trans. David Gascoyne (London: Faber & Faber, Ltd).

Breton, André (1974 [1969]) *Manifestos of Surrealism*, trans Richard Seaver and Helen R. Lane (Ann Arbor: University of Michigan Press).

Breton, André (1992 [1988]) *Oeuvres Completès*, eds Marguerite Bonnet and Etienne–Alain Hubert (Paris: Gallimard–Pléiade).

Breton, André (1993) *Conversations: The Autobiography of Surrealism*, trans. Mark Polizzotti (New York: Paragon).

Breton, André (2003 [1921]) 'Artificial Hells. Inauguration of the "1921 Dada Season"', trans. Matthew S. Witkovsky, *October* 105, Summer 2003, pp. 137–144.

Breton, André and Soupault, Philippe (1967) *Les Champs magné tiques* (Paris: Gallimard).

Brus, Günter (1999) 'Brus', *Brus, Meuhl, Nitsch, Schwarzkogler: The Writings of the Vienna Actionists*, ed. and trans. Malcom Green (London: Atlas Press), pp. 21–75.

Bürger, Peter, (1984) *Theory of the Avant–Garde*, trans. Michael Shaw (Minneapolis: University of Minnesota Press).

Butler, Judith (1990) *Gender Trouble: Feminism and the Subversion of Identity* (London and New York: Routledge).

Butler, Judith (1997a) *Excitable Speech: A Politics of the Performative* (London and New York: Routledge).

Butler, Judith (1997b) *The Psychic Life of Power: Theories of Subjection* (Stanford: Stanford University Press).

Butler, Judith (2004) *Undoing Gender* (London and New York: Routledge).

Cabanne, Pierre (1987 [1967]) Dialogue with Marcel Duchamp. Trans. Ron Padgett (New York: Da Capo Press).

Cache, Bernard (1995) *Earth Moves: the Furnishing of Territories*, trans. Anne Boyman (Cambridge: MIT Press).

Cage, John (1968 [1939]) *Silence* (London: Calder and Boyars).

Cage, John (1981) *For the Birds, in Conversation with Daniel Charles* (Boston: Marion Boyars).

Cage, John (1982) *Composition in Retrospect* (Cambridge: Exact Change).

Caillois, Roger (1971 [1961]) 'The Classification of Games', *The Sociology of Sport*, ed. Eric Dunning (London: Frank Cass & Co Ltd.), pp. 17–39.

Canjuers, Pierre and Debord, Guy (1981 [1960]) 'Preliminaries toward Defining a Unitary Revolutionary Program', *Situationist International Anthology* (1981), trans. Ken Knabb (Berkeley, CA: The Bureau of Public Secrets), pp. 305–310.

Caputo, John D. (1988) 'Demythologizing Heidegger: "Aletheia" and the History of Being', *The Review of Metaphysics*, vol. 41, no. 3 (March 1988), pp. 519–546.

Carlson, Marvin (1996) *Performance: A Critical Introduction* (London and New York: Routledge).

Catts, Oron (nd) 'The Art of the Semi–Living', www.tca.uwa.edu.au (last accessed 2/7/2014).

Catts, Oron and Zurr, Ionat (2002a) 'An Emergence of the Semi–Living', *The Aesthetics of Care*, Perth Institute of Contemporary Arts, 5 August 2002, www.tca. uwa.edu.au/ (last accessed 8/11/2014), pp. 63–68.

Catts, Oron and Zurr, Ionat (2002b) 'Are the Semi–Living Semi–Good or Semi–Bad?' www.tca.uwa.edu.au/publication/AretheSemi–Livingsemi–Goodorsemi–Evil (last accessed 13/5/2014).

Catts, Oron and Zurr, Ionat (2002c) 'Growing Semi–Living Sculptures: The Tissue Culture & Art Project', *Leonardo*, vol. 35, no. 4 (2002), pp. 365–370.

Caws, Mary Ann (1966) *Surrealism and the Literary Imagination: A Study of Breton and Bachelard* (The Hague and Paris: Mouton & Co).

Certeau de, Michel (1988) *The Practice of Everyday Life*, trans. Steven Rendall (Berkley: University of California Press).

Chadwick, Whitney (1990) *Women, Art, and Society* (New York: Thames and Hudson).

Chodorow, Nancy (1978) *The Reproduction of Mothering* (Berkeley, Los Angeles: University of California Press).

Chong, Doryun (2012) 'Tokyo 1955–1970 A New Avant–Garde', *Tokyo 1955–1970: A New Avant–Garde* (New York: The Museum of Modern Art), pp.26–93.

Chtcheglov, Ivan (1953) 'Formulary for a New Urbanism', *Situationist International Anthology* (1981), ed. and trans. Ken Knabb (Berkeley, CA: The Bureau of Public Secrets), pp. 1–4.

Chung–ying Cheng (1987) 'Confucius, Heidegger, and the Philosophy of the I Ching: A comparative inquiry into the Truth of Human Being', *Philosophy East and West*, vol. 37, no. 1 (January 1987), pp. 51–70.

Cigliana, Simona (1996) *Futurismo esoterico. Contributi per una storia dell'irrazionalismo italiano tra Otto e Novecento* (Venice: La Fenice).

Cixous, Hélène (1976) 'The Laugh of the Medusa', *Signs*, vol. 1, no. 4 (Summer, 1976), trans Keith Cohen and Paula Cohen, pp. 875–893.

Cixous, Hélène (1986) *The Newly Born Woman*, trans. Betsy Wing (Minneapolis: University of Minnesota Press).

Cixous, Hélène and Calle–Gruber, Mireille (2005) *Rootprints Memory and Life Writing*, trans. Eric Prenowitz (London and New York: Routledge).

Clancy, Peta and Pynor, Helen (2012) Email correspondence with the Author, Author's private archive, 3/10/2013.

Clark, John et al. (1976) 'Subcultures, Cultures and Class', *Resistance through Rituals*, eds Stuart Hall and Tony Jefferson (London: Hutchinson and CCCS).

Classen, Constance et al. (1994) *Aroma: The Cultural History of Smell* (New York: Routledge).

Classen, Constance (ed.) (2005) *The Book of Touch* (Oxford and New York: Berg).

Clébert, Jean–Paul (1971) *Mythologie d'André Masson* (Genève: P. Callier).

Cogdell, Christina (2011) 'From BioArt to Bio Design', *American Art*, vol. 25, no. 2 (Summer 2011), pp. 25–29.

Corbusier, Le (1986 [1927]) Towards a New Architecture . Trans John Goodman (Mineola: Dover Publications).

Corbey, R.H.A. (1994) 'Gift en Trangressie: Kanttekenignen bij Bataille', *Tijdscrift voor Filosofie*, 56ste Jaarg., nr. 2 (June 1994), pp. 272–312.

Corra, Bruno (1918) *Per l'Arte Nuova della Nuova Italia* (Milan: Studio Editoriale Lombardo).

Corradini, Bruno and Settimelli, Emilio (1973 ([1914]) 'Weights, Measures and Prices of Artistic Genius', *Futurist Manifestos*, ed. Umbro Apollonio, trans. Robert Brain (New York: The Viking Press), pp. 135–149.

Critical Art Ensemble (1998) 'Observations on Collective Cultural Action', *Art Journal*, vol. 57, no. 2 (Summer 1998), pp. 72–85.

Critical Art Ensemble (2000) 'Performing a Cult', *TDR*, vol. 44, no. 4 (Winter 2000), pp. 167–173.

Critical Art Ensemble (2001) *Digital Resistance* (New York: Autonomedia).

Critical Art Ensemble (1994) *The Electronic Disturbance* (New York: Autonomedia).

Cunningham, Merce (1968) *Changes: Notes on Choreography* (New York: Something Else Press).

Cunningham, Merce (1991) *The Dancer and the Dance: Merce Cunningham in Conversation with Jacqueline Lesschaeve* (New York: Marion Boyars).

Dachy, Marc (2005) *Archives Dada / Chronique* (Paris: Editions Hazan).

Dalí, Salvador (1968 [1942]) *The Secret Life of Salvador Dali*, trans. Haakon M. Chevalier (London: Vision).

Dalí, Salvador (1968 [1942]) 'Conquest of the Irrational', *The Secret Life of Salvador Dali*, trans. Haakon M. Chevalier (London: Vision), pp. 415–423.

Damisch, Hubert (1982) 'Indians!!??', *Jackson Pollock*, eds Daniel and Claire Stoullig (Paris: Centre Georges Pompidou, Musée national d'art modern), pp. 28–30.

De Salvo, Donna (1997) *Staging Surrealism* (Columbus, Ohio: Wexner Center for the Arts).

Debord, Guy (1981 [1956]) 'Theory of the *Dérive*', *Situationist International Anthology* (1981), ed. and trans. Ken Knabb (Berkeley, CA: The Bureau of Public Secrets), pp. 50–4.

Debord, Guy (1992 [1967]) *La societé du spectacle* (Paris: Editions Gallimard, Coll. "Folio").

Debord, Guy (1992) *Society of the Spectacle and Other Films*, trans. Richard Parry (London: Rebel Press).

Derrida, Jacques (1973) *Speech and Phenomena*, trans. David Allison (Evantson: Northwestern University Press).

Derrida, Jacques (1981) 'Plato's Pharmacy', *Dissemination*, trans. Barbara Johnson (London: Athlone Press).

Derrida, Jacques (1982) *Margins of Philosophy*, trans. Alan Bass (Chicago: The University of Chicago Press).

Demos, T. J. (2009) 'Dada's Event: Paris, 1921', *Communities of Sense: Rethinking Aesthetics and Politics*, eds Beth Hinderliter et al. (Durham and London: Duke University Press), pp. 135–152.

Doyon–Bernard, Suzette (1997) 'Jackson Pollock: A Twentieth–Century Chavin Shaman', *American Art*, vol.11, no. 3 (Autumn 1997), pp. 8–31.

Dreyfus, Hubert L. (1994) *What Computers Still Can't Do: A Critique of Artificial Reason* (Cambridge, MA: the MIT Press).

Duberman, Martin (1972) *Black Mountain: An Exploration in Community* (New York: Dutton).

Duchamp, Marcel (1994 [1975]) *La Première recherche* (Paris: Editions du Centre Pompidou).

Durland, Steven and Miller, Tim (1991) 'An Anarchic, Subversive, Erotic Soul: An Interview with Tim Miller', *TDR*, vol. 35, no. 3 (Autumn 1991), pp.171–177.

Dutton, Dennis (1990) 'Jean Baudrillard', *Philosophy and Literature*, vol. 14, pp. 234–238.

Duve, Thierry de (1988) 'Joseph Beuys, or the Last of the Proletarians', *October*, vol. 45 (Summer 1988), pp. 47–62.

Eckersall, Peter (2013) *Performativity and Event in 1960s Japan: City, Body, Memory* (Basingstoke and New York: Palgrave Macmillan).

Einstein, Albert (1920) *Relativity: The Special and General Theory*, trans. Robert William Lawson (New York: H. Holt & Co).

Eliade, Mircea (1968) *Le chamanisme et les techniques archaiques de l'extase* (Paris: Payot).

Ellul, Jacques (1966) *Politique de Dieu, politiques de l'homme* (Paris: Éditions Universitaires).

Ernst, Max (1948) *Beyond Painting* (New York: Wittenborn, Schultz, Inc).

etoy (nd), http://history.etoy.com/ (last accessed 12/3/2014).

etoy (2007) 'Mission Eternity', http://missioneternity.org/files (last accessed 12/3/2014).

Fernandès, Bruno (2014) *Pornologie vc capitalisme – Le Groupe de happening Zero Jigen – Japon 1960–1970* (Paris: Les presses du réel).

Fetterman, William (1996) *John Cage's Theater Pieces, Notations and Performances* (Amsterdam: Harwood).

Fraleigh, Sondra and Nakamura, Tamah (2006) *Hijikata Tatsumi and Ohno Kazuo* (New York and London: Routledge).

Frey, John G. (1936) 'From Dada to Surrealism', *Parnassus*, vol. 8, no. 7, December 1936, pp. 12–15.

Finley, Karen (2000) *A Different Kind of Intimacy: The Collected Writings of Karen Finley. A Memoir* (New York: Thunder's Mouth Press).

Flanagan, Mary and Booth, Austin (eds) *Reload: Rethinking Women + Cyberculture* (Cambridge, MA: MIT Press).

Fogu, Claudio (2011) 'To Measure Futurism', *California Italian studies*, vol. 2, no. 1, http://escholarship.org/uc.item/8k991673 (last accessed 3/4/2014).

Foster, Hal (1993) *Compulsive Beauty* (Cambridge, MA: MIT Press).

Foster, Kenneth E. (1963) 'Navajo Sand Paintings', *Man*, vol. 63 (March 1963), pp. 43–44.

Foucault, Michel (1976) *Histoire de la sexualité 1: La volonté de savoir* (Paris: Editions Gallimard).

Foucault, Michel (1977) *Discipline and Punish: The birth of the Prison*, trans. Alan Sheridan (New York: Vintage).

Foucault, Michel (1988) *Technologies of the Self: a Seminar with Michel Foucault*, eds Luther H. Martin et al. (London: Tavistock Publications).

Foucault, Michel (2003) *Society must be defended. Lectures at the Collège de France, 1975–1976*, eds M. Bertani and A. Fontana (Basingstoke: Palgrave Macmillan).

Foucault, Michel (2007 [1997]) *The Politics of Truth*, ed. Sylvère Lotringer, trans. Lysa Hochroth and Catherine Porter (Los Angeles: Semiotext(e)).

Frieling et al. (2008) *The Art of Participation from 1950 to Now* (San Francisco: Museum of Modern Art).

Freud, Sigmund (1949) *Introductory Lectures on Psycho–Analysis*, trans. Joan Rivière (London: Allen and Unwin).

Freud, Sigmund (1950) *Collected Papers*, vol. I, trans. Joan Rivière (London: Hogarth Press).

Freud, Sigmund (1967) *Interpretation of Dreams*, trans. James Strachey (New York: Avon Books).

Friedrich, Rainer (1983) 'Drama and Ritual', *Drama and Religion*, ed. James Redmond (Cambridge: Cambridge University Press).

Froman, Wayne J. (1988) 'Action Painting and the World-as-Picture', *The Journal of Aesthetics and Art Criticism*, vol. 46, no. 4 (Summer 1988), pp.469–475.

Fromm, Erich (1956) *The Sane Society* (London: Routledge and Kegan Paul Ltd).

Frueh, Joanna et al. (eds.) (1994) *New Feminist Criticism: Art, Identity, Action* (New York: Icon Editions).

Fusco, Coco (1995) *English is Broken Here: Notes on Cultural Fusion in the Americas* (New York: The New Press).

Galbraith, John Kenneth (1984 [1958]) *The Affluent Society* (London: Penguin Group).

Garcia, David and Lovink, Geert (1997) *The ABC's of Tactical Media*, subsol.c3.hu/subsol_2/contributors2/Garcia–lovinktext.html (last accessed 23/3/2014).

Gardner, Howard (1993 [1983]) *Frames of Mind: The Theory of Multiple Intelligences* (London: Fontana Press).

Gazzola, Guiseppe (ed.) (2011) *Futurismo: Impact and Legacy* (Stony Brook, NY: Forum Italicum Publishing).

Gaver, William W. et al. (2003) 'Ambiguity as a Resource for Design', https://www.gold.ac.uk/media/28gaver–beaver–benford.ambiguity.chi03 (last accessed 24/8/2014).

Gedrim, Ronald J. (1993) 'Edward Steichen's 1936 Exhibition of Delphinium Blooms', *History of Photography*, vol. 17, no. 4, pp. 352–363.

Gessert, George (1993) 'Notes on Genetic Art', *Leonardo*, vol. 26, no. 3, pp. 205–211.

Giannachi, Gabriella (2007) *The Politics of New Media Theatre* (London and New York: Routledge).

Giannachi, Gabriella (2004) *Virtual Theatres: an Introduction* (London: Routledge).

Gillmor, Alan M. (1983) 'Erik Satie and the Concept of the Avant–Garde', *The Musical Quarterly*, vol. 69, no. 1 (Winter 1983), pp. 104–119.

Goldberg, RoseLee (1993 [1979]) *Performance Art From Futurism to the Present* (London: Thames and Hudson).

Gooding, Mel (ed.) (1995) *A Book of Surrealist Games* (Boston and London: Shambala Redstone Editions).

Gorz, André (1989) *Critique of Economic Reason*, trans Gillian Handyside and Chris Turner (London and New York: Verso).

Grand, Gilles (2005) 'L'amiral cherche une maison à louer', *Archives Dada / Chronique*, ed. Marc Dachy (Paris: Editions Hazan), pp. 74–75.

Gray, C. H. (ed.) (1995) *The Cyborg Handbook* (London and New York: Routledge).

Green, Malcom (1999) 'Introduction', *Brus, Meuhl, Nitsch, Schwarzkogler: The Writings of the Vienna Actionists*, ed. and trans. Malcom Green (London: Atlas Press), pp. 9–20.

Greenberg, Clement (1986) *Clement Greenberg, the Collected Essays and Criticism*, vol. 1, ed. John O'Brien (Chicago: University of Chicago Press).

Grether, Reinhold (2000) 'How the etoy Campaign was Won: An Agent's Report', *Leonardo*, vol. 33, no. 4 (2000), pp. 321–324.

Grosz, Elizabeth (2008) *Chaos, Territory, Art Deleuze and the Framing of the Earth* (New York: Columbia University Press).

Häger, Bengt (1990) *Les Ballets suédois*, trans. R. Sharman (London: Thames & Hudson).

Han, Byung–Chul (2015) *Le Désir Ou l'enfer de l'identique* (Paris: Editions Autrement).

Hayles, N. Katherine (1999) *How We Became Posthuman: Virtual Bodies in Cybernetics, Literature and Informatics* (Chicago: The University of Chicago Press).

Haraway, Donna (1991) *Simians, Cyborgs and Women: the Reinvention of Nature* (London: Free Association).

Haraway, Donna (1992) 'The Promises of Monsters: A Regenerative Politics for Inappropriate/d Others', *Cultural Studies*, eds Lawrence Grossberg et al. (New York: Routledge), pp. 295–337.

Haraway, Donna (1995) 'Foreword: Cyborgs and Symbionts: Living Together in the New World Order', *The Cyborg Handbook*, ed. C. H. Gray (London and New York: Routledge).

Harraway, Donna (2003) *The Companion Species Manifesto: Dogs, People and Significant Otherness* (Chicago: University of Chicago Press).

Hardt, Michael (1998) 'The Global Society of Control', *Discourse*, vol. 20, no. 3, *Gilles Deleuze: A reason to Believe in this World* (Fall 1998), pp.139–152.

Hardt, Michael and Negri, Antonio (2000) *Empire* (Cambridge, MA: Harvard University Press).

Hardt, Michael and Negri, Antonio (2004) *Multitude: war and democracy in the age of Empire* (New York: The Penguin Press).

Harris, Mary Emma (1987) *The Arts and Black Mountain College* (Cambridge, Mass: MIT Press).

Hastrup, Kirsten (1992) 'Anthropological visions: some notes on visual and textual authority', *Film as Ethnography*, eds Peter I. Crawford and David Turton (Manchester: Manchester University Press), pp. 8–25.

Hauser, Jens (2005) 'Bio Art – Taxonomy of an Etymological Monster', *Hybrid Living in Paradox*, Ars Electronica Archive, http://90.146.8.18/en/archives/festival_archive/festival_catalogs (last accessed 11/2/2014).

Heddon, Deidree (2006) '"Personal Performance": the resistant confessions of Bobby Baker', *Modern Confessional Writing: New Critical Essays*, ed. Jo Gill (Oxon: Routledge).

Heidegger, Martin (1962) *Being and Time*, trans. John Macquarrie and Edward Robinson (Oxford: Blackwell Publishers Ltd).

Heidegger, Martin (1966) *Discourse on Thinking*, trans John M. Anderson and E. Hans Freund (New York: Harper).

Heidegger, Martin (1971) 'Building, Dwelling, Thinking', *Poetry, Language, Thought*, trans. Albert Hofstader (New York: Harper), pp.145–161.

Heidegger, Martin (1977) *The Question Concerning Technology and Other Essays*, trans. William Lovitt (New York: Harper Colophon Books).

Heidegger, Martin (2000) *Elucidation of Hölderlin's Poetry*, trans. Keith Hoeller (Amherst, NY: Humanities Books).

Helmreich, Stefan (2009) *Alien Ocean: Anthropological Voyages in Microbial Seas* (Berkeley: University of California Press).

Hendricks, Jon and Phillpot, Jon (1988) *FLUXUS Selections from The Gilbert and Lila Silverman Collection* (New York: Museum of Modern Art).

Hershman, Lynn (1999) 'Difference Engine No. 3', *Leonardo*, vol. 32, no. 4 (1999), pp. 269–270.

Hershman, Lynn (2005a) 'Private I: An Investigator's Timeline', *The Art and Films of Lynn Hershman Leeson*, ed. Meredith Tromble (Los Angeles: University of California Press Berkeley; London: Henry Art Gallery), pp.12–103.

Hershman, Lynn (2005b) 'The Raw Data Diet, All–Consuming Bodies and the Shape of Things to Come', *Leonardo*, vol. 38, no. 3 (2005), pp. 208–212.

Higgins, Dick (1976) *A Dialectic of Centuries: Notes Towards a Theory of the New Arts* (New York: Printed Editions).

Higgins, Dick (1993 [1966]) 'Statement on Intermedia', *In the Spirit of Fluxus* (1993), eds Elizabeth Armstrong and Joan Rothfuss (Minneapolis: Walker Art Center), pp. 172–173.

Higgins, Dick and Higgins, Hannah (2001 [1966]) 'Intermedia', *Leonardo*, vol. 34, no. 1 (2001), pp. 49–54.

Hijikata, Tatsumi (2000a) 'Inner Material/Material', *TDR*, vol. 44, no. 1 (Spring 2000), pp. 36–42.

Hijikata, Tatsumi (2000b) 'To Prison', *TDR*, vol. 44, no. 1 (Spring 2000), pp. 43–48.

Howes, David (1991) 'Olfaction and Transition', *The Varieties of Sensory Experience A Sourcebook in the Anthropology of the Senses*, ed. David Howes (Toronto, Buffalo and London: University of Toronto Press), pp. 128–147.

Huelsenbeck, Richard (1920) 'En Avant Dada: A History of Dadaism', *The Dada Painters and Poets An Anthology* (1981), ed. Robert Motherwell, trans. Ralph Manheim (Cambridge, MA and London: The Belknap Press of Harvard University Press), pp. 23–48.

Huelsenbeck, Richard (1969) *Memoires of a Dada Dreamer*, ed. Hans J. Kleinschmidt, trans. Joachin Neugroschel (New York: Viking).

Hughes, Holly and Román, David (1998) *O Solo Homo: The New Queer Performance* (New York: Grove Press).

Huhtamo, Erkki (1995) 'Seeking Deeper Contact: Interactive Art as Metacommentary', *Convergence: The International Journal of Research into New Media Technologies*, vol. 1, no. 2, pp. 81–104.

Irigaray, Luce (1985) *This Sex which is Not One*, trans. Catherine Porter and Carolyn Burke (Ithaca: Cornell University Press).

Igarashi, Y. (2000) *Bodies of Memory: Narratives of War in Postwar Japanese Culture, 1945–1970* (Princeton, NJ: Princeton University Press).

Jameson, Frederic (1991) *Postmodernism, or, the Cutural Logic of Late Capitalism* (Durham: Duke University Press)

Jay, Martin (1994) *Downcast Eyes* (Los Angeles: University of California Press).

Johnson, Anna (1993) 'Coco Fusco and Guillermo Gómez–Peña', *BOMB* 42, http://bombmagazine.org/article/1599/ (last accessed 3/3/2014).

Johnson, Jim (1988) 'Mixing Humans and nonhumans together: the sociology of a door–closer', *Social Problems*, vol. 35, pp. 298–310.

Kac, Eduardo (2000) 'GFP Bunny', www.ekac.org/gfpbunny.html (last accessed 18/2/2014).

Kac, Eduardo (2005) *Telepresence and Bio Art: Networking Humans, Animals and Robots* (Michigan: University of Michigan Press).

Kac, Eduardo (2009) 'Lagoglyphs: The Lepus Constellation #3', www.ekac.org/lepus.3.html (last accessed 19/2/2014).

Kac, Eduardo (2009) 'Natural History of the Enigma', www.ekac.org/nat.hist.enig.html (last accessed 18/2/2014).

Kachur, Lewis (2001) *Displaying the Marvelous* (Cambridge, MA and London: MIT Press).

Kandinsky, Wassily (1977) *On the Spiritual in Art*, trans. M.T.H Sadler (New York: Dover Publication).

Kane, Stephanie and Greenhill, Pauline (2007) 'A Feminist Perspective on Bioterror: From Anthrax to Critical Art Ensemble', *Signs*, vol. 33, no. 1 (Autumn 2007), pp. 53–80.

Kaprow, Allan (1966a) *Assemblages, Environments, Happenings* (New York: Harry N. Abrams).

Kaprow, Allan (1966b) *Some Recent Happenings* (New York: A Great Bear Pamphlet).

Kaprow, Allan (1967) *Untitled Essay and Other Works* (New York: A Great Bear Pamphlet).

Kaprow, Allan (2003) *Essays on the Blurring of Art and Life*, ed. Jeff Kelley (Berkeley and London: University of California Press).

Kaufman, Jason Edward (2008) 'Painting: What the Mind's Eye Sees: Action painters were postwar exemplars of individualism', *The American Scholar*, vol. 77, no. 2 (Spring 2008), pp. 113–117.

Kepinska, Alicja and Lee, Patrick (1986) 'Chaos as a Value in the Mythological Background of Action Painting', *Artibus et Historiae*, vol. 7, no. 14 (1986), pp. 107–123.

Kerejeta, Maria Jose (ed.) (2002) *Orlan 1964–2001*, trans Brian Webster and Careen Irwin (Vitoria–Gasteiz, Spain: Artium; Salamanca, Spain: Ediciones Universidad de Salamanca).

Kimmel, Michael S. (2008 [2004]) *The Gendered Society* (New York and Oxford: Oxford University Press).

King, Elliot H. (2002) 'Dali Anatomicus, or the Prodigious Adventure of the Lacemaker and the Rhinoceros', *SLS Annual Meeting*, 10–13 October 2002, Pasadena, California (unpublished paper).

Kirby, Michael and Kirby, Nes Victoria (1986 [1971]) *Futurist Performance* (New York: PAJ Publications).

Knabb, Ken (ed.) (1981) *Situationist International Anthology*, trans. Ken Knabb (Berkeley, CA: The Bureau of Public Secrets).

Kostelanetz, Richard (ed.) (1971) *John Cage* (UK: Allen Lane The Penguin Press).

Kostelanetz, Richard (ed.) (1993) *John Cage: Writer* (New York: Limelight).

Kostelanetz, Richard (ed.) (2003 [1987]) *Conversing with Cage* (London & New York: Routledge).

Kozel, Susan (1994) 'Spacemaking: Experiences of a Virtual Body', *Dance & Technology Zone*, www.art.net/~dtz/kozel.html (last accessed 21/8/2014).

Krauss, Rosalind (1993 [1977]) 'Mechanical Ballets: Light, Motion, Theater', *Passages in Modern Sculpture* (Cambridge, MA: MIT Press), pp. 201–242.

Kurihara, Nanako (2000) 'Hijikata Tatsumi: The Words of Butoh', *TDR*, vol. 44, no. 1 (Spring 2000), pp. 10–28.

Kurihara Nanako (2000) 'Inner Material/Material', 'Hijikata Tatsumi: The Words of Butoh', trans Jacqueline S. Ruyak and Kurihara Nanako, *TDR*, vol. 44, no.1 (Spring 2000), pp. 36–42.

Kurihara, Nanako and Ruyak, Jacqueline S. (2000) 'Hijikata Tatsumi Chronology', *TDR*, vol. 44, no. 1 (Spring 2000), pp. 29–35.

Kuroda Raiji (=KuroDalaiJee) (2001) 'Studies of Japanese Performance in the 1960s I, Zero *Jigen* as Culture, Notes for the Introductory Chapter', *The Kajima Foundation for the Arts Annual Report*, The Kajima Foundation for the Arts, pp. 362–376.

Kuroda Raiji (=KuroDalaiJee) (2003) 'The Rituals of "Zero Jigen" in Urban Space', R. Issue 02/2003, pp. 32–37, www.kanazawa21.jp/tmpImages/videoFiles/file–52–2–e–file–2 (last accessed 4/11/2014).

Lacan, Jacques (1997) *Écrits: A Selection* (London: W.W. Norton & Company Ltd).

Lambert–Beatty, Carrie (2008) 'Twelve Miles: Boundaries of the New Art/Activism', *Sings*, vol. 33, no. 2 (Winter 2008), pp. 309–327.

Lambert, Steve et al. (2009) 'The Yes Men', *BOMB*, no. 107 (Spring 2009), pp. 78–83.

Latour, Bruno (1987) *Science in Action: How to Follow Scientists and Engineers through Society* (Cambridge, MA: Harvard University Press).

Latour, Bruno (1988 [1984]) *The Pasteurization of France*, trans Alan Sheridan and John Law (Cambridge, MA: Harvard University Press).

Latour, Bruno (1993) *We Have Never Been Modern*, trans. Catherine Porter (Cambridge: Harvard University Press).

Latour, Bruno (1999a) 'On Recalling ANT', *Actor–Network Theory and After*, eds John Law and John Hassard (Oxford: Blackwell), pp. 15–25.

Latour, Bruno (1999b) *Pandora's Hope: Essays on the Reality of Science Studies* (Cambridge, MA: Harvard University Press).

Latour, Bruno (2004 [1999]) *Politics of Nature: How to Bring the Sciences into Democracy*, trans. Catherine Porter (Cambridge, MA: Harvard University Press).

Latour, Bruno (2005) *Reassembling the Social: An Introduction to Actor–Network Theory* (Oxford: Oxford University Press).

Latour, Bruno (2013) 'Another way to compose the common world: "The Onotological Turn in French Philosophical Anthropology"', The Executive Session of the AAA Annual Meeting, Chicago, 23/11/2013: www.bruno-latour.fr/sites/default/files/132-AAA-CHICAGO-PHIl-ANTH-2013.pdf. (last accessed 5/1/2015)

Latour, Bruno and Woolgar, Steve (1979) *Laboratory Life: The Construction of Scientific Facts* (Princeton: Princeton University Press).

Laurel, Brenda (1991) *Computers as Theatre* (Reading, MA and London: Addison–Wesley Publishing Company).

Le Corbusier (1986 [1923]) *Towards a New Architecture* (New York: Dover).

Leeber, Irmeline (1980) 'Joseph Beuys', *Cahiers du Musée National d'Art Moderne*, no. 4, Paris.

Lebel, Jean–Jacques (1998) 'Portfolio', *Grand Street*, no. 65, Summer, pp. 136–142.

Lebel, Jean-Jacques (2015) Email correspondence with the Author, Author's private archive, 21/7/2015.

Lefebvre, Henri (1974) *La production de l'espace* (Paris: Anthropos).

Lefebvre, Henri (1991) *Critique of Everyday Life I*, trans. John Moore (London: Verso).

Leonard, George J. (1995) *Into the Light of Things: The Commonplace from Wordsworth to John Cage* (Chicago: University of Chicago Press).

Lettrists International (1955) *Potlatch*, no.23, 13 October 1955. Centre Georges Pompidou.

Lin, Zhongjie (2010) *Kenzo Tange and the Metabolist Movement* (London and New York: Routledge).

Lippard, Lucy (ed.) (1971) *Dadas on Art* (Englewook Cliffs, New Jersey: Prentice Hall).

Lippard, Lucy (1973) *Six years: the dematerialization of the art object from 1966 to 1972* (London: Studio Vista).

Lippard, Lucy (1976) *From the Center: Feminist Essays on Women's Art* (New York: Dutton).

Lorde, Audre (1979) 'Man Child: A Black Lesbian Feminist's Response', *Conditions: Four*, vol. 2, no. 1, pp. 30–36.

Lyotard, Jean-François (1984 [1979]) *The Postmodern Condition: A Report on Knowledge*, trans Geoff Bennington and Brian Massumi (Manchester: Manchester University Press).

MacDonald, Claire (1995) 'Feminism, Autobiography, and Performance Art', *The Uses of Autobiography*, ed. Julia Swindells (London: Taylor and Francis).

MacDonald, Scott et al. (1991) 'Two Interviews. Demystifying the Female Body: Anne Severson "Near the Big Chakra". Yvonne Rainer: "Privilege"', *Film Quarterly*, vol. 45, no. 1 (Autumn 1991), pp.18–32.

MacDougall, David (1998) *Transcultural Cinema* (Princeton, NJ: Princeton University Press).

Mahon, Alyce (2005) *Surrealism and the Politics of Eros: 1938–1968* (London: Thames and Hudson).

Manovich, Lev (2000) *The Language of New Media* (Cambridge, MA: MIT Press).

Maré de, Rolf (1924) 'A propos de *Relâche*', *Comoedia*, November 27, Centre George Pompidou.

Marinetti, F. T. (1973 [1909]) 'The Founding Manifesto of Futurism', *Futurist Manifestos*, ed. Umbro Apollonio (1973), trans Robert Brain et al. (New York: The Viking Press), pp. 19–24.

Marinetti, F. T. (1973 [1913]) 'Destruction of Syntax – Imagination without Strings – Words-in-Freedom', *Futurist Manifestos*, ed. Umbro Apollonio (1973), trans. Robert Brain et al. (New York: The Viking Press), pp. 95–106.

Marinetti, F. T. (1973 [1913]) 'The Variety Theatre', *Futurist Manifestos*, ed. Umbro Apollonio (1973), trans Robert Brain et al. (New York: The Viking Press), pp. 126–131.

Marinetti, F. T. (1971) *Selected Writings*, eds and trans R. W. Flint and A. A. Coppotelli (New York: Farrar, Straus and Giroux).

Marinetti, F. T. (1990 [1927]) 'La misurazione futurista', *Misurazioni*, ed. Marialuisa Grilli (Florence: Vallecchi).

Marinetti, F. T. (2005 [1921]) 'Tactilism', *The Book of Touch*, ed. Constance Classen (Berg, Oxford and New York), pp. 329–332.

Marinetti, F. T. (2006a [1910]) 'Against Academic Teachers', *Critical Writings*, ed. Günter Berghaus, trans. Doug Thompson (New York: Farrar, Straus and Giroux), pp.81–84.

Marinetti, F. T. (2006b) *Critical Writings*, ed. Günter Berghaus, trans. Doug Thompson (New York: Farrar, Straus and Giroux).

Marinetti, F. T. (2014 [1989]) *The Futurist Cookbook*, trans. Suzanne Brill, ed. Lesley Chamberlain (London: Penguin).

Marinetti, F. T. et al. (1973 [1915]) 'The Futurist Synthetic Theatre', *Futurist Manifestos*, ed. Umbro Apollonio (1973), trans Robert Brain et al., (New York: The Viking Press), pp. 183–196.

Markov, Vladimir (1962) *The Longer Poems of V. Khlebnikov* (Berkeley: University of California Publications in Modern Philology).

Marks, Laura U. (2002) *Touch: Sensuous Theory and Multisensory Media* (Minneapolis: MIT).

Marx, Karl (1990 [1976]) *Capital: A Critique of Political Economy*, vol. 1, trans. Ben Fowles (London: Penguin Books).

Marx, Karl and Engels, Friedrich (1959) *Manifest der Kommunistische Partei*, in *Marx-Engels Werke*, vol. 4 (Berlin: Dietz).

Masson, André (1956) 'Le Peintre et ses fantasmes', *Les Etudes philosophiques*, vol. 11, no. 4 (October–December), pp. 634–636.

Mayr, W. (1924) 'Entretien avec Erik Satie', *Le Journal littéraire*, no. 24 (October 4), p. 11.

McDonough, Tom (2004) *Guy Debord and the Situationists International* (Cambridge, MA & London: MIT Press).

McDonough, Tom (ed.) (2009) *The Situationists and the City* (London and New York: Verso).

McKenzie, Jon, Schneider, Rebecca and CAE (2000) 'Critical Art Ensemble Tactical Media Practitioners: An Interview', *TDR*, vol. 44, no. 4 (Winter 2000), pp. 136–150.

McLuhan, Marshall (1964) *Understanding Media: The Extensions of Man* (London: Routledge & Kegan Paul).

Meikle, Graham (2002) *Future Active: Media Activism and the Internet* (London and New York: Routledge).

Melzer, Annabelle (1980) *Latest Rage and the Big Drum: Dada and surrealist performance* (Baltimore & London: John Hopkins University Press).

Merewether, Charles (2007) 'Disjunctive Modernity: The Practice of Artistic Experimentation in Post–War Japan', *Art Anti–Art Non–Art Experimentations in the Public Sphere in Postwar Japan 1950–1970*, eds Charles Merewether and Hiro Iezumi Rika (Los Angeles: Getty Publications).

Michelson, Annette (1984) *Kino–Eye The Writings of Dziga Vertov* (Berkeley; Los Angeles; London: University of California Press).

Miller, Tim and Román, David (1995) 'Preaching to the Converted', *Theatre Journal*, vol. 47, no. 2, *Gay and Lesbian Queeries* (May 1995), pp. 169–188.

Ming Tiampo (ed.) (2004) *Electrifying Art: Atsuko Tanaka 1954–1968*, exhibition catalogue (Vancouver: Morris and Helen Belkin Art Gallery, University of British Columbia; New York: Grey Art Gallery, New York University).

Ming, Tiampo (2011) *Gutai Decentering Modernism* (Chicago and London: University of Chicago Press).

Ming, Tiampo (2013) 'Please Draw Freely', *Gutai Splendid Ground*, eds Tiampo Ming and Alexandra Munroe (New York: Guggenheim Museum Publications), pp. 45–79.

Moore, Sally F. and Myerhoff, Barbara G (1977) 'Secular Ritual: Forms and Meanings', *Secular Ritual*, eds Sally F. Moore and Barbara G. Myerhoff (Assen and Amsterdam: Van Gorcum).

Morando, Camille (2006) 'Le corps sans limite ou l'acéphalité: le personage d'Acéphale, secret et équivoque, dans les oeuvres des artistes autour du Collège de Sociologie', *RACAR: revue d'art cannadienne/Canadian Art Review*, vol. 31, no. 1/2 (2006), pp. 81–89.

Moses, Omri (2004) 'Jackson Pollock's Address to the Nonhuman', *Oxford Art Journal*, vol. 27, no. 1, pp. 3–22.

Mouffe, Chantal (2007) 'Artistic Activism and Agonistic Spaces', *Art & Research*, vol. 1, no. 2 (Summer), pp.1–5, www.artandresearch.org.uk/v1n2/mouffe.html (last accessed 2/7/2015).

Muehl, Otto (1999 [1968]) 'Muehl', *Brus, Meuhl, Nitsch, Schwarzkogler: The Writings of the Vienna Actionists*, ed. and trans. Malcom Green (London: Atlas Press), pp. 77–126.

Mueller, Roswitha (1994) *Valie Export: Fragments of the Imagination* (Bloomington: Indiana University Press).

Muñoz, José Esteban (1999) *Disidentifications: Queers of Color and the Performance of Politics* (Minneapolis: University of Minnesota Press).

Nagatomo, Shigenori (1992) *Attunement through the Body* (Albany: State University of New York Press).

Nancy, Jean–Luc (2000) *L'Intrus* (Paris: Editions Galilée).

Naumann, Francis, M. (1999) *Marcel Duchamp: The art of Making Art in the Age of Mechanical Reproduction* (New York: Abrams).

Negri, Antonio (2008) *Goodbye Mr. Socialism: Radical Politics in the 21st Century*, Antonio Negri in conversation with Raf Valvolva Sclesi, trans. Peter Thomas (London: Serpent's Tail).

Nelkin, Dorothy and Andrews, Lori (1998) 'Homo Economicus: the Commercialization of Body Tissue in the Age of Biotechnology', *The Hastings Center Report*, vol. 28, no. 5 (September–October), pp. 30–39.

Nesta (nd), www.nesta.org.uk (last accessed 4/7/2015).

Newman, William R. (2011) 'What Have We Learned from the Recent Historiography of Alchemy?', *Isis*, vol. 102, no. 2, pp. 313–321.

Nietzsche, Friedrich (1909) *Beyond Good and Evil: A Prelude to a Philosophy of the Future*, trans. Helen Zimmerman (Edinburgh and London: T. N. Foulis).

Nietzsche, Friedrich (1967 [1909]) *Thus Spake Zarathustra: A Book for All and None*, trans. Thomas Common (London: George Allen & Unwin Ltd).

Nietzsche, Friedrich (1968) *The Will to Power*, trans Walter Kaufmann and R. J. Hollingdale (New York: Random House).

Nietzsche, Friedrich (1974) *The Gay Science: with a prelude in rhymes and an appendix of songs*, trans. Walter Kaufmann (New York: Vintage Books).

Nietzsche, Friedrich (1979) *Philosophy and Truth: Selections for Nietzsche's Notebooks of the Early 1870s*, trans. Daniel Breazeale (Atlantic Highlands: Humanities Press).

Nietzsche, Friedrich (1985) *Human, All Too Human*, trans. Marion Faber (Lincoln, Nebraska: University of Nebraska Press).

Nightingale, Andrea Wilson (2001) 'On Wandering and Wondering: "Theoria" in Greek Philosophy and Culture', *Arion: A Journal of Humanities and the Classics*, Third Series, vol. 9, no. 2.2 (Fall), pp. 23–58.

Nitsch, Hermann (1999 [1962]) 'Nitsch', *Brus, Meuhl, Nitsch, Schwarzkogler: The Writings of the Vienna Actionists*, ed. and trans. Malcom Green (London: Atlas Press), pp. 127–177.

Nyman, Michael (1974) *Experimental Music: Cage and Beyond* (New York: Schirmer Books).

O'Brien, Paul (1966) 'Art & Technology: Leaving Reality Behind?', *Circa*, no. 78 (Winter), pp. 20–23.

O'Connor, Francis (1967) *Jackson Pollock* (New York: The Museum of Modern Art).

ORLAN (nd), http://orlan.eu/adriensina/manifeste/carnal.html (last accessed 27/12/2014).

ORLAN (1996) *Ceci est mon corps …Ceci est mon logiciel/ This is my body…This is my software*, trans Tanya Augsburg and Michel A. Moos, ed. Duncan McCorquodale (London: Black Dog Publishing).

ORLAN (1997a) *de l'art charnel au baiser de l'artiste* (Paris: Editions Jean–Michel Place).

ORLAN (1997b) 'ORLAN Conférence', *de l'art charnel au baiser de l'artiste* (Paris: Editions Jean–Michel Place), pp. 34–42.

Orr, Martin (2007) The Failure of Neoliberal Globalization and the End of Empire', *International Review of Modern Sociology*, vol. 33, pp. 105–122.

Orton, Fred (1991) 'Action, Revolution and Painting', *Oxford Art Journal*, vol. 14, no. 2, pp. 3–17.

Peirce, C. S. (1960) *Collected Papers*, vol. 6, Pragmatism and Scientific Metaphysics (Cambridge: Belknap Press of Harvard University Press).

Pembrey, M. E. et al. (2006) 'Sex–specific, male–line transgenerational responses in humans', *European Journal of Human Genetics*, vol. 14, pp. 159–166.

Petrić Vlada (1978) 'Dziga Vertov as Theorist', *Cinema Journal*, vol. 18, no. 1 (Autumn), pp. 29–44.

Petrić Vlada (1993 [1987]) *Constructivism in Film: The Man with the Movie Camera – A Cinematic Analysis* (Cambridge, MA: Cambridge University Press).

Phillips, Ruth B. (1991) 'Comments on Part II "Catching Symbolism" Studying Style and Meaning in Native American Art', *Arctic Anthropology*, vol. 28, no. 1, Art and Material Culture of the North American Subarctic and Adjacent Regions, pp. 92–100.

Piper, Adrian (1996) *Out of Order, Out of Sight, Volume I: Selected Writings in Meta–Art 1968–1992* (Cambridge, MA; London: the MIT Press).

Plant, Sadie (1992) *The Most Radical Gesture: Situationists International in a Postmodern Age* (London and New York: Routledge).

Pearson, Keith Ansell (1999) 'Bergson and Creative evolution/involution: exposing the transcendental illusion of organismic life', *The New Bergson*, ed. John Mullarkey (Manchester University Press: 1999), pp.146–168.

Peirce, C. S. (1960) *Collected Papers*, vol. 5 (Cambridge, MA: Belknap Press of Harvard University Press).

Pogglioli, Renato (1968) *The Theory of the Avant–Garde*, trans. Gerald Fitzgerald (Cambridge, MA: Belknap Press of Harvard University Press).

Pollock, Griselda (2003) 'Cockfights and Other Parades: Gesture, Difference, and the Staging of Meaning in Three Paintings by Zoffany, Pollock and Krasner', *Oxford Art Journal*, vol. 26, no. 2, pp. 143–165.

Quaranta, Domenico (2004) 'Semi–Living Art Interview with Oron Catts', *Cluster On Innovation*, no. 4 (Biotech), pp. 158–163.

Richardson, Michael and Fijalkowski, Krzysztof (eds.) (2001 [1925]) *Surrealism against the Current Tracts and Declarations* (London and Sterling, Virginia: Pluto Press).

Richie, Donald (2004) *The Japan Journals 1947–2004*, ed. L. Lowitz (Berkeley, CA: Stone Bridge Press).

Richter, Hans (2004 [1965]) *Dada: Art and Anti–Art*, trans. David Britt (London: Thames and Hudson).

Rifkin, Jeremy (1998) *The BioTech Century* (New York: Jeremy P. Tarcher/Putnam).

Riis, Søren (2008) 'The Symmetry between Bruno Latour and Martin Heidegger: The Technique of Turning a Police Officer into a Speed Bump', *Social Studies of Science*, vol. 38, no. 2 (April), pp. 285–301.

Ritzer, George (1993) *The McDonaldization of Society* (Los Angeles: Pine Forge Press).

Rose, Barbara (1980) *Pollock Painting* (New York: Agrinde Publications Ltd).

Roussel, Danièle (ed.) (1995) *Der Wiener Aktionismus und die Österreicher* (Klagenfurt: Ritter Verlag).

Russolo, Luigi (1986 [1913]) 'The Art of Noises', *Monographs in Musicology*, no. 6, trans. Barclay Brown (Pendragon Press).

Russell, Ian (2007) 'The politics of presence in an intervention into "Can You See Me Now?"', www.iarchitectures.com/cysmn.html (last accessed 5/8/2013).

Sanouillet, Michel (1965) *Dada à Paris* (Paris: Jean–Jacques Pauvert).

Schechner, Richard (2003 [1978]) *Performance Theory* (London and New York: Routledge).

Schmatz, Ferdinand and Daniel, Jamie Owen (1991) 'Viennese Actionism and the Vienna Group: The Austrian Avant–Garde after 1945', *Discourse*, vol. 14, no. 2, *Performance Issue(s): Happening, Body, Spectacle, Virtual Reality* (Spring), pp. 59–73.

Schneemann, Carolee (1979) *Complete Performance Works and Selected Writings*, ed. Bruce McPherson (New York: Documenttext New Paltz).

Schneemann, Carolee (1991) 'The Obscene Body/Politic', *Art Journal*, vol. 50, no. 4, Censorship II (Winter), pp. 28–35.

Schneemann, Carolee (2003 [1995]) 'More Than Meat Joy', *Happenings and Other Acts*, ed. Mariellen R. Sandford (London and New York: Routledge), pp. 246–267.

Schneider, Rebecca (2000) 'Nomadmedia: On Critical Art Ensemble', *TDR*, vol. 44, no. 4 (Winter), pp. 120–131.

Schneider, Rebecca and McKenzie, Jon (2004) 'Keep your Eyes on the Front and Watch Your Back', *TDR*, vol. 48, no. 4 (Winter), pp. 5–10.

Schwarz, Arturo (1974) *La Mariée mise à nu chez Marcel Duchamp* (Paris: Georges Fall).

Senda, Akihiko et al. (2000) 'Fragments of Glass: A Conversation between Hijikata Tatsumi and Suzuki Tadashi', *TDR*, vol. 44, no. 1 (Spring), pp. 62–70.

Sermon, Paul (nd) 'Telematic Dreaming – Statement', www.paulsermon.org/dream (last accessed 20/8/2014).

Sermon, Paul (2007) '"The Teleporter Zone": Interactive Media Arts in the Healthcare Context', *Leonardo*, vol. 40, no. 5, pp. 426–431.

Shanken, Edward A. (2000) 'Tele–Agency: Telematics, Telerobotics, and the Art of Meaning', *Art Journal*, vol. 59, no. 2 (Summer), pp. 64–77.

Sharp, Lesley, A. (2001) 'Commodified Kin: Death, Mourning and Competing Claims on the Bodies of Organ Donors in the United States', *American Anthropologist, New Series*, vol.103, no. 1, pp. 112–133.

Shatz, Adam (1998) 'Black like Me: Conceptual Artist Adrian Piper gets under Your Skin', *Lingua Franca*, vol. 8, pp. 39–46.

Shibusawa, Tatsuhiko and Hijikata, Tatsumi (2000) 'Hijikata Tatsumi: Plucking off the Darkness of the Flesh. An Interview', *TDR*, vol. 44, no. 1 (Spring), pp. 49–55.

Shilling, Jürgen (1978) *Aktionkunst* (Frankfurt and Lucerne: C.J. Bucher).

Sholette, Gregory (2005) 'Disciplining the Avant–Garde: The United States versus the Critical Art Ensemble', *Circa*, no. 112 (Summer), pp. 50–59.

Simpson Stern, Carol and Henderson, Bruce (1993) *Performance: Texts and Contexts* (London: Longman).

Singer, Peter (2009) 'Speciesism and Moral Status', *Metaphilosophy*, vol. 40, no. 3–4, July, pp. 567–581.

Smith, William S. (2014) 'Corporate Aesthetics: The Yes Men Revolt', *Art in America*, 22 April, www.artinamericamagazine.com/news–features/interviews/corporate–aesthetics–the–yes–men–revolt/ (last accessed 28/6/2014).

Steiner, Rudolf (1998) *Bees: Lectures by Rudolf Steiner* trans. and introduction by Gunther Hauk (Hudson: Anthroposophic Press).

Stiles, Kristine (1993) 'Between Water and Stone Fluxus Performance a Metaphysics of Acts', *In the Spirit of Fluxus*, eds Elizabeth Armstrong and Joan Rothfuss (Minneapolis: Walker Arts Center), pp. 62–99.

Suleiman, Susan Rubin (1990) *Subversive Intent: Gender, Politics and the Avant–Garde* (Cambridge, MA: Harvard University Press).

Suzuki, D. T. (1953) *Essays in Zen Buddhism* (Triptree: Rider and Company).

Suzuki, D. T. (1969) *The Zen Doctrine of No Mind*, ed. Christmas Humphreys (London: Rider and Company).

Suzuki, D. T. (1972) *Living by Zen* (London: Rider and Company).

Tanaka, Atsuko (2004) *Electrifying Art*, Exhibition Catalogue (Vancouver: Morris and Helen Belkin Gallery).

Taylor, Diana (1998) 'A Savage Performance: Guillermo Gómez–Peña and Coco Fusco's "Couple in the Cage"', *TDR*, vol. 42, no. 2 (Summer), pp. 160–175.

Thacker, Eugene (2004) 'Networks, Swarms, Multitudes', *CTHEORY*, www.ctheory.net/home.aspx (last accessed 3/6/2013).

The Yes Men (2004) *The True Story of the End of the World Trade Organization* (New York: The Disinformation Company Ltd).

The Yes Men (2006) 'WTO Proposes Slavery for Africa', http://theyesmen.org/hijinks/wharton (last accessed 21/10/2014).

Thompson, Nato (2005) *Becoming Animal: contemporary art in the animal kingdom* (Cambridge, MA: MIT Press).

Thompson, Nato and Sholette, Gregory (2004) *The Interventionists: User's Manual for the Creative Disruption of Everyday Life* (Cambridge, MA and London: MIT Press).

Tisato, Veronica and Cozzi, Emanuela (2012) 'Xenotransplantation: An Over view of the Field', *Methods in Molecular Biology*, vol. 885, pp. 1–16.

Tisdall, Caroline (1981) *Joseph Beuys* (New York: Guggenheim Museum Catalog).

Tomasi, Alessandro (2007) 'Technology and Intimacy in the Philosophy of Georges Bataille', *Human Studies*, vol. 30, no. 4 (December), pp. 411–428.

Todd, Jane Marie (1986) 'The Veiled Woman in Freud's "Das Unheimliche"', *Signs*, vol. 11, no. 3 (Spring), pp. 519–528.

Tromble, Meredith and Hershman, Lynn (eds) (2005) *The Art and Lives of Lynn Hershman Leeson: Secret Agents, Private I* (Los Angeles and London: University of California Press and Henry Art Gallery).

Turner, Victor (1977) 'Variations on a Theme of Liminality', *Secular Ritual*, eds Sally F. Moore and Barbara G. Myerhoff (Assen and Amsterdam: Van Gorcum), pp. 36–53.

Turner, Victor (1982) *From Ritual to Theatre: Human Seriousness at Play* (New York: Performing Arts Journal Publications).

Tzara, Tristan (1981 [1951]) 'Dada Manifesto 1918', *The Dada Painters and Poets: An Anthology*, ed. Robert Motherwell (New York: George Wittenborn, Inc), pp. 76–82.

Vaneigem, Raoul (1961) 'Comments against Urbanism', *Internationale Situationniste* no. 6, August, Centre Georges Pompidou.

Vaneigem, Raoul (2003 [1983]) *The Revolution of Everyday Life*, trans. Donald Nicholson–Smith (London: Rebel Press).

Vaughan, David and Harris, Melissa (2004) *Merce Cunningham: Fifty Years* (New York: Aperture).

Vertov, Dziga (1984) *Kino–Eye The Writings of Dziga Vertov*, ed. Annette Micheson, trans. Kevin O'Brien (Berkeley, Los Angeles and London: University of California Press).

Viala, Jean and Masson–Sekine Nourit (1991 [1988]) *Butoh: Shades of Darkness* (Tokyo: Shufunotomo).

Werhane, Patricia H. et al. (2011) 'Social Constructivism, Mental Models, and Problems of Obedience', *Journal of Business Ethics*, vol. 100, no. 1, pp. 103–118.

Williams, Raymond (1977) *Marxism and Literature* (Oxford: Oxford University Press).

Wilson, A. N. (1999) *God's Funeral* (London: Abacus).

Wilson, E. O. (1979) *On Human Nature* (Cambridge, MA: Harvard University Press).

Virilio, Paul (2005) *The City of Panic*, trans. Julie Rose (Oxford: Berg).

Wishart, Adam and Bochsler, Regula (2006) *Leaving Reality Behind: etoy vs eToys. com & other battles to control cyberspace* (Vienna, Bari, Oldenburg: Amazon Noir).

Yamamoto, Tsunetomo (2006) *Hagakure: Selections: The Way of the Samurai* (New York: ReadHowYouWant).

Yoshimoto, Midori (2005) *Into Performance: Japanese Women Artists in New York* (New Brunswick and London: Rutgers University Press).

Young, Lisa (2000) *Biotechnology and Genetic Engineering* (New York: Facts on File).

Zhang, Xianglong (2009) 'The Coming Time "Between" Being and Daoist Emptiness: An Analysis of Heidegger's Article Inquiring into the Uniqueness of the Poet via the Lao Zi', *Philosophy East and West*, vol. 59, no. 1 (January), pp. 71–87.

Index

A

abject 117, 124
abnormal 146, 187
abreaction 111–112
absence 38, 72, 76, 132, 205–206, 208–210, 213
accursed share 107–108
action painting 10, 64, 68, 81, 161
active valuing 15
activism 206, 213, 215–217, 219–221, 223, 225, 227–229, 231, 233
actor-network theory 240
aesthetics 69, 108, 125, 240–241, 248
Agamben, Giorgio 186–187, 227
agency 57, 59, 196, 241, 245–246, 249
Agent Ruby 197–198, 211
agon 140, 233
agonistic approach 233
Akasegawa, Genpei 130
alchemy 50, 120, 124, 243, 249
aletheuein 64
alienation 86, 89–90, 104, 193, 226
Althusser, Louis 168
alypha 169
anarchy 193
Andrews, Lori 243
ankoku butoh 114
anthropology 5, 7, 58–59, 228
anthroposophy 124
Antin, Eleanor 170
Apollo 18
Apollonian art 23
appropriation 88, 154, 159, 165, 198
Aragon, Louis 31, 37–38, 41, 44
Arata, Isozaki 79
archaic thought 119
areal painting 9
Arp, Hans 32
Ascott, Roy 199
attention 36, 51, 64, 70, 74–76, 90, 112, 130, 142, 157, 171, 175, 192, 203, 221, 230, 233, 242, 247

attunement 113, 117, 127
Audre, Lorde 173
Auerbach, David 174
Austin, J.L. 37
authenticity 10, 61, 63–65, 67–69, 71, 73, 75, 77, 79, 81, 92
authoritative citation 184
authority 3, 13, 15, 37–38, 87, 168, 184, 228–230, 247
automatic drawing 10
automatic writing 10, 39–40
avant-garde 5
avatar 194, 209–210, 212, 248
Ay-O 133
Azari, Fedele 26

B

Baker, Bobby 10, 148, 161–165
Ball, Hugo 27, 29–31, 139–142
Balla, Giacomo 21
Bard, Alexander 220, 249
bare life 186
base materialism 109
Bataille, George 9–10, 107–110, 112–116, 119, 122–123, 125, 224–225
Baudelaire, Charles 94
Being 2, 7, 9, 11, 20, 22–23, 25, 27–28, 30, 38, 41, 43, 45, 50, 52, 58–59, 62–63, 67–69, 72, 74–76, 78, 81, 86, 90–91, 98, 110–111, 113–118, 122, 124, 132, 134, 141–142, 147, 151–153, 156, 159–160, 166–168, 170–176, 180–181, 183–186, 189, 195–201, 204–205, 210, 215, 219, 223, 228–229, 232, 240–241, 244
Bergson, Henri 9, 41–44, 46–51, 55, 68, 119
Beuys, Joseph 10, 108, 118–125
binary opposition 128, 169
bio-art 7
biodynamics 124
bioengineering 232, 235, 244–245

biological essentialism 168
biomechanics 54
biopolitics 186
biopower 145–147, 149, 151, 153, 155, 157, 159, 161, 163, 165, 227, 232
biotechnology 235, 242–243
Black Panthers 171, 173, 180
Black Power 145
Blast Theory 11, 205–208, 211, 213, 226
blind tactics 137–138, 141–142
Boccioni, Umberto 18
Borges, Jorge Luis 195
Botticelli, Sandro 158
bourgeoisie 213
Brecht, George 133–137
Breton, Andre 31–32, 37–41, 43–44, 49, 52–53, 61
Brus, Gunter 109, 113–114, 125
bushido 115
Butler, Judith 11, 167–171, 173, 176, 179, 181, 184
butoh-fu 116, 124

C

Cabaret Voltaire 27–28, 30–32
Cache, Bernard 104
Cage, John 5, 10, 23, 39, 69–71, 73–76, 81, 99, 121, 123, 129, 134–136, 138–139, 141, 182–185, 194, 196, 205
Caillois, Roger 140
canvas 64, 66, 82, 162, 166
capital 27, 62, 85–86, 102, 213, 215, 219, 228
capitalism 13, 85–86, 88, 90, 99, 102–103, 107, 189, 194, 232
Carlson, Marvin 3
carnal art 10, 158–159
Carnal Manifesto 158
categorisation 174, 202, 246
Catts, Oron 236, 242–245, 247, 249
cellular organisation 227, 232
cellular self-organisation 11, 225–226
censorship 44, 149, 153
Certeau de, Michel 94–95, 233
chance operations 9, 28, 32, 34–35, 52, 139, 141
chi 79
Chicago, Judy 148

chimera 241
chronarchic 96, 104
civil disobedience 230
Cixous, Hélène 10, 159–160, 164–165
Clair, René 44, 48–49, 195
Clancy, Peta 11
co-authorship 203
co-creation 203
codes of representation 209
collage 9, 28, 50–51, 89, 158
colonialism 194, 220
commodity 10, 85–87, 89–91, 93, 95, 97–99, 101, 103, 105
commodity fetishism 10, 85–87, 89, 91, 93, 95, 97, 99, 101, 103, 105
communion 3, 56, 231, 248
community 28, 79, 113, 136, 175–177, 224
companion-species 249
complexity 55–56, 151, 178, 205–206, 210, 242
computer science 5, 211
concretism 134, 138, 142
confession 176
connectivism 199
consciousness 21, 28, 30, 40, 42–43, 48–49, 51, 56, 58, 87, 97–98, 122, 132, 167, 171, 179, 181, 194, 198–199, 211, 215, 248
constitution 167–169, 185–186, 226
constructivism 5, 54, 58
consumerism 61, 83, 88, 171
consumerist strategies 87
Corbusier Le 92–93
corporation 216–217, 220–223, 233
Corra, Bruno 18, 20–21
Craven, Arthur 33
creative evolution 42, 46
creative valuing 15–16, 33–34
Crevel, René 41
Critical Art Ensemble 11, 226–228, 231–232, 235
critique 4, 7, 11, 27, 37, 85, 90, 93, 98, 100–101, 104, 123, 130, 132, 152, 156, 164–165, 171, 204, 206, 216, 237
cross-breeding 237–239
cultural practice 36, 183
cultural sphere 177
culture 2, 5, 11, 59, 115, 121, 132, 148, 152, 169, 171, 175, 177, 180,

185, 191, 206, 215–216, 222, 224, 228–229, 242, 244, 246, 249
culture jamming 216
Cunningham, Merce 10, 69–73, 81, 99
cyborg 11, 191, 193–194, 198, 203–204
Cyborg manifesto 191

D
Da Vinci, Leonardo 53
Dada 5, 27–29, 31–35, 37, 58, 85, 102, 134
Dada manifesto 27
Dadaism 5, 9, 26, 102
Dali, Salvador 10
Damisch, Hubert 67
Dasein 63, 66–69, 81
Davis, Angela 11, 170, 177, 180–183, 185–186
De Kooning, Willem 64
Debord, Guy 9–10, 85–86, 91, 94–96, 104–105, 107, 206, 214
deconstruction 10, 83, 131, 133, 143
Deleuze, Gilles 225
derive 108
Derrida, Jacques 10, 83, 128–133, 136, 138–139, 143, 146, 193, 205, 233
Desnos, Robert 41
Destruktion 131
digital culture 222
digital hijack 223
digital resistance 230
digitisation 189
Dionysian art 23
Dionysus 23, 150
direct art 113
directionality 137, 201
discipline 6–7, 111, 226, 240
disciplining 126, 146, 153, 246
discourse 29, 145–146, 148, 150, 158–159, 161, 165, 167, 196, 204, 230, 240
Disneyland 214
dispositif 146
DNA 197, 230, 239
dogma 9, 107
domination 13, 22, 35, 86, 96, 108, 145, 154, 165, 193, 215–216, 228
drag 170
Dreyfus, Hubert 211

drift 10, 94
Duchamp, Marcel 27, 34–35, 45, 47, 53, 61, 138–139, 141, 195–196
duration 6, 29, 41–44, 46–47, 49, 51, 57–59, 68, 70, 73–75, 95, 97, 137, 140, 199
dwelling 77–82
dynamism 17, 26, 57

E
Eagleton, Terry 9
Eckhart, Meister 70
economy of the spectacle 90
Einstein, Albert 46, 236
electronic colonialism 220
emptiness 74, 117, 130, 207
energetics 20, 35, 206
enframing 62–63, 69, 76
epistemology 123
erasure 92, 186
Ernst, Max 39, 41, 50, 61, 64
eroticism 34, 91, 102–103, 112, 114–117
Esposto, Gino 221
essentialism 168
ethnography 7, 198
etoy 11, 221–227, 232
eugenics 242–243
event score 133–134, 136, 143
exchange value 85–86, 219, 222
existential intimacy 109–110

F
feminism 145, 191
festival 6, 96, 98–99, 102, 149–150, 207
Filliou, Robert 133
Finley, Karen 161–162, 164, 177
Fleck, John 177
Fluxus 8, 10, 23, 128–129, 131, 133–137, 141, 143, 196, 205, 222
Ford, Henry 61, 93
Forti, Simone 149
Foucault, Michel 4–5, 7, 145–146, 150, 165, 167–168, 186, 227, 246
fourfold 77–79
Freud, Sigmund 39–41, 43, 58, 146–148, 150, 159–160, 169
Friedman, Ken 133, 217
Fromm, Erich 87, 97, 146

frottage 50–51, 54, 59
Fusco, Coco 11, 182–186
Futurism 5, 9, 17–18, 23, 26–27, 58
Futurist banquets 8, 24, 26, 35
Futurist manifesto 18, 76

G

Galbraith, John Kenneth 61
game 6, 30, 89, 134, 137–138,
 140–144, 195, 206, 208–210, 212,
 214, 217, 223
Garcia, David 228
Gardner, Howard 6
gelassenheit 69
gender politics 128
gender reassignment 180
gender-bending 11
general economy 10, 107, 112, 115,
 117, 125, 225
Genet, Jean 116
genetic dispositions 168
genome 218, 230–231
gestell 62
gift 108–110
gishiki 125–128, 136
global village 216
globalisation 189, 216, 219, 222
Goldstein, Marky 221
Gorz, André 204
governing 7, 138, 140
Gramazio, Fabio 221
grammar 94
Grosz, George 27, 81, 102
Guatinauis 182, 185
gustatory-olfactory art 23
Gutai Group 10, 76–77, 80–81, 123,
 210–211, 226

H

hacking 78
Hall, Stuart 69, 72, 75, 77–78, 105,
 134–135, 177, 187
Halprin, Anna 149
Han, Byung-Chul 9
Hansen, Al 134
happening 100–103, 105, 112
haptics 202
Haraway, Donna 9, 11, 191, 193–199,
 202–204, 211, 232, 249

Hardt, Michael 11, 105, 225–227, 230,
 232
Hausmann, Raoul 27, 102
Hayles, N. Katherine 11, 203–205,
 209–210, 225, 232–233
hegemony 4, 8, 177, 233
Heidegger, Martin 10, 62–64, 66,
 68–69, 74–81, 131–132, 196
Henderson, Bruce 2
Henry, Pierre 61, 71, 93, 134
Heredia, Paula 184–185
Hershman, Lynn 5, 9, 11, 171,
 191–199,
Hi Red Center 10, 125, 128, 130–131,
 142
Higgins, Dick 8, 133–136
hijack 223
Hijikata, Tatsumi 9–10, 108, 114–118,
 123, 125, 130
hsing 76
Huelsenbeck, Richard 27–29, 102
Hughes, Holly 177
Huhtamo, Erkki 196
Human Genome project 230
human-computer interaction 208
hybrid 6–8, 191, 194, 231, 238–240,
 246
hyperreality 11, 219, 223
hypertracking 199
hysteria 53, 110, 150

I

Ichikawa, Hiroshi 117
iconography 157
identity correction 215
identity politics 10, 34, 167, 169–171,
 173, 175, 177–179, 181, 183, 185,
 187
identity production 187, 214
immaterial 30, 134, 143, 202, 211
in-between-ness 74, 76, 136, 143
inauguration 176
indeterminacy 133, 135, 137
individualism 203–204
information processing 211
inscription 10, 95, 153, 158–160,
 165–166, 173, 209
instrumental labour 99, 101
inter-agentivity 249

interaction 19, 22, 56, 66, 72, 79, 81,
 93, 117, 131–132, 137, 142–143, 164,
 168, 174, 191, 195–198, 200, 203,
 206, 208, 210, 224, 226, 232,
 242, 249
interactivity 196, 209
interdisciplinarity 6–8
intermediality 8
intermedium 136
Internationale Situationiste 88–90, 93
interpellation 168, 173, 175–177, 183,
 185
interpenetration 48, 71–73, 152, 210
interpretation 40, 52, 63, 110, 125,
 127, 129, 131, 133, 135, 137, 139,
 141, 143, 145, 147, 179, 208, 211, 220
intersomativity 249
interspecies 11, 249
intertextuality 195
intervention 39, 147, 216
intonarumori 18, 22–23
intoxication 23, 41, 110–111, 113
intuition 18, 22, 41–42, 49
Irigaray, Luce 10, 145–154, 173, 198

J

Janco, Marcel 27–30
Jorn, Asger 85, 89

K

Kac, Eduardo 11, 236–242, 247
kami 79–80
Kandinsky, Wassily 30
Kant, Immanuel 42
Kaprow, Allan 10, 75, 98–102, 104,
 136, 222
Kato, Yoshihiro 126–127
Kimmel, Michael, S. 169
Kino Pravda 10, 55, 58
kinoks 55
Kline, Franz 62, 64
Knowles, Alison 133
kokutai 77
Kozel, Susan 200–203
Krasner, Lee 68
Krauss, Rosalind 45
Kubli, Martin 221
Kuro Hata 127
Kurz, Steve 228–229

L

laboratory 236, 242, 245, 247
labour 13, 38, 61–62, 86, 93, 99, 101,
 216, 218, 227
Lacan, Jacques 2
Lacy, Suzanne 148, 171
Laplanche, Jean 178
Larsen, Michelle 194
Latour, Bruno 11, 235–237, 240,
 245–249
Leary, Timothy 103
Lebel, Jean-Jacques 10, 98, 102–104,
 107, 112, 136, 149
Lefebvre, Henri 86, 91, 94–98, 105
legitimacy 177, 186, 240
Lenin, Vladimir Ilich 54–55
Lettrists 96
libidinal economy 161, 166
Lippard, Lucy 143
logocentrism 132
logos 131
ludic 134, 143, 205, 213, 215, 217,
 219, 221, 223, 225, 227, 229, 231, 233
ludology 143
Lyotard, François 83

M

Maciunas, George 133–134, 139
Macpherson, C.B. 203–204
Manovich, Lev 196
Marinetti, Filippo Tommaso 17–20,
 22–26
market relations 204
Marks, Laura 9–10, 94, 163–164, 166,
 179, 202, 211
Marx, Karl 10, 85–87, 154
masculinity 170
master morality 16–17, 22
material-informational entity 204
materiality 42, 80, 161, 200, 202, 209
Mauss, Marcel 109
McDonaldization 219
McLuhan, Marshall 191–192, 205,
 215, 225
means of production 62
mediation 136, 186, 206, 211, 246
mediatisation 83, 213
medical gaze 157
Mehring, Franz 102

metaplasm 249
Meyerhold, Vsevold 54
Miller, Tim 11, 139, 142, 170,
 174–178, 185–186
minoritarian 178, 180
Mishima, Yukio 114
misologist philosophy 130
Mixed Reality Lab 207
modernism 83
Montano, Lynda 34, 148, 170
morality 9, 16–18, 20, 22, 107
Moreau, Gustave 158
Mouffe, Chantal 233
multimedia 191
multiples 191, 194
multitude 51, 226–227
Murakami, Saburo 79–80, 125
myth 97, 101, 129, 153, 163, 193–194,
 236, 246, 249

N
Nakanishi, Natsuyaki 130
Nancy, Jean-Luc 183
narrative structure 195
naturalised 4, 71, 148, 172
Negri, Antonio 11, 105, 225–227, 230,
 232
Nelkin, Dorothy 243
Nenamou, Bob 103
Neo-Nietzscheans 18
netocracy 220
Nietzsche, Friedrich 9, 15–18, 20–21,
 23–24, 26–29, 32–35, 41, 87, 143,
 179
Nightingale, Andrea Wilson 6
Nitsch, Herman 109–113, 125
nonhuman 77, 191, 194, 246, 249
norm 2, 7, 58, 145, 158, 165, 171,
 177, 179, 181
normalcy 147, 186, 240
normativity 146, 193

O
Odagiri, Hideo 77
Ohno, Yoshito 115
oppression 5, 16, 96, 103, 145–146,
 154, 175, 205
organism 191, 193, 215, 239, 241

Orgies Mysteries Theatre
 Manifesto 110
ORLAN 10, 148, 153–159, 164–165,
 197
ownership 154, 204–205, 222

P
Paik, Nam June 133–134, 137
paradox 73, 129–131, 216
paranoid-critical method 10, 52, 54
parasitism 131
participatory 10, 19, 99, 102, 139, 221,
 223, 226
passive valuing 15
patriarchy 170, 194
Peirce, Charles Sanders 189
performance art 5
performative camera 54
performative document 50
performative object 49
persona 171–174
personality market 87
phallocentrism 145, 147
phenomenology 53, 63, 132
Picabia, Francis 10, 27, 31, 41, 44–49,
 57, 195
picturing 77, 80
Piper, Adrian 11, 34, 170–174,
 185–186
Piscator, Erwin 46
plantimal 238–239
Plato 129
Pogglioli, Renato 5
political economy 165, 230
Pollock, Jackson 62, 64–65, 67–69, 74,
 80–81, 123, 162, 164
Pontalis, Jean-Bertrand 178–179
posthumanism 203–204, 211
postnatal depression 162–163
potlatch 109–110, 119
power relations 13
pre-modern 246
presence 66, 129, 132, 176, 193–194,
 200, 204–206, 208–210, 224, 247
privatisation 218
property 98, 145, 154–155, 165, 178
proprioception 202
prosthesis 191–192, 205
Pynor, Helen 11, 236, 249

R

race 15, 28, 33, 102, 140, 142,
 146, 168, 173–174, 180–181, 185,
 193–194, 243
randomness 32, 205–206, 209–210
rational economy 108
Rauschenberg, Robert 70–71
Ray 34, 44, 47, 191
re-writing space 92
ready-made 33–34, 50, 72, 134, 138,
 144, 158, 202
Reclaim the Streets 206
reification 85
representation 10, 69, 86, 116, 119,
 146, 148, 150, 152–153, 158, 178,
 183, 185, 209, 211, 214, 219–220, 240
representational practices 165
repression 40, 157, 164, 177
resoluteness 22, 68
Ribemont-Dessaignes, Robert 31–32,
 37–38
Ricardo, David 107
Richter, Hans 27, 29, 31–33
Rimbaud, Arthur 50, 52
ritual 2–3, 67–68, 97–99, 101, 107,
 109–110, 112, 115–116, 119–121,
 123–125, 127–128, 161, 175–176,
 184–185, 245, 247
Ritzer, George 219
Row-Farr 206
RTMark 216–217, 220, 223
Russolo, Luigi 18–19, 22, 76

S

Sade de, Marquis 102–103, 115
Saito, Takako 133, 137–138
sand painting 65, 67
Satie, Erik 44–45, 47–48
Saussure de, Ferdinand 5, 132
Schaeffer, Pierre 134
Schapiro, Meyer 99
Schechner, Richard 3
Schneemann, Carolee 10, 148–153,
 156–157
Schwarzkogler, Rudolf 109
semi-living 242–247
serate 18, 20, 22–23
Sermon, Paul 11, 198–200, 213, 225
Servin, Jacques 216–220

shaman 67, 116
Shiomi, Mieko 133
Shiraga, Kazuo 77–79, 125
simultaneity 20, 29
Singer Peter 103, 180, 235
sintesi 18, 20–21
situationism 85
Situationists International 9–10, 85,
 88–92, 104, 205–206
slave morality 9, 16, 18, 20
Smith, Adam 107, 217, 221
society of the spectacle 85–86, 90,
 104, 206
Socrates 129
sovereign 108, 167
spectacularisation 89
Stalin, Joseph 54
Steiner, Rudolf 119–120
Stern, Carol Simpson 2
Stiles, Kristine 140, 194
subconscious 39, 91, 116
subject 11, 13, 40, 42, 46, 59, 91,
 108–109, 117, 122, 132, 146–148,
 160, 167–169, 173, 176, 178–182,
 184, 202, 204–205, 224, 226, 229,
 244, 247, 249
subjection 22, 167, 181
subjectivity 102, 156, 160–161
surplus 107–109
Suzuki, D.T. 71, 81, 129–130
SymbioticA 11, 242
symbolic exchange 222, 224–225
symbolic order 2, 7, 228–229
symbolic urbanism 88, 92–93, 99
symbolisation 211–212

T

taboo 114–115, 153, 248
tactical media 228
tactile sculpture 9, 35
tai 77, 79–80
tai chi 79
Takamatsu, Jiro 130
Tandavanitj, Nick 206
techno-human existence 191
technology 1–2, 7, 26–27, 61–62,
 79–80, 158–159, 189, 191, 196, 206,
 209, 212, 222–224, 228, 235, 243, 245
telematics 199, 201–203, 210

The Yes Men 11, 215–223, 225–227, 232
theoria 6, 9
thinking by doing 1, 5–6
throwness 68
Tissue Culture and Art Project 242
totem 116
tourism 96
tracing 58–59, 132, 137
tragoedia 110
trans-temporal 123–124, 186
transgenics 231, 238, 240
trousseau 154–156
truthing 64, 68–69, 74, 81

U

Udanty, Daniel 221
uncanny 147, 184
unconscious 37, 39–40, 51, 117, 119, 122
undecidable 128–130, 133, 144
unimpededness 72
universalism 230
unpredictability 113, 133, 138, 205, 210
use value 85–86, 115

V

Vaginal Davis 11, 170, 177, 180, 185
Valie Export 111, 156, 197
value 16, 19, 29, 42, 46, 52, 73, 85–88, 100, 112, 114–115, 122–123, 127, 136–138, 147, 165, 185, 214, 219, 222–225, 236, 247

valuing 5, 15–16, 18, 21, 23, 33–36, 248
Vamos, Igor 216, 219–220
Vaneigem, Raoul 86, 88, 93–94, 98, 107
Vertov, Dziga 10, 54–59, 64
Virilio Paul 189
virtuality 43, 189, 200, 206, 209, 225

W

walking 6, 8, 21, 45, 49, 68, 85, 90, 93–95, 104–105, 114, 126, 135
white writing 159, 164
Wilson, E.O. 6, 168
Woolgar, Steve 236, 247
world as picture 62
World Trade Organization 215
writing 10, 16, 37–41, 43–44, 50, 54, 57–59, 62, 73, 87, 92, 94, 129, 145, 147, 149, 151, 153, 155, 157, 159–161, 163–166, 236

Y

Yuasa, Yasuo 117

Z

Zaum poetry 56–57
Zen Buddhism 5, 70–71, 129
Zero Jigen 10, 125–128, 130–131, 136, 142
Zurr, Ionat 236, 242–245, 247, 249